D1254713

VIEWS OF ROME

VIEWS OF

ROME

Raymond Keaveney

Scala Books in association with the Biblioteca Apostolica Vaticana and the
Smithsonian Institution Traveling Exhibition Service

CONTENTS

Text © 1988 Smithsonian Institution
Color illustrations © Biblioteca Apostolica
Vaticana
Black and white illustrations are reproduced by
courtesy of the Trustees of the British Museum
and by permission of the British Library Board,
with the exception of those on pages 37, 39, 41,
43 and 45, and those on pages 82 and 221
which are reproduced by permission of Sergio
Benedetti

First published in 1988 by Scala Publications Ltd
26 Litchfield Street, London WC2H 9NJ

Distributed in the USA by Harper & Row
10 East 53rd Street, New York, NY10022

All rights reserved. No part of this book may be
reproduced or utilized in any form or by any
means, electronic or mechanical, or by any
information and retrieval system, without
written permission from the Publisher.

ISBN 0 935748 92 X (paperback)

ISBN 0 935748 89 X (US hardback)
LC 87 063617

ISBN 1 870248 15 5 (UK hardback)

Edited and produced by Scala Publications Ltd
Designed by Roger Davies
Text edited by Paul Holberton
Filmset by August Filmsetting Ltd, England
Printed and bound in Italy by Graphicom,
Vicenza

FRONTISPIECE: Anonymous, Italian, late 16th
century: *The Procession of the Magi* (showing the
Colosseum): Ashby collection, Bodart no. 387

FRONT COVER: Jakob Philipp Hackert: *The
Colosseum with the Temple of Venus and Rome*
(detail of No. 27)

The endpapers of this volume reproduce the panorama of Rome published by Giuseppe Vasi in 1765. The locations of the various monuments and sites depicted in the pages that follow are indicated on Vasi's panorama by their entry numbers as listed below:

Acknowledgements

This fascinating exhibition of VIEWS OF ROME: DRAWINGS AND WATERCOLORS FROM THE COLLECTION OF THE BIBLIOTECA APOSTOLICA VATICANA gives the visitor a unique opportunity to observe European draftsmanship of the highest order from the Renaissance to the age of Romanticism. The exhibition does not present a historic survey of European drawing of Rome, but it does exemplify the richness and importance of the Vatican Library collections, as well as providing a reflection of the development of public and private taste. In this regard the Vatican Library is unique among the great European libraries, as it has been from its foundation intended as a public collection.

VIEWS OF ROME was selected with scholarly discrimination by Raymond Keaveney, Assistant Director, National Gallery of Ireland, and Donald McClelland, Exhibition Coordinator and Curator, Smithsonian Institution Traveling Exhibition Service. Mr McClelland's sensitive essay sets the tone of the exhibition. The important and complete catalogue entries for the drawings were undertaken and written by Raymond Keaveney, whose knowledge and careful scholarship make this catalogue a genuinely important document in the study of European drawings. Marc Worsdale's essay on Rome itself also adds enormously to the study and better understanding of these varied impressions of the city.

We at the Smithsonian Institution Traveling Exhibition Service are indeed fortunate to have been given a substantial grant from Franklin H. Kissner in producing this publication. Mr Kissner's special interest in Rome spans many years, during which he has collected both books and drawings on our subject. His assistance has thus been invaluable in the development of the exhibition. Mr and Mrs Richard Gray have also been staunch friends of the exhibition and its American tour, and we are grateful to them as well.

The entire undertaking would not have been possible without the special interest and cooperation of Father Leonard Boyle, Prefetto of the Biblioteca Apostolica Vaticana, and his able staff, particularly Dott. Alfredo Diotallevi, Curator of Prints and Drawings, Piero Tiburzi of the Conservation Department, who restored and mounted the drawings, and Enzo Valci of the Photographic Department, who photographed them for this volume. Father Boyle's engaging discussion of Thomas Ashby's devotion to Rome and of the transfer of his outstanding collection of prints and drawings to the Vatican Library adds further insight to this notable exhibition.

At the Smithsonian Institution Traveling Exhibition Service, staff recognition goes to: Linda Bell, Assistant Director for Administration; Lee Williams, Registrar, and her staff; Andrea Stevens, Publications Director; Deborah Bennett, Director of Public Relations; Marci Silverman and Gregory Naranjo, Exhibition Assistants. Without their daily efforts and

constant enthusiasm, the exhibition and this book would not have been possible.

For the production and design of the catalogue, we are indebted to Philip Wilson, Michael Rose and Hugh Merrell of Scala Publications, London, also to Paul Holberton, editor, and Roger Davies, the designer of this volume.

To all of the above we express our gratitude for their help in bringing to the United States, Canada, and Ireland this exhibition of VIEWS OF ROME, which expresses the legendary brilliance and grandeur of the city, as well as its spiritual history.

EILEEN ROSE
Acting Director, Smithsonian Institution Traveling Exhibition Service

Author's Acknowledgements

It has been my great good fortune and pleasure to have been requested to compile the commentaries for the exhibits in the present show organized by the Smithsonian Institution Traveling Exhibition Service in collaboration with the Biblioteca Vaticana. Both Donald McClelland and Father Leonard Boyle, O.P., are owed a deep debt of gratitude for their promotion of this event which will, for the first time, present to the public a selection of eighty-one items from the heretofore little known collection formed by the great scholar of Roman topography, Thomas Ashby. Though I myself have known and lived in Rome for varying amounts of time since my student days, I cannot dare to say that I am an expert in the history and culture of the eternal city; indeed, such is the vast range of this subject that no mortal can begin to master all its riches, and consequently I have been obliged to seek direction and information from a multitude of sources, benefitting enormously from the kindness and assistance of a small army of advisors and supporters.

My first words of gratitude, however, must be to Donald and Father Boyle for their trust and encouragement, not to mention their generosity and forbearance. Michael Rose of Scala Publications must also be lauded for his kindness and support; indeed, were it not for his constant yet considerate persuasion, it is doubtful whether or not this publication could have been produced in time. What has been produced has benefited enormously from the intelligent and eagle-eyed scrutiny of Paul Holberton, who did more than simply trawl the text for errors, and in addition made all the uncredited translations into English. Among the many who have given freely of their time and expertise, sometimes more than one might reasonably be given to expect, were Sir Joseph Cheyne, Marco Chiarini, Jean-Pierre Cuzin, Alfredo Diotallevi, Sir Richard Brinsley Ford, Dottoressa Giulia Fusconi, Elisabeth Kieven, Professor Michael Kitson, Wouter Kloek, Michael Liversidge, Felicity Owen, Philip Pouncey, Professor Marcel Roethlisberger, Professor Seymour Slive, Lindsay Stainton, Christof Thoenes, Nicholas Turner, Luciana Valentini, Dr. An Zwollo. In Dublin I received not inconsiderable help from Sergio Benedetti, Barbara Dawson, Mary Kelleher, Veronica Montag and Michael Wynne. Finally, I must express my heartfelt thanks to my wife Kim-Mai, who for too long has had to cohabit with the ruins of Rome without enjoying any of their pleasures. I promise to make amends.

RAYMOND KEAVENEY
National Gallery of Ireland

VIEWS OF ROME

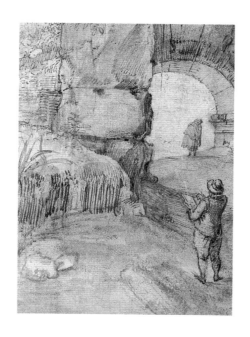

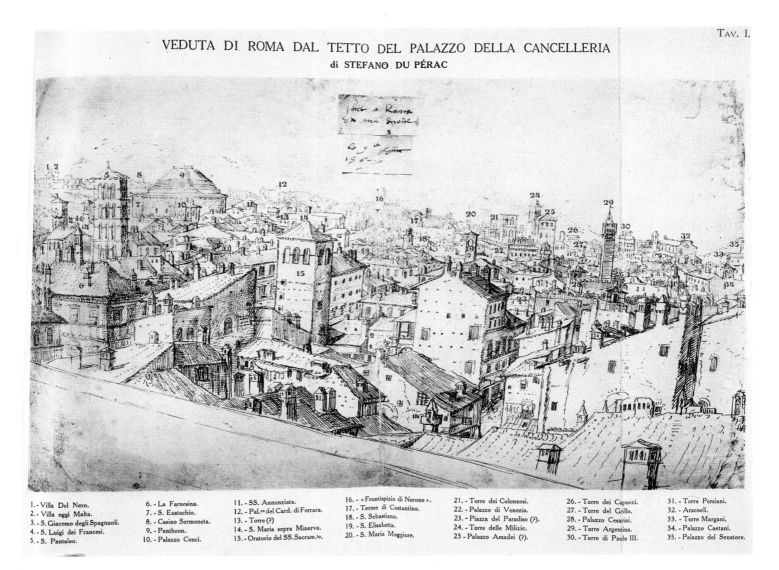

Tav. I.

VEDUTA DI ROMA DAL TETTO DEL PALAZZO DELLA CANCELLERIA
di STEFANO DU PÉRAC

1. - Villa Del Nero.	6. - La Farnesina.	11. - SS. Annunziata.	16. - «Frontispizio di Nerone».	21. - Torre dei Colonnesi.	26. - Torre dei Capocci.	31. - Torre Persiani.
2. - Villa oggi Malta.	7. - S. Eustachio.	12. - Pal.zo del Card. di Ferrara.	17. - Terme di Costantino.	22. - Palazzo di Venezia.	27. - Torre del Grillo.	32. - Aracoeli.
3. - S. Giacomo degli Spagnuoli.	8. - Casino Sermoneta.	13. - Torre (?).	18. - S. Sebastiano.	23. - Piazza del Paradiso (?).	28. - Palazzo Cesarini.	33. - Torre Margani.
4. - S. Luigi dei Francesi.	9. - Pantheon.	14. - S. Maria sopra Minerva.	19. - S. Elisabetta.	24. - Torre delle Milizie.	29. - Torre Argentina.	34. - Palazzo Caetani.
5. - S. Pantaleo.	10. - Palazzo Cenci.	15. - Oratorio del SS. Sacram.to.	20. - S. Maria Maggiore.	25. - Palazzo Amadei (?).	30. - Torre di Paolo III.	35. - Palazzo del Senatore.

View of Rome (with the Pantheon on the left), by Etienne Dupérac, as reproduced and
annotated by Thomas Ashby in his article, 'Due vedute di Roma attribuite a Stefano du Pérac',
in *Miscellanea Francesco Ehrle: Scritti di Storia e Paleographia*, II. Rome 1924, in which he showed
the view to have been drawn from the roof of the Palazzo della Cancelleria

The Collection of Thomas Ashby in the Vatican Library

THOMAS ASHBY, sometime Director of the British School at Rome, died on 15 May 1931 in an accidental fall from a train between New Malden and Raynes Park, Surrey. He was some five months short of his 57th birthday, and had been married for just ten years. He was buried at St Margaret's Bay, near Dover in Kent.

Two years later his widow, Caroline May Ashby, began a correspondence from London with Monsignor (later Cardinal) Eugène Tisserant, then Pro-Prefect of the Vatican Library, with a view to selling the famous Ashby collection of prints and drawings to the Library. As it survives, the correspondence begins on 14 February 1933, but clearly this first letter of Mrs Ashby was in reply to some query or other from Tisserant about the possibility of acquiring some part of her husband's collection. Mrs Ashby reports that an expert 'has organized and catalogued' the collection, then in the British School at Rome, and is sure that he 'will be very glad to be able to show you, or your representative, the true worth and scope of the collection of prints'. She was pleased, she said, with the approach from Tisserant, and indeed hoped 'most sincerely that the Vatican Library will be inclined to take over the collection, as I shall be much happier in my mind when it is safe and sound in that beautiful library and amongst that great and glorious collection. Apart from all questions of money — it is the great desire of my heart that the prints should come to rest finally at the Vatican. It was my husband's wish too. I feel that I am doing what he would like.'

It was a conviction which was repeated in other letters over the next five months. She was in no doubt that she was doing the right thing, for, as she wrote in a letter of 13 April, 'I also knew, for we had spoken of it often, that he would like them at the Vatican after his death'.

This is not entirely surprising. Thomas Ashby had had a long and affectionate connection with Rome and the Vatican Library. He was born at Staines, Middlesex, on 14 October 1874, the only child of Thomas Ashby, a member of a well-known Quaker family which owned Ashby's Brewery at Staines. In 1890, his father settled in Rome for a time, giving his son his first glimpse of the city and its countryside.

Young Thomas Ashby was then sixteen and a schoolboy at Winchester, from which he went up to Oxford on a scholarship at Christ Church in 1892. Three years later he gained a first class degree in classics and again, in 1897, in *Litterae Humaniores*. Awarded a Craven Fellowship by Oxford in that year, he took up residence in Rome, and came under the spell of the archaeologist and topographer Rodolfo Lanciani, whose lectures at the University of Rome he followed, and of whom he wrote movingly on Lanciani's death in 1927. When the fellowship was over, Ashby continued to visit Rome whenever he could, staying generally at the Albergo Cont-

inentale on via Cavour, which was the address he used on 7 January 1900 when he was first admitted to study in the Vatican Library.

Those were the days when the German Jesuit Franz Ehrle, Prefect of the Library from 1895 to 1913, was slowly bringing the Library into the modern era, after what an article by Tisserant has called 'a long sleep'. As a result of reforms introduced by Pope Leo XIII in 1881, the Library had been restructured, and the generality of scholars was now more welcome than hitherto. By 1900, when the young Ashby was admitted, the number of annual *tesserae* (or readers' tickets) had grown from the trickle of the early 1880s to about 150, and before the end of Ehrle's term of office in 1913 would reach 250 and more.

On any given day, however, there were hardly more than twenty to twenty-five readers, with a regular core of about fifteen very distinguished scholars. What is interesting is that on the fringe of this group of proven scholars there was a scattering of graduate students. Ashby, no doubt, was still in this category in 1900, though he had published in 1898 a fine paper on the site of Lake Regillo in the Reports of the Accademia dei Lincei. In his application to the Library he described his subject as 'Roman archaeology'. Though in later annual applications he sometimes listed himself as engaged in 'Classical archaeology', there is no doubt that his real passion was then, as it was always, Roman archaeology and, in particular, Roman topography.

A year after he had first begun to work in the Vatican Library, a splendid opportunity came Ashby's way of dedicating himself wholly, and in Rome itself, to topographical studies. The British School at Rome was founded in 1901 in the Odescalchi Palace (Piazza SS Apostoli). Ashby became its first scholar, and in 1902 published the first of five long articles on 'The Classical Topography of the Roman Campagna' in the new *Papers of the British School at Rome*. In 1903 he became Assistant Director of the School, and in 1906 its Director, a post he held until 1925. During almost twenty years of office he made the School a vibrant center of studies in archaeology and topography, and in 1911 organized its transfer from the Odescalchi Palace to its present location in Valle Giulia.

As Director of the School, he maintained his connection with the Vatican Library, regularly applying until 1925 for his annual reader's card. He and Ehrle became friends. In his edition in 1905 of the maps of Rome by Dupérac-Lafrey (1577), Ehrle thanks Ashby, among others, for his help. Ashby, in turn, thanks Ehrle profusely in his own edition (1914) of the important map of the Roman Campagna by Eufrosino della Volpaia (1547), which in fact Ehrle had asked Ashby to edit for the new series of maps of Rome published by the Library, and which was one of a valuable collection

of maps of Rome donated to the Library by Pope Pius X. Given this common interest in Rome and its topography, it was entirely in keeping with the friendship between the two scholars that Ashby's contribution to a Festschrift for Ehrle, now a Cardinal, in 1924, should have taken an aspect of Roman topography as its topic (see illustration p.14). By then his knowledge of Rome and the Roman countryside was legendary.

Of course, Ashby's publications between 1898 and 1931 were not all confined to Rome and its topography, but his most influential works have these subjects as their center, notably *The Roman Campagna in Classical Times* (1927), a thoroughly revised edition of Platner's *Topographical Dictionary of Ancient Rome* (1929), and *The Aqueducts of Ancient Rome* (published posthumously in 1935).

All of his work was marked by what one would call today an interdisciplinary approach. From the outset of his studies, he was determined not only to know as much as possible about a given site as it survived, but also to explore and document as far as possible its past history. On the one hand, he became an expert photographer, and over forty years roamed the Campagna on foot or by bicycle, amassing in that span of time an extensive archive of about 9000 negatives and photographs which has recently been the subject of a notable exhibition at the British School (*Thomas Ashby. Un archeologo fotografa la Campagna Romana tra '800 e '900*, Rome 1986). On the other hand, he was just as assiduous in exploring printed works, manuscripts, sketches, prints and archival holdings, for the historical documentation of the past of what he had recorded and photographed *in situ*.

Thus, as early as 1899–1901, he bought from an English family the fine collection of six albums of unpublished sketches by Carlo Labruzzi (1756–1818), about which in 1903 he published a long article in the *Mélanges* of the French School at Rome; and in 1902 he acquired the manuscript notes of Diego Revilles (1690–1742) on Tivoli and the surrounding countryside from the library of the antiquarian Costantino Corvisieri. By the time of his death in 1931, he had put together, generally through purchases in London, an estimable collection of about 6000 prints and perhaps 1000 drawings, not to speak of maps, bearing for the most part directly or indirectly on the Roman countryside.

It was this collection of prints and drawings, then housed at the British School in Valle Giulia, that occasioned the correspondence between Mrs Ashby and Msgr Tisserant from February to July 1933.

During the negotiations, Mrs Ashby remained in London, leaving day-to-day details to her representative in Rome, Dr Calabi of Milan. By mid-March, barely a month after the first letter of Mrs Ashby, an agreement had

been reached, and Tisserant duly sent a cheque for 48,000 lire (about $25,900 or £6400 at the then rate of exchange) to Mrs Ashby's bank in London for the prints and drawings.

Just when all seemed settled, a misunderstanding over duplicates among the prints and drawings caused a further flurry of letters. It was during this second exchange of views that it suddenly came home to Mrs Ashby that, by agreeing to sell her husband's collection of prints and drawings, she was in fact risking the fragmentation of what her husband had worked so hard to bring together. For his collection as such included much more than just prints and drawings. There was also a valuable cache of maps and plans which she had overlooked until now. If her husband's collection was to preserve its identity, then these maps and plans should also be in the Vatican Library with the prints and drawings.

Accordingly, Mrs Ashby made a new proposition to Msgr Tisserant on 21 June 1933:

If I get the duplicates back from you, it means more trouble and worry for me, and it also means that more and more the collection loses its entity. I do not know where they would go – and I do not want the money enough to care for more bargaining and valuing. Besides I want, before I die, to make sure that all his beautiful things are safe and appreciated – and I have been so glad to think that they are at last at the Vatican.

So – What I want you to do now is, – if you will consider it – Will you take over the rest of the collection that is now at the British School? So that I shall feel that it is all *together* again? I enclose a list of what remains at the British School – and if you decide to take these over, I will write at once to the Director.

Msgr Tisserant quickly saw the logic of Mrs Ashby's plea to 'make the *whole* "Collection of Dr Thomas Ashby" a part of the Biblioteca Vaticana'. His offer of 14,000 lire ($7500 or £1850), which was precisely the estimate of Dr Calabi, was accepted by Mrs Ashby on 8 July. On 16 July she wrote again to say that she was 'so very glad to hear that you have taken the last remaining pieces of the collection from the British School', and that these included a cabinet of 'extra prints and maps' which had eluded Calabi's original inventory. She was also 'delighted with the little stamp with *Coll. Ashby*' which Tisserant had had made when the Ashby collection was being accessioned in the Library, and which he now sent her, as she had requested. She was, she concluded, 'so content now to know that the Biblioteca has everything safe'.

Her last known letter to Tisserant, on 20 July 1933, is in the same contented vein. She had just received a notice from her bank 'that the 14,000 lire have been placed to my account in Italy', and now sends him 'my sincerest thanks, not only as the acknowledgement of the money but also for the kindness and courtesy with which you have treated me

throughout these negotiations, and for the patience with which you have endured these very tiresome delays and annoyances – which, alas, were unavoidable by me. I was most grateful for your kind intimation that you were going to speak to the Holy Father of the successful issue of our bargain: I sincerely trust that I shall hear some time from you that he is satisfied with our results.'

Whether or not there was any further correspondence between Mrs Ashby and Msgr Tisserant, we do not know at present. In the Library, the work of cataloguing the Ashby Collection began at once under the care of Dr Lamberto Donati, but it was not until forty years later that anything substantial on the prints and drawings was published. This was Didier Bodart's *Dessins de la Collection Thomas Ashby à la Bibliothèque Vaticane* (Biblioteca Apostolica Vaticana, Documenti e Riproduzioni 2, 1975), which reproduces and catalogues 447 items.

In a letter of 4 April 1933 to Msgr Tisserant, Mrs Ashby wrote, 'It is a great relief to me to know that these dear and beautiful possessions of ours, in which my husband took such delight, are now in the safe keeping and care of the B.V., where as we had hoped always – they will now be seen and appreciated – and will be on exhibit again: so fulfilling their purpose and aim. I am very happy to think my husband's wish is fulfilled too – as he wished them properly appreciated and available.'

The present exhibition, so ably devised by Mr Donald McClelland of the Smithsonian Institution Traveling Exhibition Service, and presented so carefully here by Raymond Keaveney of the National Gallery of Ireland, is a modest attempt to fulfil the wishes of Mrs Ashby and her husband.

LEONARD E. BOYLE O.P.
Prefetto
Biblioteca Apostolica

Jakob Philipp Hackert: *The Colosseum with the Temple of Venus and Rome* (a detail of No. 27)

The Noble Simplicity and Calm Grandeur of Rome

ROME has held the fascination of men for centuries. Its grandeur captivates and overwhelms the visitor, for it is a city designed for the art of the spectacle, a stage set for the drama of power. There is, however, a sense of intimacy in the often irregularly shaped piazza that perhaps echoes the plan of a bygone Roman *campo*. The Forum itself displays a curious classical imbalance, with its meandering Via Sacra which, like a shepherd's path, seems to retain the modesty of the human spirit amid the glories of ancient Rome.

The strength of the city lies in itself, where the old and the new appear to accommodate each other easily, without fear of interference. Some monuments still retain their original function, some have been altered, and some completely abandoned. All, however, have given inspiration for thought and accomplishment from generation to generation. The past is always present in Rome, and it is not difficult to see how its majesty has stimulated successive cultural revivals, from the Renaissance through Neoclassicism and on to the modern movements.

Yet these revivals did not arise suddenly. The spirit of humanism, with its concern for the classical age, might not have held the interest of an audience beyond scholars, had not great discoveries been made in classical art and, more importantly, had not Hebrew, Greek and Latin manuscripts been found or rediscovered that focused attention on a higher code of ethics for the conduct of life itself. The humanists recaptured the moral philosophy of the ancient world and counseled that men who wanted to live honorably, productively and profitably should turn to Aristotle's *Ethics* and Cicero's *De Oratore*. New ideas spread from the humanists to the courts and churches of Rome at an uneven pace, and gradually the ideals of the Renaissance became a part of the everyday fabric and architecture of the city. One cannot fully appreciate Rome without understanding this fact.

During the period which this exhibition covers, the sixteenth to the nineteenth centuries, Rome ruled as capital of the ecclesiastical world, a city enlivened by towers whose bells conveyed the message of the Church, a message of joy as well as of alarm. The robes of clerics and those used in religious festivals, together with those of pilgrims from every land, seemed to blend easily with the costumes of carnival, beggars and gypsies. It is to this day a city of colonnades, façades and, above all, fountains. Little has changed, yet everything. But, as Jacob Burckhardt pointed out, 'the ruins within and outside Rome awakened not only archaeological zeal and patriotic enthusiasm, but an elegiac, or sentimental Melancholy'.[1]

From its very beginnings, Rome has stood at the center of Western life, its rich religious and artistic traditions a teacher and a haven for all. This

pre-eminence is reflected in the works of art collected by Thomas Ashby (1874–1931), a distinguished classical archaeologist who was for nineteen years Director of the British School at Rome. They were collected, I believe, mainly to document for Ashby the various views of the city, and as a source for the study of those archaeological sites and landscapes that had vanished or radically changed their appearance over the centuries. It would be fair to say that Ashby, as a topographical explorer, actually used these drawings for the study and observation of Rome and the Campagna. At the same time, his extensive acquaintance with the material things of Rome did not obscure his love of the images as works of art, for they were collected by a connoisseur/scholar with a most discriminating eye.

The drawings and watercolors in this exhibition do not attempt to trace the history of drawing in Western European art, but they are representative of many different national schools and styles. The close study of a single watercolor, such as Hackert's view of *The Colosseum with the Temple of Venus and Rome* (No. 27), provides an exceptional opportunity to observe and be a part of Roman life during the last quarter of the eighteenth century. As the eye and mind sharpen to a fine degree of perception, you become party, if only for a moment, to the customs, manners and views of the time in which the artist lived, and which determined the way that he, or she, constructed and looked at his or her world.

There have always been a number of academies and studios in Rome where artists could be apprenticed and trained. The French Academy was among the first of the foreign schools founded in the mid-seventeenth century, and was followed by others from both Europe and America. Traditionally, the most promising students were sent to study at first hand the examples of Ancient, Renaissance and Baroque art which, before the establishment of public museums, could best be found in Rome's palaces and churches. It was an essential facet of the student's training to copy directly from the masterpieces of the past. Yet, among the most delightful studies produced by these visitors were the informal landscapes of the Campagna and the different views of Rome itself painted from life.

Let us begin our close observation of Rome by discussing Jakob Philipp Hackert, who was born in Prenzlau in Prussia in 1737. He studied with his father and an uncle, both well-known portraitists of their day, and attended drawing classes at the Berlin Academy in 1755. His teacher, Le Sueur, encouraged him to become interested in landscape painting and to go to Paris to study and work. In 1762–63 he traveled to Straslund and to the Isle of Rugen, and then in 1764 to Sweden. Hackert eventually moved to Paris in 1765 where he was followed by his brother Johann Gottlieb, a landscape and animal painter. The brothers' success in Paris, with their idealized

views and landscapes of a mountainous and castellated Germany, enabled them to travel to Rome in 1768. During an extended visit to Naples in 1770 they met and worked for the collector and connoisseur William (later Sir William) Hamilton, the British Ambassador to the King of Naples, and his first wife who seemed to be equally impressed with Hackert both as man and artist. While in Rome, Hackert received a commission in 1771 from Catherine II of Russia to paint six pictures representing the naval battle of Tchesme and the burning of the Turkish fleet. The commission may have come through Johann Friedrich de Reiffenstein, counselor to the Empress, who was then in the process of recruiting artists and craftsmen to rebuild the Hermitage in St Petersburg and refurbish the Imperial Residence at Tsarskoe Selo.

When Johann Gottlieb moved to England in 1772, Hackert called another brother, Georg, to Rome where he made engravings of Philipp's work. During the next decade Hackert traveled to Sicily, to northern Italy and on to Switzerland. Beginning in 1782 he was employed by King Ferdinand IV of Naples and was named court painter in 1787. However, he continued to spend considerable time in Rome, where in 1787 he first met and later traveled with Johann Wolfgang von Goethe. As Goethe writes in his *Italian Journey*:

Frascati, November 15 — The rest of our company are already in bed, and I am writing in the sepia I use for drawing. We have had a few rallying days of genial sunshine, so that we don't long for the summer. This town lies on the slope of a mountain, and at every turn the artist comes upon the most lovely things. The view is unlimited; you can see Rome in the distance and the sea beyond it, the hills of Tivoli to the right, and so on.

Yet I find it hard to decide which are the more entertaining, our days or our evenings. As soon as our imposing landlady has placed the three-branched brass lamp on the table with the words 'Felicissima notte!' we sit down in a circle and each brings out the drawings and sketches he has made during the day. A discussion follows: shouldn't the subject have been approached from a better angle? Has the character of the scene been hit off? We discuss, in fact, all those elements in art which can be fudged from a first draft.

Thanks to his competence and authority, Hofrat Reiffenstein is the natural person to organize and preside at these sessions, but it was Philipp Hackert who originated this laudable custom. An admirable landscape painter, he always insisted on everyone, artists and dilettantes, men and women, young and old, whatever their talents, trying their hand at drawing, and he himself set them a good example. Since his departure this custom of gathering together an interested circle has been faithfully kept up by Hofrat Reiffenstein; and one can see how worthwhile it is to stimulate in everyone an active interest.

When we run out of conversation, some pages are read aloud from Sulzer's *Theory*, another custom introduced by Hackert. Though, judged by the strictest standards, this work is not altogether satisfactory, I have observed with pleasure its good influence on people of a middling level of culture.[2]

Several months later Goethe wrote of meeting Hackert in Naples:

Naples, Feb. 28, 1788 – Today we paid a visit to Philipp Hackert, the famous landscape painter who enjoys the special confidence and favor of the King and Queen. One wing of the Palazzo Francavilla has been reserved for his use. He has furnished this with the taste of an artist and lives very contentedly. He is a man of great determination and intelligence and, though an inveterate hard worker, knows how to enjoy life.[3]

An artist of great vision and technical proficiency, Hackert was a mentor for many German artists who had left their troubled homeland for Rome. The elegant form and serenity of the Italian classical landscape became a source of security and certainty for many of the German School, whose philosophies were undergoing a profound change as they attempted to incorporate the ideals of southern Europe.

From the seventeenth to the nineteenth centuries, most foreign artists lived in the section of the city adjacent to the Pincian Gate, especially in via Margutta and via del Babuino, and for a time Hackert lived in this area himself. It included the Piazza del Popolo, which contained all the picturesque crowds and popular figures that so delighted the artists as well as the ladies and gentlemen on the Grand Tour – women drawing water from a fountain, beggars, gypsies, cheese and wine sellers, ox carts, and flocks of sheep and cattle moving from one part of the city to another. Artists began to live in this quarter of Rome towards the end of the sixteenth century, and for a time those from abroad were granted a tax exemption from the Pope on their professional licences. There is a record that Dutch painters lived on via Margutta as early as 1594. Claude Lorrain is said to have lived at Trinità dei Monti in 1625, while Poussin's studio was in via del Babuino from 1624 to 1640. It comes as no surprise, then, to find G J Hogernaff, in his important study of via Margutta, concluding that:

. . . if the ideal classical landscape was not exactly born on the Via Margutta, it was born close by, and it certainly had its greatest development there.[4]

I am confident that such an association of place was not lost on Hackert, or his friends, while they were in Rome.

Painters had been working directly from nature in the environs of Rome for a great many years. Following a manner that had become common from the middle of the seventeenth century until almost the close of the nineteenth, artists would paint a number of small studies directly from nature in which they attempted to catch the tonal effect of a scene. Forms were not modeled in a full sense but instead took on substance only through the spatial suggestions of carefully related colored paint. It was the organization of color that provided the theme of the painting and when

an artist developed more detailed versions of his work in the studio, he took care that the total impression which had given his small studies their character should not be lost. The studies themselves were never painted over or developed, remaining instead the control by which the final painting could retain its natural integrity.

But artists working in this field followed two distinct, though sometimes intermingling, traditions. One procedure was based on the careful drawing of isolated subjects that would later become the motifs for freely composed paintings. For the organization of this type of scene, the artist might even use a *camera obscura* or some other device, verbally indicating the colors in marginal notes with great care. This was the method followed by many German artists, and by the Italian *puristi* who continued this exacting discipline well into the nineteenth century. The other tradition, which goes back at least to the eighteenth century and was used by Hackert, involved an attempt to capture directly in paint the specific effect of forms in light, and to consider the total luminous effect of the scene, rather than just the particularized object as the artistic motif. In some ways, this broader procedure was akin to the academic method of laying out history painting in broad patches of color. But the landscape painter was devoted to reproducing an effect out of such patchwork unity as was discernible in nature, not a unity that he constructed himself. Artists liked to say that they set out to surprise nature in its most telling moments.

Perhaps Goethe can best describe Hackert's approach to his work:

Though Hackert is always busy drawing and painting, he remains sociable and has a gift for attracting people and making them become his pupils. He has completely won me over as well since he is patient with my weakness and stresses to me the supreme importance of accuracy in drawing in a confident and clear-headed approach. When he paints he always has three shades of color ready. Using them one after another, he starts with the background and paints the foreground last so that a picture appears one doesn't know from where. If only it were as easy to do as it looks! With his usual frankness he said to me 'You have talent, but you don't know how to use it. Stay with me for 18 months, and then you will produce something which will give pleasure to yourself and others.' Is this not a text which one should never stop teaching to all dilettantes? What fruit it is going to bear in me remains to be seen.[5]

Hackert left southern Italy in 1799 when Napoleon's armies entered Naples. He moved with his brother to Florence and died in 1807 at San Piero di Careggio, a little way out of the city.

As we begin to study closely the watercolor showing a view of *The Colosseum with the Temple of Venus and Rome*, with its romanticized impression of the Colosseum (Byron's 'noble wreck in ruinous perfection'[6]), we can follow the Via Sacra past the Temple and into the Forum, with the

attic of the Arch of Titus to the left in the far distance, and end up at the tower of the Senator's Palace (see p.20). Perhaps here we should take a moment to consider how the destruction of the ancient monuments, as seen in this watercolor, took place.

In a letter to a friend, written from retirement in Bethlehem, St Jerome lamented the sacking of Rome by Alaric the Visigoth in AD 410.

I shudder when I think of the calamities of our time. For 20 years Rome has shed blood daily between Constantinople and the Alps. Scythia, Thrace, Macedon, Sicily, Dacia, Achaea, Epirus – all the regions have been sacked and pillaged by Goths and Alans, Huns and Vandals. How many noble and virtuous women have been made the sport of these heathens. Churches have been overthrown, horses stalled in the holy places, the bones of Saints dug up and scattered. Indeed, the Roman world is falling. Can we still hold up our heads instead of bowing them? The East, indeed, seems to be free from these perils; but now, in the year just past, the wolves of the North have been released from their latest fastness and have overrun great provinces. They have laid siege to Antioch, have infested the cities that were once the capitals of no mean state.

And now a dreadful rumor has come to hand. Rome has been besieged, and its citizens have been forced to buy off their lives with gold.

My voice cleaves to my throat; sobs choke my utterance, the city which had taken the whole world captive is itself captive. Famine too has done its awful work.

The world sinks into ruin; all things are perishing save our souls; these alone flourish. The great city is swallowed up in one vast conflagration; every day more Romans are in exile.

Who could believe it? Who could believe that Rome, built up through the ages by the conquests of the world, has fallen; that the mother of nations has become their tomb? Who could imagine the proud city, with its careless security and its boundless wealth, brought so low that her children are outcasts and beggars? We cannot indeed help them; all we can do is sympathize with them; and mingle our tears with theirs.[7]

It is obvious that Hackert was as attracted to the history and traditions of Rome as Thomas Ashby himself. Classical Rome was in one sense immediate to artists and collectors, while in another sense very remote. The age of Romanticism, from about 1750 to 1860, witnessed the erection of some of Rome's most beautiful and familiar buildings. Artists and travelers alike were interested in the new developments of the city as well as its classical antiquities. There was a taste for the romantic and colorful life that Rome offered, and that had in many ways vanished from the cities of northern Europe. It would be fair to say that the artists were almost as fascinated by the inhabitants as they were by the grandeur and formalities of the city. Rome itself was very much a part of the age of revolution and political change, yet this was strangely an era of chaste refinement in the arts, a Neoclassicism that was perhaps most at home in the land that had produced the classic itself. Perhaps the terms 'noble simplicity' and 'calm grandeur', used by the German archaeologist and scholar Johann Joachim Winckelmann (1717–68), best describe Hackert's view of Rome. Certainly

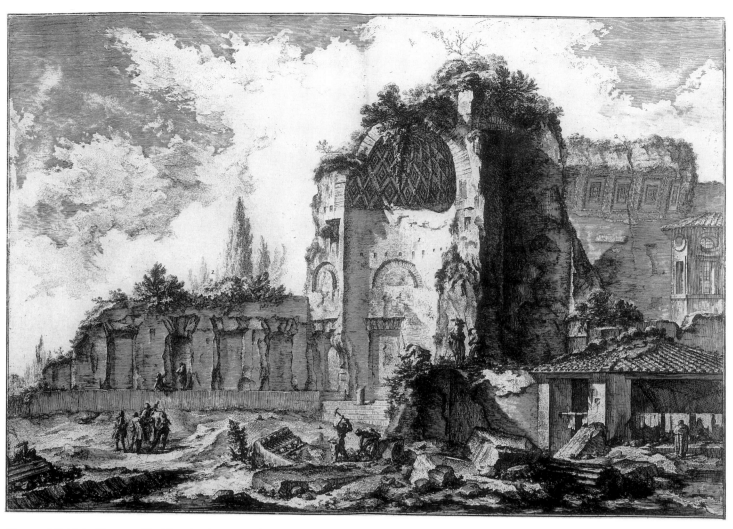

Giovanni Battista Piranesi: *The Temple of Venus and Rome,* then believed to be part of the Golden House of Nero

there is a calm grandeur in this work of art which embraces both classical ruins and romanticized peasantry.

The Colosseum was not completely excavated and uncovered until early in the nineteenth century and so, in Hackert's picture, is still half-filled with dirt and rubble. The watercolor was painted from the northwest side of the building probably in late fall, since the vegetation in the stonework, as well as the trees, seems to have taken on the autumnal colors of Rome. It was probably executed during the painter's first year in Rome and is a good example of his approach to this type of work, a type especially prized by tourists to Italy. Emphasis has been placed on exactitude towards the natural topography and the picturesque, depicting with freshness the bright, form-defining light of Rome.

It might well be best at this point to let Thomas Ashby describe the Colosseum, which he does in a manner nicely contrasted to Hackert's more romantic representation, where it is covered with a rich accretion of vegetation that had, by Ashby's day, been removed for the better preservation of the building. (During an early study of the Colosseum it was learned by botanists that wild exotic plants grew in the crevices of the monument until almost the end of the nineteenth century. The seeds probably arrived in Rome in animal feed brought from the Middle East and Africa along with beasts intended for public entertainment and slaughter.) The Colosseum, whose correct name is the Flavian Amphitheater, was begun in AD 72 by Vespasian on the site of Nero's artificial lake which adjoined his Golden House. The amphitheater was opened in AD 80 and completed shortly afterwards under Vespasian's son Titus, whose family name was Flavius.

To quote Ashby:

The building is elliptical in plan, and measures 620 feet on the longer axis, by 513 feet on the shorter axis. It was raised on two steps in the middle of a great esplanade paved with travertine, the pavement of the corridors up to the inner corridor sloping outward, to allow any rain which might beat in to run out. Of the eighty entrances, two of which were reserved for the Emperor and his suite, and two for gladiatorial processions, seventy-six were numbered and gave access to all parts of the *cavea*. The *cavea* was divided into three parts — the podium, a terrace of $11\frac{1}{2}$ feet wide; then the main part of the *cavea*, which was divided into two zones, separated by a passage, and consisted of marble seats reaching up to the bottom of the third external order; then came a wall with doors, windows and niches, and above it a covered colonnade with a flat roof, under which were wooden seats, while there were doubtless seats on the roof of it also. The total number of spectators cannot have been more than about 45,000.

The arena measured 287 feet by 180 feet, and was surrounded by a wall 15 feet high, with iron grilles and other protection on the top. The excavations undertaken by the French in 1811–13, revealed the existence of numerous passages round the center communicating with the dens in which the wild beasts were shut up; putlog holes exist in

the walls of the passages under the arena in which joists carrying a series of inclined planes were provided leading from the dens to the arena level, and arrangements for lifts were also to be seen.

The exterior is divided into four stories, the three lower ones being pierced with a series of arches of equal dimensions, forming, as it were, a continuous arcade round the building, and divided by three-quarter detached columns of the Tuscan, Ionic and Corinthian orders, superimposed in the respective stories, and carrying each a complete entablature, the architraves of which are voussoired and carried back into the solid wall. The upper story is unpierced except by small windows lighting the corridor underneath the upper range of seats or gallery, and its wall is decorated with Corinthian pilasters on lofty pedestals superposed on the other orders below. Above the windows outside are three projecting corbels in each bay to carry the masts of the *velarium* (the awning by which the auditorium was shaded) which carried flat arches, forming a terrace for the sailors whose duty it was to attend to the *velarium*.

The complete entablature of each order is carried round without a break, and this and the sturdy nature of the three-quarter detached columns give a monumental effect to the Colosseum which it would be impossible to rival. The applied decoration of the orders, their superposition, and the jointing of the architraves, in principle are all wrong, and should be condemned; but the portions of the external wall which remain, rising to their full height of 157 feet, and the splendid nature of the masonry, disarm all criticism and constitute the Colosseum as one of the most sublime efforts of Roman architecture.[8]

The effects of the systematic destruction of the Forum over the centuries, and of its use as a quarry, can be observed in the middle ground of the watercolor, with its uneven ground levels caused by the constant dumping of rubbish which had buried the ancient pavement of the Via Sacra in some places at least 40 feet under the ground. Something of this change of levels was observed by Hackert when he depicted the cattle as they slowly moved towards the fountain called the Meta Sudans, and on to the Forum filing past ancient walls of varying heights. The Forum itself was, even in Hackert's day, largely occupied by gardens, open pastures, numerous workshops, cattle markets, a central vegetable market, and small houses of the peasantry which clustered about the ancient temples and churches, with a few columns protruding here and there from heaps of vine-covered rubble. The whole area was popularly known as the Campo Vecchio, for the word Forum had almost been forgotten.

Raphael, in 1519, formed a plan for the restoration of the ancient site and several excavations were begun. The plan was never completed and such excavations as were made were used solely to find works of art or ancient inscriptions and, as tradition seemed to dictate, filled in again with rubbish. It was not until the nineteenth century, well after Hackert's death and during Ashby's residency in Rome, that a systematic study of the Forum, the most important site in ancient Rome, was made.

Let us look again at the watercolor. To the right of the parade of cattle

can be seen some shepherds and their flock. This work was, as I have mentioned, probably executed during the late Roman fall, since the mounted cattle herder appears to be huddled in a heavy winter cloak. Perhaps it is the Abruzzesi shepherds whom we see; it was they who traditionally played the 'pastoral' to the Infant Jesus at Christmas time. These shepherds, called *zampognari*, generally made a pilgrimage to Rome at Advent, playing before the shrines of the Madonna and Child and elsewhere from the festival of the Madonna held on 8 December until just before Christmas. They always traveled in pairs with a small flock, one playing the *piffero*, or pastoral pipe, which carried the tune, the other accompanying on the *zampogna*, or bagpipe.

The cattleman and his herd are heading to one of Rome's oldest fountains, known as the Meta Sudans. Built by Domitian (AD 81–96), it stands on the Via Sacra at the entrance to the Forum. Only the brick core of the cone-shaped fountain now remains, but in Hackert's day it was still surrounded by a circular base, part of which was demolished in the restoration plan of 1936. The name came from the shape, which resembles one of the *metae* or markers in the circus; it was probably surmounted by a bronze globe, with many jets, which poured out water in a surrounding veil. Horace said that he was the friend of fountains, and indeed no true Roman, whether ancient or modern, can fail to have some sentiment for them, for they are the joy of Rome. It was the Aqueduct of Agrippa that brought the water to the Meta Sudans; together with the Aqueducts of Caligula and Claudius it marches across the Campagna, a reminder of the love of water so eloquently expressed in the fountains and baths of the city.

Near the Meta Sudans, to the right in Hackert's view (where the shepherd stands with his flock), is a flat, square piece of masonry called the Basis. Here the herders of the eighteenth century assembled their animals for market, but in the time of Hadrian (AD 117–138) this had been the site of the colossal bronze statue of Nero (AD 54–68), presented as god of the sun, crowned, so it is reported, with rays and standing about 118 feet high. Soon after Nero's death his Golden House and the statue fell into disarray and decay, and the statue was transferred by order of Hadrian to the Basis so that his new Temple of Venus and Rome could be constructed on its site. It is said that the architect Demetrianus used many pairs of elephants to move it.

The new temple, one of the largest and proudest in Rome, was dedicated to the city's two protectresses Venus and Roma; its ruins dominate the middle ground of the watercolor, to the left of the Colosseum. Despite the fact that Hadrian himself supervised the design and construction of the Temple, Trajan's great architect, Apollodorus of Damascus was harshly

critical of the project and paid with his life for the pleasure of his comments. The Temple in its final form had a truly original plan. It was composed of two apsidal *cellae* on opposite sides with two façades. The one on the Colosseum side, which we see in the watercolor, was dedicated to Venus who was the founder of the *gens Julia*, the race of Caesar. The one on the Forum side, which is still reasonably intact but cannot be seen in the watercolor, was dedicated to the goddess Roma, queen of the world.

Directly behind the ruined temple can be seen parts of the church of Santa Francesca Romana (formerly Santa Maria Nova) with its beautiful Romanesque bell tower. In the middle of the ninth century, when it became evident that the church of Santa Maria Antiqua was falling into decay and would have to be abandoned, Pope Leo IV founded a new church dedicated to the Virgin Mary at the eastern end of the Forum and adjacent to the Temple of Venus and Rome. Damaged by fire, Santa Maria Nova was rebuilt by Alexander III in the twelfth century, when the marble-working Cosmati family built the Romanesque campanile, which is one of the finest in the city. In the sixteenth century the church was transferred to the Benedictine Olivetans and given its present dedication. Santa Francesca dei Ponziani was a Roman and was the foundress in 1421 of an order of Oblate nuns. She was canonized by Pope Paul V in 1608 and is buried in the church crypt; forty years later Bernini made a splendid portrait of her for her tomb. In 1655 the church was given a Baroque façade by Carlo Maderno: a most successful, restrained and tasteful work.

To the right of the Temple ruins can be seen part of the conventual buildings of Santa Francesca Romana, and above that the sloping roof of the ruins of the Basilica of Maxentius, which was begun in AD 306–10 by Maxentius and completed by Constantine in 330. It was used for administrative, legal and trading purposes. The Basilica collapsed as the result of an earthquake in 1349 and its last surviving column now stands in front of Santa Maria Maggiore.

In the distance to the left can be seen a small village from which protrudes, on the far left horizon, the attic story of the Arch of Titus. This is situated on the Via Sacra, and forms a triumphal entrance to the Palatine and the Roman Forum. The inscription on the attic tells us that the arch was dedicated by the Senate and People of Rome to the divine Titus, son of Vespasian and conqueror of Jerusalem in AD 71. It was actually built by Domitian in AD 81, after Titus's death, and was at one point incorporated into the medieval fortress of the Frangipane which was also strengthened with battlements. The arch as seen by Hackert still forms a part of the Forum's medieval complex.

In the far distance can be seen the joint image of the Palace of the Senator

and its distinctive tall tower. This, designed by Martino Longhi the Elder, was erected in 1579 to replace an older one which had been damaged. The buildings itself faces on to the piazza designed by Michelangelo.

Thus ends Hackert's view. Rome, however, has lost few of its attractions from the past; rather, it has gained over the centuries by the many contrasts with the modern, so that the old now appears even more impressive. The archaic temples, the imposing ruins of the imperial age, the austere medieval cloisters and churches, the magnificent villas and palaces of the Renaissance and the Baroque, all retain their beauty for Hackert, for Thomas Ashby and for us. To Hackert and other artists of the age, the ruins of the Forum became particularly associated with nature through sentiment and memory. The Forum evoked a gentle melancholy, and renewed their enjoyment of the characteristically Roman mixture of man's accomplishments from the earliest times with the accomplishments of nature — a nature that appeared to harmonize with the antique and create a mood that acted as an inspiration both to poet and to painter.

As we study the drawings and watercolors in this book we are able to observe at first hand the various artistic movements and points of view that mirror the times in which they existed, and again and again come startlingly close to a world that remains with us only in pictures such as these.

His Holiness Pope John Paul II wrote in his introduction to *The Vatican Collections*:

In accordance with the purpose of the exhibition itself, the works of art will begin to relate the long and interesting relationship between the Papacy and art throughout the centuries. Above all, these works of art will have a contribution to make to the men and women of our day. They will speak of history, of the human condition in its universal challenge, and of the endeavours of the human spirit to attain the beauty to which it is a credit.[9]

Rome continues to defy change, and remains astonishingly the same. Perhaps it is this aspect of Rome to which we feel most attracted in these drawings and watercolors. For they represent a mixture of ideas and attitudes, from the sixteenth through to the nineteenth centuries, that offer us a unique opportunity to behold the beauty of man's creative imagination.

Hackert's view, its quality of disclosure so quietly perceived and intensely observed, combines a deep appreciation of the past, of the *antichità romane*, with a love of the present, *his* present, view of Rome.

DONALD R. MCCLELLAND
Exhibition Coordinator and Curator
Smithsonian Institution Traveling Exhibition Service

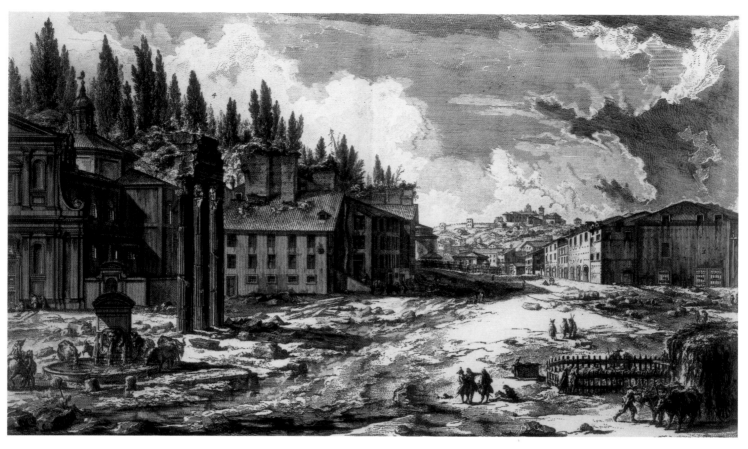

Giovanni Battista Piranesi: *The Campo Vaccino (the Roman Forum) with the three remaining columns of the Temple of Castor and Pollux and the Palatine in the left background*

NOTES

1. Jacob Burckhardt, *The Civilization of the Renaissance in Italy*, I, reprinted New York 1958, p.195.

2. J W Goethe, *Italian Journey (1786–1788)*, reprinted San Francisco 1982, pp.125–126

3. Goethe, p.177.

4. G J Hogernaff, 'Via Margutta, centro de vita artistica,' *Rivista di Studi Romani*, i, 1953, pp.2–3.

5. Goethe, p.179.

6. George Gordon, Lord Byron, *Childe Harold*, canto IV, stanza cxii.

7. M Lincoln Schuster, *A Treasury of the World's Great Letters*, New York 1940, pp.32–33.

8. Thomas Ashby, *The Architecture of Ancient Rome*, New York, pp.92–96.

9. Pope John Paul II, 'Message,' in *The Vatican Collections*, New York 1982, p.7.

Changing Times in the Eternal City

IN THE HUNDRED and eighteen years that have passed since she became the capital of the newly united Italian nation, Rome has changed faster than in any previous period. It is remarkable that she has also changed less, probably, than any other city in the world, and it is surely on account of this exceptional continuity that, of all the poetic appellations given to Rome in the litany of praise to her glory through the ages, the most universally accepted is the title of 'Eternal City'.

If we dwell for a moment on the distinctions, rather than the similarities, between present-day Rome and the Rome represented in the drawings and watercolors here discussed, it might prove useful for an appreciation of their significance. Although present-day Rome provides ample opportunity for us to imagine what she must have been like for these artists and writers, it is still necessary to overcome the intrusive presence of modern buildings. Nor are the drawings mere records of fact: they often have little regard for accuracy, and are in many cases more concerned with composition or mood. To recognize, therefore, the frame of mind that gave rise to such interpretations of reality, one has to have recourse to memory, as transmitted by the testimony of the written word.

A characteristic representative of an authentically Roman point of view is G Moroni, author of the monumental *Dizionario di erudizione storico-ecclesiastica*. In his article on Rome in Volume LVII, published in 1852, he cites a reaction to Rome which must have been that of many an artist and writer. In the words of the Chevalier d'Agincourt:

In Rome, without even meaning to, you can live like a lord at little expense; you stroll past fallen grandeurs, you learn, if you deign to occupy yourself with them, the secrets of Europe. Walking over the ruins of the past, you can glimpse the present, you see arise the clamour of factions, which to the eyes of a serene and observant spirit confirms that spectacle of peace and instruction which Rome offers to her sons, and to those who come to entreat her to be a tender mother for them too.[1]

A silent meditation along these lines lies behind many of the drawings and watercolors in this book.

From the sixteenth to the early eighteenth centuries, the theme with which it was evidently considered most appropriate to preface the publication of views of Rome was that of the struggle between Time and Fame. On the title-page of a collection of engravings by Etienne [Stefano] Dupérac entitled *I Vestigi dell'Antichità di Roma*, published in 1575[2], Father Time is represented, with his scythe and hourglass, reclining on a pedestal which bears the wistful lament: 'And yet I cannot tame a mortal's fame'. On the opposite side of the title-page his antagonist is tranquilly 'fearless of Time or of his rage', as her accompanying inscription proclaims. She represents Fame, which she loudly trumpets abroad, earned by the *Virtuosi* on

whose attributes she leans. These refer to feats of arms and the achievements of arts, sciences and letters — represented by armor, drawing implements, a sculpture, an architect's square, compasses, an armillary sphere, and other similar accouterments, including a goodly number of books which she appears to find a sufficiently comfortable support.

Books are the most numerous weapon in Fame's arsenal against Time, for it was having one's virtuous deeds committed to paper that was considered the most effective way of attaining immortality. The very act of drawing the ruins of Rome was to eternalize them (and oneself — *ars lunga, vita brevis*) by preserving the virtue that still shone in them from being swallowed up by the voracious jaws of Time. Indeed, the crumbling edges of the ruins of Rome are made to look as if they have been literally gnawed away, like crumbs from some giant's table. Other similar title-pages, deriving from Dupérac's, appeared again in 1606 and 1660[3], but the series culminates in a much more vivid variant, the frontispiece of *Italie ... oud en Nieuw Rome*, printed in Holland in 1724.[4] Here the obelisk that Minerva is trying to prevent Time from toppling over symbolizes the light of ancient wisdom, of which she is the tutelary goddess.

The notion of Time which underlies such allegories warrants a word of explanation, since it presupposes a view of history which greatly differs from our own. Whereas we tend to think of Time as being a linear progression towards a future that lies ahead, the traditional representation of Time was the circular figure of a snake swallowing its own tail. And indeed, this symbol does appear in the title-page of 1575. Thus the 'head-end' of history was considered to be at the beginning, in the pristine paradise of ages past. However virtue, which was to be learnt from the past, was seen as having periodically regained what had been lost through the effects of Time — as in the Golden Age after the Floor, or in the Augustan Age. Such was the conscious aim which the word *Renaissance* implies: through the study of the architectural, artistic and literary monuments that had outlived the onslaught of Time it was hoped to revive eternal values that were considered to have already been established once and for all. This is not to say that innovation was rejected, but rather that progress was considered to arise from fidelity to tradition.

It is because Rome had accumulated monuments of ancient virtue in greater quantity than Time could devour that her destiny as the Eternal City was confirmed. As Moroni does not fail to point out:

Rome is the first link in that mysterious chain that binds earth to heaven ... Furthermore, Rome is the link that joins the modern world to the ancient, sacred history to the profane, Christian greatness to the temporal, science to the arts.[5]

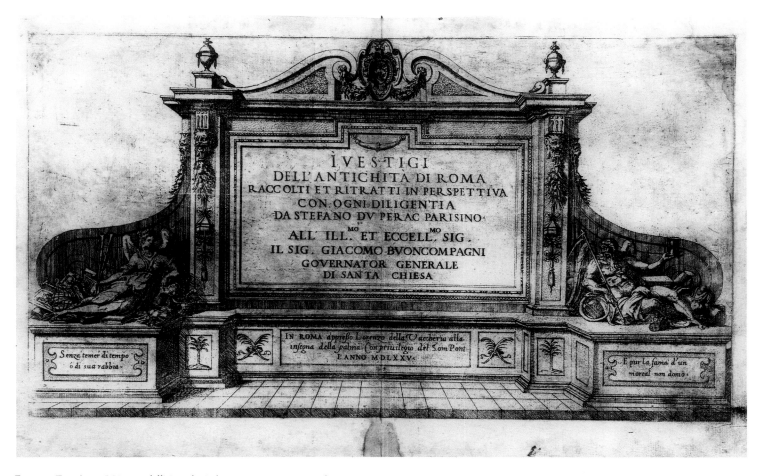

Etienne Dupérac, *I Vestigi dell'Antichità di Roma*, Rome 1575, frontispiece

Moroni's solemnly latinate prose must have been richly evocative to the ears of contemporaries steeped in classical literature, which was still the basis of education. He cites Pliny for the unshaken conviction that:

Rome was chosen by the will of the Gods to make heaven itself brighter, so that she might gather into one the scattered empires, and refine manners, and tie the discordant and savage tongues of so many peoples with a common bond of speech, and bring men to a single consort and gentility, and, to put it briefly, so that the whole world might be the fatherland of all peoples.[6]

Moroni parallels this vision of universal harmony under the *Pax Romana* with the much more expansive embrace of:

The Rome of St Peter did not limit herself to the confines of the Roman Empire, but stretched beyond the immense ocean and went so far as to reach the extremities of the world, into the two very vast regions last discovered, *America* and *Oceania* ... It was through the Rome of the Popes that so many peoples of savage and mutually dissonant tongues heard *Prayer* rise before God in a single language, and celebrated in that language and with beautiful uniformity the sacred *Rites* and *Liturgies*, learning among themselves the heavenly language of charity and love.[7]

The last phrase may echo the verbal association between Roma and love providentially contained in their spelling – *Roma* being the mirror-image of *Amor*. Moroni typifies the assumption that the actual world order as it had 'always' been, with the Eternal City at its center, was included in Christ's guarantee that the gates of Hell would not prevail against His Church, founded on the rock of Peter:

By high and admirable decree of divine providence, the way for the Catholic religion was opened and made level by the Roman Empire, which in its expansion lovingly stretched out its motherly arms toward every nation, so that all peoples might grow accustomed to respecting her, and to obeying the new papal and Christian Rome, become a sure haven for all peoples, universal mother and mistress of the faithful by the supreme chair of truth, there founded by the supreme will and marvellously preserved now for XIX centuries, in the face of the most violent persecutions, even against the visible head of the Church, and so many assaults to which was subjected the city destined to be queen over all the others (wherefore it remained dominant through religion and through the fine arts that flourish there), at the hands of the ancient and latter-day barbarians, from fires, floods, earthquakes and other calamities, most especially those of a political nature.[8]

Moroni's image of Rome's motherly embrace of the world echoes an idea given visual expression in Bernini's colonnade of St Peter's Square. The subtly marked concavity of the pavement of the piazza has the effect of accentuating the natural dome-like appearance of the sky, thereby combining it with the earth into a single orb. The embrace of the expansive elliptical curve of the colonnade thus appears to encompass everything, as does the horizon. The piazza, which contemporary documents refer to as a

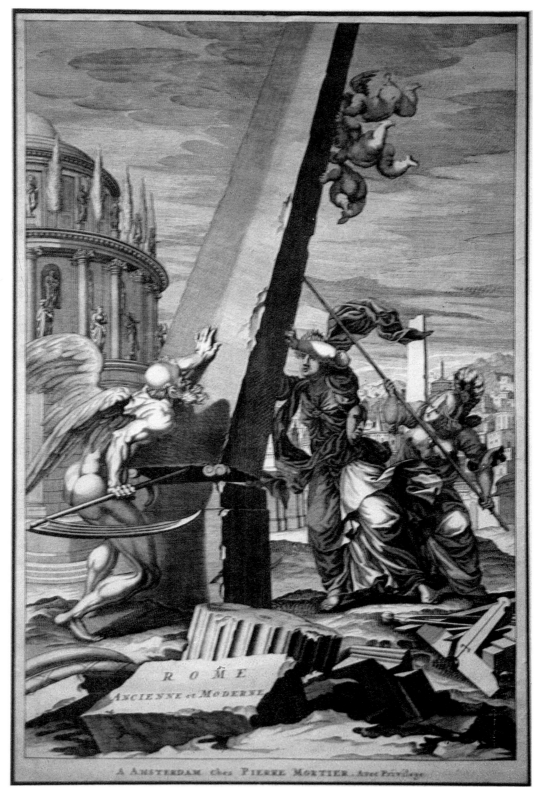

Joan Blaeuw, *Italie . . . oud en Nieuw Rome*, Graavenhaage 1724, frontispiece

theater — for such it seems by its evocation of ancient amphitheaters — provides a perfect architectural metaphor of the definitive setting for the sacred representation of the pope's universal blessing, *Urbi et orbi*.

This expression plays on the happy homophony between the Latin words for City and World. It conveys with lapidary succinctness the message that the pope's blessing reaches one and all by virtue of its being addressed to the City, *Mater et Caput Mundi*, Mother and Head of the World. For the city includes the world within itself. Moroni recalls other analogous expressions proclaiming the universality of Rome:

at all times and among every nation she has been called *the* City . . . Among the immense flock of those who have rightly praised Rome the Egyptian Atheneus did not hesitate to call her with beautiful paraphrase *Orbis Compendium*, Compendium of the World, and others *Compendium totius Orbis*, Compendium of the whole World, exclaiming: *What and how many other cities are as admirable as Rome? What and how many still survive after such rack and ruin?*[9]

Moroni typically gives the arts pride of place alongside religion as an integral part of Rome's spiritual leadership:

Rome the center of Catholicism is also the civilized world's school in the fine arts, and possesses the treasures of the ancient world as well as of the modern, drawing to herself an immense number of artists from every nation and religious belief. In truth, without his going for a stay in Rome, an artist's education cannot be perfectly completed, and in consequence of this the city abounds with the studios of sculptors, painters and other artists who live there well received and protected.[10]

Although the artistic leadership which Rome had maintained from the High Renaissance onwards had dwindled somewhat by the end of the seventeenth century, it had considerably regained prestige by the late eighteenth century, through the renewed interest in antique sculpture re-flected in the works of Canova and Thorvaldsen and promoted in the influential writings of Winckelmann. However, Neoclassicism was to be the last attempt to recover the eternal canons of ancient art from the ravages of Time — and Time itself was to take on a completely different meaning. Art that had striven to lessen the effects of Time gradually ceded this role to science, which could pave the way for progress. Henry James witnessed this change and keenly observed the tell-tale signs. In 1877 he commented:

as we move about nowadays in the Italian cities, there seems to pass before our eyes a vision of the coming years. It represents to our satisfaction an Italy united and prosper-ous, but altogether scientific and commercial.[11]

Already in 1873 he had written:

But now that Italy is made the Carnival is unmade; and we are not especially tempted to envy the attitude of a population who have lost their relish for play and not yet acquired

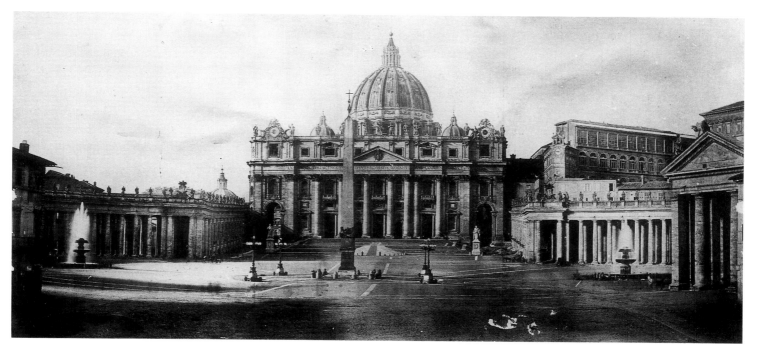

St Peter's and the Piazza, in a nineteenth-century photograph

to any striking extent an enthusiasm for work. The spectacle on the Corso has seemed to me, on the whole, an illustration of that great breach with the past of which Catholic Christendom felt the somewhat muffled shock in September 1870. A traveller acquainted with the fully papal Rome, coming back any time during the past winter, must have immediately noticed that something momentous had happened – something hostile to the elements of picture and colour and 'style'. My first warning was that ten minutes after my arrival I found myself face to face with a newspaper stand. The impossibility in the other days of having anything in the journalistic line but the *Osservatore Romano* and the *Voce della Verità* used to seem to me much connected with the extraordinary leisure of thought and stillness of mind to which the place admitted you. But now the slender piping of the Voice of Truth is stifled by the raucous note of eventide vendors of the *Capitale*, the *Libertà*, and the *Fanfulla*; and Rome reading unexpurgated news is another Rome indeed. For every subscriber to the *Libertà* there may well be an antique masker and reveller less. As striking a sign of the new regime is the extraordinary increase of population.[12]

Henry James touches here on a number of points about which we may need reminding, since they concern surprising differences and similarities between the old Rome and the new, not necessarily represented in the drawings but nonetheless important factors in creating the atmosphere that inspired such pictorial evocations. Last in order, but most indicative of the change of pace, is the extent of the population. The stillness, and indeed the monumentality of the city, must have been greatly enhanced by the astonishingly low density of the population. When building work began on St Peter's Square in the 1650s the population was scarcely above 100,000[13] – less than half of the quarter of a million people that it was said to be able to contain. In the early nineteenth century the young Viollet Le Duc wrote home that one could walk for a whole hour without meeting anyone.[14] Whether this means anyone at all, or anyone who is anyone, is not quite clear, however.

James' mention of Carnival points to another essential feature of Rome: her traditional love of spectacle. Seventeenth- and eighteenth-century chronicles show how absorbing a passion this was.[15] The splendor of such events which, together with the characteristic costumes and customs of everyday life not shown in the drawings, was the subject of an equally plentiful production of illustrations and is typified by the fireworks of 1662 celebrating the birth of the Dauphin.[16]

Even though Rome may often have changed little as a setting, the spectacle that originally gave it its significance has altered completely. Expressing his regret at the disappearance of a way of life that manifested 'representationally . . . an order which proclaimed stateliness a part of its essence'[17], Henry James commented that:

an Italian dandy is a figure visually to reckon with, but these goodly throngs of them scarce offer compensation for the absent monsignori, treading the streets in their purple

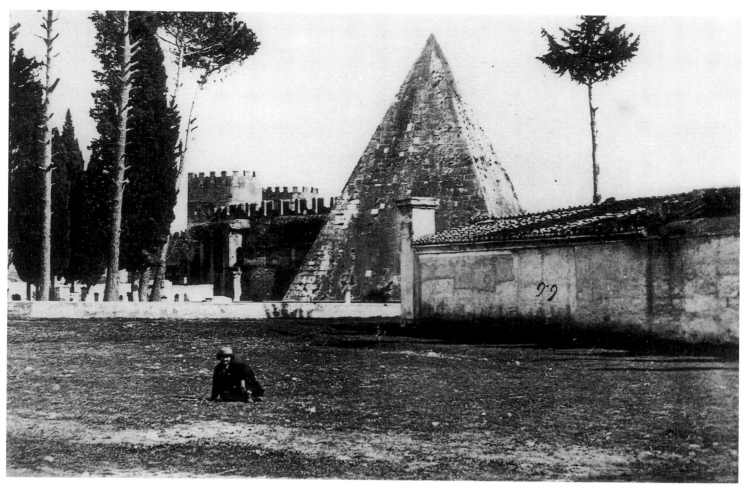

The Porta San Paolo and the Pyramid of Cestius, in a photograph of *c1865*

stockings and followed by the solemn servants who returned on their behalf the bows of the meaner sort; for the mourning gear of the cardinals' coaches that formerly glittered with scarlet and swung with the weight of footmen clinging behind; for the certainty that you'll not, by the best of traveller's luck, meet the Pope sitting deep in the shadow of his great chariot with uplifted fingers like some inaccessible idol in his shrine. You may meet the King indeed, who is as ugly, as imposingly ugly, as some idols, though not so inaccessible.[18]

Of course, the transformation of Rome did not take place overnight, nor had the city remained so far 'behind' the rest of Europe that changes were not already initiated before 1870. One example among many of the will to be up-to-date, evident during the reign of Pius IX, is the introduction in 1852 of incongruous lamp-posts around the obelisk in St Peter's Square[19]. But change was to accelerate at a completely new pace when Rome finally succumbed in 1870 to the accumulation of events which, at their European outbreak in 1848 and despite the shortlived Roman republic of 1849, had until then scarcely affected the city. Indeed, Moroni's confidence in papal Rome's immutable permanence can only have been reinforced by the prompt downfall of the Republic, like that of the one before it.[20] By comparison with present-day Rome, 'the young capital' as Henry James described it, seems far more remote than the 'fully papal Rome' can have seemed to him on the morrow of the unification of Italy. The material fabric of Rome had not yet begun to undergo the upheaval that was to come. Besides, much of Rome did remain virtually the same as before, as indeed it has continued to do until the present day. The Pyramid of Caius Cestius, for example, looks almost exactly the same now as it does in a photograph of c1865, taken from the same angle as in one of the drawings in this collection (No. 52). However, on the other side of the wall the landscape, as shown in another photograph of c1865, has entirely disappeared. And yet Henry James had complained as early as 1877 that 'on issuing from the door that has admitted you to the beautiful past [you] are confronted with something that has the effect of a very bad joke.'[21]

Furthermore, many of Rome's traditional institutions lived on more vigorously than one would suppose from Henry James's dirge-like evocation of extinguished splendor. Photographs as recent as 1948 show the refulgent illuminations of St Peter's, by no means artificially rekindled, but then still part of a living tradition of which, however, they were to be the glorious sunset[22]. Even more recently the pontifical services in the Sistine Chapel still presented the same timeless spectacle that can be observed in a painting of 1814 by Ingres and in almost identical photographs of the 1960s. The accompanying polyphonic music, so enthusiastically 'discovered' there by Goethe[23], dated mostly from the sixteenth century and was therefore closely contemporary with Michelangelo's frescos. Every

The Aurelian Walls, the Porta San Paolo and the Pyramid of Cestius, in a photograph of *c*1865

gesture was rooted in centuries of precedent going back to imperial Roman court ritual, thus manifesting metaphorically the dimension of eternity which it is of the essence of the Church to anticipate. This she did by making the visible earthly city conform to the poetic idea of a heavenly city. Moroni testifies that in 1852 Rome was as mindful as ever of such a role, for which he cites the authority of the Church Fathers who 'called her a City second only to the triumphant city of Paradise'. He recalls St Fulgentius who exclaims: 'How beautiful must the heavenly city be, if the earthly Rome is so refulgent?' And St Bernard: 'If the stable is so great, how much greater the palace?'[24]

The untiringly repetitive cyclic rhythm of liturgical time on which Rome's life was based had, however, already been paradoxically undermined by the new archaeological interest in the ruins of ancient Rome, which increased what Henry James called 'this spiritual solitude, this conscious disconnection of the great works of architecture and sculpture that deposits a certain weight upon the heart'.[25] This increasing estrangement of the past, beginning even before 1870 with the ruins, can be traced in photographs[26]. Whereas the ruins had been naturally integrated into the city, and more recent dwellings seemed in no way out of place, now they were gradually fenced off and walled in.

Emblematic of the demise of the old 'sentimentalism' and the advent of the new scientific spirit are the contrasting characters in Henry James's story of the imprudent Daisy Miller and the sensible Winterbourne. In the setting of the Colosseum by moonlight (cf. No. 26), where three centuries before Cellini had invoked diabolical assistance in pursuance of his amorous aims, Winterbourne 'as he stood there ... began to murmur Byron's famous lines, out of *Manfred*; but before he had finished his quotation he remembered that if nocturnal meditations in the Colosseum are recommended by the poets, they are deprecated by the doctors. The historic atmosphere was there certainly, but the historic atmosphere scientifically considered, was no better than a villainous miasma.'[27] But whereas he was able to indulge in the picturesque with moderation, Daisy Miller's reckless lingering in the 'plaguy dark' was to be the death of her.

The triumph of the new linear concept of time, to which Winterbourne would have subscribed, is graphically reflected in the passage in which Henry James expresses his own acceptance, 'the first irritation past', of the changes, remarking that 'regret is one thing and resentment another.'[28]

For, if we think, nothing is more easy to understand than an honest ire on the part of the young Italy of today at being looked at by all the world as a kind of soluble pigment. Young Italy, preoccupied with its economical and political future, must be heartily tired of being admired for its eyelashes and its pose. In one of Thackeray's novels occurs a

mention of a young artist who sent to the Royal Academy a picture representing 'A Contadino dancing with a Trasteverina at the door of a Locanda, to the music of a Pifferano.' It is in this attitude and with these conventional accessories that the world has hitherto seen fit to represent Italy, and one doesn't wonder that, if the youth has any spirit, he should at last begin to resent our insufferable aesthetic patronage. He has established a line of tram-cars in Rome, from the Porta del Popolo to the Ponte Molle, and it is in one of these democratic vehicles that I seem to see him taking his triumphant course down the vista of the future . . . Like it or not, as we may, it is evidently destined to be; I see a new Italy in the future which in many important respects will equal, if not surpass, the most enterprising sections of our native land. Perhaps by that time Chicago and San Francisco will have acquired a pose, and their sons and daughters will dance at the doors of *locande*.[29]

Indeed, the trend set by the lamp-posts in St Peter's Square was soon to lead to the appearance within sight of the obelisk of tram-cars, at first horse-drawn and soon afterwards powered by electricity.[30] The latter stridently displayed commercial advertising which Henry James would surely have felt a grave offense to the dignity of the place — even if one to be patiently borne as the reverse of a coin that was ultimately to enrich the economical and political future of young Italy. The trams, and the motor cars that succeeded them, have now been removed out of respect for the solemn monumentality of the Piazza. The 'temporary' mobile post office which has taken their place will presumably, in spite of its apparent permanence, also make an eventual exit. Even then the Piazza will bear the mark of changing times in the form of spotlights, loudspeakers, signposts and security barriers, though these too may one day acquire the venerability of the 'historical' as the lamp-posts seem to have done already. A more serious alteration, which severely undermines the grandeur of the Piazza, is the diminution of pressure in the fountains, whose astonishingly vigorous jets of still recent memory had deservedly earned them the admiration expressed in such epithets as 'rivers in the air'.[31]

Though the Piazza may have changed faster in more recent years, yet it still remains the embodiment of that continuity and renewal that justifies Rome's title of 'Eternal City'. Though the obelisk has witnessed many a change, and itself changed place, it is still the only one of all the obelisks in Rome that Time has never since antiquity been able to topple.

MARC WORSDALE
Assistant Professor
Renffelaer School of Architecture, Troy, New York

NOTES

1. G Moroni, *Dizionario di Erudizione Storico-Ecclesiastica*, vol. LVIII, Venice 1852, p.109.

2. The plates are all reproduced in the exhibition catalogue *Vestigi delle Antichità di Roma . . . et altri luochi. Momenti dell'Elaborazione di un'Immagine*, a cura di Anna Grelle, Rome 1987, pp.71–96.

3. Cf. *ibid.* pp.97, 123. For a discussion of the editions see T. Ashby, *Le diverse edizioni dei Vestigi di Roma di Stefano du Pérac*, Florence 1915.

4. (Joan Blaeuw), *Nieuw Vermeerderd en Verbeterd Groot Stedeboek van Geheel ITALIE . . . oud en Nieuw Rome . . .* [Rutgert Christoffel Alberts], Graavenhaage 1724.

5. Moroni, *cit.* note 1, p.110.

6. *Ibid.* p.107.

7. *Ibid.*

8. *Ibid.* pp.105–106.

9. *Ibid.* p.103.

10. *Ibid.* p.108.

11. Henry James, *Italian Hours*, reprinted London 1986, p.112.

12. *Ibid.* pp.136–137.

13. M Petrocchi, *Roma nel Seicento*, Bologna 1975, p.56.

14. E Viollet Le Duc, *Lettres d'Italie 1836–1837 Adressées à sa Famille*, annotées par G Viollet Le Duc, Paris 1971, p.304.

15. Cf. G Gigli, *Diario Romano (1608–1670)*, ed. G Riciotti, Roma 1958, *passim*; M Andrieux, *Daily Life in Papal Rome in the Eighteenth Century*, translated by Mary Fitton, London 1968, ch.7 (original title *La Vie Quotidienne dans la Rome Pontificale*, Paris 1968).

16. Cf. M Fagiolo dell'Arco and S Carandini, *L'Effimero Barocco. Strutture della Festa nella Roma del '600*, I, Rome 1977, pp.185–193.

17. James, *cit.* note 11, p.205.

18. *Ibid.*

19. In the photograph reproduced on p.41 the lamp-posts have already acquired their expanded form but have not yet been linked by the second ring of bollards.

20. Cf. Andrieux, *cit.* note 15, pp.201–210.

21. James, *cit.* note 11, pp.110–111.

22. The last complete illumination of the dome took place in 1940. The system employed was based on the model of 1750 attributed to Luigi Vanvitelli (cf. exhibition catalogue *Roma 1300–1875. L'Arte degli Anni Santi*, a cura di M Fagiolo e M L Madonna, Milan 1984, pp.454–55 no.XI.21). The tradition is said to go back to 1675 when Bernini held the post of architect of St Peter's (cf. A Schiavo, 'L'Illuminazione Esterna di S. Pietro e Luigi Vanvitelli', *Studi Romani*, iv, 1975, pp.486–91). A stirring account of the acrobatic prowess of the workman who installed the lamps can be found in L Gessi, 'L'Illuminazione della Basilica di San Pietro', *L'Illustrazione Vaticana*, iv, 1933, no.23, pp.965–968. For the illumination of the colonnade in 1948 cf. *Enciclopedia Cattolica*, 1949, II, tav. XXXVII.

23. J W Goethe, *Italian Journey (1786–1788)*, translated by W H Auden and E Mayer, [Penguin Classics], London 1970, pp.474, 478, 482–84. Many other writers, including Viollet Le Duc (cf. *op. cit.* note 14, pp.185, 212), recorded their deep admiration for the services in the Sistine Chapel.

24. Moroni, *cit.* note 1, p.104.

25. James, *cit.* note 11, p.125.

26. See the increasingly permanent character of the railings and the disappearance of dwellings around the Forum in A Manodori, *Roma mai più Roma: attraverso le fotografie di Alessandro Vasari* Rome 1983, pp.107, 111, 113, 115.

27. Henry James, *Daisy Miller* (*Daisy Miller and Other Stories*, reprinted New York 1969, p.73).

28. James, *cit.* note 11, p.125.

29. *Ibid.* pp.111–112.

30. Cf. Mandori, *cit.* note 27, pp.169, 171.

31. Cf. the remarks of Queen Christina of Sweden, Président de Brosses and Madame de Staël in F Zanetti, 'Le Fontane della Piazza di S. Pietro', *L'Illustrazione Vaticana*, v, 1934, no.15, pp.644–646.

The basis of the following commentary is the *Dessins de la Collection Thomas Ashby à la Bibliothèque Vaticane* (Biblioteca Apostolica Vaticana, Documenti e Riproduzioni 2, 1975) by Didier Bodart; the Bodart Catalogue Numbers are given for each item and the attributions made in this fundamental work have for the most part been retained. More recent study of the material, however, has inevitably brought new facts to light. Bodart himself expressed doubts about some of his attributions, and it is clear that in a number of cases further research is needed before they can either be accepted with confidence or positively altered. I hope that my own observations on this subject will do something to clarify the situation, though I cannot pretend to have resolved more than a few of the problems with any degree of certainty. In this regard the assistance of the various scholars consulted, and those whose opinions I have quoted, has of course been invaluable.

Watermarks are mentioned where they exist, and reference should be made to the Bodart catalogue for full details and, in many cases, facsimile reproductions. R.K.

EIGHTY-ONE DRAWINGS AND WATERCOLORS FROM THE THOMAS ASHBY COLLECTION

1 ANONYMOUS

DUTCH, c1544–45

The Construction of St Peter's Basilica

Pen and brown ink with salmon-pink and gray wash: 297 × 436 mm

Inscribed, recto, bottom right, in brown ink: 79; upper left, in brown ink: *diemurenvanderstadt; divisorio*; center, in brown ink: *Sinte pieters kercke*; upper right, in brown ink (partly cut): *De Toren gaet me*; number *142* stamped on verso, bottom center. Printed label on mount: *A SS PIO XI OMAGGIO GIUBILARE DELL'ISTITUTO NAZIONALE FARMACOLOGICO MEDICO 'SERENO'/Ignoto artista olandese – S. Pietro con gli edefici adiacenti nel 1530 c.*

WATERMARK on support

CONDITION: some staining

LITERATURE: Egger 1911, p. 25, pl. 20; Egger 1932, p. 24, pl. 20; Ackerman 1961, I, p. 93; Millon and Smyth 1976, pp. 142ff; Thoenes 1986, pp. 481–501

BODART NO. 330

The Church of St Peter, in one sense, is not the first church of Christendom, since the Chapter of St John Lateran has priority, according to the Bull of 21 December 1569; however, St Peter's is the better known church, and has had a greater number of privileges and prerogatives, and is today the most magnificent church of them all ... One should start by pointing out that its site has been sacred since the first century of the Church, sanctified by the blood of many Martyrs. Tacitus tells with horror of the cruelties that Nero devised for them, in the year of Christ 64. 'And the condemned, as an additional sport, were covered in the hides of animals, so that thus they should be torn to pieces by dogs, or were crucified, or were set out to be burnt, so that when the sun went down they should glow like torches' (*Annals*, XV, 44). These indecent spectacles took place in Nero's own gardens, which verged on the Circus, and along the Triumphal Way, going out towards Monte Mario; which is the very spot where St Peter's is built. Probably most of the Martyrs were buried near to it, or at least they were transferred there later, in the time of Constantine; for we have always been told that this Temple was the cemetery of the first Christians to die for their faith, and on 22 June the Feast of the 10,000 martyrs resting in this church is celebrated.

Joseph-Jérome Lefrançois de Lalande, *Voyage d'un Français en Italie fait dans les Années 1765 & 1766*

Julius II set about the building of this temple with the kind of spirit that conquers nations ... He constructed the most splendid temple, to be the equal not just of the stars, but of the sun itself, and he placed it on the site of the tomb of St Peter, the apostle who, in Julius's words, had interpreted the glory of God to the world. When Bramante, the leading architect of the time, whom Julius had employed for the many other buildings he had constructed but primarily and above all for this one — when Bramante attempted to persuade Julius that the apostle's tomb should be transferred to a more suitable site, and the façade of the church should be set towards the south, rather than facing east as it did then (with the intention that the obelisk, in the atrium of the temple, should rise up impressively before those coming up to it), Julius refused, insisting that the sacred should be immutable, and denying Bramante permission to displace what should not be touched; and when Bramante persisted, promising that the results would be as suitable and fitting as

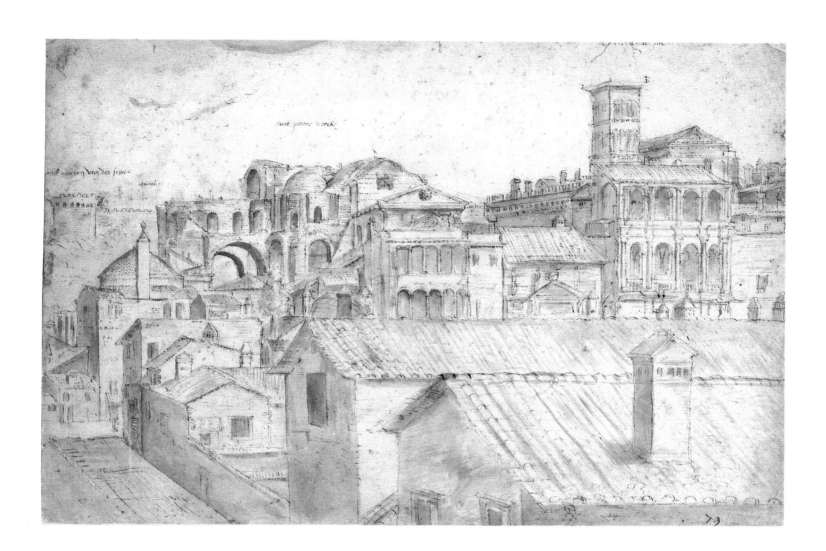

sante pietro kercke

die muuren van der stat

79

could be, were Julius to have the shrine of Julius Caesar (as the obelisk was widely believed to be) in the atrium of the church: it would increase the sense of awe and be for the benefit of religion, since those approaching the church to perform the sacred rite would be amazed and astonished at the sight of the extraordinary colossus; besides, it was difficult to remove rock from the hills, while it was easy to carry downhill material that had already been worked; those that had no particular feelings for the place would not mind, while those moved by love for it would be able without trouble to prostrate themselves at the chapels and altars; he would see to the transfer of the tomb himself, nothing would be displaced, and he promised to transport the tomb together with its surrounding soil so that nothing should crumble away;— all the more did Julius remain determined, that nothing on the site of the old temple should be disturbed; he said that he would suffer nothing from the tomb of the first pope to be handled; as for the deserts of Caesar's obelisk, he, Julius, would see to them, and he would put sacred before profane, religion before show, and piety before splendour.

From the writings of Cardinal Egidio da Viterbo (early 16th century)

Bramante's spirit being thus grown great, and seeing the Pope's wish corresponded with his own desire to pull down the church of S. Pietro and build it anew, he made a great number of designs, one being especially admirable, displaying his wonderful skill. It has two campaniles, one on either side of the façade, as we see in the coins of Julius II and Leo X, designed by Caradosso, an excellent goldsmith, unequalled for his dies, and by the fine medal of Bramante himself. The Pope then decided to undertake the stupendous task of building S. Pietro, and caused a half to be pulled down, intending that in beauty, invention, order, size, richness and decoration it should surpass all the buildings ever erected in that city by the power of the republic and by the art and genius of so many able masters. Bramante laid the foundation with his accustomed speed, and before the Pope's death the walls were raised as high as the cornice, where the arches to all four pilasters are, and he vaulted these with the utmost rapidity and great art. He also vaulted the principal chapel where the niche is, and proposed to push forward the chapel called after the King of France. He discovered the means of making vaulting by using wooden frames, that it may be carved with friezes and foliages of stucco, and showed the way to make the arches with a hanging scaffolding, an invention followed by Antonio da Sangallo. In this part, finished by himself, the cornice running round the interior is such that it would be impossible to improve its design. The strange and beautiful olive leaves of the capitals and the beauty of the exterior Doric work show the tremendous character of Bramante's genius, so that if his strength had equalled his genius he would have accomplished unheard-of marvels. Since his death many architects have meddled with this work, so that, excepting the four outside arches bearing the tribune, there is nothing of his left.

Giorgio Vasari, *Life of Bramante* (1568) (translated by A B Hinds)

THE origins of the great basilica of St Peter's date back to the time of the Emperor Constantine, when churches as we understand them did not exist. Up to this time the faithful, who would have numbered possibly one third of the total 800,000 population of Rome, held their religious services in the houses of the more affluent members of the community. These domestic dwellings would have had a part of their interior given over for use by the congregation, and in exceptional cases possibly the whole house was devoted to religious functions. The 'Houses of the Church' were generally identified by the name of the holder of the original title to the property, and later when these buildings were re-modeled for religious use they became the 'titular' churches of the burgeoning Christian community (see Santi Giovanni e Paolo, No. 36).

With the accession of Constantine (312–37) a new era dawned for Christianity. Following the Edict of Milan in 313 the Church increasingly became the recipient of official imperial patronage, with the construction of great religious centers becoming one of the key policies of the Emperor. Constantine and his family directly financed the building of a number of magnificent basilicas, religious structures modeled on the traditional law courts and business halls of the Romans. These buildings became the prototypes for the new public centers of congregation of the recently emancipated faithful everywhere.

It was reputedly in the circus built by Caligula on the Vatican Hill that the Apostle St Peter suffered death in 64, a fate shared by a large number of his religious brethren, all executed by Nero following the great fire that year which had devastated almost half of Rome. Following his martyrdom, the remains of the saint were laid to rest in a cemetery nearby, at that time shared by pagans and Christians alike. The site of his burial soon became a place of special veneration and some time between AD 160 and 180 it was walled off and the tomb covered by a *tropaia* (trophy) or small aedicule proclaiming the martyr's victory over death. Cult centers laid out around the tombs of the martyrs were a common feature of this period and the Christian community would regularly gather at these shrines to hold commemorative celebrations in honor of the departed. Constantine's decision to erect a basilica over the tomb of the Apostle was a gesture of particular significance as the siting of the tomb on the slope of the hill made it an excep-

tionally unsuitable location for the erection of a great building. To construct his basilica Constantine had both to excavate into the hill to the west and to build up foundations to a height of approximately 25 feet toward the east, preparing an area of 750 by 400 feet. Most probably this work was initiated some time between 324 and 330 and continued almost until the end of the century, with only the western portion of the structure complete at the time of the Emperor's death in 337. The interior of this magnificent basilica was 368 feet long and 190 feet wide, with the wall of the nave rising to a height of 120 feet. Externally, the building presented a sober façade, but internally, with its dimly lit nave and light-filled transept, illumined by 16 large windows, the building was endowed with sumptuous decoration. The nave was flanked by two rows of 22 gigantic columns, above which the walls were covered in the fifth century by mosaics.

The first extensive repairs to the basilica are recorded during the pontificate of Leo the Great (440–61), when an earthquake damaged a number of the colossal columns and the ceiling. Leo also placed mosaics on the façade. Pope Symmachus (498–514), resident at the Vatican because the Lateran was then occupied by an anti-pope, added a fountain, known as the *cantharus*, to the enclosed square or atrium before the church, incorporating a giant pine cone of bronze which may have come from the nearby mausoleum of Hadrian (see No. 7). The pine cone is now in the courtyard of the Belvedere. The atrium, completed by the year 397, was provided for the catechumens not permitted to enter the church proper. Measuring 200 by 180 feet, with colonnades on all four sides, it was entered from the outside by way of a two-storied portico of three arches. Early on it acquired the name 'Paradise', possibly on account of its luxuriant vegetation of shrubs and flowers, removed when the area was paved by Pope Donus I (676–78). During the pontificate of Honorius I (625–38) the church was re-roofed with tiles pillaged from the Temple of Venus and Rome. Pope Adrian I (772–95) was responsible for extensive work on the portico and campanile. More work on the atrium was carried out under Gregory IV (827–44). In August 846 the building was damaged during the Saracen raid on the city. The simple western façade above the atrium was extensively renovated by Gregory IX (1227–41) who opened up windows, including a rose

window, into the nave. Leo's mosaics had to be replaced as a consequence. During the fourteenth century the building fell into very poor condition and it was necessary for Nicholas V (1447–55) to undertake a program of repairs. Pius II (1458–64) commissioned the building of the Benediction Loggia, a work continued under Paul II (1464–71). This structure, modeled on ancient prototypes and incorporating six columns pillaged from the Porticus of Octavia, may be considered one of the first works of the Renaissance in Rome. We have no documentary evidence stating who the architect was; however, there is evidence to suggest that he was a Florentine and it has consequently been surmised that its author was the renowned humanist and architect Leon Battista Alberti (1404–72). To the left of the entrance to the atrium stood the church of Sant'Apollinare ad Palmata. It was reputedly constructed by Pope Honorius in the seventh century.

This anonymous drawing was not part of the original Ashby collection, but is stored with his material in the Vatican Library. It shows the site from the east, with the remains of the basilica and its appendages obscuring the growing bulk of Julius II's new fabric (see No. 2). The arcaded structure to the right is the Benediction Loggia. To its right is the gatehouse, here shown with pedimented portico. This feature must date back at least to the pontificate of Paul I (757–67), who commissioned the mosaics for its façade. Inside was the small chapel of Santa Maria in Turri. It was within this portal that Giotto placed his mosaic called the *Navicella* (c1310). To the left of the gatehouse is another arcaded structure which formed the house or palace of the Archpresbyter. Rising behind these buildings are, from right to left: the palace of Innocent VIII, the campanile, the Sistine Chapel, the nave of the old basilica divided from the bulk of the new building by the *muro divisorio* erected by Sangallo in 1538, and the small church of Santa Maria della Febbre (see No. 5) fronted by the obelisk from the circus of Caligula and Nero.

The drawing was made at a time when the construction of the basilica was again beginning to gain some momentum, after the site had been inactive for many years due to lack of funds. As remarked by Christof Thoenes (1896), the new basilica, incomplete and covered with all kinds of opportunistic growths, then appeared more like an ancient Roman ruin than a modern Christian basilica. The date of this particular view can be determined quite accurately with the help of documents and other dated views of the scene, most notably the fresco by Giorgio Vasari in the Palazzo della Cancelleria (1546). Millon and Smyth (1976, pp.142 ff.) date the drawing between late 1544 and early 1545, after the curve of the masonry on the east vault had been completed and before documented work was carried out on the old campanile.

The authorship of the drawing, which may possibly be a copy, remains a mystery. The inscription indicates that the artist must have been Dutch, but nothing more precise can as yet be said.

ANONYMOUS

DUTCH, *c*1524

The Construction of St Peter's Basilica viewed from the south-west

The verso displays an extensive drawing of Roman ruins in red chalk, possibly the Baths of Caracalla (according to Bodart they are the ruins of the Aedes Severianae)

Pen and brown ink with some black chalk: 198 × 408 mm

Inscribed, verso, bottom right, in ink: *Briquet 761/Udine 1533*; bottom right corner, in an old hand, in black chalk: *no 153*

WATERMARK

CONDITION: restored lacunae bottom left. Some staining. Previously backed. Fold mark 135 mm from left side

PROVENANCE: Van Thermet, Utrecht; Bernard Houtakker, Amsterdam; Sotheby's 28/29 November 1922, lot no. 87 (as Dupérac)

LITERATURE: Ashby 1924, pp. 456–459; Egger 1932, p. 29, pl. 38; Frommel 1984, p. 303, no. Z. 15. 45a; Thoenes 1986, pp. 490–491

BODART NO. 329

The Holy Father, in honoring me, has laid a heavy burden upon my shoulders: the direction of the work at St Peter's. I hope, indeed, I shall not sink under it; the more so, as the model I have made for it pleases his Holiness and has been praised by many connoisseurs. But my thoughts rise still higher. I should like to revive the handsome forms of the buildings of the ancients. Nor do I know whether my flight will be a flight of Icarus. Vitruvius affords me much light, but not sufficient.

Raphael Sanzio, Letter to Count Baldassare Castiglione (27 August 1518) (translated by R Klein and H Zerner)

On the 19 I went to visite St Pietro, that most stupendious and incomparable Basilica, far surpassing any now extant in the World, and perhaps (Solomon's Temple excepted) any that was ever built.

The largeness of the Piazza before the Portico is worth observing, because it affords you a noble prospect of the Church; crowded up, for the most part in other places where great Churches are erected: In this is a fountaine out of which gushes a river, rather than a streame, which ascending a good height, breaks upon a round embosse of marble into millions of pearls, which fall into the subjacent basin: making an horrible noise: I esteeme this, one of the goodliest fountaines that I ever saw.

The next which surprises your wonder is that stately Obelisque, transported out of Aegypt, and dedicated by Octavius Augustus Nepot to Julius Caesar, whose ashes it formerly bore on the summit; but being since overturn'd by the Barbarians, was re-erected with vast cost & a most stupendious invention by Domenico Fontana Architect to Sixtus V. The Obeliske consist[s] of one entire Square stone without Hieroglyphic, & is in height 72 foote, comprehending the base & all 'tis 108 foote high, & rests upon 4 Lyons of gilded Copper, so as you may see through twixt the base of the Obelisque, and Plinth of the Pedestal: Upon two faces of the Obelisque is engraven thus...

It now bears on top a Crosse, in which Sixtus V 'tis sayd inclos'd some of the holy wood, and under it is to be read by good eyes...

After I had well contemplated these Inscriptions, I tooke notice of some Coaches which stood before the stepps of the Ascent, of which, one belonging to Card: Medicis had

all the metall worke of Massie Silver, viz, the bow behind and other places; & indeede the Coaches at Rome, as well as Covered Wagons, which are also much in use, are generally the richest & largest that I ever saw. Before the Faciata of the Church is ample pavement.

The Church was first began by St Anacletus, when rather a Chapel, upon a foundation (as they give out) of the Greate Constantine's, who in honour of the Apostles 'tis sayd, carried 12 baskets-full of sand to the Worke: After him Julius Secundus took it in hand, unto which all his since successors have more or less contributed. The Frontispiece is suppos'd to be the largest, and best studied piece of Architecture in the World: To this we went up by 4 stepps of marble: The first entrance is supported with huge Pillasters: The Volto within is certainly the richest in the Earth, overlayed with gold: next I considered the 5 large Anti-Ports, twixt which are Columns of enormous altitude & compass, with as many Gates of brasse, the worke & sculpture of Pollaiuolo the Florentine full of cast figures & histories in a deepe relievo. Over this runns a tarrac of like amplitude and ornament, where the Pope upon sollemne times bestows his benedictions of the Vulgar. On each side of this Portico are two Campaniles or Towers, whereoff there was but one perfected, of admirable art, & aspect. Lastly on top of all runns a Balustrade which edges it quite round, and upon this at equal distances, Christ & the 12 Disciples of gigantic bignesse & stature; yet below shewing no greater than the life . . .

John Evelyn, *Diary* (19 November, 1644)

BY the mid-fifteenth century the venerable basilica constructed by Constantine above the tomb of St Peter was in a state of advanced deterioration and in dire need of repair or replacement. Pope Nicholas V (1447–55), impressed by the views of Leon Battista Alberti concerning the matter, engaged the architect Bernardo Rossellino to construct a massive choir to buttress the apse at the west end of the tottering structure. With the death of Nicholas in 1455, however, the project, which had already been advanced some little way, was abandoned. It was not until Julius II ascended to the papacy in 1503 that the condition of the ancient basilica was again reconsidered seriously.

It may well be, as Vasari and Condivi later wrote, that Julius first became interested in the building of the new St Peter's because he wished to provide a suitable site for the great tomb which he had recently commissioned from Michelangelo. Vasari states in his *Life* of Giuliano da Sangallo that the architect encouraged Julius in his desire to erect a magnificent tomb and advised the pontiff to have a new chapel built expressly to hold it *'and that it ought not to be placed in old San Pietro, for there was no room'*. To build the new church Julius chose as his architect Donato Bramante (1444–1514), then a man of over sixty years of age. By 18 April 1506 plans were far enough advanced for the foundation stone to be laid. The medal struck to commemorate this momentous event presents us with an intriguing image of Bramante's plans for the building, which was initially conceived in the form of a Greek cross surmounted by a great cupola, with minor domes above the corners and a flanking pair of campanili. Work on the four great piers to support the dome and some of the vaulting progressed rapidly just beyond the choir of the ancient basilica, the nave of which was already partially demolished. With the death of Julius in 1513 and Bramante in 1514 the project received the first of many setbacks. Bramante's intention to set on top of the basilica a great hemispherical cupola, modeled on that surmounting the Pantheon, presented his successors with complex engineering problems, as the solid concrete dome would certainly have been too heavy to be supported by the piers already constructed. Also, the design concept of a Greek cross posed considerable difficulties to the liturgical exigencies of the new church; Bramante was aware of these and it may be that he preferred a Latin cross design in his later plans.

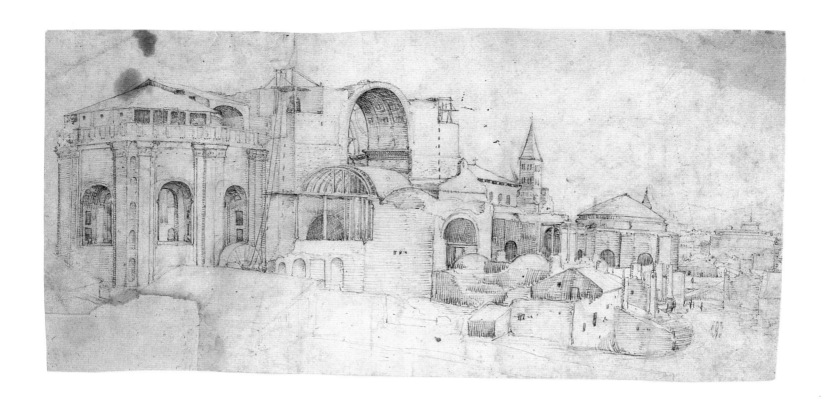

Following the death of Bramante, Julius's successor Leo X appointed the young Raphael as architect-in-chief on the project, later engaging Antonio da Sangallo and Baldassare Peruzzi as his assistants. During this pontificate little progress was achieved, due both to structural problems which presented themselves and to financial ones. Raphael and his assistants made many drawings working out the design of the building and apparently decided on a Latin cross plan. These drawings did not have much direct impact for the future evolution of the building, though Raphael's development of a process to provide orthographical projections showing elevations of the design made a crucial contribution to the working practice of future architects.

After the death of Raphael in 1520, Antonio da Sangallo the Younger assumed control of the construction with Peruzzi continuing to assist. Though critical of much of what Raphael had proposed he accepted the revised outline, a Latin cross with a dome above the crossing. Progress continued to be painfully slow during the papacy of the ascetic Hadrian VI (1522–23), and even after the election of Clement VII, due to lack of funds. That may have been one reason for the intermittent return of the Greek cross plan, as this design would have involved less expenditure. During the papacy of Clement VII both Peruzzi and Sangallo evolved centralized plans for the building. The devastation visited upon Rome by imperial troops during the sack of the city in May 1527, an event comparable to the attacks of the Goths in late imperial times, severely interrupted what little progress was being made. In the late 1530s Sangallo engaged Antonio Labacco to make up a scale model in wood to illustrate his latest designs. The model, which survives, took over four years to construct at a cost of 5000 ducats. This, and the raising of the floor level by about 10 feet, was Sangallo's most important contribution before his death in 1546. Much else of what he had managed to put up was razed by Michelangelo when he took on responsibility for the building immediately afterwards.

The appointment of Michelangelo as architect to St Peter's was a crucial moment in its history. The building campaign was injected with new vigor as the 70-year-old Florentine obtained from Pope Paul III (1534–49) complete autonomy in the future design and construction of the basilica. An additional factor in speeding up progress must have been Michelangelo's refusal to accept payment for his services, a gesture in marked contrast to the demands of Sangallo and his assistants (from 1529 to 1540, of the 17,620 ducats made available for the building, 7000 went to the architects). Michelangelo immediately set about clearing away all the confusion which had arisen due to the submission of so many conflicting and unworkable designs. He alone of Bramante's successors grasped the truly monumental vision of the original approach. By 1549 he had had a model made up, and was given license by the Pope to proceed with the building. Retaining Bramante's original centralized plan, Michelangelo, with some ingeniously simple modifications, transformed the fabric bequeathed by Sangallo into a cohesive, organic unit. Having determined the organization and decoration of the interior spaces and exterior profile, Michelangelo could finalize his plans for the great cupola, as work had progressed as far as the drum to support the dome. His final choice was modeled on the double-shell Gothic cupola of the Cathedral of Florence. Initially experimenting with an oval shape, he eventually decided on a simple hemispherical form surmounted by a tall lantern. At his death in February 1564 the cupola had not yet been begun, and it was left to Giacomo Della Porta to complete this critical feature, a task he accomplished between 1588 and 1593. However, the dome as constructed by Della Porta does not accurately reflect Michelangelo's last thoughts, as Della Porta effected a number of alterations to it, somewhat raising its profile, increasing the decorative features and reducing the profile of its sixteen great ribs.

This view of St Peter's documents the state of the basilica at a time shortly after the death of Raphael in 1520. It is dominated by the incomplete choir of Bramante rising to the west (left) of the composition, with the massive piers to support the cupola to the center, and some of the vaulting already complete. Beyond the crossing of the new transept can be seen part of the nave of the old basilica, with the old campanile rising above the atrium. To the right can be seen Santa Maria della Febbre (see No. 5). Just above its domed roof is visible the tip of the obelisk, later moved to the piazza in front of St Peter's by Pope Sixtus V. To the extreme right is the simple profile of Castel Sant'Angelo. Christoph Frommel (1984, pp.241–310), using documents relating to the construction of the basilica, has dated the view to a period some time between 1521 and 1524. According

to Christof Thoenes (1986, pp.490–491), the dating is more likely to be 1524–5, as payment for one of the cranes erected on the site is documented in 1524.

The author of the drawing must remain anonymous, though Christoph Frommel (*ibid*. p.303, no. z.15.45a) relates that Konrad Oberhuber suggested it could be by Jan van Scorel (1495–1562). The drawing indeed shares certain characteristics with the work of Scorel. Comparison with the known works of the master, however, such as his *View of Bethlehem* in the British Museum (inv. no. 1928–3–10–200) or his *View of a Ruined City* in the print room at the Rijksmuseum in Amsterdam (inv. no. 1913:2), show Scorel to have had a lighter touch to his penwork and to have used a less complex manner of shading to indicate the volume of the forms represented. The traditional attribution to Etienne Dupérac was dismissed by Thomas Ashby (1924, pp.456 ff.).

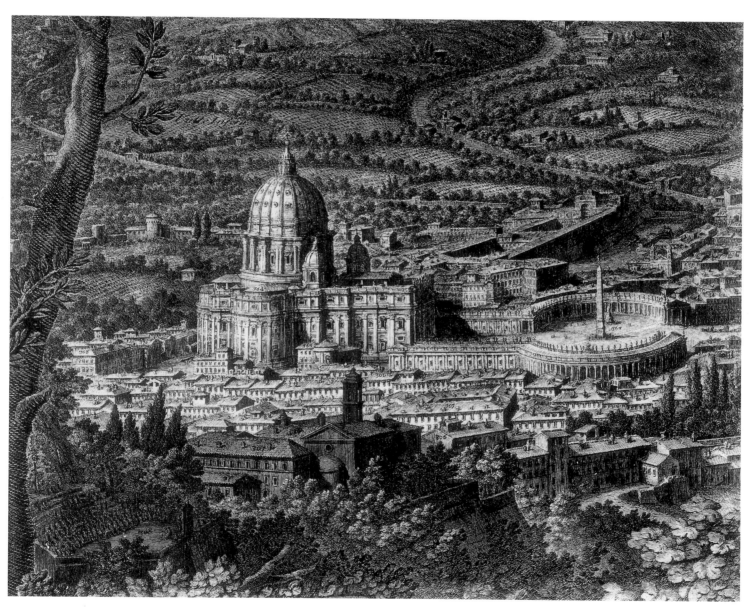

Giuseppe Vasi: *Prospect of Rome* (detail): *St Peter's Basilica*

3 FERDINAND BECKER

BATH, late 18th century—1825 BATH

The South Flank of St Peter's Basilica

Pen and gray ink wash with traces of black chalk: 291 × 417 mm

Inscribed, verso, lower left, in pencil: *From a Quarry near S^t Peter's, Rome*; in Ashby's hand, upper right center, in pencil: *63*

CONDITION: some discoloration, notably at the edges

BODART NO. 24

Vasari had no sooner reached Rome, before the beginning of 1551, when the Sangallo faction made a conspiracy against Michelagnolo, to induce the Pope to summon all the builders in S. Pietro, to show him by false calumnies that Michelagnolo had spoiled the structure. He had already made the King's recess, where the three chapels are, with the three windows above, and not knowing what was to be done in the vaulting, they had ignorantly informed Cardinal Salviati the elder and Marcello Cervini, afterwards Pope, that S. Pietro was badly lighted. When all were assembled the Pope told Michelagnolo that they stated that the recess was badly lighted. He answered: 'I should like to hear these deputies speak.' Cardinal Marcello replied: 'We are they.' Michelagnolo said: 'Monsignor, three more windows of travertine are to go to the vaulting.' 'You never told us that', said the Cardinal. 'I am not obliged to tell you or anybody else what I propose to do,' retorted the artist. 'Your office is to collect the money, and protect it from thieves; you must leave the design and charge of the building to me.' Turning to the Pope, he said: 'Holy Father, you see what profit I have; for if these labours do not benefit my soul, I am losing my time and trouble.' The Pope, who loved him, laid his hands on his shoulders, and said: 'Do not doubt that you will gain both in soul and body.' The Pope's love for him was thus greatly increased by removing this obstacle.

Giorgio Vasari, *Life of Michelangelo* (1568) (translated by A B Hinds)

FOR comment on the drawings of Ferdinand Becker, who is well represented in the Ashby collection, see No. 9.

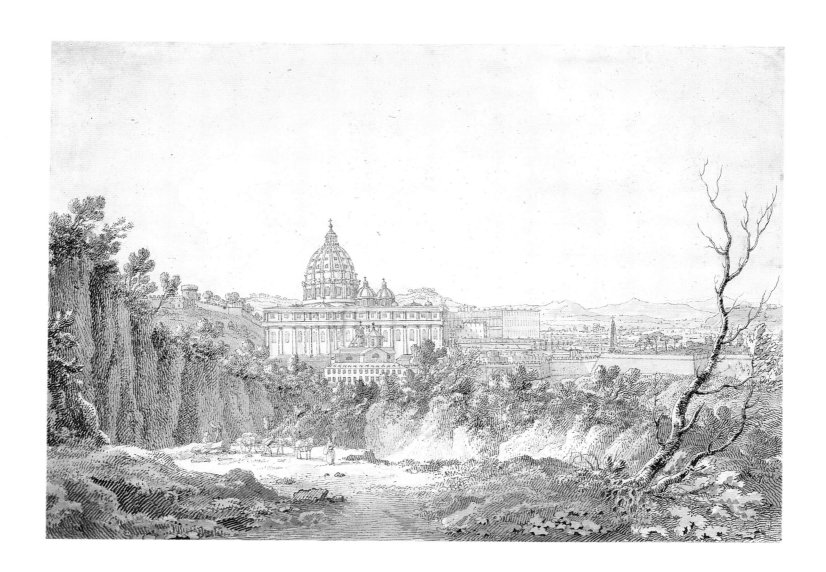

4 ALEXANDER NASMYTH

EDINBURGH 1758–1840 EDINBURGH

View of St Peter's from Monte Mario

Black chalk, on laid paper: 124 × 211 mm

Inscribed, verso, bottom left corner, in red ink: */:/:H.*; on front of paper support, below bottom edge of drawing, in black ink: *St Peter's from Monte Mario done on the spot in 1783*; to the right of this inscription, also in ink: *A Nasmyth*; below this, in pencil: *8.20w × 4.75h*; on inside of mount, below left of drawing, in pencil: *Percy Heseltine Collections*; bottom center, in pencil: *Alexander Nasmyth/St Peters from Monte Mario*; further to the right, in pencil: *Sotheby 2:5:0.*; on front of windowed mount, bottom right, in pencil: *904*

Border in ink. Periodic measurement marks along bottom and sides

CONDITION: collection stamp disfiguring appearance

PROVENANCE: Percy Heseltine

BODART NO. 210

Let me not defer any longer your visit to St Peter's; but would you not rather go by yourself, and allow me to be satisfied with what I have already written about it in a letter to Neuilly? How can I give a satisfactory account of that wonderful place? What has been written about it would form a little library. We will, nevertheless, throw ourselves upon that treasure house of art. I may begin by telling you that you might come to it every day of your life without being bored – there is always something new to observe, and it is only after many visits that one gets to know it at all. I would advise you only to visit St Peter's on bright days; the dull days are not favourable for seeing it, nor any other interior for that matter. The shortest way to reach St Peter's from the Piazza d'Espagna does not give one a favourable idea of Rome. One passes through a number of squalid streets, and it is not until the Bridge of St Angelo is reached that it improves. I have already spoken of that bridge, and of its balustrade of statues, and of the remains of the superb Mausoleum of Hadrian, now the Castle of St Angelo. You are aware that it is the fortress of Rome. I have much less pleasure in seeing it now, with its five bastions, than in imagining what it was like with its three-storeyed tower, surrounded by porticoes and colonnades, all covered with statues. That wicked Pope Alexander VI built the long gallery which joins it to the Vatican, by which, in the case of surprise, he could take refuge in the fortress. A useless expense now that the popes no longer inhabit the Vatican, and, since they govern peacefully, have to fear popular sedition or hostile invasion no longer.

Leaving the bridge you drive straight on to the church; the façade appears quite close, and you will be surprised at what a distance it still is. The interval which lies between the bridge and the church was formerly occupied by the tomb of Scipio, by Nero's Circus, and by a temple of Apollo. In the days of the ancient Romans oracles were here consulted. 'Vaticanum, ubi vates canebant.' Now, oracles are still given here, so that now, as formerly, the place is rightly called Vatican. The whole space might with advantage be cleared between the bridge and the colonnade, and the ugly little buildings which separate the Borgo-Vecchio from the Via Traspontino should be taken down, and a fine avenue of trees planted, or, if possible, a colonnade built. This ugly little square place, which now makes such an ugly termination to the great circular space –

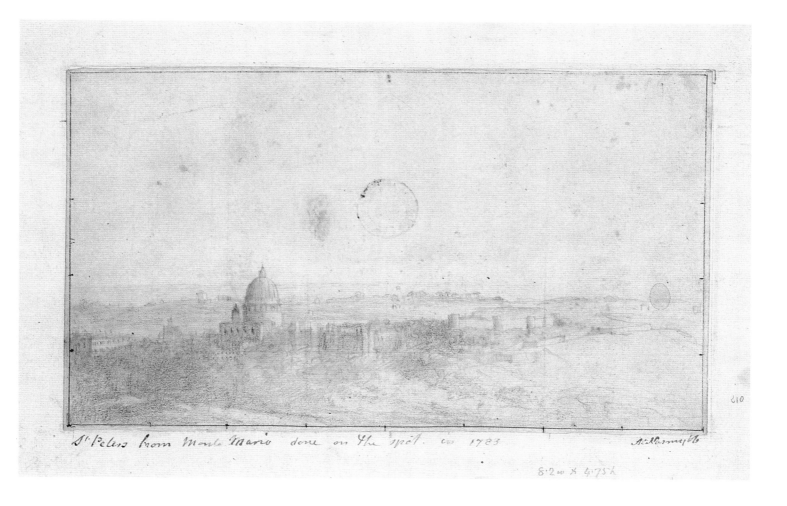

St Peters from Monte Mario done on the spot in 1783 A. Hamilton

8.2 w x 4.75 h

the finest site in the world, to my mind, for I doubt that the Almeydan of Isfahan, which I have not seen, and never shall see, can be finer, and certainly St Mark's Place, the Place Vendôme, Belle-court, &c, are not to be compared to it — should be changed in some manner or other. The space is surrounded by two semicircular porticoes, each formed of four rows of Doric columns, on the top of which is a balustrade covered with statues. This splendid colonnade was made by Alexander VII, and Bernini the architect. It is one of the finest works of modern times. In the centre rises Nero's obelisk, erected by Fontana, and I never tire of watching the two fountains playing on either side.

On St Peter's the most celebrated Roman and Florentine architects exhausted their skill during the course of two centuries. Bramante and Vignola had the greater share in the external part; Lorenzetto in the internal; and dome and cupola were the chef-d'oeuvre of Michael Angelo. The work was continued by Della Porta and Fontana. The portico is by Carlo Maderno; it is the least satisfactory portion. Had the design of the Pantheon been followed, or of those temples with fluted columns of which Vitruvius gives the design, it would have been better.

Président de Brosses, *Letters* (1739) (translated by Lord Ronald Sutherland Gower)

NASMYTH'S somewhat impressionistic view of St Peter's, as indicated in the inscription, was done on the spot, from Monte Mario, in 1803. It shows the basilica towering above the surrounding Borgo, simply dwarfing everything in its vicinity. Running away into the distance, to the right of the composition, can be seen the ribbon-like profile of the Leonine wall, with its length punctuated at regular intervals by towers. These walls were erected in the ninth century by Leo IV (847–55), who obtained funds for the purpose from the Emperor Lothair I, and from levies imposed on the wealthy ecclesiastical establishments in Campania. At this time the threat posed by the Saracen fleet was considerable: already in 846 it had attacked the city, causing much damage to areas outside the Aurelian walls, and making off with many of the treasures of St Peter's. The fortifications, begun in 847, were completed six years later. They were laid out around the Vatican hill, running from Castel Sant'Angelo, round behind St Peter's and back towards the river to Santo Spirito. Along their length they were strengthened by 46 towers, and had four gates. Pope Leo himself officiated at their consecration, walking barefooted as he prayed and administered his blessing. The construction of this great wall formally separated the *civitas Leonina*, or 'Borgo', within its boundaries from the rest of the city, a distinction which was to last far into the Middle Ages — indeed the Borgo could be said to have retained its distinct character until via della Conciliazione was driven through it in 1938.

The composition, with its soft, delicate modeling, is a fine example of Nasmyth's approach to landscape drawing.

5 *Attributed to*

JACOB VAN DER ULFT

GORINCHEM 1627–1689 NORDWIJK

An Imaginary View with Santa Maria della Febbre

Pen and bistre wash on laid paper: 128 × 188 mm

Inscribed, verso, top left corner, in the artist's hand, in ink: *binnen hof bij S. Giovan Lateran*, lower left, in ink: *3.5–6.7–nd*; on back of mount, bottom center, in pencil: *Meatyard 3.30 16 VII 20/Fanciful – on back* EEN HOF BIJ SAN GIOVAN LATERAN/*but it is really the imperial mausoleum on/site of sacristy of S. Peters*; on front of mount, bottom right, in pencil: *Fairfax Murray Coll. J de Bisschop*; and in right corner: *cat S.5535 4/4/–*

Border of black ink

CONDITION: fair

PROVENANCE: Fairfax Murray

BODART NO. 99

Sacristy of St Peter's
Before going on to speak of this magnificent sacristy it has to be remarked that in this place there was once an ancient chapel dedicated to Our Lady, popularly known as 'Our Lady of the Fever'. This, being directly beside the old basilica of St Peter, was converted by Pope Gregory XIII to the use of a sacristy for the basilica until a new one could be made, appropriate to the size and magnificence of the new basilica; but it remained in that state until the present pontificate of Pius VI. This great Pope, instilled with a love of great enterprises, decided to undertake the work, since it was both splendid and necessary; and he carried it out according to the plan and under the direction of Carlo Marchionni entirely successfully.

Mariano Vasi, *Itinerario istruttivo di Roma* (1814)

The name of this old church abutting the Vatican basilica recalls the temples set up by the Romans in places where the air was bad or the ground marshy, dedicated to the goddess Fever or the god Pallor. The Christian religion, rendering all holy, pure and noble, re-applied the title to the Queen of Heaven, the true and effective febrifuge both of the body and of the soul, as it were to purge the ground of the methane of that stupid and idolatrous superstition.

Mariano Armellini, *Le Chiese di Roma* (1887)

FOR almost 1500 years the small circular church of Santa Maria della Febbre stood by the south flank of the basilica of St Peter's. Probably built in the second decade of the third century, it was originally designed as a circular tomb for a patron whose identity is unknown but who certainly was a member of a rich and powerful family. Around the year 400 it was joined by a slightly smaller twin, the mausoleum of the family of the Emperor Honorius (395–423), which in 757 was dedicated to St Petronilla, a third-century martyr, though according to legend she was a daughter of St Peter. Because of the proximity of the obelisk, brought to Rome by Caligula in 37, the entrance to the rotunda may originally have been on its west flank. With the construction of the mausoleum of Honorius, however, access through this entrance would have become difficult. While it was a private, quite possibly abandoned mausoleum this would not have mattered greatly, but it must have posed

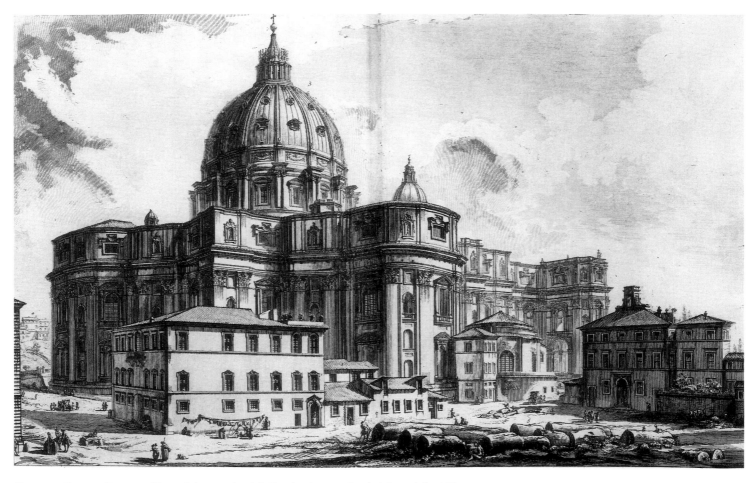

Giovanni Battista Piranesi: *View of the outside of St Peter's, showing Santa Maria della Febbre*

difficulties after Pope Symmachus (498–514) dedicated it to St Andrew. At some date a new entrance was made from St Peter's by way of the vestibule of Santa Petronilla. After the construction of the south transept of Julius's basilica, Santa Petronilla was demolished, but its companion, by now dedicated to Santa Maria della Febbre, remained. During the reign of Gregory XIII (1572–85) it became the sacristy of the basilica. Eventually, the small classical rotunda suffered the same fate as its younger sister: sacrificed to the demands of the great basilica, it was demolished to make way for the new sacristy constructed (1776–84) by Carlo Marchionni for Pius VI. Today, all that remains of the monuments which once flanked the old basilica is the obelisk in Piazza San Pietro, removed there in 1586 by Domenico Fontana on the instructions of Sixtus V.

The determination of the authorship of this *capriccio* presents some problems. The artists Jan de Bisschop and Jacob van der Ulft worked in a similar style, and it is generally accepted that Van der Ulft copied motifs from the works of his compatriot. Bodart attributes the piece to De Bisschop, though An Zwollo (oral communication) considers that it may well be the work of Van der Ulft, as she believes the element of fantasy is more consistent with his approach. Interestingly, Bodart remarks that there is a slightly larger version (170 × 228 mm) of this composition in an album of copies by the artist after designs by De Bisschop in the Fondation Custodia in Paris. He believes that the inscription refers to the Baptistery at the Lateran, an octagonal building erected during the pontificate of Sixtus III (432–40).

6 FERDINAND BECKER

BATH, late 18th century — 1825 BATH

The Campanile of Santo Spirito in Sassia

Pen and gray ink wash with traces of black chalk: 286 × 423 mm

Inscribed, verso, lower left center, in pencil: *Castle & Bridge of St. Angelo, Rome*; in Ashby's hand, upper left center, in pencil: *60*

CONDITION: some marked discoloration around the edges

BODART NO. *26*

This Schola Saxonum is the oldest and the foremost of the foreign colonies which clustered round St Peter's, in the low unhealthy ground formerly occupied by the gardens of Agrippina the Elder. It dates from AD 727, while the Schola of the Longobards was only founded about 770 by Queen Ansa, and those of the Franks and Frisians by Charlemagne towards the end of the same century. It consisted of a hospice for pilgrims and of a chapel dedicated to the Virgin Mary. The chapel is still in existence, near the gate of the Leonine city called Posterula Saxonum (Porta di Santo Spirito), although much altered and modernized under the name of Santo Spirito in Sassia. The colony flourished for many years, extending as far as Ponte S. Angelo on the site of the present Arciospedale di S. Spirito, and the name Burg or Burgh, by which its dwellers designated it, is still in use, Italianized as Borgo.

The reconstruction of this interesting quarter after the fire and pillage of the Saracens in 846 is connected with the establishment of Peter's pence, about which so much information has been given by Garampi, Cancellieri, and De Rossi. To keep accommodations for the pilgrims in good order, to supply them with food and clothing, to nurse them in their ailments, and to offer the Pope tribute for the maintenance of the places of pilgrimage, a national contribution was established towards the beginning of the ninth century, under the names of Romescot, Romfeah, Rompening etc., to be shared by every paterfamilias owning a certain amount of property.

Rodolfo Lanciani, *New Tales of Old Rome* (1901)

THE tomb of the Apostle St Peter in the magnificent basilica constructed by Constantine attracted, from earliest times, great numbers of pilgrims. Among them were the Emperor Theodosius, who came to pray for victory over his rival Eugenius, Justinian's powerful general Belisarius, the Ostrogoth Totila and Charlemagne.

Pilgrims required accommodation for the duration of their stay in the eternal city. The hospices erected to meet their needs were originally organized on a national basis, each being known as the 'schola' of the particular nation concerned. The earliest of these institutions, which were generally located in the neighborhood of the great church, was the Schola Saxonum erected by King Ine (689–726) for pilgrims from the Anglo-Saxon kingdom of Wessex. In 1198 this establishment was converted to a hospital by Innocent III, who entrusted its administration to Guy de Montpellier who had founded the Hospital Order of the Holy Spirit in France. Both original hospice and adjacent church suffered many vicissitudes through the centuries: after severe fire damage during the pontificate of Paschal I (817–24) the Schola was sacked by the Saracens in 846, and again partially razed during the Sack of 1527. It was rebuilt by Antonio da Sangallo the Younger between 1538 and 1544, the façade being added by Ottaviano Mascherino during the pontificate of Sixtus V (1585–90). The campanile which dominates Becker's view is slightly earlier, dating to 1471. Behind the campanile can be seen Castel Sant'Angelo with the Ponte Sant'Angelo spanning the Tiber.

For comment on the drawings of Ferdinand Becker see No. 9.

7 LOUIS TOEPUT *called* POZZOSERRATO

ANTWERP 1550–1603/05 TREVISO

Castel Sant'Angelo

Pen and ink with bistre wash on laid paper, laid down:
271 × 409 mm

Inscribed on front of mount, bottom center, in brown ink: *Ag. Caracci*; on back of support, bottom right, in brown ink: *no 19 may 8*; top left, in ink: *N. 11568*; center right, in pencil: *1622*; indecipherable mark, top center, in ink

CONDITION: fold mark down center. Some lacunae

BODART NO. 303

The only appearance of a fortification in this city is the castle of St Angelo, situated on the further bank of the Tyber, to which there is access by a handsome bridge: but this castle, which was formerly the moles Adriani, could not hold out half a day against a battery of ten pieces of cannon properly directed. It was an expedient left to the invention of the modern Romans, to convert an ancient tomb into a citadel. It could only serve as a temporary retreat for the pope in times of popular commotion, and on the other sudden emergencies; as it happened in the case of Pope Clement VII when the troops of the emperor took the city by assault; and this only while he resided at the Vatican, from whence there is a covered gallery continued to the castle: it can never serve this purpose again, while the pontiff lives on Monte Cavallo, which is at the other end of the city. The castle of St Angelo, howsoever ridiculous as a fortress, appears respectable as a noble monument of antiquity, and though standing in a low situation, is one of the first objects that strike the eye of a stranger approaching Rome. On the opposite side of the river are the wretched remains of the Mausoleum Augusti, which was still more magnificent.

Tobias Smollett, *Travels Through France and Italy* (1766)

The Emperor Hadrian had a veritable passion for architecture, as the ruins of the famous Villa Adriana on the road to Tivoli well demonstrate. There he had scale copies built of all the celebrated monuments he had seen on his travels. It was realised in his time that there was no more space left in the Mausoleum of Augustus for the ashes of the emperors. Hadrian seized the opportunity to build himself a tomb; no doubt memories of what he had seen in Egypt played a part in his resolution. He chose the site of the Gardens of Domitian, which were immense, and immediately beside the Tiber. The building was the marvel of the century.

On a square base, of which each side was 253 foot long, there rose the great round mass of the mausoleum, of which may now be seen only what it has been impossible to destroy. The marble dressing, the superb masonry, the ornament in all its variety have been torn down. We know only that the remains of the square base lasted until the eighth century. The enormous round tower that we see

72

today was merely the nucleus of the monument. Originally it was surrounded by a corridor and by a second wall that constituted its façade: which has all gone now. Above the huge cylinder, following precedent, there rose several immense steps, and the whole was crowned by a magnificent temple, also round. Twenty-four columns of pink marble made a portico running all round the temple, and at the highest point of the dome was placed the pinecone after which one of the Vatican gardens is named, and which we noticed there. This was the bronze tomb in which the ashes were deposed of one of the most intelligent men who ever held a throne. He had the passions of an artist, and could be cruel. If Talma had been emperor, would he not have sent the Abbé Geoffroy to his death? Hadrian had lived a long time in Egypt, and too long to keep his good name. The unfortunate goings-on there have tarnished it today still more than his cruelties. He was right to think that a tomb such as the one of which we study the formless remains was more elegant than a pyramid; but the pyramids are still there, while the fates have conspired to reduce what was perhaps the finest tomb that ever existed to the object called today the Castle of the Holy Angel or Hadrian's Barrow.

Stendhal, *Voyages en Italie* (early 19th century)

WHEN the last available *loculum* in the Mausoleum of Augustus was filled, following the death of Nerva in 98, his successor, Trajan, was forced to look elsewhere for a suitable burial ground. Contrary to the custom which forbade burial within the city walls, Trajan contrived to have his ashes deposited beneath his Column adjacent to the Forum in the heart of the city. It was left to Hadrian, Trajan's heir, to construct a new dynastic monument for the imperial family. For this purpose Hadrian chose a site on the right bank of the Tiber in an area known as the Hortus Domitiani, which had been in the possession of the imperial family for over 100 years. This locality had by then become a sacred precinct, containing temples, monuments and public buildings as well as a necropolis with many important tombs (it would later accommodate some modest Christian burial places, including that of the Apostle St Peter).

As a model for his sepulchral monument Hadrian, an amateur architect of some talent, chose the imposing structure of the Mausoleum of Augustus. Constructed between 28 and 23 BC and located just 800 yards upstream, this monument was itself modeled on the *tumulus* tombs of the Etruscans. Hadrian's Mausoleum was made up of a large cylindrical drum, 68 feet high, placed on a rectangular base, 280 feet square, and topped with an earthen mound from which rose a smaller circular structure crowned by decorative sculpture. The brick façade of the exterior walls was covered in marble while cypresses graced the earthen mound. The massive structure, begun in 135, just three years before Hadrian's death, was completed by his adopted son Antoninus Pius in 139, when it was consecrated to the deceased Emperor and Sabina, his already deified consort. It remained a family tomb for the next 60 years, receiving the remains of all the emperors from Hadrian to Septimius Severus, whose ashes were placed there in 211. In 270 the Mausoleum was incorporated into Aurelian's defences of the city, and became known as the Castel Sant'Angelo from about the tenth century.

This rather extraordinary drawing shows the Castel Sant'Angelo from a point downstream from the monument, with the profile of the Palazzo Altoviti (?) on the extreme right at the top of the Ponte Sant'Angelo. The small tower rising just above the bridge, to the left, is the Borgia tower, which was demolished in 1690. To the left of the castle can be seen Santo Spirito in Sassia. In the middle ground, floating on the river, are a number of mills whose presence on the waters of the Tiber can be documented back to classical times.

The attribution of this piece to Pozzoserrato is due to An Zwollo. Another view of the Castel Sant'Angelo by Pozzoserrato was sold at Sotheby's on 7 July 1966 (lot 17), this time showing the half completed dome of St Peter's in the distance. This may be the same drawing which went for sale, again at Sotheby's, on 11 December 1980 (lot 6, 177 × 376 mm). There is also a drawing of the Castel Sant'Angelo by Pozzoserrato in the Hermitage in Leningrad (inv. no. 7464). According to an inscription on a drawing by the artist in the Albertina in Vienna, showing the interior of a Roman ruin (Franz 1966–67, II, pl.lxxxix, fig. 2), Pozzoserrato visited Rome in 1581.

8 GIOVANNI BATTISTA BUSIRI

ROME 1698–1757 ROME

Castel Sant'Angelo

Pen and brown ink on laid paper: 174 × 239 mm

Inscribed, verso, bottom center, in pencil: *93*; just above former inscription, in pencil: *1656*; on front of mount, underneath drawing, in pencil: *2–0–0*, center, in pencil: *orizinti*; bottom center, in pencil: *orizonti*; bottom right corner, in pencil: *1174*; center right, under drawing, indecipherable inscription

CONDITION: some slight staining, foxing

PROVENANCE: Richard Johnson, died *c*1877, England (Lugt 2216, applied with glue to top left corner of verso)

BODART NO. 112

In the meanwhile, another Gothic assault was under way against the Porta Aurelia [Cornelia]. The tomb of the emperor Hadrian stands outside this gate, about a stone's throw away. It is a most notable sight, for it is made of Parian marble, and the stones fit together so closely that there are no joins visible. It has four equal sides (each a stone's throw, 300 feet, in length, while their height is greater than that of the city wall). Above this, there are statues of men and horses, of the same marble, superb pieces of craftsmanship. Since this tomb seemed a fortress which could threaten the city, it had been enclosed by two covering-walls from the Wall [of Aurelian], thus incorporating it in the city defence...

Constantinus had been appointed by Belisarius to command the garrison at the Mausoleum, and also on the flanking walls, which were very lightly held... The Goths began an assault on the gate and the Mausoleum: they lacked siege engines, but brought up a large number of scaling ladders, and thought that by discharging huge quantities of arrows they could easily overpower the garrison. Holding shields before them... they managed to get to close quarters before the Romans saw them, for they were under cover of the colonnade which goes to the church of the Apostle Peter. From this shelter they launched their attack, and the defenders could not fire their ballistae, which can only fire straight in front of them, nor repel them by ladders... The Goths were on the point of placing their scaling ladders on the wall, and had surrounded the defenders of the Mausoleum... For a short time the Romans were in panic, unable to decide how to save themselves. Then, by common agreement, they broke up most of the statues, which were very large, and used the great number of stones thus provided to hurl down on the heads of the enemy, who gave way before them... then the Romans brought their siege engines into play, and reduced their opponents to dismay, so that the assault was soon abandoned... so was the position restored at the Aurelian Gate.

Procopius, *Gothic War* (March 537) (translated by D R Dudley)

The plague continued to rage, and the pope ordained that on Easter Day a procession should march around the city, bearing the picture of the Blessed Virgin which is in the

possession of the church of St Mary Major. This picture, according to the common opinion, was painted by Saint Luke, who was as skilled in the art of painting as he was in medicine. And all at once the sacred image cleansed the air of infection, as if the pestilence could not withstand its presence; wherever it passed, the air became pure and refreshing. And it is told that the voices of angels were heard around the picture, singing: 'Queen of Heaven, rejoice, alleluia! For He Whom thou wert worthy to bear, alleluia! hath risen as He said, alleluia!' Then, above the fortress of Crescentius, he saw a mighty angel wiping a bloody sword and putting it back into its sheath. From this he understood that the plague was at an end, as indeed it was. And thenceforth this fortress was called the Fortress of the Holy Angel.

Jacopo da Voragine, *The Golden Legend: Life of St Gregory the Great* (late 13th century) (translated by G Ryan and H Ripperger)

Leaving this place, we went through the Campo Santo, and entered by St Peter's. Then we came out just at the Church of Sant'Agnolo, and reached the great gate of the castle with much difficulty; for Rienzo da Ceri and Orazio Baglioni were attacking and slaughtering all those who had left their places on the walls. Reaching this gate, we found some of the enemy had entered Rome, and they were at our heels. As the castellan wished to let the portcullis fall, he had to clear the way somewhat, and so we four got inside. No sooner had I entered than the captain, Pallone de' Medici, took possession of me as a member of the castle household, and thus forced me to leave Alessandro, which I did much against my will. While I was going up to the donjon, Pope Clement had entered by the corridors. He had been unwilling to leave the palace of St Peter's before this, never imagining that the enemy would make their way into the city. Now, having got inside in the way I have described, I took my post near some big guns, which were the charge of a bombardier called Giuliano the Florentine. This Giuliano, hanging over the battlements of the castle, saw his poor house being sacked and his wife and children outraged; so, lest he should massacre his own kith and kin, he did not dare discharge his guns, but threw his fuse upon the ground, and wailed aloud, and tore his face. And other bombardiers were doing the same. Therefore I seized one of the fuses, and, with the help of some who were calmer in their minds, pointed some swivels and falconets where I saw a chance, slaughtering therewith a great many of the enemy.

The Life of Benvenuto Cellini, Written by Himself (1562) (translated by Anne Macdonnell)

THE legend of the angel appearing over the Mausoleum of Hadrian refers back to the papacy of Pope Gregory I (590–604) and the devastating pestilence which was threatening the city at that time, and had already carried away Pope Pelagius II (575–90). The story would seem to date back to some time around 950–1150, as indicated by the reference in Jacopo da Voragine's account to the Mausoleum as the castle of the Crescenzi, and the mention of St Luke's painting of the Virgin. The bronze image of the Archangel Michael which today stands on top of the castle is the work of Peter Anton Verschaffelt (1710–93). Installed in 1752, it replaced an earlier marble work by Raffaele da Montelupo (1540).

Bodart's attribution of this drawing to Busiri is supported by Marco Chiarini (letter to the author, 1987), who states that it compares well with other known compositions by the artist. The strong graphic qualities in the work are reminiscent of the pen sketches of Guercino and the seventeenth-century Bolognese landscapists, particularly Giovanni Francesco Grimaldi (1606–80) with whose work Busiri's pen drawings have sometimes been confused. In the British Museum there is another view of the Castel Sant'Angelo by Busiri, showing it from further down river, below the bridge. The drawing, pasted into an album, is in the same technique as the present piece and has virtually identical dimensions (174 × 235 mm). Other drawings in the album show views of the Ponte Milvio, the Ponte Salario (?), the Pyramid of Cestius and the Ponte Lucano. At Christie's (26 November 1973, lot 313) an album of 159 drawings by the artist was sold, many of its pen and ink sketches showing a close similarity to the drawing under discussion.

9 FERDINAND BECKER

BATH, late 18th century — 1825 BATH

Castel Sant'Angelo

Pen and Indian ink wash with black chalk: 285 × 421 mm

Inscribed, verso, lower center, in pencil: *Bridge & Castle St Angelo, with St Peter's & the Vatican in the distance*; in Ashby's hand, upper right corner, in pencil: *58*

CONDITION: some staining

BODART NO. 11

To facilitate access to his magnificent tomb, Hadrian had a bridge constructed across the Tiber. This beautiful bridge, spanning the river in a sequence of elegant archways, is now known as the Ponte Sant'Angelo, though it was originally called the Pons Aelius. Only the three central archways out of the original eight have survived. During the Holy Year of 1450 one of the spans of the bridge collapsed causing the death of many pilgrims. In 1667 the Rospigliosi Pope, Clement IX, commissioned Bernini to repair the bridge and fit it out as a monumental gateway to the Vatican and the Basilica of St Peter's. Bernini designed ten pieces of sculpture, which were completed and put in place on the parapets by 1672. The original Roman ramps leading on to the bridge were uncovered during the excavations carried out in 1892 to provide the Tiber with its present-day embankment. The ancient remnants were regrettably destroyed to facilitate the continuation of this important civil engineering project.

The present drawing is typical of the monochrome technique of Becker, who is represented by a total of 85 compositions in the Ashby collection depicting views of Rome, Latium, Umbria, Tuscany, the Marches and North Italy (nos. 11–95). Other landscapes, of the same modest quality, are recorded in the possession of DLT Oppé and in the Witt Collection in London. Iolo Williams (1970, p.240) notes that the stiff and careful views of Rome in pen and wash suggest that Becker may have been a pupil of Richard Cooper. He considers that these drawings may have been done *c*1780. Later works by the artist, including landscapes in the Lake district, have a rather freer pen and wash approach.

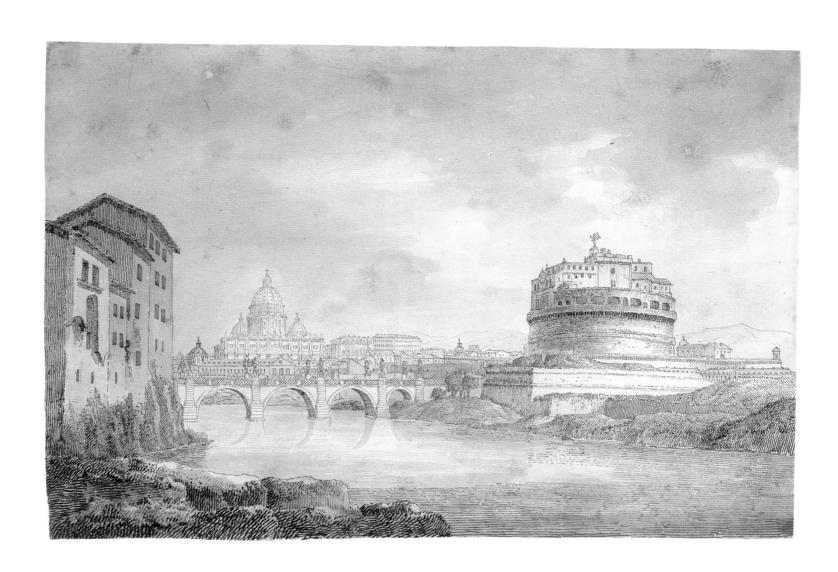

10 MICHEL CORNEILLE the YOUNGER

PARIS 1642–1708 PARIS

Palazzo Sacchetti

Pen and bistre wash with traces of black chalk on paper, laid down: 219 × 325 mm

Inscribed, recto, top left, in ink: *Veue dun palais proche Le pontife* (?'*ponsiste*'?); monogram, bottom left, in ink: *MDC*; bottom right, in ink: *20*; on back of support, lower right, in pencil: *Quirinal with Palazzo Mazzorino*; upper left, in indelible pencil (purple): *117*

CONDITION: fair

PROVENANCE: collector's mark on blue trim of support

BODART NO. 125

Casa del Ceoli. The façade in front is 50 paces. The wings are 55. It has two principal windows in front and one only in one of the wings. It has seven smaller windows, and the door in the middle. The courtyard, 24 paces along and 18 across, gives on to two loggias, one at the entrance and the other opposite at the far end, seven paces broad; but above the one at the end there is no second storey, except that on the left-hand side beneath the level of the *piano nobile* there are small rooms which abut it. Although the wing on the right as you enter is broader than the left-hand side, there are four rooms on the ground floor that give on to the hall. Going up the stairs you come out in a loggia where there are five rooms on the right plus three little rooms; below the five rooms correspond to these in the wings. Then there are three rooms with the salon, and these follow on from the ones mentioned, and have off them three little rooms; and at the end is a long gallery overlooking the river...

From a document describing the Palazzo Sacchetti in 1601

Signori Sacchetti in the palace at San Giovanni de'Fiorentini. Works by painters of note; among them a *Venus* reclining with a vase of perfume, by Titian, and a *Madonna with Saints* by the same, finished by Guido [Reni], a head by Albrecht Dürer, the *Rape of the Sabines* by Pietro da Cortona, by whom are also the architecture, decoration and

frescoes in the villa owned by the Sacchetti called il Pigneto, outside the Porta de'Cavalli Leggieri.

Giovanni Pietro Bellori, *Nota delli Musei, Librerie, Galerie... di Roma* (1664)

The design of this grand and comfortable palace is by Antonio Sangallo, who built it for himself to live in. After his death it passed into the hands of Cardinal Giovanni Ricci da Montepulciano, who finished it, and enlarged it under the direction of Nanni Bigio the Florentine architect, and had it decorated with pictures by Cecchino Salviati. He painted in the gallery several scenes in fresco from the life of David, of marvellous beauty both of design and of colour, as witness Raffaello Borghini, and others who speak of Salviati. The palace in question was then bought by the Cevoli family, and then by the Acquaviva, and from the Acquaviva it passed into the hands of the Sacchetti, who have it at present. Once there were also to be seen there, besides the pictures mentioned, many more in oil by the most famous masters, and also busts and marble heads both antique and modern, and fine marble tables, and other rare and precious things. But the pictures are in the Gallery on the Campidoglio, and the busts passed to the Marchese Lucatelli.

Filippo Titi, *Descrizione delle pitture, sculture e architetture esposte al pubblico in Roma* (1763)

SITUATED on via Giulia, Julius II's fine and ambitious exercise in urban planning, the Palazzo Sacchetti was originally the home of the architect Antonio da Sangallo the Younger (1483–1546). We know from documents that in 1519 Sangallo already owned part of an older house on this site and that in 1542 he purchased the rest of it, which enabled him to commence the construction of his palace. By the time of his death Sangallo had completed a symmetrical five-bay structure which was to form the core of the subsequent building, stretched to seven bays. His son Orazio, who inherited the palace, sold it to Giovanni Ricci da Montepulciano in 1552. Cardinal Ricci immediately set about improving it, employing first Nanni di Baccio Bigio and later, around 1574, Giacomo della Porta. He commissioned frescos from Francesco Salviati, who decorated the Salone d'Udienza and the Salone dei Mappamondi. Other

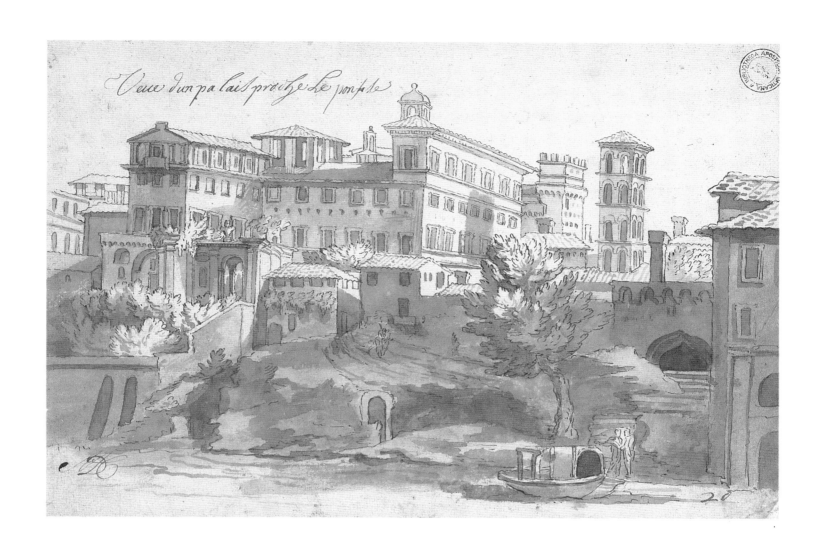

Veue d'un palais proche le pont te

BIBLIOTHECA APOSTOLICA VATICANA

20

PALAZZO DE SIG.ᴿᴵ SACCHETTI PRESSO S·GIOVANNI DE FIORENTINI IN STRADA GIVLIA NEL RIONE DI PONTE ARCH·ᵀᵀᴵ DI ANT·ᴬᴵᴼ DA S.GALLO

Gio·Batt·falda disse·et incis· Gio·Iacomo Rossi le stampa in Roma alla pace cõ priu·del S·P·

Giovanni Battista Falda: *Palazzo Sacchetti, Rome*

frescos were executed by the equally talented Taddeo Zuccaro. Cardinal Ricci also formed here an important collection of classical sculpture, later removed by Pope Benedict XIV (1740–58) to form the foundation of the Capitoline collection. The Ceoli, who acquired the palace in 1576, continued to add to the building, extending it in the direction of the Tiber and adding the garden wing. Three years after the death of Tiberio Ceoli in 1605 the palace was purchased by Cardinal Acquaviva. In 1649 it passed into the hands of the Sacchetti, in whose possession it remains to this day. In 1660 Carlo Rainaldi designed the wall giving on to the Tiber, and in 1699 the wing towards the river received an additional storey, to the designs of Giovanni Battista Contini. The first oleander trees to grow in Rome were cultivated in the garden of the palace.

The attribution of this drawing to Corneille is probably correct, since it has, as Bodart has pointed out, many points in common with the many drawings by the artist in the print room in the Louvre (see Guiffrey and Marcel 1909, III, nos. 2304–2704), though there are no other Roman views with which it can be directly compared. Nonetheless, the graphic quality and application of wash are so similar in all instances that the same artist must be involved, an opinion shared by Jean-Pierre Cuzin (letter to the author, 1987).

11 PAOLO ANESI

ROME 1697–1773 ROME

View along the Tiber

Black chalk on laid paper: 217 × 184 mm

Inscribed, verso, top right, in brown ink, in the artist's hand: *veduta di Santa Anna dei bresciani con le c . . .* (lacuna) / *di roma fatta da me Pauolo Anesi.*; on front of mount, top left, in brown ink, in an early hand (?): *Di Paolo Anesi Pittor Romano*; top right, in same hand: *SI* (or *51*).

CONDITION: fair

PROVENANCE: Thomas Hudson 1701–79 (Lugt 2432, recto, below left); Parsons and Sons, Art Dealer, London, end of 19th century (Lugt 2888 and Supplement p.401; this mark was used for sheets which were considered of little value)

LITERATURE: Busiri Vici 1976

BODART NO. 7

The Church of Santa Maria del Suffragio
From the year 1594 certain devout persons had formed a confraternity in the nearby church of San Biagio, for the purpose of praying for the souls in Purgatory. After receiving the approval of Clement VIII, the Confraternity built this church, and the oratory beside it, to a design by Rainaldi. The chapels are adorned with marble, gilt stucco and pictures by Giovanni Battista Natale, Giuseppe Ghezzi, Nicolò Berettoni, il Calandrucci and Benaschi. Passing into the street on its left, you can see the church of Sant' Anna dei Bresciani, built in 1575 by a devout society of Brescians, by whom it was then restored and embellished under the direction of Fontana. Returning to via Giulia, you may see beneath the houses on the left various blocks of travertine, which were the foundations of the Curia that Julius II wished to build on this spot, but which was later established at Monte Citorio by Innocent XII.

Next comes the parish church of San Biagio, called 'della Pagnotta', meaning *pane benedetto* or blessed bread, which was distributed here on the feast of St Blaise. It was formerly a Benedictine abbey, and was later merged by Eugenius IV with the chapter of San Pietro in Vincoli.

Mariano Vasi, *Itinerario istruttivo di Roma* (1814)

ACCORDING to Bodart this drawing shows a view of the Velabro, though the artist himself has written on it that the view represents the church of Sant'Anna dei Bresciani and another building, beginning with 'c'. This can only be the Carceri Nuove (New Prison), some distance further down the Tiber. The Velabro (see No. 15) is a low-lying area between the Forum and the Tiber which contains, among other monuments, the small Hellenistic circular temple commonly, though incorrectly, known as the Temple of Vesta. Dated to about 100 BC or perhaps earlier, it is, with its 20 Corinthian columns, the oldest standing marble temple in Rome. Bodart believes this to be the structure visible in the upper right center of the composition. With the aid of Giuseppe Vasi's view of Rome of 1765 it can be demonstrated, however, that the building depicted is not in fact the ancient Roman temple, but rather the dome of a church of much later date, though not Sant'Anna dei Bresciani as indicated by Anesi. It is in fact the church of Santo Spirito dei Napolitani, which is downriver from the Carceri Nuove

and therefore shown in the correct relationship to it, whereas Sant'Anna is sited upstream and would have to be shown to the left of the prison if viewed from this angle.

In the fifteenth century a church known as Santa Aura in Strada Julia occupied the site of the Neapolitans' church. Having fallen into poor repair it was given by Pope Gregory XIII to the Neapolitans, who leveled it in 1572 to make way for the new church dedicated to the Holy Spirit. The architect Ottaviano Mascherino was employed on the project and the plan of the layout is almost certainly his. The façade was added around 1649 by Cosimo Fanzago. The dome contains frescos by Giuseppe Passeri.

The Prison known as the Carceri Nuove was constructed by Antonio del Grande for Innocent X in 1652 to replace the old Corte Savella and the Tor di Nona. Completed in 1655, it was the first penal establishment to contain the modern cell system. The large structure rising up in the center of the composition must represent the prison, though its form does not fully agree with the shape of the prison as we know it today.

This particular view along the Tiber may be usefully compared to another view of the river formerly in the Phillipps Fenwick collection and now in the British Museum (Popham 1935, p.121). The view, in black chalk and measuring 233 × 375 mm, carries the inscription: *Veduta del Ponte Sisto della Parte delle Monichelle fatta da me Pauolo Anesi / No. 1404 AP*. Another Tiber vista, dated 1728, is noted by Marco Chiarini (1972, no. 138). Bodart dates the present drawing to the artist's early years and compares it to a view of the Ponte Rotto published by Chiarini (1972, no. 136, illus.), which is dated 1719 and is one of a number of drawings by the artist in the Uffizi.

Giuseppe Vasi: *Prospect of Rome* (detail): *Carceri Nuove (New Prison)*

12 *Attributed to*
CORNELIS VAN POELENBURGH

UTRECHT 1586?–1667 UTRECHT

The Ripa Grande

Red chalk on laid paper: 108 × 176 mm

Inscribed, verso, bottom right, in pencil: *J. Callot/V.P. . . . 209*; on front of mount, bottom right, in pencil: *C. Van Poelenburgh/ 1586–1667*; lower down, in pencil: *M. Tomkinson Coll.*; also: *N/S/–* and *25/–*

WATERMARK

CONDITION: heavily foxed. Slightly damaged, bottom left corner

PROVENANCE: M Tomkinson; P Huart? (Lugt 2084, collector's mark, verso, lower left)

BODART NO. 283

Innocent XII was responsible for this quay, where the barges coming up from the sea unload their cargoes. The same pope also had built a customs house embellished with a fine portico designed by Matteo de' Rossi, and Pope Pius VII had a lantern built above it . . . From here the remains of the ancient Pons Sublicius can be seen, and south of the Aventine, which is opposite, the ruins of the ancient boat-builders' hangars, and of other buildings mentioned above. It was in the region of the Ripa Grande that Mucius Scaevola performed his famous deed, entering Porsenna's camp in order to kill him; but having killed the wrong man burning his hand in Porsenna's presence. The Roman Senate was moved by the noble deed to present him with the whole area in which Porsenna had been encamped, which therefore took on the name of the Prati Muzii. It was also here that the noble Roman maiden Cloelia, at the head of her companions, swam across the Tiber.

Antonio Nibby, *Itinerario di Roma* (1830)

THE Ripa Grande was the main inland port of Rome serving small vessels arriving upriver from Ostia and Fiumicino. Its prosperity dates from the Middle Ages; in ancient times the landing facilities had been located on the opposite bank of the river between the Velabro and the Ponte Sublicio. There the grain from Africa was unloaded, as was the marble used for so many of Rome's prestigious buildings. With the decline in trade, however, that area gradually fell into disuse.

By the Middle Ages the right bank had won superiority, possibly because it was more convenient for the pilgrims, who by landing there were more handily placed for their short journey to St Peter's. As early as the eleventh century we find a reference to the area as the Ripa Romea, acknowledging its popularity with these pilgrims, while the left bank became known as the Ripa Greca in reference to the church of Santa Maria in Cosmedin, then known as the Schola Greca. By the fourteenth century a customs house had been established on the site. Sixteenth-century views show this old customs house, or Dogana Vecchia. In the final decade of the seventeenth century Pope Innocent XII commissioned a new building to replace it, with Matteo de'Rossi and Carlo Fontana as architects. The new Dogana survived until the late nineteenth century and the construction of the embankment along Lungotevere.

This drawing is closely related to a small sketchbook, dated *c*1620, in the Uffizi in Florence illustrating 42 views of Rome and Tivoli, and executed in the same technique of red chalk (see Kloek 1975, nos. 710–754 and Reznicek 1964, figs. 54–55). Bodart's assertion that the present drawing and the Uffizi sketchbook are by the same artist is supported by Wouter Kloek (oral communication). The view of the Ripa Grande may most usefully be compared to the sketch depicting shipping on the Tiber (Kloek 1975, no. 752, 163 × 272 mm). The attribution of the sheet to Poelenburgh is simply for the sake of convenience, since it is generally accepted that he is not the author either of this drawing or of the Uffizi sketchbook. Poelenburgh, it should be noted, generally worked in pen and wash, though there are some drawings in red chalk which are confidently considered to be by his hand.

Giovanni Battista Piranesi: *The Ripa Grande*

13 FERDINAND BECKER

BATH, late 18th century–1825 BATH

The Ponte Rotto

Pen and gray wash with traces of black chalk: 280 × 411 mm

Inscribed, verso, lower left center, in Ashby's hand (?), in pencil: *On the Tiber,/Rome*; upper right center, in Ashby's hand (?), in pencil: *54*

CONDITION: some staining

BODART NO. 15

From her situation, Rome is exposed to the danger of frequent inundations. Without excepting the Tyber, the rivers that descend from either side of the Appenine have short and irregular course; a shallow stream in the summer heats; an impetuous torrent, when it is swelled in the spring or winter, by the fall of rain, and the melting of the snows. When the current is repelled from the sea by adverse winds, when the ordinary bed is inadequate to the weight of waters, they rise above the banks, and overspread, without limits or control, the plains and cities of the adjacent country. Soon after the triumph of the first Punic war, the Tyber was increased by unusual rains; and the inundation, surpassing all former measure of time and place, destroyed all the buildings that were situate below the hills of Rome. According to the variety of ground, the same mischief was produced by different means; and the edifices were either swept away by the sudden impulse, or dissolved and undermined by the long continuance of the flood. Under the reign of Augustus, the same calamity was renewed: the lawless river overturned the palaces and temples on its banks; and, after the labours of the emperor in cleansing and widening the bed that was encumbered with ruins, the vigilance of his successors was exercised by similar dangers and designs. The project of diverting into new channels the Tyber itself, or some of the dependent streams, was long opposed by superstition and local interests; nor did the use compensate the toil and cost of the tardy and imperfect execution. The servitude of rivers is the noblest and most important victory which man has obtained over the licentiousness of nature; and if such were the ravages of the Tyber under a firm and active government, what could oppose, or who could enumerate, the injuries of the city after the fall of the western empire? A remedy was at length produced by the evil itself: the accumulation of rubbish, and the earth that has been washed down from the hills, is supposed to have elevated the plain of Rome, fourteen or fifteen feet perhaps, above the ancient level; and the modern city is less accessible to the attacks of the river.

Edward Gibbon, *The Decline and Fall of the Roman Empire* (1776–88)

Late on Sunday the 27th, the feast-day of St John the Evangelist, the river finally retreated to its bed. Then everyone could see the damage that had been done. Streets destroyed, houses ruined, the Ponte Sant'Angelo in a bad way with the parapets thrown down both in the river and over the bridge. The Ponte di Santa Maria half ruined, and everything laid waste.

An eye-witness's account (Giacomo Castiglione) of 1598

This bridge was built by M Flavius Scipio and Lucius Mummius the Censor. It was called the Pons Senatorius, because the Senate passed over it on the business of the republic. Today it is called the Ponte di Santa Maria after the nearby church dedicated to St Mary of Egypt, or rather now the Ponte Rotto, since the half of it has fallen into the Tiber; it is made of *pietra dura*.

Pietro Rossini, *Il Mercurio Errante* (1693)

Under Paul III Michelagnolo had begun to rebuild the Ponte S. Maria at Rome, damaged and weakened by the current and its age. He made the foundations with cofferdams and diligently repaired the piles, finishing a great part, and incurred great expenses on wood and travertine. In a congregation of clerks of the chamber under Julius III it was proposed to give it to Nanni di Baccio Bigio to finish in a short time at a small cost, pretending to relieve Michelagnolo, who neglected it, they said, and who would never get it done. The Pope, who disliked quarrels, innocently gave power to those clerks who had charge of it as their affair. They gave it to Nanni with a free hand without Michelagnolo knowing of it. Nanni, not understanding the necessary precautions, removed a great quantity of traver-

tine with which the bridge had been annually strengthened and paved, and which rendered it stronger and safer, and put cement in its place, with buttresses outside, so that it seemed completely restored. But it was so weakened that it was destroyed five years after in the flood of 1557, showing the ignorance of the clerks of the chamber and the damage suffered by Rome in neglecting the advice of Michelagnolo, who frequently predicted this accident to his friends. I remember, when we were passing it on horseback, he said, 'Giorgio, this bridge shakes, let us ride carefully lest it fall while we are on it.'

Giorgio Vasari, *Life of Michelangelo* (1568) (translated by AB Hinds)

THE ancient Pons Aemilius, nowadays known as the Ponte Rotto on account of its ruinous condition, was the first stone bridge to be built in Rome. Initiated in 179 BC by the censors Marcus Fulvius Nobilior and Marcus Aemilius Lapidus, it was probably constructed to compensate for the loss of two other bridges in the disastrous floods of 193 BC. The primitive wooden structure laid on stone piers did not receive stone arches, however, until 142 BC, when it was completed by Scipio Africanus and Minucius. For a long time known as the Pons Lapideus, and later given other names, including Senatorio, Maggiore, Palatino and Santa Maria, the bridge has had an eventful history as the treacherous Tiber many times brought sections of it crashing down into its rushing torrents. In February of the year 1231 it was badly damaged by floods, collapsing for the first time then, and was repaired by Gregory IX. Damaged again in 1422 it was repaired by Martin V, and by Nicholas V in preparation for the Holy Year of 1450. By the sixteenth century the bridge began to exhibit severe structural faults and in 1548 Pope Paul III found it necessary to commission Michelangelo to supervise its restoration in preparation for the Jubilee Year of 1550. Though this work was later continued by Nanni di Baccio Bigio the bridge continued to develop faults and in 1557 two of the arches collapsed. These were restored in 1574 by Gregory XIII for the Holy Year of 1575. Even more destructive, however, was the almost apocalyptic flood of Christmas 1598 which swept away two of the supporting pillars and three of the arches. Such was the extent of the damage on this occasion that the bridge was never again restored to its original condition, though in 1853 the three remaining arches by the right bank were again linked to the left bank by an iron suspension bridge, providing a pedestrian walkway. The final chapter in the bridge's history came in 1885 when, to make way for the new Ponte Palatino, this structure was dismantled and two of the ancient arches removed, leaving just the one original arch stranded in midstream, a dumb testament to the engineering prowess of the Romans and an even more eloquent witness to the awesome power of the great river god, for the past one hundred years rendered silent by the embankment constructed in the 1870s.

14 *Artist using the monogram* A B

Active 1723–45

View of the Ponte Rotto with the Aventine

Red chalk on paper, laid down: 273 × 431 mm

Autograph (?) inscription, verso, bottom left center, in ink (concealed by support but visible against the light), transcribed on to the back of the support, upper left center, in pencil: *Veduta di Ponte Roto cio e Ponte Senatorio e il/Monte/Aventino*; further to the right, in pencil: *AB 1732*; below this, in pencil: *£1:0:0*; lower left center, in pencil: *oppe (790)*; back of support, center, in an old hand: *£84–10*

WATERMARK on support

CONDITION: fair

PROVENANCE: Jonathan Richardson Jr., 1694–1771 (Lugt 2170, recto, bottom right corner); Lugt 474, recto, bottom center (unidentified mark, erroneously given to Crozat)

BODART NO. 201

Pont Palatin (nowadays Ponte Rotto – Broken Bridge) one of the most antient bridges of Rome. It was commenced by M Fulvius and finished by Scipio Africanus and L Mummius when censors. It has been broken down three times by the swelling of the Tiber and is now in ruins. It was likewise called the Senatorial bridge because the Senators passed over it when they went to consult the books of the Sybils which were conserved at Mount Janiculum. There are fine views from here up and down the Tiber – with two other bridges and a few reliques of the Sublician bridge where Horatius Cocles defended the city singly against a host of Enemies.

Washington Irving, *Journals and Notebooks* (2 April 1805)

In very close vicinity we came upon the Ponte Rotto, the old Pons Emilius, which was broken down long ago, and has been pieced out by connecting a suspension bridge with the old piers. We crossed by this bridge, paying a toll of a *baiocco* each, and stopped in the midst of the river to look at the Temple of Vesta, which shows well, right on the brink of the Tiber. We fancied too, that we could discern, a little farther down the river, the ruined and almost submerged piers of the Sublician bridge, which Horatius Cocles defended. The Tiber here whirls rapidly along, and Horatius must have had a perilous swim for his life, and the enemy a fair mark at his head with their arrows. I think this is the most picturesque part of the Tiber in its passage through Rome.

Nathaniel Hawthorne, *Passages from the French and Italian Note Books* (1857)

THE nine red chalk drawings in the Ashby collection (nos. 200–208) showing views of Rome, Tivoli, Frascati and the Lake of Bolsena all belong to a small corpus of drawings by an unidentified artist who initialed his works with the monogram *A.B.* Another eleven compositions by the same monogrammist were in the Phillipps Fenwick collection, now in the British Museum (Popham 1935, pp.155–156). Other sketches by the same hand are in the National Gallery of Scotland (inv. nos. D854; R.S.A. 163; R.S.A. 368) and the Fitzwilliam Museum, Cambridge. The Ashby drawings all bear autograph inscriptions by the artist on the verso of each sheet. In the eighteenth century the collector Jonathan Richardson mounted the sheets and copied the original inscriptions on to the supports. The known oeuvre of the artist is documented, on the basis of dated inscriptions, to the period 1723 to 1745, the Ashby sheets being dated 1732 to 1745 (see also Nos. 46 and 74). Though all the known views are of Italian scenes, the artist is thought to have been German.

15 ANONYMOUS

SPANISH, end of the 18th century

San Giorgio in Velabro

Gouache on white cartridge paper: 183 × 311 mm

Inscribed, verso, top right corner, in dark brown ink: *Templo de S. Jorge con parte d...*; below this inscription, in ink: *R 25*; remains of old inscription, top right, in ink: *Templo...*

CONDITION: fair

BODART NO. 439

Thus the Velabro according to the ancient writers was simply a saucer-shaped hollow formed by the discharge of water from the three hills surrounding it; and the Tiber, before it changed its course, was nearby, and would fill it; and since there was no means by which the water could escape, a lake was formed, which could not be crossed except in small boats; and from the Latin word *vehere*, which means 'transfer by boat', it was called Velabro, since, as I say, people who wished to cross from other hills of the city to the Aventine could not get there without being borne by boat. The place has kept its ancient name to our time, for the church that is there is called San Giorgio in Velabro — even though Tarquinius Priscus managed to change the course of the river and to drain and fill in the lake, which, in such low ground, was bound to affect the health of those who lived there. After the place had been rendered habitable by this means, reputedly many buildings, both religious and secular, were raised there; in one of which Publius Scipio (who defeated Hannibal in Africa) is said to have lived...

Today in this Forum the only thing worthy of note among so many that were once there is a square arch near San Giorgio in Velabro, which supposedly the local merchants and artisans erected in honour of Septimius Severus and Marcus Aurelius after obtaining exemptions and privileges from those generous spirits, never mean towards those whom it was their duty to foster (such privileges should always be granted by good princes, so that merchants, taking advantage of their immunity, in their eagerness for gain will be the readier to render the fortunate ruler's cities abundant and prosperous). The arch for this reason is still called the Arch of the Moneychangers. It is of the Composite order, and is decorated with sculptures in which are represented with great accomplishment the sacrifice of oxen, and also the portrait of Lucius Septimius wearing the toga and dispensing justice to the people; and there are also many other scenes, all showing the glorious deeds of those emperors, which I have largely recounted when treating of the other arches raised in honour of their immortal feats and so need not repeat here.

Bernardo Gamucci da San Gimignano, *Libro Quattro dell'Antichità della città di Roma* (1565)

According to Varro the name of the Velabrum was derived from *vehere*, because of the boats which were employed to convey passengers from one hill to the other. Others derive the name from the *vela*, also in reference to the mode of transit, or, according to another idea, in reference to the awnings which were stretched across the street to shelter the processions, — though the name was in existence long before any processions were thought of.

It was the waters of the Velabrum which bore the cradle of Romulus and Remus from the Tiber, and deposited it under the famous fig-tree of the Palatine.

Augustus Hare, *Walks in Rome* (1893)

The thursday be fore the first sunday of lenton is the stacion at a cherch of seynt george where that his hed is shewid his spere and the banyer with whech he killid the dragon. The hed stant there on a auter that day in a tabernacle of sylvyr and gilt mad soo that a man may lyft up certeyn part therof and touche and kisse the bare skul.

John Capgrave, *Ye Solace of Pilgrims* (c1450)

THE church of San Giorgio in Velabro stands at the foot of the Aventine in the low-lying area close to the Tiber in the path of the natural drainage from the Forum and the nearby Capitoline and Palatine hills. The Cloaca Maxima, the great sewer constructed by Tarquinius Priscus in the 6th century BC, runs through this area on its way to the river. The first church constructed on this site, some time about the year 600, was dedicated to St Sebastian and recalls the legend that the saint was here thrown into the Roman sewer after being cudgeled to death during the reign of the Emperor Diocletian (285–305). Its foundation was related to the establishment of a *diaconia*, a form of regional welfare center. In the eighth century, the head of St George was rediscovered in a forgotten reliquary, and was translated by Pope Zacharias (741–52) to this church, which was then rededicated as San Giorgio 'ad Velum Aureum'. *Velum* derives from an Etruscan expression which signifies marshy ground, while *aureum* refers to the golden colored sand from the banks of the Tiber: together they form the expression *Velabro* or 'marsh of the golden sand'.

Most of the church we see today, including the nave with its 16 antique columns and the portico, has its origins in a campaign of reconstruction carried out at the behest of Pope Gregory IV (827–44). The campanile was added during the twelfth century. At the beginning of the thirteenth century the beautiful trabeated colonnade was erected against the portico. In 1926 the structure was restored by Antonio Munoz.

Standing to the left of the portico can be seen the small but finely carved Arcus Argentariorum, erected in the year 204 in honor of Septimius Severus and his family. The arch, or more correctly the monumental gate, was commissioned by the bankers and moneychangers. The reliefs carved on its surface represent members of the imperial family offering sacrifices to the gods. Originally the arch was probably surmounted by statues of the imperial family. It stands 22 feet high and 19 feet wide.

The other ruins strewn about the composition are purely imaginary.

The author of this modest, though colorful, sketch remains to be identified. Bodart, refering to the inscription, which he considers to be in Spanish, believes the composition could be by a Spanish artist of the eighteenth century. A companion piece (no. 440) showing a view of the Capitol displays the same characteristics and is obviously by the same hand.

16 ANONYMOUS

Second half of the 18th century

The Circus Maximus with the Palatine in the background

Brush and gray ink with bistre wash on laid paper: 416 × 622 mm

Inscribed, recto, bottom right, in ink (?): *G.P. Panini*; verso, bottom center, in pencil: *Bf − 10/6*; top left, in pencil: *2*; on mount, bottom left, *Monte Palatino*; bottom right: *31*

WATERMARK

CONDITION: strip measuring 35 cm added to bottom of sheet. Tear mark, center of right edge

BODART NO. 429

Nor should you neglect the horse races. Many are the opportunities that await you in the spacious Circus. No call here for the secret language of fingers; nor need you depend upon a furtive nod. Nobody will prevent you sitting next to a girl. Sit as closely as you like. That's easy enough; the seating compels it.... Now find an excuse to start a pleasant conversation, and begin by saying things that you can say quite audibly. Be sure you ask her whose horses are entering the ring; and, whatever her fancy may be, hasten to approve her choice ... If, as may well happen, a speck of dust falls into your lady's lap, brush it gently away; but, should none fall, still persist in brushing ... If her cloak hangs low and trails on the ground, gather it up and lift it carefully from the dirt. As a reward, she won't hesitate to allow you a glimpse of her leg. At the same time, look to the row behind and see that a stranger's knees are not pressed into her tender back. Light natures are won by little attentions. The clever arrangement of a cushion has often done a lover service ... Such are the advantages that the circus offers you when you are set upon a new affair.

Ovid, *The Art of Love* (about the time of the birth of Christ)
(translated by N Lewis and M Reinhold)

THE origins of the Circus Maximus, the great hippodrome built for chariot races in the Murcia valley between the Palatine and Aventine hills, reputedly dates back to the time of Tarquinius Priscus, the first Etruscan king of Rome. Down through the centuries the primitive wooden circus was progressively developed and enlarged, the simple timber structure gradually giving way to the great stone and timber edifice which, at the height of its popularity during the fourth century AD, was reckoned to extend to nearly 2000 feet in length and nearly 650 feet in width. The Romans were fanatical in their enthusiasm for the enthralling spectacle of the Circus, and it attracted huge attendances, the Regionary Catalogues of the fourth century estimating a capacity for upwards of 385,000 spectators.

The races, which each lasted for seven laps, were between up to twelve competing chariots. These raced round the *spina* which ran down the center of the stadium, which had at each end a gilded conical *meta*. Seven huge eggs made of wood were used to record the completion of each lap of the 1860 foot course. They were installed in 174 BC,

together with stone *carceres*, or starting gates, at the straight western end. In 33 BC Agrippa added seven bronze dolphins as lap counters. The helmeted jockeys in the chariots, pulled by teams of two, three or four horses, each wore the color of one of the four competing factions, white, red, green or gold. Each faction attracted intense devotion from its supporters, though this partisan fervor does not seem to have spilled over into the kind of serious crowd violence we have become all too accustomed to at many major sporting events today. At the hippodrome in Constantinople in January 512, however, over 30,000 people were killed when rivalry between the greens and blues got out of hand and ended in a calamitous riot. There was much money to be made at the Circus, both by the contestants and the attending masses who gambled heavily on the outcome. The series of races culminated each year with the holding of the Ludi Romani or Magni which were contested between the 4th and 18th of September. The last races held in the Circus were those organized in 549 by Totila the Ostrogoth.

In the year 10 BC the Emperor Augustus installed a great obelisk on the *spina* of the Circus Maximus. This Egyptian monolith, which rises to a height of 78 feet, was originally quarried by Seth II, who died *c*1304 BC, the second Pharaoh of the XIXth Dynasty. Appropriated by his son Ramases II, it was first erected at Heliopolis, the ancient center of the Egyptian sun-cult. Following his conquest of Egypt in 30 BC Augustus instructed that it should be lowered and transported to Rome and set up in the Circus. In the late sixteenth century it was removed to Piazza del Popolo (see No. 47) where it still stands. Constantius II erected a second obelisk in the Circus in AD 357. This was the obelisk of Thutmosis III, a king of the XVIIIth Dynasty (1570–*c*1343

BC). This obelisk, the tallest of all the Roman monoliths (107 feet in height), was transported to Piazza di San Giovanni in Laterano in 1587.

Other hippodromes in and around Rome were the Circus of Flaminius, built in 221 BC by the censor C Flaminius by what is now via Catalana; the Circus of Caligula and Nero, begun by Caligula in an area directly adjacent to where St Peter's Basilica now stands; and the Circus of Maxentius along the Appian Way, the best preserved, which was dedicated in AD 309. The great fire of AD 64, which devastated so much of Rome, started in the Circus Maximus.

Behind the Circus Maximus on the southern slopes of the Palatine rise the ruins of the Domus Augustana and Aedes Severianae. The massive arcades visible to the right were raised during the reign of Septimius Severus (193–211) to provide the foundation for an extension of the Domus Augustana at a time when virtually all of the Palatine had already been built over. The ruins were given over to the monks of San Gregorio in 975, at which time we know there were 35 arcades still standing.

The author of the present drawing and its companion (No. 17) has yet to be identified. The quality of both compositions is high and they are probably the work of some noteworthy artist working in Rome towards the end of the eighteenth century or the beginning of the nineteenth. There is a pronounced Neoclassical quality in the drawing of the figures while the landscape has an epic feel to it, reminiscent of the work of some of the German artists working in Rome at about this time. The inscription '*GP Panini*' on the recto should be ignored.

17 ANONYMOUS

Second half of the 18th century

The Palatine with the Church of San Bonaventura

Brush and gray ink with bistre wash on laid paper: 427 × 630 mm

Inscribed, bottom right, in ink: *G.P. Panini*; on front of support, bottom left, in ink: *Monte Palatino*; bottom right, in ink: *31* (over existing pencil inscription: *39*); on back of support, top left, in pencil: *0/8*

WATERMARK

CONDITION: the drawing shows damage about its circumference. Torn near top right corner. Some discoloration

BODART NO. 430

The Palatine Hill

More than any other hill of the city, the Palatine was adorned in ancient times with residences and palaces filled with every splendour and artifice, since it had always been the place where the kings and emperors of the world lived; as a result, though the hill is low and not eminent, the Palatine is equal in greatness to the other six, higher hills of Rome. Of this there is incontrovertible proof in the marvellous ruins to be seen there in our time. The hill was no more than 1000 paces in circumference; the ancient writers affirm that the name 'Palatine' comes from the city in Arcadia called Palantea, or from Palante the son of Evander, because it was he who came here to live with his people. Others would have it rather that before Romulus built here the city of Rome it was called Balatino from the bleeting (*belare*) of the flocks of sheep pasturing here. This hill is a lesson in the vicissitudes of Fortune, which at one time had it as grazing for sheep; then she made it the residence of kings and emperors, and now she has reduced it to its present unhappy state as sheep pasture. There is no visible trace or sign of its former glory; there is only a church built by Pope Calixtus in honour of St Nicholas. This hill, so celebrated in literature, has lost not only its greatness but even its name, since nowadays it is known as the Palazzo Maggiore.

Bernardo Gamucci da San Gimignano, *Libri Quattro dell'Antichità della città di Roma* (1565)

Having seen the Capitol the day before, Oswald and Corinne continued their tour with the Palatine. The palace of the emperors, known as the Golden Palace, occupied its entire extent. The hill today offers nothing but its debris. Augustus, Tiberius, Caligula and Nero built its four wings; stones, draped by luxuriant plants, are all that remains today: Nature has reclaimed its empire from the work of men, and the beauty of the flowers softens the ruin of the palaces.

In the time of the Kings and of the Republic, the sumptuous was to be found only in public buildings; private houses were very small and very simple. Cicero, Hortensius, the Gracchi, all lived on the Palatine, while during Rome's decadence it was hardly large enough for one man's habitation. During their last years the Romans were no more than a nondescript mass, distinguished from generation to generation only by the name of their ruler: one looks in vain for the two laurels planted in front of the door of Augustus's house, the laurels of war and of the fine arts, cultivated in time of peace: both have gone.

Madame de Staël, *Corinne ou l'Italie* (1807)

The history of the Palatine is the history of the city of Rome. Here was Roma Quadrata, the 'oppidum', or fortress of the Pelasgi, of which the only remaining trace is the name of Roma, signifying force. This is the fortress where the shepherd-king Evander is represented by Virgil as welcoming Aeneas.

The Pelasgic fortress was enclosed by Romulus within the limits of his new city, which, after the Etruscan fashion, he traced round the foot of the hill with a plough drawn by a bull and a heifer, the furrow being carefully made to fall inwards, and the heifer yoked to the near side, to signify that strength and courage were required without, obedience and fertility within the city ... The locality thus enclosed was reserved for the temples of the gods and the residence of the ruling class, the class of patricians or burghers, as Niebuhr has taught us to entitle them, which predominated over the dependent commons, and only suffered them to crouch for security under the walls of Romulus. The Palatine was never occupied by the plebs. In the last age of the republic, long after the removal of this partition, or of the civil distinction between the great

classes of the state, here was still the chosen site of the mansions of the highest nobility.

In the time of the early kings the City of Rome was represented by the Palatine only. It was at first divided into two parts, one inhabited, and the other called Velia, and left for the grazing of cattle. It had two gates, the Porta Romana to the north-east, and the Porta Mugonia — so called from the lowing of the cattle — to the south-east, on the side of the Velia.

Augustus was born on the Palatine, and dwelt there in common with the other patrician citizens of his youth. After he became emperor he still lived there, but simply, and in the house of Hortensius, till, on its destruction by fire, the people of Rome insisted upon building him a palace more worthy of their ruler. This building was the foundation-stone of 'the Palace of the Caesars', which in time overran the whole hill, and, under Nero, two of the neighbouring hills besides, and whose ruins are daily being disinterred and recognised, though much confusion still remains regarding their respective sites. In AD 663, part of the palace remained sufficiently perfect to be inhabited by the Emperor Constans, and its plan is believed to have been entire for a century after, but it never really recovered from its sack by Genseric in AD 455, in which it was completely gutted, even of the commonest furniture; and as years passed on it became imbedded in the soil which has so marvellously enshrouded all the ancient buildings of Rome, so that till 1861 only a few broken nameless walls were visible above ground.

Augustus Hare, *Walks in Rome* (1893)

THE Palatine has the most distinguished history of all the hills of Rome. Here Romulus is considered to have established his first settlement and here also the emperors built their magnificent palaces. The legend that the abandoned infants Romulus and Remus were washed up on its slopes some time in the eighth century BC after the Tiber had flooded may have some foundation in history as excavations this century have uncovered the post holes of Iron Age huts on the hill. In imperial times the hut of Romulus was reputedly still preserved on the south-west corner of the hill and was the object of special veneration, as was the nearby Lupercal, a cave below the western corner of the hill where the she-wolf is said to have suckled the twins before the good Faustulus took care of them. The hill was also the location of festivities in honor of the goddess Pales, the gentle mistress of herds and shepherds. Her rite was celebrated on April 21, the traditional date of the founding of Rome. It may well be that her cult is the origin of the name of the hill, though this is far from certain. What is certain is that the Palatine has given its name to the great residence known as 'palaces', as it was on this hill that the emperors of Rome established their sumptuous dwellings.

The hill had been a sought-after place of residence during Republican times, with its convenient and salubrious location above the surrounding marshy ground, enjoying a fresh breeze and views of the not too distant sea. Among the noted personalities who lived there were Fulvius Flaccus, Lutatius Catulus, Cicero and Mark Antony. On its slopes Gaius Octavius, later to become emperor under the title of Augustus, was born in 63 BC. In 36 BC he purchased the house of the orator Hortensius and later adapted it to make a modest palace. Successive emperors remodeled and enlarged the original buildings, most notably Tiberius (AD 14–37), Nero (54–68), Domitian (81–96) and Septimius Severus (193–211), until virtually the whole hill had been appropriated to the imperial court and the splendor of regal residences, temples and gardens.

The present view shows in the background the church and convent of San Bonaventura alla Polveria, close to the ruins of the Domus Augustana. The church was founded by Cardinal Francesco Barberini for the use of the Spanish Discalced (Alcantarine) Franciscans in 1675. In the middle ground are some of the remains of the Aqua Claudia. Both monuments are shown from a different angle in No. 20.

18 *Attributed to*

CLAUDE-LOUIS CHATELET

PARIS *c*1750–1795 PARIS

The Ruins of Nero's Palace on the Palatine

Pen and brown ink with watercolor wash on paper, laid down: 106 × 184 mm

Inscribed, recto, bottom left corner, in brown ink: *Palais de Néron*; on front of mount, bottom right corner, in pencil: *Chatelet*; on back of mount, bottom right corner, in brown ink: *Chatelet*; lower right, in pencil: *26 × . . .14 (26 Xbre 94)*

CONDITION: good

PROVENANCE: Léon Millet, Paris (stamp, back of mount, lower right corner)

BODART NO. 121

There was nothing, however, in which he [Nero] was more ruinously prodigal than in building. He made a palace extending all the way from the Palatine to the Esquiline, which at first he called the House of Passage, but when it was burned shortly after its completion and rebuilt, the Golden House. Its size and splendour will be sufficiently indicated by the following details. Its vestibule was large enough to contain a colossal statue of the emperor 120 feet high; and it was so extensive that it had a triple colonnade a mile long. There was a pond too, like a sea, surrounded with buildings to represent cities, besides tracts of country, varied by tilled fields, vineyards, pastures and woods, with great numbers of wild and domestic animals. In the rest of the house all parts were overlaid with gold and adorned with gems and mother-of-pearl. There were dining rooms with fretted ceilings of ivory, whose panels could turn and shower down flowers and were fitted with pipes for sprinkling the guests with perfumes. The main banquet hall was circular and constantly revolved all day and night, like the heavens. He had baths supplied with sea water and sulphur water. When the edifice was finished in this style and he dedicated it, he deigned to say nothing more in the way of approval than that he was at last beginning to be housed like a human being.

Suetonius, *The Lives of the Caesars* (first half of the 2nd century AD) (translated by JC Rolfe)

More recently there was the serious and severe, but at the same time overly florid painter Famulus. By his hand there was a Minerva which continued to face the viewer no matter from what angle he looked at it. He used to paint for only a few hours a day, but this was done with great gravity, since he always wore a toga, even when he was in the midst of his painter's equipment. The *Domus Aurea* was the prison for his artistry, and for that reason there are not many other examples of his work extant.

Pliny the Elder, *Natural History* (1st century AD) (translated by J J Pollitt)

THE present view of the Palatine offers scarce information for the identification of the ruins represented. Previous to the catastrophic fire of AD 64 Nero, like all emperors since Augustus, resided on the Palatine and made contributions to the development of the imperial complex there. He modified existing buildings and constructed new ones, the largest being the Domus Transitoria linking the Palatine and the Esquiline. Following the great fire Nero was given a unique opportunity to remodel much of the city, erecting for himself a fabulous new residence while at the same time issuing building regulations controlling the construction of buildings by the citizens. The regulations were primarily aimed at reducing the threat of future conflagrations, and called for each house to be structurally independent and built of fire-resistant materials where possible, with the use of wood reduced to a minimum. The height of each block was to be restricted to 70 feet. Laid out in a regular pattern along new wide streets, these dwellings were a considerable improvement on their ramshackle predecessors.

The most celebrated building of Nero's reign was his new residence, constructed after the great fire. Occupying the valley between the Palatine, Caelian and Oppian hills, it covered an area of approximately 125 acres. This sumptuous dwelling, known as the Domus Aurea (Golden House), was designed and laid out more in the manner of a vast country villa than a palace. The configuration of many of the structural elements, including a great octagonal fountain hall, was novel for the period, as was the extensive use of concrete, a material only just beginning to replace the traditional ashlar blocks. The architects of the building were Severus and Celer, who were also employed by Nero on the failed project to cut a canal between Lake Avernus and the Tiber. The decoration was entrusted to an artist named Fabullus (or Famullus), whose work and that of his colleagues became the inspiration for that form of decoration known as *grottesche*. During the Renaissance, excavating the caverns or grottos in which the remains of Nero's house were buried, the artists who came upon this antique style of fantastic decoration quickly adopted its use in their own commissions, most notably in the Loggie in the Vatican and inside Castel Sant'Angelo (the former decorated by Raphael and assistants, the latter by Perino del Vaga and assistants).

Determining the identity of the author of this small view presents just as many difficulties as the identification of the monuments. Bodart retains the traditional attribution without much enthusiasm. The present author is unable to suggest any convincing alternative. Jean-Pierre Cuzin (letter to the author, 1987) believes the drawing could be earlier than Châtelet, possibly dating to the beginning of the eighteenth century.

Attributed to

JACOB VAN DER ULFT

GORINCHEM 1627–1689 NORDWIJK

The Septizonium Severi

Pen and bistre wash with traces of black chalk: 144 × 198 mm

Inscribed, recto, bottom left, in brown ink: *A/ /c.trib. poi/ /y. Cosa/ /fortunatissimis. nobilissimusque*; on front of support, below right corner of drawing, in pencil: *J. van der Ulft*; top right corner, in pencil: *1109*

Border of dark brown ink

WATERMARK

CONDITION: some very light foxing

BODART NO. 308

Septisolium alsoo was a famous place it stant fast be seynt gregories monasterie a mervelous place of bildyng for in the west side it is mad of grete aschler stones and thoo are all to schake as though thei schuld falle. The othir iii sides are open with peleres of marbil so disposed that there be distincte vii setis be twix these pileres and so soundith the name of the place, for septem is sevene and solium a sete that is for to say sevene setis. A bove these sevene setis are othir sevene & eke above tho sevene are othir sevene that it is merveil who tho hevy pileres of marbil myth be caried up so hy. Of this place be thre opynyones whereof that it served. The romanes sey that thei dwelt there the vii wise men whech they clepe the *vii sages*. We rede that there were vii wise men in grece whos names be redy in cronicles... But these men leved not all of ones at o tyme and though thei had be at o tyme I were that thei come nevyr at rome...

An othir opinion red I in dominicus book de arecio that it was clepid *septisolium* for whann octavian cam hom fro all his conquests and was in pees with al the world the romanes ordeyned ther that he was receyved with vii sundry worchippis peraventur of every sciens of the vii liberal uas mad sum special pagent in comendacioun of the man. I red eke a nothir tale at seynt gregories monasteri be the shewyng of an englisch monk. It was and is writyn here that seynt gregory occupied this place with grete maisteris of all

sevene sciens at his cost that what man wold com lerne ony of the sevene he schuld frely lerne in that place.

John Capgrave, *Ye Solace of Pilgrims* (c1450)

Passing the said circus [Maximus] one finds at the far corner of the Palatine the ancient edifice known to many as the Septizonium of the Emperor Severus. Many suppose it to have been a tomb, built for himself by the Emperor at truly royal expense on the Appian Way, so that those arriving from Africa could see the grandeur with which were preserved the relics of one who had been one of their greatest compatriots, if also one of their greatest enemies — particularly of Leptis, where he was born, and which he took by force of arms and conquered, as was told in full in the discussion of his Arch above. And this was the reason why he wanted his ashes placed in this structure, that Africans coming into the city, necessarily passing along this way, finding the tomb of Severus in the said Septizonium, should have been able to see the honour with which their compatriot was treated by the Romans even in death. But other writers hold that Severus wished to be buried in this place in order that in the minds of the Africans who came to Rome the terror that they had of him in life should be undying, when they looked upon his everlasting tomb.

Bernardo Gamucci da San Gimignano, *Libri Quattro dell'Antichità della città di Roma* (1565)

THE great ruin known as the Septizonium stood on the south-west slope of the Palatine, facing the Via Appia. Also known during the Renaissance as the Scala di Virgilio, it was built by Septimius Severus (193–211) as a purely decorative façade to close off that corner of the Palatine and conceal the buildings behind. Its unique design resembled the monumental fountains or *nymphaea* erected in the first and second centuries AD in the cities of Asia Minor, for instance that constructed at Miletus to honor Trajan's father. Rising to a height of approximately 125 feet and extending to about 330 feet, it was made up of three superimposed orders of Corinthian columns, with three semicircular apsed recesses flanked by two shallow rectangular wings. It was most probably equipped with fountains. Its name suggests that it also exhibited some symbolic device

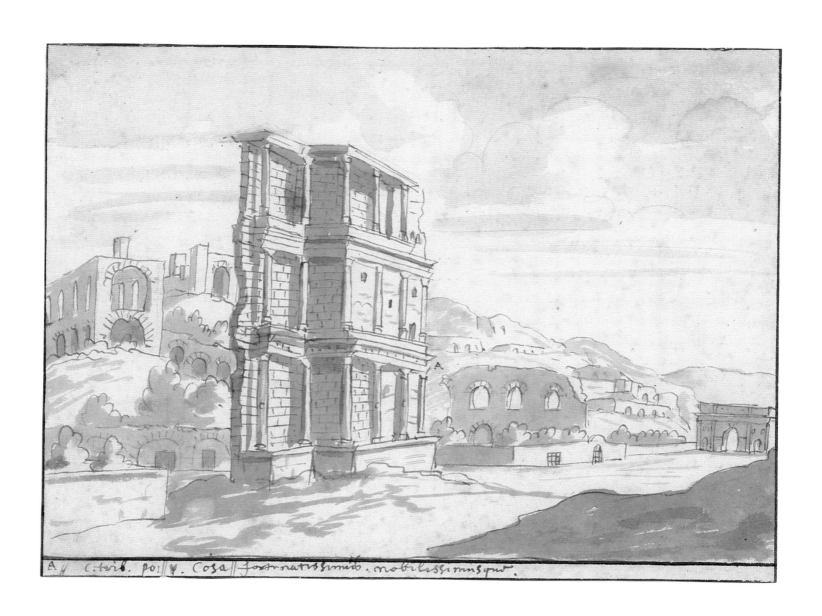

A ∫ C:terb. po∤ ¥. Cosa∬ fortinatissimis. nobilissimusqͥ.

related to the seven planets. The inscription accompanying Dupérac's engraving (1575) of the ravaged ruin refers to 'sette solari' which were then still visible on the rear of the monument. According to the Emperor's biographers its magnificence was intended principally to impress his compatriots arriving from Africa along the Appian Way.

The monument was already falling to ruin in the eighth century when it was noted by the Anonymous of Einsiedeln. Adapted as a fort, in the tenth century it was given by the monks of San Gregorio, who then possessed the Palatine, to Stephen, the son of Hildebrand. In 1084 it was damaged during the attack of Henry IV against the nephew of Gregory VII. In 1116 it was used as a refuge by Paschal II and in 1121 the anti-pope Burdino was imprisoned there. The Frangipane gained possession of it in 1145, along with the Circus Maximus. In 1241 it was the venue for the conclave which elected Celestine IV to the papacy. In 1249

it was returned to the possession of the monks of San Gregorio. Finally, in 1588 Pope Sixtus V demolished the remaining eastern corner to provide materials for the construction of his family chapel in Santa Maria Maggiore and other projects.

In the foreground of the present view are the remains of the Septizonium, with the ruins of the Palatine to the left, the Aqua Claudia in the middle ground to the right and the Arch of Constantine in the distance to the extreme right.

Bodart's attribution of this composition to the talented Jacob van der Ulft, on the evidence of the inscription, is not really tenable, though he may have intended to keep the traditional attribution for the sake of convenience. He was certainly correct, however, in claiming that the design is derived from Dupérac's print of the same subject published in his book of views of Roman ruins in 1575.

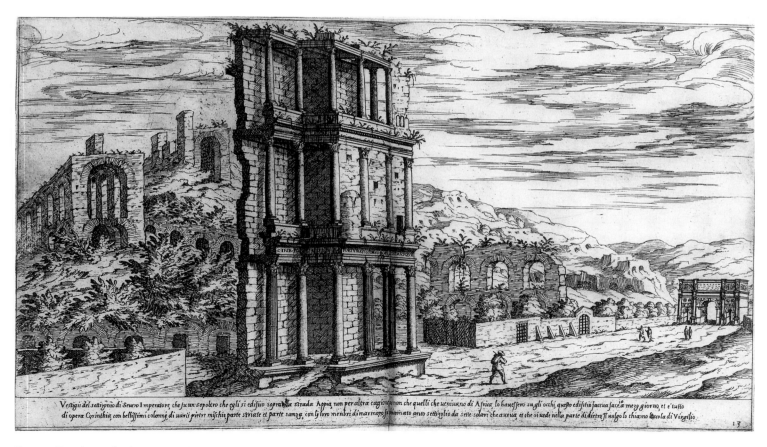

Etienne Dupérac: *The Septizonium Severi*

20 *Attributed to*
CONSTANT BOURGEOIS DU CASTELET

FRENCH 1767–1836

The Claudian Aqueduct

Graphite with pen/brush and light brown wash: 158 × 225 mm

Inscribed, recto, bottom right corner (partially trimmed), in pencil: *ruines du palais des empereurs*; on verso, bottom right corner, the stamp of Léon Millet, with above it, in pencil: *7 fvr 1895*.

CONDITION: fair

PROVENANCE: Léon Millet (stamp, bottom right corner, with date in pencil: *7 fvr 1895*)

BODART NO. 104

Water supply by earthenware pipes has these advantages. First, in the construction: if a break occurs, anybody can repair it. Again, water is much more wholesome from earthenware pipes than from lead pipes. For it seems to be made injurious from lead, because white lead is produced by it; and this is said to be harmful to the human body. So if what is produced by anything is injurious, there is no doubt that the thing itself is not wholesome. We can take an example from the workers in lead who have complexions affected by pallor. For when lead is smelted in casting, the fumes from it settle on the members of the body and, burning them, rob the limbs of the virtues of the blood. Therefore it seems that water should by no means be brought in lead pipes if we desire to have it wholesome. Everyday life can be used to show that the flavour from earthenware pipes is better, because everybody (even those who load their tables with silver vessels) uses earthenware to preserve the purity of water.

Vitruvius, *On Architecture* (early 1st century AD) (translated by N Lewis and M Reinhold)

The aqueduct which only quite recently was begun by Gaius and completed by Claudius surpassed all other aqueducts in cost, since the Curtian and Caerulean springs and the Anio Novus were made to flow into the city from [as far out as] the fortieth milestone at such a height that all the hills of the city were supplied with water; the amount expended on this work was three hundred million sesterces. Now if one were to reckon accurately the plentiful amount of water in public buildings, baths, pools, channels, private houses, gardens, suburban villas, and if he were to consider the distance traversed by the water, the arches raised to support it, the mountains which had to be tunneled through, the valleys which had to be traversed with level courses, he would have to admit that there is no work more worthy of admiration in the whole world.

Pliny the Elder, *Natural History* (1st century AD) (translated by JJ Pollitt)

After Augustus and Agrippa, Gaius Caesar, the successor of Tiberius, finding seven aqueducts hardly sufficient for both public and private pleasures, began two more in the second year of his reign, in the consulate of M Aquila Julianus and P Nonius Asprenas, A.U.C. 791. This work Claudius most magnificently finished and dedicated in the consulship of Sulla and Titianus on the first of August, A.U.C. 803. One supply, from the Caerulean and Curtian springs, was called the Claudia; and this comes nearest the Marcia in excellence. The other came to be called the Anio Novus, to distinguish more readily the two Anio supplies which had now begun to flow into the City, the earlier Anio being called Vetus.

The head source of the Claudia is on a by-road from Via Sublacensis at the thirtyeighth milestone, within 300 paces to the left. The water comes from two very copious and beautiful springs, the Caerulean, so designated from its blue appearance, and the Curtian. It also receives the spring called Albudinus, which is of such excellence that, when the Marcia needs supplementing, this water answers the purpose so well that its addition makes no change in the quality of the Marcia. Aqua Augusta was also turned into the Claudia, because it was evident that the Marcia was not of sufficient volume in itself; though the Augusta still remained a reserve for the Marcia, on the understanding that it should serve the Claudia only when the Marcia could not take it.

The conduit of the Claudia has a length of 46,406 paces,

of which 36,230 are in a subterranean channel and 10,176 on structures above ground: of these last there are arched works at various points in the upper course of the aqueduct amounting to 3076 paces, while near the City, from the seventh mile, 604 paces are on substructures and 6491 on arches.

The Claudia was the second highest in level; while it and the Anio Novus are carried together from their catchbasins on lofty arches, the Anio being above. Their arches end behind the gardens of Pallas, whence they are carried in pipes for the use of the City.

The Claudia being more abundant than the others is especially exposed to depredation. In the Records it has only 2855 quinariae, while I found at the source 4607 quinariae — 1752 more than the records. Our gauging is rendered more trustworthy by the fact that, at the seventh milestone from the City, at the settling tank, where the gauging cannot be questioned, we find 3312 quinariae, 457 more than in the Records...

Frontinus, *Of the Aqueducts of the City of Rome* (late 1st century AD) (translated by Thomas Ashby)

...Before you is the city gate which opens upon the Via Appia Nuova, the long gaunt file of arches of the Claudian aqueduct, their jagged ridge stretching away like the vertebral column of some monstrous mouldering skeleton, and upon the blooming brown and purple flats and dells of the Campagna and the glowing blue of the Alban Mountains, spotted with their white, high-nestling towns...

Henry James, *Italian Hours* (1909)

AMONG the most striking of all Roman remains are the majestic remnants of the great aqueducts, some of which can still be seen stumbling their way across the Campagna to Rome. The aqueducts were artificial channels constructed by the Romans to conduct water from sources in the outlying countryside to the city itself. This usually involved letting the water flow along piping or conduits which, depending on the terrain, ran underground or were carried over arcades. Vitruvius, in his treatise on architecture, recommended a fall of just six inches every hundred feet to obtain a steady flow in the supply. To keep the water cool and free from any impurities the channel or *specus* was covered over and numerous small apertures or *lumina* were inserted at regular intervals to induce the circulation of fresh air. When it reached the city the water was distributed by a series of lead or earthenware pipes from the nodal *castellum* or water-tower. Eleven in number (nineteen, counting branches), from the earliest Aqua Appia (312 BC) to the Aqua Alexandriana (AD 226), the Roman aqueducts altogether measured over 250 miles in length and delivered some 317,000,000 US gallons of water per day to the city. In classical times, when Rome's population totaled about one million, this gave more than 300 US gallons per head per day, as against 88 US gallons per head per day in 1965.

The Claudian Aqueduct, whose ravaged arches constructed in *opus quadratum* with tufo and peperino stone run for more than six miles across the Roman countryside, was begun by Caligula in AD 38 and completed by Claudius in 52. Its total length, from its sources in the valley of the Aniene River to the point at the Porta Maggiore where it reaches the city alongside the Aqua Marcia, is an impressive 42 miles, of which more than 25 miles ran underground. Within the city it supplied water for the Esquiline, the Viminal and the Quirinal, with a subsidiary, the work of Nero and Domitian, supplying the Caelian, the Palatine and the Aventine.

Bodart attributes this drawing to Jean-Jacques de Boisseau on the basis of perceived similarities between this composition and other Italian studies by the master in the Louvre, notably the sheet illustrating the ruins of a palace on the Palatine (Guiffrey and Marcel 1909, I, p.71, no. 337, illus.). It is difficult, however, to be enthusiastic about this attribution, as the delightfully transparent studies by Boisseau (see Perez 1979, figs. 25–36b) are technically different, besides being of higher quality. In the present composition the artist obviously had some difficulty with the perspective, particularly of the walled-up gateway. Jean-Pierre Cuzin (letter to the author, 1987) has suggested that the author might be the little-known Constant Bourgeois du Castalet (1767–1836; see Guiffrey and Marcel 1909, II, nos. 1647 ff.), though he admits that such an attribution would need more investigation as it, too, poses difficulties.

21 GIACOMO QUARENGHI

BERGAMO 1744–1817 ST PETERSBURG

The Arch of Constantine viewed from the Colosseum

Pen and ink with watercolor on card: 182 × 288 mm

Inscribed on front of mount, underneath drawing, probably in the hand of Dr J. Percy, in pencil: *Cav. Giacomo Quarenghi. B. at Bergamo in 1744. D. at S'Petersburg in 1817. / A pupil of R Mengs & S Pozzi. Catharine II attracted him to St Petersburg, where / he erected several public buildings. See 'Die Künstler'. He practised as an architect. / On the back of the old mount was written in ink as follows: View of the Arch of Constantine taken / under one of the lower Arches of the Colliseo – drawn by Giacomo Quarenghi, principal Architect to the Empress of Russia for Ozias Humphry. 1778. Bought of Hogarth. / JP March. 12, 1876.; below this, in Ashby's hand, in pencil: The background is engraved – Looks like Uggeri*

WATERMARK

CONDITION: good

PROVENANCE: Dr J Percy, London 1817–89 (Lugt 1504, verso, bottom left)

BODART NO. 285

Arch of Constantine

This monument is still intact, and all of it is visible, except the base which is buried to half its height. The arch has three openings, one large and two small; eight columns of the Corinthian order, breaking forward, with cabled fluting (a rarity in classical architecture, for which these columns are not the more beautiful) and supporting eight figures of Dacians. The sides of the arch lack columns; their only decoration is a low relief at the level of the attic, and two medallions or round low reliefs above the entablature. Within the middle arch are two large low reliefs, and over each of the smaller arches are two relief roundels set side by side. All these reliefs represent the deeds of Trajan, and seem to have been brought here from an older monument.

The general form of the Arch of Constantine, and also the details of its articulation, are excellent; the voids and solids are well balanced, and so are the intervals of the central opening compared to those of the smaller side arches. The columns are neither too large nor too small in relation to the other elements. They impart to the whole a richness further augmented by the figures they support. The size of the Arch is so well judged and so natural, that when the hero of the triumph passed through it would be most effective, and all the reliefs, figures and the arches themselves would be in proportion to him. These figures, reliefs and decorations are placed judiciously; and although the effect is rich, serenity also reigns to a large degree. The aspects of the Arch are very beautiful and strikingly magnificent seen both from the front and from the sides, both from far and from near.

Joseph-Jérome Lefrançois de Lalande, *Voyage d'un Français en Italie fait dans les années 1765 & 1766*

Descending from the Capitol to the Forum is the triumphal Arch of Sept[imius] Severus, less perfect than that of Constantine, though from its proportions & magnitude a most impressive monument. That of Constantine, or rather of [Trajan *deleted*] Titus, (for the reliefs & sculpture & even the colossal images of Dacian captives were torn by decree of the Senate from an arch dedicated to the latter to adorn that of this stupid & wicked monster Constantine, one of whose chief merits consisted in establishing a religion [which had destroyed *altered to*] the destroyer of those arts which

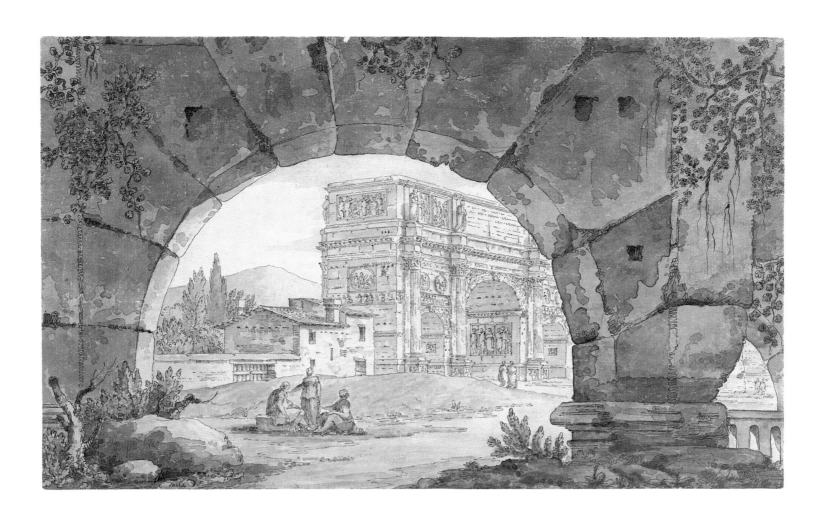

would have rendered so base a spoliation unnecessary) is the most perfect. It is an admirable work of art. It is built of the finest marble, & the outline of the reliefs is in many parts as perfect as if just finished. Four Corinthian fluted columns support on each side a bold entablature, whose bases are loaded with reliefs of captives in every attitude of humiliation & slavery. The compartments above express in bolder relief the enjoyment of success, the conqueror on his throne or in his chariot, or riding over the crushed multitudes who writhe under his horses' hoofs, as those below expressed the torture of & abjectness of defeat. There are three arches, whose roofs are pannelled with fretwork, & their sides adorned with similar reliefs. The keystone of these arches is supported each by two winged figures of Victory, whose hair floats on the wind of their own speed, & whose arms are outstretched bearing trophies, as if impatient to meet. They look as it were borne from the subject extremities of the earth on the breath of the exhalation of that battle & desolation which it is their mission to commemorate. Never were monuments so completely fitted to the purpose for which they were designed of expressing that mixture of energy & error which is called a Triumph.

Letter from Percy Bysshe Shelley to Thomas Love Peacock (23 March 1819)

The triumphal arch of Constantine still remains a melancholy proof of the decline of the arts, and a singular testimony of the meanest vanity. As it was not possible to find in the capital of the empire a sculptor who was capable of adorning that public monument, the arch of Trajan, without any respect either for his memory or for the rules of propriety, was stripped of its most elegant figures. The difference of times and persons, of actions and characters, was totally disregarded. The Parthian captives appear prostrate at the feet of a prince who never carried his arms beyond the Euphrates; and curious antiquarians can still discover the head of Trajan on the trophies of Constantine. The new ornaments which it was necessary to introduce between the vacancies of ancient sculpture, are executed in the rudest and most unskilful manner.

Edward Gibbon, *The Decline and Fall of the Roman Empire* (1776–1788)

THE Arch of Constantine, the largest of the three remaining triumphal arches in Rome, was erected to commemorate Constantine's victory over Maxentius at the Milvian Bridge on 28 October 312. Similar in broad outline to that erected in 203 to honor the achievements of Septimius Severus, it has one large opening flanked by two smaller archways together with a number of columns, raised on plinths, which stand free from the structure itself. Its surface is sumptuously decorated all over with sculpture and carved reliefs and dedicatory inscriptions. Unlike its predecessor, though, the attic section is divided in three with its sculptured panels arranged so as to correspond with the disposition of the archways below.

The carved panels, medallions and free-standing figures which cover the surface of the Arch were, for the most part, assembled from various other locations, possibly from buildings and other structures damaged during the great fires of AD 283 and 307. (This form of official pillaging was later to become standard practice during the Middle Ages and the Renaissance.) In any event, since Rome was no longer the functioning capital of the Empire, there was a dearth of artistic talent which by then had dispersed to more lucrative centers. What talent remained conceived its art differently from its predecessors, who were more proficient in the creation of large-scale works. The borrowed pieces, which included columns, capitals and fragments of cornices as well as sculptures and friezes, mostly date from the times of Trajan, Hadrian and Commodus. The pieces specially commissioned for the monument are those panels positioned above the side arches, on the end of the arch and on the bases of the columns. These include reliefs which show Constantine himself: The Departure of the Army of Constantine from Milan; The Siege of Verona; The Battle of Ponte Milvio; The Entry of Constantine into Rome; Constantine's Speech from the Rostrum; The Distribution of Money in the Forum. The form which these carvings take suggest that they were executed by artists who were most comfortable working on small-scale commissions such as the decoration of sarcophagi.

The Arch was dedicated on 25 July 315, on the tenth anniversary of Constantine's accession to the throne of the Empire. It is 82 feet high, with a central archway 21 feet wide and 37 feet high. The lengthy inscription, which is repeated on the attic story of both façades, reads as follows:

To the Imperator Caesar Flavius Constantinus Maximus, Pius, Felix, Augustus – since through the inspiration of the Deity, and in the greatness of his own mind, he with his army avenged the Commonwealth with arms rightly taken up, and at a single time defeated the Tyrant and all his Faction – the Senate and the People of Rome dedicated this Arch adorned with Triumph.

The reference to the 'inspiration of the Deity' has been interpreted as referring to the legend of the vision of the Cross to Constantine prior to the battle of the Milvian Bridge, a supposition which is most unlikely as the Emperor's conversion to Christianity came about later. In medieval times the Arch was known as the Arco de'Trasi, possibly in reference to the sculpted figures of Thracians or Dacians, taken from monuments erected during the time of Trajan or Domitian, which can be seen standing above the columns. During the Middle Ages the Arch was adapted to make a fortified tower. It was later appropriated by the Frangipane family. Restored on a number of occasions during the seventeenth century, it was finally set free in 1804 from all the various parasitical and disfiguring accretions which had become attached to it over the centuries.

Quarenghi's study of the ancient monuments of Rome formed the basis of his development as an architect. The Biblioteca Civica in Bergamo has numerous drawings by him illustrating Roman monuments (see Angelini 1967), mostly executed during his stay in the city over the period 1775–79. According to the inscription, the drawing in the Ashby collection was made for the English collector Ozias Humphry in 1778. Humphry's correspondence from Rome (Williamson 1918, p.70) indicates that he had 'made the acquaintance of one Giacomo Quarenghi'. He possessed a number of drawings by the artist, as inscriptions on drawings in other collections prove. A view of the Forum, formerly in the possession of Anthony Blunt, once belonged to Humphry, as did another showing the Colonnade of St Peter's which was sold at Christie's (11 December 1985, lot 117), and also a similar view in the Whitworth Art Gallery in Manchester.

22 ELIZABETH SUSAN PERCY

ENGLISH c1778–1847

The Arch of Constantine

Black chalk (or charcoal?) with light gray wash: 239 × 339 mm

Inscribed, verso, bottom right, in pencil: *Nero's Golden Palace & Arc of Constantine / From* [?] *Coliseum —*; on front of support, center, below drawing, in pencil: *Nero's Palace & Arch of Constantine/fm. the Coliseum*

CONDITION: fair

BODART NO. 236

IN his catalogue of the Ashby collection, Bodart refers to the author of this drawing as Elizabeth Simon Percy. However, it is virtually certain that the artist who signed herself SE Percy on no. 256 was in fact Elizabeth Susan Percy, daughter of the Earl of Beverley, who is known to have spent a great deal of time in Italy. Curiously enough her uncle, the illegitimate son of her grandfather, the Duke of Northumberland (whose family name was Smithson before he changed it to Percy on accession to the title), provided funds to set up, in Washington DC, 'an establishment for the increase and diffusion of knowledge among men', to be known as the Smithsonian Institution.

This somewhat romantic view of the Arch of Constantine from the Caelian is one of a total of 44 drawings (nos. 234–277) by Lady Elizabeth Percy in the Ashby collection. The other compositions, which all come from a collection of views entitled *Sketches from the Journey to and from Naples*, show a variety of landscapes drawn in Rome and the surrounding countryside as well as sketches done in Naples and its environs. Felicity Owen, who has very kindly provided information on this artist, says that a number of her drawings have come up for sale from time to time in London, notably at Agnew's. An album of sketches of Rome and Frascati by Lady Elizabeth Percy was sold at Christie's, 4 November 1975 (lot 2).

23 ISRAEL SILVESTRE

NANCY 1621–1691 PARIS

The Colosseum

Pen and ink with slight traces of red chalk, and gray ink wash:
115 × 195 mm

Inscribed, verso, bottom right corner, in black chalk: *Sylvestre*;
bottom left corner, in black chalk: *fr.—*; below this, in black chalk: *a roma*.

Faintly squared in red chalk. Border of dark brown ink

WATERMARK

CONDITION: fair

BODART NO. 295

I chanced to stop in at a midday show, expecting fun, wit, and some relaxation, when men's eyes take respite from the slaughter of their fellow men. It was just the reverse. The preceding combats were merciful by comparison; now all trifling is put aside and it is pure murder. The men have no protective covering. Their entire bodies are exposed to the blows, and no blow is ever struck in vain ... In the morning men are thrown to the lions and the bears, at noon they are thrown to their spectators. The spectators call for the slayer to be thrown to those who in turn will slay him, and they detain the victor for another butchering. The outcome for the combatants is death; the fight is waged with sword and fire. This goes on while the arena is free. 'But one of them was a highway robber, he killed a man!' Because he killed he deserved to suffer this punishment, granted ... 'Kill him! Lash him! Why does he meet the sword so timidly? Why doesn't he kill boldly? Why doesn't he die game? Whip him to meet his wounds! Let them trade blow for blow, chests bare and within reach!' And when the show stops for intermission, 'Let's have men killed meanwhile! Let's not have nothing going on!'

Seneca, *Moral Epistles* (1st century AD) (translated by N Lewis and M Reingold)

There is, however, in this wide sweep of splendid ruins, one monument, great above all, and beautiful as great, which it would be gracious to ascribe to other causes than human turpitude and human error. Even now as it moulders it seems some visionary fabric raised by the magic of sweet sounds, by the vibrations of some Amphion's lyre; and falling as it rose, in harmony. It is so beautiful in ruin, that taste and feeling can send back no regrets for its former state of perfectness. This is the Coliseum — the last and noblest monument of Roman grandeur, and Roman crime — erected by the sweat and labour of millions of captives, for the purpose of giving the last touch of degradation to a people whose flagging spirit policy sought to replace by brutal ferocity. The first day's games given in this sumptuous butchery cost the nation eleven million in gold. The blood of five thousand animals bathed its arena. Man and his natural enemy the beast of the desert, the conqueror and conquered writhed in agony together on its ensanguined floor: and eighty seven thousand spectators raised their horrid plaudits, while captive warriors were slain 'to make a Roman Holiday'. Here was waged the double war against human life and human sensibility; and men were brutified while animals were butchered. All the recollections of this unrivalled edifice are terrible; and its beauty and its purport recall some richly wrought urn of precious ore, destined to enshrine the putrid remnants of mortality.

Lady Sydney Morgan, *Italy* (1824)

AMONG the many obligations which weighed heavily on the shoulders of the Roman emperors, one of the most demanding and frustrating was that of somehow keeping the population of the capital city of the empire fed and entertained. When one considers that in the second century AD the capital of the greatest empire on earth numbered at least one million inhabitants, and possibly even one million and a half, the scale of this particular problem can be readily appreciated. The fact that a great many of the urban proletariat were unemployed and that the rest with jobs enjoyed almost countless public holidays made the task even more daunting. Of the many pastimes subsidized by the imperial coffers the most admired by the modern observer are the magnificent public baths, such as those of Caracalla and Agrippa. The pastime which we today find altogether

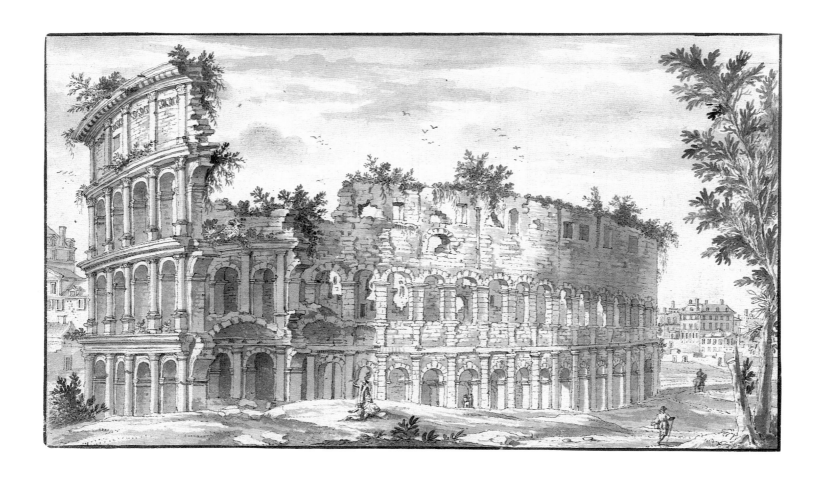

more repulsive is the gladiatorial games, in which thousands upon thousands of men and women were slaughtered for the delectation of the mob.

The origins of the gladiatorial combats reach back to the religious practices of the Etruscans for whom the ritual related to the burial of their warriors. Gradually, however, the religious element in the ritual was diluted until by the time of Julius Caesar the custom of staging gladiatorial combats during funeral games had virtually ceased and the practice became an end in its own right, or a means for the amusement and appeasement of the *plebs*. The earliest known amphitheater purpose-built to accommodate such an event was that of the Sullan colony of Pompeii which has been dated to *c*80 BC. In Rome itself, that built by Statilius Taurus around 29 BC is reckoned to have been the earliest. When Vespasian constructed the Colosseum he won double praise from the citizens of Rome, for in doing so he not only provided them with a magnificent arena for their favorite spectator sport, but also gave back to the people a large area of the inner city which his predecessor, Nero, had appropriated for his own selfish enjoyment.

Those who fought in the amphitheaters were usually criminals and captives from the many military campaigns, though also numbered among the combatants were down-at-heel free men and some fanatics. Women also appeared in the arena as fully trained and armed adversaries, until Septimius Severus passed a decree forbidding their participation in 200. Training was critical to the whole spectacle: the participants, willing or unwilling, were all tutored and specially fed so as to provide the best entertainment affordable. Even when they entered the arena they had their trainers lashing at their heels to make them give of their best. On most days when gladiatorial games were held at the Colosseum the 'show' started early, usually with a big parade. The combatants presented themselves to the Emperor with the salutation: '*Ave, Caesar, morituri te salutant!* (Hail, Emperor, those who are about to die salute thee!)'. Then the combats began. A measure of the degree of expertise and sophistication with which this barbarous spectacle was endowed was the development of four main gladiatorial categories, requiring the combatants to fight armed and equipped in four different ways: the Samnite with his shield and sword; the Thracian with his round buckler and dagger (*sica*); the Myrmillo, the fishman, wearing a helmet with a fish-shaped crest; and the Retiarius, who employed a net and trident to ensnare his adversary. For 'sport', untrained and unequal adversaries were also paired together. Sometimes mock combats were staged as a prelude to the real thing. The complete spectacle usually lasted many days and sometimes months, involving not simply ordinary gladiatorial combats or *hoplomachia*, but also *naumachia* or simulated sea battles on the waters of the flooded arena and *venationes* or wild beast hunts in the specially landscaped arena. The Fasti Ostienses record a gladiatorial festival lasting 117 days in which 4941 pairs of gladiators took part.

This view of the Colosseum is most unusually placed in a fantastic setting, for the buildings in the background are characteristically French. Bodart has suggested that this may indicate that the drawing is a recollection of the Colosseum, rather than a design done on the spot. The ruin was engraved twice by Israel Silvestre (Le Blanc 4 and 83).

24 *Attributed to*
JAN BRUEGHEL the ELDER

BRUSSELS 1568–1625 ANTWERP

An Artist drawing in the Ruins of the Colosseum

Pen and brown ink with gray wash, on laid paper: 360 × 254 mm

Inscribed, recto, bottom left, in the artist's hand, in brown ink: *Septembris 13 – 1593*; indecipherable inscriptions on verso covered by support; on reverse of support, lower left center, in pencil: *Colosseum / P. Bril*; lower right, in pencil: *294*; top center, in ink: *no 8*; upper right corner, in pencil: *3/–*.

Border of dark brown ink

WATERMARK on support

CONDITION: some creasemarks

BODART NO. 111

Last Friday I spent a delightful afternoon clambering about the Coliseum, but alas! not without a custode, and not, I regret to confess it, without horrible green gates with spikes at the tops — isn't it disgusting? They are making terrible reparations too! with wheelbarrows! But still the idea of vastness, which you have nowhere but from the upper range, is wonderful, though I must allow, it touches me but little. I brought away two house-leek sorts of things, the ugliest, vulgarest, basest vegetation I could find, as sacred to the memory of the spiritual deformity of the Coliseum, to be dried in remembrance of the same, as the most fitting symbols of what the Emperors had substituted in place of the great days of Rome. The memory of Polycarp, the friend of St John, was the only one I could find hovering about the place, which I could welcome.

Florence Nightingale, *Letter* (winter of 1847–1848)

One of course never passes the Colosseum without paying it one's respects — without going in under one of the hundred portals and crossing the long oval and sitting down awhile, generally at the foot of the cross in the centre. I always feel, as I do so, as if I were seated in the depths of some Alpine valley. The upper portions of the side towards the Esquiline look as remote and lonely as an Alpine ridge, and you raise your eyes to the rugged skyline, drinking in the sun and silvered by the blue air, with much the same feeling with which you would take in a grey cliff on which an eagle might lodge. This roughly mountainous quality of the great ruin is its chief interest; beauty of detail has pretty well vanished, especially since the high-growing wild flowers have been plucked away by the new government, whose functionaries, surely, at certain points of their task, must have felt as if they shared the dreadful trade of those who gather samphire.

Henry James, *Italian Hours* (1909)

THE vast, half-ruined structure of the Colosseum rises over an area previously occupied by the artificial lake (Stagnum Neronis) attached to the magnificent Golden House of Nero (whose colossal statue is reputed to have given the amphitheater its name). Begun early in the reign of Vespasian (AD 69–79), it replaced the amphitheater built by

Statilius Taurus, destroyed in the fire of 64, and the wooden structures which had since replaced it. The edifice was constructed as a venue for gladiatorial combats, the first of which took place in 80, when the yet uncompleted building was dedicated by the Emperor Titus (79–81). It was a spectacular gladiatorial show lasting one hundred days, and is reputed to have included a *venatio* or wild beast fight during which 5000 animals were slaughtered. Work on the construction of the amphitheater was finally terminated by the Emperor Domitian (81–96). Its final performance was in 404, when an edict of the Emperor Honorius (395–423) banned the promotion of gladiatorial combat.

On a purely statistical level, the Colosseum, or Flavian Amphitheater as it is also known, is a truly impressive monument. Built according to the elliptical plan which was common for theaters in the Roman world, it measured 617 by 512 feet externally and rose to a height of almost 165 feet. Access to its approximately 45,000 marble seats was by way of 80 numbered entrances, known as *vomitores*, through which the public gained access by presentation of their numbered entry ticket or *tessera*. Four of the entrances were reserved to provide access for the emperor and his entourage and for the gladiators. To protect the crowd from the heat of the midday sun and the vagaries of the weather a vast awning or *velarium* could be drawn across the stadium by a team of specially trained sailors who were barracked close by specifically to perform this function. The most impressive statistic, however, is the fact that the structure has survived for so many centuries despite the depredations of nature and the despoliations of man. Its travertine blocks, drawn from the quarries of Tivoli along a road specially constructed for the purpose, offered to subsequent ages a free and easy source of building blocks and lime. What remains of the external walls (two fifths of the whole) was restored and strengthened under the supervision of Valadier in 1820 at the instigation of Pope Pius VII.

The present drawing is a somewhat larger variant of a similar composition (262 × 210 mm) in the print room of the Staatliche Museen in Berlin, which Bodart considers to be a copy of the Ashby drawing. He notes the spontaneity of the handling in the Vatican sheet and argues that, though it is known that Brueghel made copies of drawings by Matthijs Brill (1550–83), in this particular instance the Brueghel composition should be regarded as a study executed directly from nature. According to Matthias Winner (1967, no. 149), the signature 'BRUEGHEL' on the Berlin sheet is authentic and the manner of the representation indicates that it, too, is a study done directly from nature, some time during the artist's sojourn in Rome. He considers the Ashby drawing to be the work of Paul Brill (1554–1626) and believes that both works may have been done when the two artists went on a sketching trip together in September 1593. Bodart notes that another two drawings in the Worcester Museum of Art and the Fondation Custodia in Paris (Van Hasselt and Blankert 1966, no. 17), by Paul Brill or his pupils, represent a view similar to that of the Vatican and Berlin drawings. Certainly, the Berlin drawing seems more delicate and suggestive than the Ashby sheet, which still shows strong traits of the somewhat geometric style practiced by Matthijs Brill, whose drawings served as exemplary didactic models for the instruction of the younger generation of northern artists working in Rome at this time.

25 JEAN GRANDJEAN

AMSTERDAM 1752–1781 ROME

A Gallery in the Colosseum

Pen and bistre wash with traces of black chalk on laid paper:
417 × 318 mm

Signed, verso, bottom left, in pencil: *J. Grandjean / fr.sc* (or: *50*);
inscribed, recto, lower right, on second block of pillar, in ink: *in
Coliseo Roma 1781*; verso, bottom right, in pencil: *1781 / date of his
Death*; bottom left corner, in black ink: *No 373*; center bottom, in
pencil: *1781 date of his death.*

Framed with border of black ink

WATERMARK

CONDITION: tear mark, upper center, left border, and top left
(repaired)

BODART NO. 142

One evening the priest began to make his preparations, and
told me I was to find a companion or two, but not more. I
called on my great friend Vincenzio Romoli, and he
brought with him a Pistoja man, who was also given to
necromancy. Together we set off for the Coliseum, and
there, having dressed himself after the wont of magicians,
the priest began to draw circles on the ground, with the
finest rites and ceremonies you can imagine. Now he had
bidden us bring precious perfumes and fire, and evil-
smelling stuff as well. When all was made ready, he made an
entrance to the circle, and, taking us by the hand, led us one
by one within. Then he distributed the duties. The pentacle
he gave into the hands of his companion magician; we
others were given the care of the fire for the perfumes; and
he began his conjuring. This had lasted more than an hour
and a half, when there appeared many legions of spirits, so
that the Coliseum was full of them. I was attending to the
precious incense, and when the priest perceived the great
multitudes, he turned to me and said, 'Benvenuto, ask of
them something'. I answered, 'Let them transport me to my
Sicilian Angelica'. That night he got no reply at all, but my
eager interest in the thing was satisfaction enough for me.

The Life of Benvenuto Cellini, Written by Himself (1562) (translated by
Anne Macdonnell)

THE massive internal arcading of the Colosseum obvi-
ously had a strong fascination for artists working in Rome.
Its great moldering forms, gigantic in scale and ravaged by
time, presented the viewer with a variety of images which
excited the imagination. The present sketch is just one of a
number of views which Grandjean made of this ancient
monument. Two other views of similar dimensions
(320 × 418 mm and 315 × 415 mm), also dating to 1781,
were exhibited at the Rijksprentenkabinet, Amsterdam, in
1971 (*Ontmoetingen met Italia, 1970–72*). Another smaller
view (315 × 230 mm) was exhibited in Rome in 1984
(*Paesaggisti ed altri Artisti olandesi a Roma intorno al 1800,*
1984). There is another drawing of the Colosseum by Gran-
djean in the Staatliche Museen, Berlin (inv. no. KD2 26328).
Bodart indicates that the drawing may usefully be com-
pared with a similar view by Jacques-Louis David in the
Louvre.

26 RICHARD WILSON

PENEGOES 1713?–1782 COLOMMENDY

The Colosseum by moonlight

Black chalk with stubbing and sepia with white highlights on gray colored laid paper: 137 × 206 mm

Inscribed, verso, bottom left corner, in brown ink: *1818 WE –P116 –N161*; bottom right center, in brown ink: *Wilson*; on front of support, bottom right, in pencil: *Richard Wilson Interior of / Colosseum / 877 / 2.15.0 / 10.2.20*; inside support, bottom left, in pencil: *From the Esdaile Colln*; bottom center, in pencil: *From the Colln of C. Fairfax Murray Esq*; bottom right, in pencil: *Wilson (Richard) 1714–1782 / View of the Roman Forum by moonlight / with figures (really Colosseum) / sepia, heightened in white on greyish paper / Parsons 2:15:0 / oppe reg.877*; bottom right corner: *0/5/–* and *2/15/–*; in black ink: *3*; on front of mount, bottom right, in pencil: *Richard Wilson / interior of Colosseum / 877 / 2.15.0 / 10.2.20.*

Border of black chalk

CONDITION: good

PROVENANCE: C Fairfax Murray; William Esdaile (Lugt 2617 recto, bottom right corner)

BODART NO. 323

From the great multitude of wondrous things, I would select the Colosseum as the object that affected me the most. It is stupendous, yet beautiful in its destruction... To walk beneath its crumbling walls, to climb its shattered steps, to wander through its long, arched passages, to tread in the footsteps of Rome's ancient kings, to muse upon its broken height, is to lapse into sad, though not unpleasing meditation.

But he who would see and feel the grandeur of the Colosseum must spend his hour there at night, when the moon is shedding over it its magic splendour. Let him ascend to its higher terraces, at that pensive time, and gaze down into the abyss, or hang his eyes upon the ruinous ridge, where it gleams in the moon-rays, and charges boldly against the deep blue heaven. The mighty spectacle, mysterious and dark, opens beneath the eye more like some awful dream than an earthly reality, — a vision of the valley and shadow of death, rather than the substantial work of man. Could man, indeed, have ministered either to its erection or its ruin? As I mused upon its great circumference, I

seemed to be sounding the depths of some volcanic crater, whose fires, long extinguished, had left the ribbed and blasted rocks to the wildflower and the ivy. In a sense, the fancy is a truth: it was once the crater of human passions; there their terrible fires blazed forth with desolating power, and the thunder of the eruption shook the skies. But now all is still desolation. In the morning the warbling of birds makes the quiet air melodious; in the hushed and holy twilight, the low chanting of monkish solemnities soothes the startled ear.

Thomas Cole, *Notes at Naples* (1832)

Arches on arches! as it were that Rome,
Collecting the chief trophies of her line,
Would build up all her triumphs in one dome,
Her Coliseum stands; the moonbeams shine
As 'twere its natural torches, for divine
Should be the light which streams here to illume
This long-explored but still exhaustless mine
Of contemplation; and the azure gloom
Of an Italian night, where the deep skies assume

Hues which have words, and speak to ye of Heaven,
Floats o'er this vast and wondrous monument,
And shadows forth its glory. There is given
Unto the things of earth, which Time hath bent,
A spirit's feeling, and where hath leant
His hand, but broke his scythe, there is a power
And magic in the ruin'd battlement,
For which the palace of the present hour
Must yield its pomp, and wait till ages are its dower.

... 'While stands the Coliseum, Rome shall stand;
When falls the Coliseum, Rome shall fall;
And when Rome falls — the World' ...

Lord Byron, *Childe Harold's Pilgrimage* (1812)

Later still the moon shines through the arches and softens and hallows the ruins of the old amphitheatre; an owl plaintively hoots from the upper cornice, and from the grove nearby you hear the nightingale's hearthrobbing into song; voices are talking under the galleries, and far up a torch

wanders and glimmers along the wall, where some enterprising English party is exploring the ruins. The sentinel passes to and fro in the shadowy entrance, and parties of strangers come in to see the 'Colosseum by moonlight'. They march backward and forward, and their 'guide, philosopher, and friend', the courier, in broken English answers their questions.

William Wetmore Story, *Roba di Roma* (1871)

When on his return from the villa ... Winterbourne approached the dusky circle of the Colosseum, it occurred to him, as a lover of the picturesque, that the interior, in the pale moonshine, would be well worth a glance. He turned aside and walked to one of the empty arches ... Then he passed among the cavernous shadows of the great structure, and emerged upon the clear and silent arena ... One half of the gigantic circus was in deep shade; the other was sleeping in the luminous dusk ... Winterbourne walked to the middle of the arena, to take a more general glance ... The great cross in the centre was covered with shadows; it was only as he drew near it that he made it out distinctly. Then he saw that two persons were stationed upon the low steps which formed its base ...

Presently the sound of a woman's voice came to him distinctly in the warm night air. 'Well, he looks at us as one of the old lions or tigers may have looked at the Christian martyrs!' These were the words he heard in the familiar accent of Miss Daisy Miller.

Henry James, *Daisy Miller* (1883)

IN 1744 Pope Benedict XIV issued a decree to protect the ruins of the Colosseum from those intent on using it as a quarry for building materials. At the same time he consecrated the arena to the memory of the multitude of Christians martyred there. In its center he placed a large cross and round the edge of the arena he arranged the fourteen Stations of the Cross. A pulpit was erected and from its platform a Capuchin monk would every Friday preach a sermon. These religious fixtures remained in place until P Rosa had them removed while carrying out excavations in the arena in February 1874. In an earlier campaign in 1871 Rosa supervised the complete cleaning of the interior, sweeping away the bewildering array of flora which had so fascinated many visitors to the ancient ruin. In 1813 Antonio Sebastiani in his *Flora Colisea* numbered 261 species and some 40 years later, in 1855, the English botanist Richard Deakin in his beautifully illustrated *Flora of the Colosseum* catalogued an amazing 420.

The extent to which the Colosseum was used for the martyrdom of Christians has in the past probably been exaggerated. Nonetheless a great number of Christians, along with a hapless multitude of other unfortunates, met their death in its arena. The Christians were the subject of imperial disapproval principally because their faith undermined the authority of the Roman gods and consequently the power of the state. In this respect they were no different from a number of other sects, notably the Jews, who also resisted instructions to offer homage to the imperial gods. Though technically their religion was considered illegal Christians generally suffered little harassment until their community grew large enough to constitute a serious threat to pagan traditions. There were sporadic campaigns of persecution, the first notable one being that of Nero, who sought scapegoats to deflect public criticism of his administration following the great fire of AD 64. Another outbreak of persecution occurred during the reign of Domitian (81–96). Further persecutions followed during the reigns of Septimius Severus (193–211) and Maximus (235–38). In 257 Valerian issued edicts of persecution against the Christians in an attempt to suppress the cult completely. This particular campaign of religious repression, which lasted until 259, is reckoned to have been the most severe. Diocletian in about the year 298 made an unsuccessful attempt to purge the civil service and army of

Giovanni Battista Piranesi: *The Colosseum*

Christians and during the final days of pagan rule Maximinus (308–13) made a futile bid to restore the fortunes of the ancient gods. With the edict of Milan in 313 the emancipation of Christianity was assured and by the year 325 it had become the state religion. The restoration of a pagan régime under Julian the Apostate (361–63) ended in failure.

Among the first Christians to have suffered death in the Colosseum was Ignatius of Antioch, who was martyred *c*107 during the reign of Trajan (98–117). This saintly bishop, quite possibly a convert of St John the Evangelist, is known to us from a sequence of important letters which he wrote to the churches in Asia Minor while on his way to Rome to be executed. Before being thrown to the lions he is reported to have exclaimed: 'I am as the grain of the field, and must be ground by the teeth of lions, that I may become fit for His table.'

The drawing, a poetic image of the interior of the Colosseum, apparently represents the arena with the Stations of the Cross arranged round its perimeter. To the left is depicted a monk in prayer. Bodart mistook the structure on the left to be the remains of a Roman temple.

27 JAKOB PHILIPP HACKERT

PRENZLAU 1737–1807 SAN PIERO DI CAREGGIO

The Colosseum with the Temple of Venus and Rome

Pen and ink and watercolor, with traces of black chalk, on paper, laid down: 370 × 535 mm

Inscribed on front of mount, bottom right, in black ink: *Drawn By Ph- Hacket* (sic); on back of support, bottom center, in brown ink: *4*; bottom right, in pencil: *no 1922*; top right corner, indecipherable, upside down, in red chalk: *di . . .*; traces of lost inscription, upper center, in pencil (?)

Border of black ink

WATERMARK on support

CONDITION: good

BODART NO. 149

Thanks to his competence and authority, Hofrat Reiffenstein is the natural person to organize and preside at these sessions, but it was Philipp Hackert who originated this laudable custom. An admirable landscape painter, he always insisted on everyone, artists and dilettantes, men and women, young and old, whatever their talents, trying their hand at drawing, and he himself set them a good example. Since his departure this custom of gathering together an interested circle has been faithfully kept up by Hofrat Reiffenstein; and one can see how worthwhile it is to stimulate in everyone an active interest.

Johann Wolfgang von Goethe, *Italian Journey* (15 November 1786) (translated by W H Auden and E Mayer)

BODART remarks that this brilliant sketch may be compared with an album of sketches by the master in the Municipal Museum in Göttingen (Wilde 1967, pp.297–329). For further commentary on this composition see the introductory essay in this volume by Donald McClelland.

28 JOHN SMITH called WARWICK SMITH

IRTHINGTON 1749–1831 LONDON

The Temple of Venus and Rome

Watercolor: 107 × 176 mm

Inscribed, verso, bottom center, in pencil: *Rome*; on front of mount, bottom right, in pencil: *John 'Warwick' Smith*; below this, in pencil: *21/–* and *Rome*; bottom left, in pencil: *1598*

CONDITION: good

BODART NO. 298

Hadrian first drove into exile and then put to death the architect Apollodorus who had carried out several of Trajan's building projects – his forum, the odeum and the gymnasium. The pretext given for Hadrian's action was that Apollodorus had been guilty of some serious offense, but the truth is that when Trajan was at one time consulting with Apollodorus about a certain problem connected with his buildings, the architect said to Hadrian, who had interrupted them with some advice, 'Go away and draw your pumpkins. You know nothing about these problems.' For it so happened that Hadrian was at that time priding himself on some sort of drawing. When he became emperor he remembered this insult and refused to put up with Apollodorus' outspokenness. He sent him the plan for the Temple of Venus and Rome, in order to demonstrate that it was possible for a great work to be conceived without his [Apollodorus's] help, and asked him if he thought the building well designed. Apollodorus sent a reply saying that, as far as the temple was concerned, it should have been placed in a higher position and that the area beneath it should have been dug out, both so that the temple would have had a more imposing effect on the Via Sacra by being raised above it and so that the hollow space beneath the temple could have received the machines. (There they could be put together out of sight and brought into the theater without anyone knowing about it beforehand). With regard to the cult images he said that they were made on a scale which was too great for the height of the cella. 'For if the goddesses should wish to stand up and leave the temple',

he said, 'they would be unable to do so.' When he wrote all this so bluntly, Hadrian was both irritated and deeply pained, because he had fallen into an error which could not be rectified; nor did he attempt to restrain his anger or hide his pain; on the contrary, he had the man slain.

Dio Cassius, *History* (early 3rd century AD) (translated by J J Pollitt)

Behind S. Francesca Romana, and facing the Coliseum, on the ridge which is sometimes considered to be the Velia, an outlying part of the Palatine, are the remains generally known as the Temple of Venus and Rome (Venus Felix and Roma Aeterna), also called Templum Urbis (now sometimes called by objectors the 'Portico of Livia'), which, if this name is the correct one, was originally planned by the Emperor Hadrian to rival the Forum of Trajan, erected by the architect Apollodorus. It was built upon a site previously occupied by the atrium of Nero's Golden House. Little remains standing except a *cella* facing the Coliseum, and another in the cloisters of the adjoining convent (these, perhaps, being restorations by Maxentius, *c*307, after a fire had destroyed most of the building of Hadrian), but the surrounding grassy height is positively littered with fragments of the grey granite columns which once formed the grand portico (400 by 200 feet) or *peribolus* of the building: some marble steps near S. Francesca Romana mark its façade towards the Forum. The pedestals partly exist, which supported colossal statues of Venus and Rome in the apses. A large mass of Corinthian cornice remains near the cella facing the Coliseum. This was the last pagan temple which remained in use in Rome. It was only closed by Theodosius in 391, and remained entire till 625, when Pope Honorius carried off the bronze tiles of its roof to St Peter's.

Augustus Hare, *Walks in Rome* (1893)

DEDICATED in AD 135, Hadrian's Temple of Venus and Rome must have been one of the most impressive sights of the imperial city. It was rivaled in size only by Caracalla's Temple of Serapis erected almost 100 years later (see No. 43). Hadrian's monument was built on the Mons Velia, in an area previously occupied by the vestibule to Nero's Golden House. We do not know with any certainty when work on the project began, though it was once

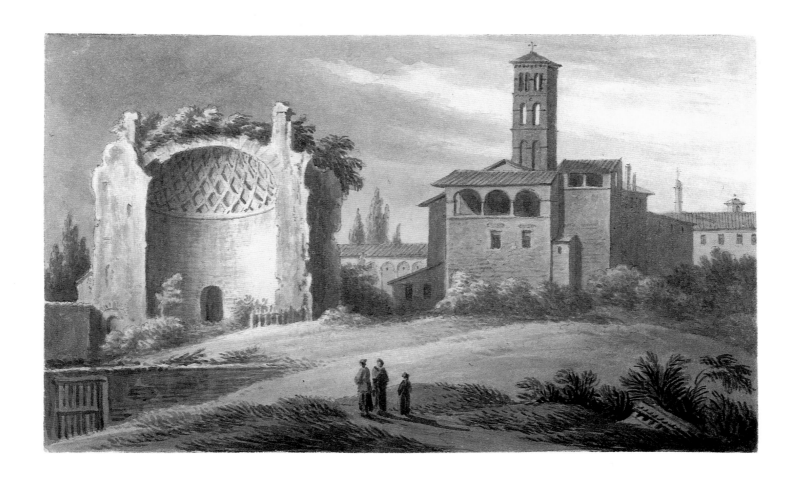

thought that it may have been around 121. To clear the site for its construction, the Emperor Hadrian, who in this instance was both patron and architect, had first to remove to a new location a colossal statue of Nero, over 100 feet in height, a task achieved by the employment of 24 elephants. The new temple exhibited the unusual feature of twin back to back *cellae* to accommodate sanctuaries dedicated to two separate deities.

The overall design of the temple was closely modeled on Greek precedents. This pedigree, however, was not pursued in all the essential details and the outcome would appear to have been less than satisfactory, at least in the opinion of the architect Apollodorus. Placed on a slight base, rather than the traditional elevated podium, the great mass of the temple must have presented the viewer with a somewhat earthbound, rather squat appearance. Great columns of Egyptian granite ran down the two longer sides of the platform, while the temple proper displayed ten magnificent columns of blue-veined Proconnesian marble across both façades, and 20 more down either flank. Its dimensions totalled 217×348 feet. As built by Hadrian, the *cellae* did not possess absidal bays to accommodate the statues of the two goddesses; these were added later in the extensive remodeling of the temple carried out under Maxentius. Maxentius's campaign of reconstruction was undertaken in 305–11 to repair damage caused to the building by fire, possibly in 283. Of the two apses constructed by Maxentius, that facing the Forum is the best preserved. In this niche was placed the image of Rome, while the statue of Venus faced towards the Colosseum. Most of what we see today is in fact the remains of the restoration effected by Maxentius.

Sources indicate that the temple had already been abandoned by the year 391, though it would appear to have remained intact for possibly another two centuries. One of the earliest references to its destruction is the notice that Pope Honorius (625–38) received permission from the Emperor Heraclius to take bronze from the roof for use on St Peter's. Some time during the pontificate of Paul I (757–67) a church dedicated to the Apostles Peter and Paul was erected within the grounds of what must have been by then a derelict site. In the sixteenth century the ruins were further despoiled, again to provide materials for St Peter's. The site was excavated by Nibby in the early nineteenth century (1827–29).

This view of the Temple of Venus and Rome has a companion piece depicting Sant'Andrea on the Via Flaminia (No. 58) which is in the same technique and of the same small dimensions. Its small scale and rather subdued lighting contrasts markedly with the ambitious and more luminous works produced by Smith in Rome under the influence of his colleague Thomas Jones, who opened his eyes to the brilliant effects of the bright Mediterranean sunlight. Among the many fine watercolors now in the British Museum produced by Smith during his Roman sojourn, there is a large, brightly lit view of the Forum (inv. no. 1936–7–4–19) showing the church of Santa Francesca Romana and portions of The Temple of Venus and Rome. The present drawing most probably dates to the same period as the view of Sant'Andrea; like its pendant, it may have been based on an engraving. Besides these two small views, the Ashby collection contains three other compositions by John 'Warwick' Smith (nos. 296, 297 and 300).

29 ANONYMOUS

DUTCH, end of 16th century

The Roman Forum with the Temple of Antoninus and Faustina and the Church of Santi Cosma e Damiano

Pen and brown ink on laid paper: 196 × 285 mm

Inscribed, recto, bottom left corner, in ink: *P. Brill*; center, in ink: *Campo vaccino*; bottom right, in ink: *4–26*

CONDITION: some staining

LITERATURE: Ashby 1916, pl.30, fig. 51; Egger 1932, p.14, pl. 16; Röttgen 1968, p.300, fig. 7; Bodart 1970, p.259

BODART NO. 338

On the 7th we went into Campo Vacino by the ruines of the Templum Pacis. Built by Titus Vespatianus, and thought to be the biggest & most ample as well as richly furnished of all the Roman Dedicated places; It is now an heape, rather than a Temple; yet dos the roofe & Volto, continue firme, shewing it to have formerly been of incomparable workmanship: This goodly structure was (none knows how) consumed with fire, the very night (by all computation) that our B: Saviour was borne.

From here we passed by the place, rather than any signs, of the Lake or Vorago into which Curtius is sayd to have precipitated himselfe for the love of his Country ...

The Oratories or Churches of St. Cosmo and Damiano opposite to these, heretofore the Temples of Romulus and Remus, a pretty odd fabrique, with a Tribunal or Tholus within, wrought all of Mosaic; the Gates before it are brasse, & the whole adornement much obligd to Pope Urban the 8th. In this sacred place lyes the bodys of those Two Martyrs, and in the Chappell at the right hand, a rare Painting of Cavaliero Baglione.

John Evelyn, *Diary* (7 November 1646)

Were an antiquarian to lament over any fall, any metamorphosis of antient Rome, perhaps it might be the present state of the Forum, where, now, there is every Thursday and Friday a market for cows and oxen, on the very spot where the Roman orators were accustomed to thunder out their eloquence in the cause of their clients, their country, and their gods: Accordingly, the Forum now is known by the name of Campo Vaccino.

Samuel Sharp, *Letters from Italy* (1767)

The Forum next engaged my attention. As I strolled amidst its ruins I endeavoured to consider what it once was, and was grieved to find that the very place where the ancient Romans met to decide causes, the seat of eloquence, the most frequented part of Rome, was become a market for cattle; the very Smithfield of her degenerated sons. Where are now its Temples, its Basilicas, its Porticos! — It is difficult even to ascertain the places where they stood. The splendid ruins that remain serve only to maintain the superiority of the ancient over modern architecture. The Barbarians, when they destroyed the rest, might as well have spared us that unnecessary mortification.

Peter Beckford, *Familiar Letters from Italy to a Friend in England* (1805)

The Forum is a plain in the middle of Rome, a kind of desart full of heaps of stone & pits & though so near the habitations of men, is the most desolate place you can conceive. The ruins of temples stand & around it, shattered columns & ranges of others complete, supporting cornices of exquisite workmanship, & vast vaults of shattered domes (laquearis) distinct with the regular compartments once filled with sculptures of ivory or brass. The temple of Jupiter & Concord, & Peace, & the Sun & the Moon, & Vesta are all within a short distance of this spot. Behold the wrecks of what a great nation once dedicated to the abstractions of the mind. Rome is a city as it were of the dead, or of those who cannot die, & who survive the puny generations which inhabit and pass over the spot which they have made sacred to eternity. In Rome, at least in the first enthusiasm of your own recognition of antient times, you see nothing of the Italians. The nature of the city assists the delusion, for its vast & antique walls describe a circumferance of sixteen miles, and thus the population is thinly scattered over this space nearly as great as London.

Percy Bysshe Shelley, *Letter* (17 or 18 December 1818)

Nothing could be more venerable, since it is so old, than the temple of Romulus and Remus here. We are on the soil on which Rome began. The cella of the temple is round. It seems to have been repaired around the time of Constantine (310). In 527, Pope Felix IV built here a church which he dedicated to Sts Cosmas and Damian; he made the sanctuary of the temple of the founders of Rome the portico of his church. On the orders of Pope Urban VIII the floor was raised; a stair close by the high altar enables you to descend to the ancient temple.

Stendhal, *Voyages en Italie* (24 January 1828)

We now reach the circular edifice which has been so long known as the temple of Remus, and which, owing to recent excavations, must now be entered from the side street. The porphyry pillars at the original entrance, supporting a richly sculptured cornice, were probably set up thus when the temple was turned into a church. The bronze doors were brought from Perugia. If, as was long supposed, the temple on this site was that of the Penates, the protectors against all kinds of illness and misfortune, the modern dedication to the protecting physicians Cosmo and Damian may have had some reference to that which went before.

The Church of SS Cosmo e Damiano was founded within the ancient temple by Pope Felix IV in 527, and restored by Adrian I in 780; Sergius I built the ambones and ciborium above the confession in 695. In 1633 the whole building was modernized by Urban VIII, who, in order to raise it to the later level of the soil, cut the ancient church in half by the vaulting which now divides the upper and lower churches. To visit the lower church a monk must be summoned, who will bring a torch. This is well worth while. It is of great size, and contains a curious well into which Christian martyrs in the time of Nero are said to have been precipitated. The tomb of the martyrs Cosmo and Damian is beneath the altar, which is formed of beautiful transparent marble. Under a side altar is the grave of Felix IV. The third and lowest church (the original crypt), which is very small, is said to have been a place of refuge during the Christian persecutions...

Augustus Hare, *Walks in Rome* (1893)

THE Via Sacra was the most famous street in ancient Rome. Along its path victorious generals rode in triumphal procession to the temple of Jupiter Capitolinus. Throughout its length it was flanked by the most imposing of secular and religious edifices, and among the many religious buildings which graced its route from the Palatine to the Capitol was the Temple of Antoninus and Faustina.

This temple was erected in AD 141 by Antoninus Pius (138–61) in honor of his deceased wife Faustina. Following his own death in 161 the dedication was extended to the Emperor and the temple was subsequently referred to as the Aedes Divi Pii. The present representation shows the temple in a much ruined state, roofless and buried in rubble virtually as far as the doorway, yet with its external walls and great marble columns still standing. (The ground in front of the temple was cleared only in 1876.) Originally the temple stood on a high podium and was approached by a flight of 21 steps. We can gain some idea of how it then looked by examining contemporary coinage on which it is represented. It was decorated by sculptures and reliefs of which virtually all that remain are the griffons and candelabra carved on the marble cornice. The ten columns of the *pronaos* were of Carystian or Euboean (*cipollino*) marble, 56 feet in height. They were each topped by carved Corinthian capitals in white marble.

In the Middle Ages, possibly as early as the seventh or eighth century, and certainly by the eleventh century, the temple was transformed into a church, San Lorenzo in Miranda. In the fourteenth century Pope Urban V used some of its stone for the reconstruction of the Lateran. Martin V (1417–31) later ceded the church to a confraternity of apothecaries who modified its appearance, introducing a hospital for the young of their profession and establishing chapels and kiosks among the columns of the *pronaos*. Pope Paul III cleared the *pronaos*, freeing the columns, on the occasion of Charles V's triumphal return from Tunis (1536). In 1601–14 the *cella* was rebuilt by Orazio Torriani (active 1601–57), who was also responsible for the lower half of the façade, the upper portion being completed in the late seventeenth century. Inside the church are paintings by Pietro da Cortona and Domenichino.

In 1902 a very ancient necropolis was discovered at the eastern angle of the temple. This burial ground, generally

P. Bril. Campo Vaccino 4 26

referred to as the Sepulcretum, would originally have occupied a large part of the Forum. The cremated remains in hut-shaped urns must be dated to the regal period (*c*700–509 BC).

Close by, further east along the Sacred Way, was the Temple of Peace (Templum Pacis), erected in the period 71–75 by the Emperor Vespasian. Also misleadingly known as the Forum of Vespasian, it was constructed primarily to celebrate the capture of Jerusalem. The vast area of the temple, which was not so much a single edifice but rather an area which had been sanctified by ritual, contained a number of buildings devoted to different functions, including the *aedes* or the temple proper. It is generally considered that the structure that Pope Felix IV (526–30) chose as the site for a new church, dedicated to Sts Cosmas and Damian, was the library. The Pope commissioned mosaics to cover the arch and vault of the apse, which included an image of the Pope himself presenting a model of the church as an offering. Originally the church could be approached directly from the Forum by way of the Temple of Romulus, specially converted to make an atrium (see No. 31). In 1512 Cardinal Alessandro Farnese, later Paul III, ceded the church to the Third Order of St Francis, who possess it to this day. The Franciscans became concerned about its condition and by the fact that the faithful were abandoning it because of its unsalubrious location amid the festering ruins of the Forum, and it was decided in the early seventeenth century to restore the church. This work was undertaken by Pope Urban VIII, himself a Franciscan, who commissioned Orazio Torriani to supervise the project. Torriani's plans were, however, later replaced by new designs drawn up by Luigi Arigucci between 1622 and 1634 at the behest of Cardinal Francesco Barberini. Apart from the remodeling of the interior, including a fine gilt ceiling, the most substantial change was the raising of the floor level by 23 feet to alleviate the dampness caused by its low-lying position, creating in the process an underground crypt.

During the pontificate of Pius IV (1559–65) the architect Giovanni Dosio discovered, while excavating near the back wall of the church, fragments of the Forma Urbis, the great map of Rome incised on marble slabs. This plan of the ancient city, which probably served administrative purposes, was drawn during the reign of Septimius Severus (193–211) and originally measured 770 square feet. Towards the end of the nineteenth century more fragments were discovered and today about one tenth of the original plan is known to us. Though only a small portion, it constitutes the most important source of documentation for the topography of imperial Rome. At the moment these fragments are preserved in the Palazzo Braschi.

This view of the Sacred Way and Forum shows a mix of classical and medieval monuments. To the left are the remains of the roofless temple of Antoninus and Faustina, with the Torre dei Conti rising up in the background. This great fortified tower was constructed by Innocent III (1198–1216). To the right of the composition are the church of Santi Cosma e Damiano with its campanile and the remains of the Temple of Romulus as a vestibule. To the far right rise the impressive vaults of the Basilica of Maxentius (see No. 30).

The drawing carries an inscription with the name of Paul Brill. It is just one of a number of identical views of the same scene, both drawn and engraved, which are all obviously derived from the same model. Other drawings in the same style are in the Louvre, the Albertina in Vienna and in the Fondation Custodia in Paris. It would seem that the originals are the work of Matthijs Brill (1550–83), who arrived in Rome about 1575. He apparently exerted great influence on the work of his younger contemporaries who copied his drawings in large numbers, learning the practice of topographical draughtsmanship. Bodart considers this drawing to be the finest of the numerous copies after an original in the Louvre (Lugt 1949, no. 357, pl. xix). Another version is in the Rijksprentenkabinet in Amsterdam (where it is given to Willem van Nieulandt). The view was engraved by Nieulandt (Hollstein XIV, p.163, no. 3) who added some picturesque details. Another replica was formerly in the collection of Fairfax Murray. Wouter Kloek (oral communication) considers that the present sheet could be catalogued as circle of Paul Brill.

30 ANONYMOUS

FRENCH, first half of 18th century?

The Basilica of Maxentius and the Church of Santa Francesca Romana

Pen and brown ink with traces of black chalk on laid paper:
196 × 650 mm

Inscribed recto, top left, in brown ink: *4.* (within a rectangle); top
right, in gray ink: *n⁰ 126*; verso, top left, in brown ink: *Live 2*

The drawing is pieced vertically in three sheets (joined at 85 mm
from right edge and 122 mm from left)

CONDITION: good

BODART NO. 341

A little further on are three gigantic arches, being all that
remains of the magnificent Basilica of Constantine, which
was 320 feet in length and 235 feet in width. The existing
ruins are only those of one of the aisles of the basilica. There
are traces of an entrance towards the Coliseum. The roof
was supported by eight Corinthian columns, of which one,
remaining here till the time of Paul V, was removed by him
to the piazza of S. Maria Maggiore, where it still stands.
This site was previously occupied by the Temple of Peace,
burnt down in the time of Commodus. This temple was the
great museum of Rome under the empire, and contained the
seven-branch candlestick and other treasures brought back
from Jerusalem, as well as all the works of art which had
been collected in the palace of Nero and which were re-
moved hither by Vespasian. A statue of the Nile, with chil-
dren playing round it, is mentioned by Pliny as among the
sights in the Temple of Peace. The building of Constantine
is remarkable as the last which bears the impress of the
grandeur of ancient Roman genius.

Augustus Hare, *Walks in Rome* (1893)

O NE of the most impressive of all the great buildings
of imperial Rome must have been the basilica erected on the
eastern slopes of the Mons Velia beside the Via Sacra. Even
in its present much ruined state one can still grasp the
essentials of this spectacular structure, which must have
required considerable technical knowledge and resources to
accomplish. Begun by Maxentius (286–305), it was built
over an area which previously supported the Horrea
Piperataria, an extensive complex of shops, dating from
Flavian times, which specialized in spices and drugs. Fol-
lowing the death of Maxentius the building was continued
and completed by Constantine. The finished basilica, which
contained a number of substantial alterations to the original
plans drawn up for Maxentius, covered an area of
330 × 213 feet. Its basic layout closely resembled that of
the great central enclosures of the imperial bath houses,
which were themselves refered to as *basilicae*. Essentially, it
consisted of a massive nave (260 × 80 feet) made up of
three lofty cross-vaulted bays rising to a height of 115 feet,
contained by aisles consisting of three gigantic barrel-
vaulted *exedrae* on either side. The weight of the great cen-

tral vault was partly supported by eight splendid fluted columns of Proconnesian marble, each 48 feet high, of which only the one removed to Piazza di Santa Maria Maggiore in 1613 by Paul V has survived. Of the basilica itself, only sections of the great barrel-vaulted *exedrae* remain to testify to its magnificence. These coffered *exedrae* offered the inspiration for the architecture of St Peter's where the vaulting is of the same style and dimensions. In the courtyard of the Palazzo dei Conservatori on the Capitol is preserved the massive remains of the colossal acrolithic statue of Constantine, discovered in 1487, which stood in the apse of the basilica.

The church of Santa Francesca Romana, locked between the remains of the Basilica of Maxentius and the Temple of Venus and Rome, is partly built over the ruins of the latter. The earliest church on this site was dedicated to the Apostles Peter and Paul during the pontificate of Paul I (757–67). Some time later, another church was built here, which in 847 was ceded the rights of Santa Maria Antiqua which had been struck by a landslide that same year. In acknowledgement of this fact the church was given the title of Santa Maria Nova. Some time later a convent was attached to the church. It then passed through the possession of several religious orders before finally becoming, in 1352, the property of the Benedictine Olivetans in whose hands it has remained until today. Francesca de'Ponziani, founder of a congregation of oblates, used to frequent the church and on her death in 1440 was bured in its crypt. Following her canonization in 1608 the church was placed under her patronage. Almost immediately work began on the remodelling of the fabric of the building which quickly lost its medieval character. This baroque transformation was undertaken under the supervision of Carlo Lombardi (1554–1620), who completed the task by 1615. Of the original medieval structure all that is immediately recognizable is the twelfth-century campanile.

This interesting drawing shows the church of Santa Francesca to the right of the composition and the spreading ruins of the Basilica of Maxentius in the center, with its cluster of medieval houses to one side. It is not known who made this composition, though Bodart believes the author may have been French. The view must have been drawn after the completion of the façade of Santa Francesca in 1615.

31 LODOVICO LAMBERTI *or* LAMBERTINI

ITALIAN 1689–?

The 'Temple of Romulus'

Red chalk with gray wash on paper, laid down: 184 × 260 mm

Signed, verso, in ink: *Lo Lambertini*; inscribed on back of support, bottom right center, in pencil: *S. Cosma e Damiano / Chiesa in Campo Vaccino*; below this inscription, in brown ink: *N.o Lambertini*

CONDITION: some staining and discoloration. Small holes at bottom of sheet

BODART NO. 176

ALONG the ancient Via Sacra which runs through the Roman Forum, situated between the Temple of Antoninus and Faustina and the massive remains of the Basilica of Maxentius, is located the so-called Temple of Romulus, a small circular building dating to the fourth century AD. Essentially it is a domed rotunda built of brick, fronting on to a curved forecourt with containing walls pierced by four niches destined for the placement of sculpture. The entrance porch, flush with the flanking walls, has its entablature supported on two porphyry columns standing on pedestal-like plinths and surmounted by white marble capitals. The great bronze door is original, complete with working lock.

It is generally accepted that the building was erected some time after 307, in an area which is known to have been redeveloped by Maxentius after the fire of that year. A drawing by Panvinio, however, shows a Constantinian inscription on the façade which might indicate a slightly later date. When the rectangular building backing on to the rear of the rotunda was converted into the church of Santi Cosma e Damiano by Felix IV (see No. 29), the rotunda was adapted as a vestibule and linked to it by a passageway. In 1632, to preserve the link with the church, which had recently been extensively reworked, the beautiful entrance door with its flanking porphyry columns was raised. The door was returned to its original level in the nineteenth century.

Despite its marvelous state of preservation, the proper identification of this small building has been a source of great puzzlement to archaeologists down through the years. It was traditionally considered to have been constructed by the Emperor Maxentius in memory of his son M Valerius Romulus, who died in 309. Medieval literature refers to a 'Tempio di Romulo' in this area, which may, however, be a confused identification of the Basilica of Maxentius. A more recent examination of the evidence has given rise to the proposal that the rotunda may in fact have been the Temple of Jupiter Stator, a building previously identified with some ruins which stand close to the Arch of Titus. According to the Regionary Catalogue, which dates to the time of Constantine, there was a temple dedicated to Jupiter Stator in this very area on the right of the Via Sacra as one proceeds from the Colosseum towards the Capitol. The origins of this temple are reputed to go back to the time of Romulus, although the primitive open structure was replaced in 294 BC by a building commissioned by M Attilius Regulus, following his victory over the Samnites.

This view of the 'Temple of Romulus' is one of just four drawings, all in the Ashby collection, which can be identified as the work of Lodovico Lamberti. Of the other three pieces, two show views in northern Italy (nos. 173 and 174), whilst the third shows a farm close to a river (no. 175). One drawing (no. 173) carries the inscription: *fiume chiaon a Breganse, 16 settembre 1689*. On the verso of this sheet there is an additional inscription identifying the artist as: *Lo. Lamberti*. One of the other drawings (no. 175) also carries an inscription on the verso identifying the artist as *Lodovico Lamberti*. The name of Lodovico Lamberti is inscribed alongside that of Giovanni Carboncini in a design in the Museo Correr in Venice for a *peotta* (a ceremonial boat) commissioned to honor Ferdinand, Prince of Tuscany, during his visit to the carnival of 1668. It cannot be determined if there is any connection between this artist and the author of the Ashby drawings.

32 *Attributed to*
GIUSEPPE VASI

CORLEONE 1710–1782 ROME

View of the Palatine from the Forum, with the Church of Santa Maria Liberatrice and the Temple of Castor and Pollux

Pen and ink with colored wash and watercolor, and traces of black chalk, on paper, laid down: 245 × 420 mm

Inscribed on front of support, across bottom, in black ink: *Vestigia del Palazzo de Cesari volgarmente chiamata casa aurea, colla chiesa di santa Maria Liberatrice e le Tre Colonne del Tempio di Giove / Stator con una Parte di Campo vaccino*; on front of support, bottom right, in pencil: *1394*; also, in pencil: *12*; bottom right, just below drawing, faint remains of inscription, in pencil: – *Richard Wilson* (?); on reverse of support, center, in pencil (crossed out): *179*; lower right, in pencil (also crossed out): *179*

WATERMARK

CONDITION: repaired or strip added to bottom of sheet

BODART NO. 312

It was here, according to the old tradition, that Pope St Sylvester by the force of prayer entrapped a terrible dragon that was befouling the city with its stench; after which the saint built the present church, dedicated to the Madonna and called in consequence Santa Maria Liberatrice. It was also called San Silvestro *in lacu*, perhaps because the ancient Lake Curtius was near here, of which the name was still preserved. The church was then restored by several popes, and was a convent of Benedictine nuns until the pontificate of Julius III, who took it from them and gave it to the religious of Santa Francesca Romana. When these in turn moved to the Torre di Specchi, it became the responsibility of two chaplains. Cardinal Marcello Lante gave it its present form in 1617, using the architect Onorio Longhi. The images of the Madonna and of St Francesca were painted by Parocel. In the second chapel there are two paintings representing St Sylvester with the dragon. On the left of the church, beside the modern buildings used as granaries, can be seen two tall walls of terracotta, which are believed to be remains of the Curia Hostilia, in which the Senators discussed public affairs. Almost opposite the church of Santa Maria Liberatrice, can be seen the remains of:

The Temple of Jupiter Stator
The three most noble fluted columns, standing isolate in the Campo Vaccino, are the remains, according to the usual opinion, of the portico of the Temple of Jupiter Stator. Certain students consider them to belong to the Temple of Castor and Pollux; others to the Comitium; others again to the bridge with which Caligula joined the Capitol to the Palatine. Granted that it is in fact the Temple of Jupiter Stator, it is thought to have been raised for the first time by Romulus in fulfilment of a vow he had made in the battle that took place here against the Sabines; it was then rebuilt by Attilius Regulus in the foundation year of the city 459, after the Samnite War. Its portico consisted of 30 Corinthian columns, of the same kind as the three that remain, which are without doubt one of the most beautiful ancient ruins to be seen, and a lesson for architects in the proportion and decoration of the Corinthian order. They are $6\frac{1}{2}$ palms in diameter and 66 palms high, including base and capital. Though the entablature they bear is enormous and majestic, for all that it is carved minutely and with great diligence.

Mariano Vasi, *Itinerario istruttivo di Roma* (1814)

THE church of Santa Maria Liberatrice, in the Roman Forum, was constructed about the remains of an earlier basilica known as Santa Maria Antiqua. This earlier structure was itself constructed from the remains of an ancient ceremonial hall which by the sixth century had become the guardroom by the ramp that ascended to the palace where the Byzantine governor resided. As early as 642 this had become the church known under the title of Santa Maria Antiqua. Between 705 and 795 its interior was decorated with frescos at the request of Popes John VII, Zacharias and Paul I, who are each represented with the square halo traditionally used to designate persons still alive. These frescos have a strong Byzantine character and

bear witness to the influence of eastern culture on the Rome of the period.

During the reign of Leo IV (847–55) the church of Santa Maria Antiqua was buried in a landslide from the adjacent outcrop of the Palatine. Over its ruins, some time during the thirteenth century, a new church was erected. Known today as Santa Maria Liberatrice, it was also referred to in earlier times as Sancta Maria de Inferno and Sancta Maria Libera Nos a Poenis Inferni, titles which relate to the medieval legend concerning the locality. It was once believed that here in the Forum there was an entrance to Hell, and the Virgin's intercession was sought for protection against this evil. It would seem that this legend is a Christian variation of the story of Marcus Curtius who is reputed to have rode into an abyss in the Forum. It was near this place, under the temple of Vesta, that the dragon subdued by St Sylvester was supposed to have hidden.

The church of Santa Maria Liberatrice was rebuilt and restored many times during its history, first by Gregory XIII (1572–85), then by Sixtus V (1585–90) and finally by Cardinal Lante, who commissioned Onorio Longhi to remodel the fabric extensively in 1614. It underwent further restoration in the first half of the eighteenth century. In 1900 it was demolished to facilitate excavations on the original basilica and other remains from antiquity. The existence of the original Santa Maria Antiqua had been rediscovered in 1702.

The three columns, capped with Corinthian capitals, which stand to the right of the church, are all that remain of the temple dedicated to Castor and Pollux, also referred to as the Dioscuri, the mythical sons of Jupiter and Leda. According to Roman legend they appeared at the battle of Lake Regillus (499 BC) and led the Romans to victory over Tarquinius Superbus. The dictator Aulus Postumius vowed to erect a temple in their honor, which was duly built and dedicated in 484 BC by his son. The temple was restored and rebuilt on a number of occasions, most importantly in 117 BC and 73 BC. After the fire of 14 BC it was again reconstructed, this time by Tiberius and Drusus, and it is the remains of this structure which are represented in the present sketch and which can still be seen standing in the Forum.

Bodart attributes this composition to Giuseppe Vasi on the basis of its close similarity to an engraving of the same subject by the artist. Marco Chiarini (letter to the author, 1987) is not convinced by this coincidence and considers that the drawing may be later, possibly towards the end of the eighteenth century, and probably by a different hand.

33 ISRAEL SILVESTRE

NANCY 1621–1691 PARIS

The Capitol

Pen and ink with slight traces of red chalk with light gray wash on laid paper: 115 × 195 mm

Inscribed, verso, bottom right, in black chalk: *Sylvestre*; bottom left, in black chalk: *fr...*; traces of erased inscription, bottom left corner.

Composition squared in red chalk. Border of black ink

WATERMARK

CONDITION: good; some very light staining

BODART NO. 294

The Capitol, to which we climbed, by a very broad ascent or degrees, is built about a square Court, at the right hand of which, going up from Campo Vacino gusshes a plentifull streame from the statue of Tybur in Porphyrie, very antique, and another representing Rome; but above all is admirable the figure of Marforius, casting [water] into a most ample Concha. The front of this Court is crown'd with an incomparable fabrique, containing the Courts of Justice, and where the Criminal Notary sitts, and others: In one of the Halls, they shew the statue of Greg[ory] the 13th and Paule the 3d with several others; To this joynes an handsome Towre, the whole faciata adorn'd with noble statues both on the out side, & battlements, ascended by a double payre of staires and a stately posario. In the center of the Court stands that incomparable Horse bearing the Emp: Marcus Aurelius of Corinthian mettal, as big as the life, placed on a Pedistal of marble, with an inscription, and esteemed one of the noblest pieces of worke now extant in the world, antique, & very rare. There is also a vast head of a Colosean magnitude fixed in the Wall of white marble: At the stayres descending (on either hand) are set two horses of white marble, govern'd by two naked slaves, taken to be Castor & Pollux, brought from Pompey's Theatre: On the Balustrade, the Trophies of Marius against the Cimbrians, very antient & instructive: & at the foote of the stepps, towards the left hand, that Colomna Militaria, with the globe of brasse on it,

being the same we mention'd to have formerly ben set in Campo Vacino.

On the same hand is the Palace of the Signiori Conservatori, or 3 Consuls, now the Civil Governors of the Citty, containing the fraternities or Halls & Guilds (as we name them) of sundry Companys, and other Offices of State...

We now left the Capitol, certainly one of the most Renowned places in the World; even as now built by the designe of the famous M: Angelo. Returning home by Ara Coeli, we mounted to it by more than 100 marble stepps, not in devotion, as some I observ'd to do on their bare knees; but to see those two famous statues of Constantine in White marble plac'd there out of his Bathes: In this Church is a Madona reported to be painted by St. Luke...

John Evelyn, *Diary* (7 November 1644)

You will perhaps reproach me, Countess, for not having spoken of the Capitol, as the first object on which the traveller's attention should alight; but the few ancient beauties that remain there are completely swamped by the new ones, by façades, by vistas: in a word, this celebrated spot has been so cut down to size by all the modern beauties of Rome that it now has to be ranked as ordinary.

Marquis de Sade, *Voyage d'Italie* (1775–1776)

The Modern Capitol is still grand. You ascend by a great flight of steps to a large court. The palace of the Senator is at the end, that of the Conservators, the modern Consuls on one side, and the Museum on the other. The second is the work of Michael Angelo, and the last built on the same model. Their architecture is large & bold, the piers ornamented with Corinthian pilasters and the architrave supported by Ionick columns: the intervals are so great that it contracts a weak and meagre look.

1. The Equestrian statue of M Aurelius, found near the Lateran but supposed to have stood in the Area before the temple of Antoninus. The whole is great and spirited. Horse connoisseurs admire the animal: others criticise it. Should not we know something more of the manège of the Romans and of their breed of horses?

2. Four Basso relievos taken from the Arch of M Aurelius. The submission of the Captives to the Emperor which should be placed first. His reception by the Senate and

people. The people is represented by the figure of Rome. Surely Rubens was never reproached with a more improper mixture of history and allegory. The third is the triumph and the fourth the sacrifice in which the form of the Capitol is in some measure shadowed out. They are fine; wrought with great elegance and in general composed in a very pure taste.

3. A Groupe of a lion tearing a horse in bronze, very animated.

4. Some remains of a marble colossus of Domitian: the face feet &c. From a foot 7 foot long the height must have been fully fifty. It cannot have been the Equestrian Colossus of Domitian.

Edward Gibbon, *Journal* (1764)

THE Capitol, the smallest of Rome's seven hills, was, virtually from the founding of the state, the most important religious center within the city. Here Romulus is reputed to have offered asylum to those who fled from neighboring states, and to have erected the first small sanctuary. Romulus's primitive structure was eventually replaced during the sixth century BC by the Tarquin dynasty, who erected the temple dedicated to the Capitoline Triad, Jupiter, Juno and Minerva. Located to the right of where the Palazzo dei Conservatori now stands, it was inaugurated at the beginning of the Republican epoch in 509 BC. The temple was severely damaged on a number of occasions, for instance during the great fires which devastated the Capitol in 83 and 69 BC, and later in the conflagration of AD 80. Each time it was rebuilt in marble, the last reconstruction ocuring during the reign of Domitian (81–96). With the establishment of Christianity as the state religion the temple fell into disuse, and crumbled into ruin. Eventually the area where it stood became so overgrown and wild that it was called Monte Caprino (the hill of the goats), somewhat in the same way as the ruined Forum eventually came to be called the Campo Vaccino (the cow field).

On the opposite corner of the hill, across the other side of the small valley known as the Asylum (where Piazza del Campidoglio now stands), was the temple dedicated to Juno Moneta beside which stood the mint. On the corner of the hill which looks out over the Forum, and where the Palazzo del Senatore now stands, was the Tabularium, the city archive built by Q Lutatius Catulus after the fire of 83 BC. The ruins of this ancient building are incorporated into the present Palazzo del Senatore.

In the Middle Ages the Capitol became the seat of the municipal government of Rome. This municipal body, however, did not have much real authority, though through its choice of location it did pay homage to the grandeur which was Rome and no doubt wished for some of this past glory to reflect on it. In the sixteenth century the lip service to a great past gained more substance with the decision of Paul III to develop the site and to endow it with a monumental setting worthy of its history. The initial catalyst for this transformation was the triumphal entry into the city of Charles V, the secular head of the Holy Roman Empire, in 1536, following his military expedition to Tunis against the Muslim forces.

To effect the *renovatio* the Pope employed Michelangelo as his architect. One of the first decisions taken was to transfer in 1538 the classical equestrian statue of Marcus Aurelius from its previous resting place beside the Lateran to the center of the open space before the medieval Palazzo del Senatore. This fabulous relic of the imperial age was to become the focal point of the new development, and about it Michelangelo was to arrange the new square as a fitting backdrop. Michelangelo's name is first documented in connection with this scheme in 1539. His first task was to determine what he was to do with the existing medieval buildings, the Palazzo del Senatore, in the center, and the Palazzo dei Conservatori, which stands to the right side of the square. Rather than demolish them he chose instead to modify their design and integrate them into the new layout. He envisaged a replication on the left of the newly remodeled Palazzo dei Conservatori (on the right). By 1544 a new three-bay loggia was added to the flank of Santa Maria in Aracoeli, serving as a new entrance to the church directly from the square. It was complemented in 1553 with a similar arrangement linking the area adjacent to the Palazzo dei Conservatori. In the meantime a double stairway was added to the façade of the Palazzo del Senatore. These works were followed up in the early 1560s with the major tasks of rebuilding the façades of the Palazzo del Senatore and the Palazzo dei Conservatori, together with the erection of a balustrade across the west front of the

Piazza. Work on the Senatore was not completed until about 1600, while the Conservatori was already completed by 1584 under the supervision of Giacomo della Porta, who succeeded Michelangelo as architect after his death in 1564. The façade of the Palazzo dei Conservatori displayed a revolutionary design which employed the new giant order – gigantic pilasters rising the full height of the façade uniting both the ground and first stories in the one sweep. Della Porta also completed the laying of the *cordonata*, the access ramp to the square from Piazza d'Aracoeli. The final stage in the project, the construction of the Palazzo Nuovo to replicate the Palazzo dei Conservatori, was undertaken during the period 1603–54. The balustrade guarding the western front of the square contains a number of notable pieces of Roman sculpture, including the twin group of the *Dioscuri* (Castor and Pollux). Dating to the late imperial period, they were recovered in the late sixteenth century in the Theater of Pompey and placed here in 1583. Also incorporated into the balustrade in 1590 were the Trofei di Mario, carved trophies which had decorated one of the monumental water cisterns of the Aqua Julia in what is now Piazza Vittorio Emanuele (see No. 38).

Rising high to the left of the Piazza, behind the Palazzo Nuovo, is Santa Maria in Aracoeli, one of the most colorful of all Rome's great churches. Standing on the site of the ancient temple dedicated to Juno Moneta, its establishment dates back to a Byzantine foundation of the sixth century (*c574*), itself preceded by a Christian community of some age. Legend has it that the Emperor Augustus here consulted the Tiburtine Sibyl after he had been informed that the Senate wished to elevate him to the status of a god, a proposal of which he disapproved. In answer to his questioning the sibyl prophesied, 'There are signs that justice will be done, soon the earth will be bathed in a sweat and from the sun will descend the King of future centuries'. As she spoke a miraculous vision appeared in the sky with the Virgin clothed in light standing on an altar (*ara coeli*) with the infant Christ in her arms. In the ninth century the church was in the possession of the Benedictines and later, in 1250, it was given over to the Franciscans by Innocent IV. They carried out extensive restorations to the fabric of the building and constructed a convent nearby. The splendid brick façade, which dates to the thirteenth century, was to have been covered in mosaics, of which some traces can still be seen. The vertiginous ascent of 124 steps from the square below was constructed in 1348 with stones pillaged from the Temple of Serapis on the Quirinal (see No. 43). The monies for this project were donated by the faithful in thanksgiving for having been spared from the virulent plague which had decimated the population elsewhere. The nave of the interior is flanked by columns taken from the nearby Forum. In the Middle Ages the church served as a meeting place for civic dignitaries. It houses the most popular *presepio* (Christmas crib) in all Rome and every Christmas Santa Maria in Aracoeli becomes a focal point for the community, with the shepherds coming in from the nearby hills to pay their homage to the 'Santo Bambino'.

Israel Silvestre was an energetic topographical draughtsman who traveled widely and used the drawings he made on his journeys as the basis for many fine engravings. In 1935 thirty-five Italian views by the artist were exhibited at Colnaghi's, most of them showing the city of Rome and its environs. This view of the Capitol may be compared to two prints Silvestre made of the subject, one of which (Le Blanc 9) has similar dimensions to the drawing, while the other (Le Blanc 85) is somewhat larger.

34 *Attributed to*
BARTHOLOMEUS BREENBERGH

DEVENTER 1598–*c*1657 AMSTERDAM

The Baths of Caracalla

Pen and bistre wash with traces of black chalk, laid down:
265 × 410 mm

Inscription stamped on front of window mount, bottom center: *Baths of Caracalla, Rome*; also stamped on front of mount, lower right: *Bartholomeus Breenbergh*; bottom right corner, in pencil: *935*.

Border of black ink

WATERMARK

CONDITION: slightly discolored

BODART NO. 107

Among the public works which he left in Rome were the remarkable baths which bear his name; within these baths is the *cella soliaris* which architects declare it is impossible to duplicate in the same manner in which it was built [i.e. the great *frigidarium* in the centre of the bath complex]. For latticework grates made of bronze or copper are said to have been raised as supporting arches, and the entire vault rested on these; yet its size is so great that men who have expert knowledge in the field of mechanics deny that it could have been built in this way.

Historia Augusta: Antoninus Caracalla (4th century AD?) (translated by J J Pollitt)

This poem was chiefly written upon the mountainous ruins of the Baths of Caracalla, among the flowery glades and thickets of odoriferous blossoming trees, which are extended in ever-winding labyrinths upon its immense platforms and dizzy arches suspended in the air.

Percy Bysshe Shelley, preface to *Prometheus Unbound* (1820)

The ruins of the Baths of Caracalla are something so enormous that one would have thought that they were barracks for a whole species. There are immense halls for the Gladiator's fights, but when I found that I could not be

in my bath and look on at the murders all in one, which would have been the beauty of luxury, or the 'luxury of beauty', I thought the whole concern contemptible.

Florence Nightingale, *Letter* (December 1847)

THE great *thermae* or bath houses of ancient Rome have their origins in the small communal baths of the classical Greeks and their Campanian successors. The Romans had been building bathing halls in their own houses and villas since the middle of the third century BC, but it was not until the second century BC that the idea of public baths gained acceptance. By the time of Agrippa, in 33 BC, the number of bath houses had already risen to 170. The Regionary Catalogue of 354 listed 952. At the height of their popularity the great public baths of Imperial Rome constituted vast leisure complexes which could be interpreted as temples of physical and intellectual culture, with their gigantic shells housing not simply places to bathe in, but also exercise compartments, libraries and lavish displays of the decorative arts. Entrance to these magnificent facilities was open to all, usually for just a small charge. For a time both men and women were permitted to use the amenities simultaneously, a practice which not surprisingly gave rise to mounting anxiety concerning public morals, provoking Hadrian, some time during the period 117–38, to pass a decree forbidding mixed bathing. The baths usually operated from around noon, or a little earlier, till sunset.

The classic 'imperial' style of public bath can be traced back to the *thermae* which Titus built in great haste and dedicated in AD 80 in time to celebrate the opening of the Colosseum. It is possible, though, that the layout had already been determined with the construction of the Baths of Nero some 20 years earlier. This model design is based on the duplication of the compositional units about a central axis, which has at its core a basilical hall.

The Baths of Caracalla, or more correctly the Thermae Antoninianae, were constructed by Caracalla between 212 and 216. Among the most impressive of all Roman buildings of the imperial age, their ruins cover an area of almost 50 acres. Built according to the classic formulae established some one hundred years earlier, the baths contained all the facilities which made bathing the major pastime of the ancient Romans. The most prominent among its amenities

Vestigy d'una parte di dentro delle Terme d'Antonino caracala qual fu adornata di grandissime et belle colonne di granito orientale con le sue membri intagliati con bella diligentia et li muri furono incrustati di diuerse pietre di mischi et marmori come hoggidi se ne uede ancho uestigij et non molti anni sono fu donata da Papa Pio IIII. una di detti colonne al gran Duca, quale fu da lui mandata in Fiorenza, Il luoco d'oue erano dette colonne si uede a questo segno. A

21

Etienne Dupérac: *The Baths of Caracalla*

were the *apodyteria* or changing rooms, the *frigidarium* or cold bath, the *tepidarium* where one could take a lukewarm bath, the *calidarium* which may be interpreted as a hot bath, the *laconicum* where the patrons would sit and sweat, and the *natatio* or swimming pool. The *palaestrae*, where exercise was taken, were located in the extreme east and west wings along the central axis. Water was supplied by the Aqua Antoniniana Jovia, a branch of the Aqua Marcia.

The baths continued in use until 537, when the invading Goths, under the command of Witiges, damaged the aqueducts and cut off the water supply. It was among the ruins of these baths that some of the most important pieces of Roman sculpture unearthed in the sixteenth century were found, notably the Farnese *Hercules*, *Bull* and *Flora*, which are now in the Museo Nazionale in Naples. More recent excavations in 1911—12 uncovered the remains of a *mithraeum* in the north-east corner of the complex. Nowadays the great *calidarium* (110 feet in diameter) is used to stage opera performances during the summer months.

35 FERDINAND BECKER

BATH, late 18th century – 1825 BATH

Ruins of the Baths of Caracalla

Pen and gray ink wash: 243 × 352 mm

Inscribed, verso, lower center, in Ashby's hand (?), in pencil: *Remains of the Baths of Caracalla, Rome*; right center, in Ashby's hand (?), in pencil: *67*

WATERMARK

CONDITION: some diagonal streaking across upper half of composition

BODART NO. 38

Bathing was certainly necessary to health and cleanliness in a hot country like Italy, especially before the use of linen was known: But the purpose would have been much better answered by plunging into the Tyber, than by using the warm bath in the *thermae*, which became altogether a point of luxury borrowed from the effeminate Asiatics, and tended to debilitate the fibres already too much relaxed by the heat of the climate. True it is, they had baths of cool water for the summer: but in general they used it milk-warm, and often perfumed: they likewise indulged in vapour-baths, in order to enjoy a pleasing relaxation, which they likewise improved with odoriferous ointments. The thermae consisted of a great variety of parts and conveniences; the *natationes*, or swimming places; the *portici*, where people amused themselves in walking, conversing, and disputing together, as Cicero says, 'In porticibus deambulantes disputabant'; the *basilicae*, where the bathers assembled before they entered, and after they came out of the bath; the *atria*, or ample courts, adorned with noble colonnades of Numidian marble and oriental granite; the *ephibia*, where the young men inured themselves to wrestling and other exercises; the *frigidaria*, or places kept cool by a constant draught of air, promoted by the disposition and number of windows; the *calidaria*, where the water was warmed for the baths; the *platanones*, or delightful groves of sycamore; the *stadia*, for the performances of the *athletae*; the *exedrae*, or the resting-places, provided with seats for those that were weary; the *palestrae*, where every one chose that exercise which pleased him best; the *gymnasia*, where poets, orators, and philosophers recited their works, and harangued for diversion; the *eleotesia*, where the fragrant oils and ointments were kept for the use of the bathers; and the *conisteria*, where the wrestlers were smeared with sand before they engaged. Of the *thermae* in Rome, some were mercenary, and some opened *gratis*. Marcus Agrippa, when he was edile, opened one hundred and seventy baths, for the use of the people. In the public baths, where money was taken, each person paid a *quadrans*, about the value of our halfpenny, as Juvenal observes,

Caedere Sylvano porcum, quadrante lavari
The victim pig to god Sylvanus slay,
 and for the public bath a farthing pay.

Tobias Smollett, *Travels through France and Italy* (1766)

36 *Attributed to*

CRESCENZIO ONOFRIO

ROME 1632–*c*1713 FLORENCE

Santi Giovanni e Paolo

The verso of the sheet shows a view from the Coelian Hill towards the Palatine, described in pen and brown ink with wash

Pen and brown ink with wash on light gray laid paper: 330 × 449 mm

Inscribed, verso, top left corner, in pencil: *569* (inscribed within a circle); bottom center and right, partially illegible, in pencil: *30 . . . 1895*

Both compositions, recto and verso, display borders of light brown ink set in slightly from the edge of the sheet.

CONDITION: quite heavily stained, especially in the sky

BODART NO. 230

Church of Santi Giovanni e Paolo

This was built in the fourth century by the monk St Pammachius, above the house of the brothers Sts John and Paul, who were decapitated by Julian the Apostate. Several of its titular cardinals have restored it, and particularly Cardinal Fabrizio Paolucci, who rebuilt it almost completely to the designs of Antonio Canevari. Nicholas V gave it to the Gesuati, and then, when that order was suppressed, it was given to the Spanish Dominicans, and then to Mission priests, and it is now occupied by the Passionists, by order of Clement XIV. The church is embellished with a fine portico of eight columns of granite; it has a nave and aisles, divided by 28 columns of divers marbles. Its floor is also of marble, including a considerable quantity of porphyry. On the right in the nave is the stone on which the brothers were decapitated, and their bodies repose beneath the high altar in a porphyry urn.

Mariano Vasi, *Itinerario instruttivo di Roma* (1814)

In the Clivo di Scauro, in the garden next to the monastery of St Gregory, where his family house was, there is an underground bath, in which various pictures composed of little figures can be seen, showing games in *cymbae* or little boats in which the people play instruments, or with hooded *putti* doing various things, and in the middle of the arch are two portraits in a roundel, the subjects of which are dressed in pink.

Giovanni Pietro Bellori, *Nota delli Musei, Librerie, Galerie . . . di Roma* (1664)

Beneath the Church of St Giovanni and St Paolo, there are the jaws of a terrific range of caverns, hewn out of the rock, and said to have another outlet underneath the Coliseum — tremendous darkness of vast extent, half-buried in the earth and unexplorable, where the dull torches, flashed by the attendants, glimmer down long ranges of distant vaults branching to the right and left, like streets in a city of the dead; and show the cold damp stealing down the walls, drip-drop, drip-drop, to join the pools of water that lie here and there, and never saw, or never will see, one ray of the sun. Some accounts make these the prisons of the wild beasts destined for the amphitheatre; some the prisons of

the condemned gladiators; some, both. But the legend most appalling to the fancy is, that in the upper range (for there are two stories of these caves) the early Christians destined to be eaten at the Coliseum shows, heard the wild beasts, hungry for them, roaring down below; until, upon the night and solitude of their captivity, there burst the sudden noon and life of the vast theatre crowded to the parapet, and of these, their dreaded neighbours, bounding in!

Charles Dickens, *Pictures from Italy* (1846)

Even if you are on your way to the Lateran you won't grudge the twenty minutes it will take you, on leaving the Colosseum, to turn away under the Arch of Constantine, whose noble battered bas-reliefs, with the chain of tragic statues – fettered, dropping barbarians – round its summit, I assume you have profoundly admired, toward the piazzetta of the church of San Giovanni e Paolo, on the slope of the Caelian. No spot in Rome can show a cluster of more charming accidents. The ancient brick apse of the church peeps down into the trees of the little wooded walk before the neighbouring church of San Gregorio, intensely venerable beneath its excessive modernisation; and a series of heavy brick buttresses, flying across to an opposite wall, overarches the short, steep, paved passage which leads into the small square. This is flanked on one side by the long mediaeval portico of the church of the two saints, sustained by eight time-blackened columns of granite and marble. On another rise the great scarce-windowed walls of a Passionist convent, and on the third the portals of a grand villa, whose tall porter, with his cockade and silver-topped staff, standing sublime behind his grating, seems a kind of mundane St Peter, I suppose, to the beggars who sit at the church door or lie in the sun along the farther slope which leads to the gate of the convent. The place always seems to me the perfection of an out-of-the-way corner – a place you would think twice before telling people about, lest you should find them there the next time you were to go. It is such a group of objects, singly and in their happy combination, as one must come to Rome to find at one's house door; but what makes it peculiarly a picture is the beautiful dark red campanile of the church, which stands embedded in the mass of the convent. It begins, as so many things in Rome begin, with a stout foundation of antique travertine,

and rises high, in delicately quaint mediaeval brickwork – little tiers and apertures sustained on miniature columns and adorned with small cracked slabs of green and yellow marble, inserted almost at random. When there are three or four brown-breasted *contadini* sleeping in the sun before the convent doors, and a departing monk leading his shadow down over them, I think you will not find anything in Rome more sketchable.

Henry James, *Italian Hours* (1909)

THE church of Sts John and Paul on the western slope of the Caelian is one of the oldest places of Christian worship in Rome. Flanking the ancient roadway known as the Clivus Scauri, it is built over the remains of five Roman houses, one of which was the home of the two saints. According to the author of the *Golden Legend*, the two young men, who had been officials at the court of Constantine and were in the service of his daughter Constantia, were secretly martyred by Julian the Apostate (361–63), who then had their bodies walled up within their own house.

The location soon became a place of congregation for the Christian community. Between the years 398 and 410 the situation was regularized, and the heretofore domestic structure became the site of a new basilica founded by Bizante, a senator, and his son Pammachius, also a senator, along with Paulinus of Nola, who contributed further funds to the undertaking. Pammachius, a wealthy citizen of some importance, who took his religious obligations seriously, was a correspondent of St Jerome after the latter left Rome in 385. The new church received the appellation of *titulus Bizantis*, since at this time it was normal practice to name religious venues after their owners. At the time of the last persecutions there were 25 such *tituli* in Rome, including the *titulus Clementis* (San Clemente) and *titulus Anastasiae* (Sant'Anastasia).

The venerable basilica suffered many vicissitudes down through its history. Already in 410 it sustained major damage during the invasion of the Visigoths led by Alaric. In 442 it was damaged by an earthquake, a relatively frequent occurrence in Rome. Towards the end of the eighth

century Pope Adrian I (772–95) paid for repairs to the roof. In the year 1084 it again was severely damaged when the city was sacked by the Normans under Robert Guiscard. A major rebuilding campaign was undertaken by Cardinal Teobaldo during the pontificate of Paschal II (1099–1118), which included the rebuilding of the adjacent convent and the commissioning of the campanile, completed by Cardinal Giovanni da Sutri c1150. It was at this time also that the original narthex was replaced by the existing colonnaded portico. Further restoration was carried out during the fifteenth and sixteenth centuries, including a new roof in 1598. The basilica apparently retained its Early Christian appearance despite these interventions. In the late seventeenth century and early eighteenth centuries, however, two successive programs of 'restoration' swept clear most of the surviving medieval material from the interior. Particularly culpable in this respect was the work done for Cardinal Fabricio Paolucci by Antonio Canevari (1681–c1751) during the period 1715–18. All was not lost, fortunately, and towards the end of the last century the subterranean section was explored, revealing Early Christian remains, including some frescos which date as far back as the fourth century.

The present view shows the rear of the church from below the hill, with the alley to its right, the Clivus Scauri, obscured by the oratories attached to the nearby church of San Gregorio Magno. The diaphragm arches across the Clivus Scauri and the buttresses fanning off from the apse can be clearly seen. A feature of the apse is the lovely medieval gallery of 15 small arches. Unusually, the apse contained four windows, long ago closed up, which lit the interior. Roman churches did not normally have windows in this position, and a darker, more suggestive atmosphere was preferred for prayer. Just visible above the crown of the roof is the tip of the campanile, the foundations of which are made of blocks from the Temple of Claudius which stood close by. The campanile was restored, along with much of the convent (seen to the left), during the period 1948–52, with funding supplied by Cardinal Spellman. This program

of restoration also revealed a beautiful arcade above the medieval colonnaded portico, dating back to the original building erected by Pammachius.

The Clivus Scauri which runs along the side of the church, separating it from San Gregorio Magno and its three oratories, was an ancient street. The dark, narrow alley is one of the few to have survived intact from classical times and is fairly typical of Roman streets. It has been suggested that it dates to about the year 100 BC and may derive its name from Marcus Aemilius Scaurus, consul in 115 BC and censor in 109 BC. The arches spanning the way are probably of ancient origin though they may have been rebuilt during the Middle Ages. Up until the fifteenth century they were surmounted by a second sequence spanning the alley.

This drawing is one of eleven in the Ashby collection bearing attributions to Crescenzio Onofrio (nos. 220–230). The strong graphic quality of the sheet is a characteristic of most of this artist's output, as are the mannequin-type figures — Onofrio had other artists add the figures to his paintings. It should be noted, however, that the manner of representing the foliage of the shrubs and trees is not typical of the artist, who usually depicts leaves with a continuous outline. This characteristic was commented upon by Nicholas Turner (oral communication), who expressed reservations about the attribution, preferring to consider the drawing a product of the Bolognese school, somewhere in the ambit of Francesco Grimaldi (1606–80). Bodart compares the composition to a view of S Lorenzo fuori le Mura exhibited in Rome in 1971 (*Vedute Romane* no. 82, illus.) as anonymous, early eighteenth-century. He also remarks on similarities between this work and the oeuvre of Abraham Genoels. Though Onofrio's authorship of the present sheet is very much in doubt, it should be stated that other drawings in the collection attributed to his hand are very much closer in style to his known work, and almost certainly by the artist.

37 ANONYMOUS

DUTCH(?), second half of 16th century

St John Lateran

A fragmentary composition on the verso shows three prostrate warriors, with one other standing. This is executed in pen and brown ink with wash and traces of black chalk

Pen and brown ink with brown wash on laid paper: 209 × 279 mm

Inscribed, front of mount, below window, in pencil: *Lorenzo fuori delle Mure/S. Giovanni Laterano old apse . . . Brill*; below bottom left corner of window, in pencil: *14*; bottom right corner, in pencil: *134*; back of mount, upper right center, in pencil: *Northwick coll . . . Spencer Churchill sale/Sotheby*; lower right, in pencil: *Oppe 837./S.C./44/10/—*; lower center, in pencil: *S. Maria in Trastevere? . . . Not S. Lorenzo fuori/S. Giovanni Laterano*

WATERMARK

CONDITION: some staining

BODART NO. 331

The Church, or basilica, of San Giovanni Laterano, is the principal, and I believe the oldest, in Rome. It is said to have been founded by Constantine the Great. The number and variety of the epithets bestowed upon it, attest its holiness and antiquity; and in fact the *orbis mater et caput*, the *basilica aurea*, well images the power, wealth, and genius of the system to which it belonged. Submitting to the touch of time, it was falling to ruin; but it was indeed too considerable an image of the Pontifical influence not to claim the attention of the Popes. The Cattedrale de Sommo Pontefice, as the Romans call it, has in consequence been re-edified, adorned, and enriched by every pontiff, from St Sylvester (who consecrated it) downward. It now wears a character of antique splendour, of barbarous magnificence, and Gothic gloom, infinitely more imposing to the imagination, than all the light and lustre of St Peter's. The sumptuous, but dismal chapels look as if they were decked with the plunder, and raised by the taste, of new-converted Huns. The canons were performing service when we first visited it; but their voices died away in faint echoes through its vastness, which was wholly unoccupied, even by a single votarist. This is the fate of all the greater churches of Rome: a few parish churches in the heart of the modern city, and the church of the Jesuits, are alone frequented by the inhabitants.

Lady Sydney Morgan, *Italy* (1824)

THE basilica of San Giovanni in Laterano, or St John Lateran, the mother of all churches, was founded possibly as early as 312 by the Emperor Constantine, who donated the site to Pope Melchiades. The land on which it was built had been the property of the Plauti Laterani, a wealthy patrician family whose possessions were confiscated by Nero for their part in the Pisonian conspiracy. This area also housed the barracks for the Equites Singulares, the emperor's personal bodyguard. The basilica was originally dedicated to the Savior and was known as the Basilica Sancti Salvatoris. When first built it consisted of a great nave running east-west, flanked by two aisles on either side, with massive columns supporting the roof. Its dimensions, 250 × 180 feet, were not in any way exceptional, though it was large enough to accommodate a congregation of

several thousand. There was no transept as such in the original structure, which was characterized by a simple outer façade contrasting with a sumptuous interior.

The Constantinian basilica has had an eventful history — wrecked by barbarians, ravaged by earthquakes, struck by lightning and fire — all of which incidents have provoked numerous restorations and alterations to its original design. Pope Leo I commissioned the redecoration of the apse in 455–61 after the depredations of the Vandals. Adrian I had further work carried out during the period 772–95. Following the collapse of the roof of the nave in the earthquake of 896, Pope Sergius III commissioned its reconstruction and rededicated the church to St John the Baptist. In 1291 Pope Nicholas IV commissioned the construction of the transepts and the apse. The basilica was severely damaged by a fire in 1308 and again in 1361, provoking the poet Petrarch to lament its roofless condition. The ensuing repairs and embellishments continued into the fifteenth century. In 1562 Pius IV contracted work on the façade of the transept, adding an attic story between the towers. Some 20 years later Sixtus V commissioned further work on the north transept, the façade of which was designed by his favorite architect Domenico Fontana. In 1646 the architect Borromini was instructed to remodel the interior of the basilica in preparation for the Holy Year of 1650. His alterations obliterated most of the Paleochristian and medieval character of the church and gave it the appearance which we see today. In the early eighteenth century Pope Clement XII held a competition for the design of the main façade, which was constructed by Alessandro Galilei in 1733–35. The east façade was erected 1876–86.

The exterior of the medieval apse, constructed under Nicholas IV in 1281–85, presented the viewer with a six-sided surface, though internally its surface was smooth and semicircular. In the present drawing it stands against the wall of the transept which as yet has no windows, a feature added during the pontificate of Clement VIII (1592–1605). Nor does it show evidence of the work carried out after 1586 by Domenico Fontana on the façade just below the tower to the left. A fresco in the Vatican Library showing a view of this area from a different angle was done at about the same time as this anonymous drawing, which must be dated to some time shortly before 1586. The apse was demolished in 1886.

According to Bodart Thomas Ashby incorrectly noted this composition as a view of San Lorenzo fuori le Mura. In his catalogue of the collection he remarks that the author of the piece was probably a Netherlandish artist of the late sixteenth century. Wouter Kloek (oral communication) has observed that the composition shares certain characteristics with works executed by the followers of Maerten van Heemskerck (1498–1574). An Zwollo (oral communication) considers the style of the drawing to be reminiscent of the work of Anton van den Wyngaerde (known 1510–1572), an itinerant topographical artist who is known to have made views of English, Italian, Spanish and Netherlandish scenes. Considering the state of the Basilica and its surrounds, it would seem reasonable to date the view to some time around 1580.

Bodart notes that the design on the verso is unlikely to be from the same hand as the present view. He relates that figure sketch to one of the compositions executed by Taddeo Zuccaro for his frescos in the church of Santa Maria della Consolazione.

38 FERDINAND BECKER

BATH, late 18th century – 1825 BATH

The 'Trophies of Marius'

Pen and gray ink wash: 234 × 339 mm

Inscribed, recto, across bottom, in ink: ... *distance the Church of Sta Croce./the View...*; verso, lower left center, in Ashby's hand (?), in pencil: *Near S^{ta} Maria Maggiore;/in the distance the Church of S^{ta} Croce./Rome*; upper right center, in Ashby's hand, in pencil: *34*

WATERMARK

CONDITION: some slight staining top center and right, and bottom center and left

BODART NO. 41

But to return to the matter of the Trophies, there is no need to resort to authorities since on one side they show very well what they were: for on a block of marble you can see a breastplate and a young man with his hands tied behind his back, and on the other side shields, swords and other weapons feature – clear evidence that these are trophies. However, I do not say without hesitation that they are Marius's, because Plutarch has these on the Capitol; and besides it can very well be seen that this structure was a water tank, taking water from the aqueduct of the Aqua Marcia, because of the three openings (which you may see in the figure; also in the plan, which shows their operation), which were made in these tanks to distribute the water for the use of the city, as was explained above. And because there is none in Rome better preserved than this one, I have taken the trouble to show its appearance not only in a drawing but also in a plan. The reader should not wonder that I do not show it whole, because my intention is to represent things only as they appear today, and not as they must have been formerly.

Bernardo Gamucci da San Gimignano, *Libri Quattro dell'Antichità della città di Roma* (1565)

Although many students have supposed that this monument was part of the Aqua Marcia, nevertheless Piranesi has observed that it can only belong to the Aqua Julia. According to very recent discoveries, it has been recog-nised not to be a water tank but rather a magnificent foun-tain serving this part of the city. Its water, as we saw, was brought to Rome by Marcus Agrippa, who made use of the aqueduct of the Aqua Marcia. The structure is now known as the Trophies of Marius, taking its name from the two marble trophies which were once in two niches of the foun-tain, but which now are to be seen on the parapet of the Campidoglio. Although it is generally supposed that these trophies were raised to Marius after his double victory over the Cimbri and the Teutoni, nevertheless attentive examin-ation reveals that they belong to a later epoch, and both the style and execution of the reliefs and the construction of the building suggest a date close to the time of Septimius Severus, who is well known to have restored Rome's aqueducts and other buildings. The fountain was situated originally at the fork of the Via Labicana and the Praenest-ina, which left the city as described above...

Antonio Nibby, *Itinerario di Roma* (1830)

IN the north corner of Piazza Vittorio Emmanuele on the Esquiline are the remains of the only Roman fountain to have survived from classical times, the so-called 'Trofei di Mario'. This name, which it received during the Renaissance, refers not to the fountain as such, but rather to the two marble reliefs dating to the age of Domitian which were removed thence in 1590 to decorate the balustrades of the Capitol, where they have remained to this day. The trophies were not in fact part of the original construction but were brought there from another location. They are believed to have been carved to celebrate the victory of Marius over the Cimbri at Vercelli in 101 BC. The original name of the fountain, which can be dated to the time of Alexander Severus (AD 222–35), was the Nymphaeum Alexandri. It is represented on some coins minted during his reign which are datable to 226. The trapezoidal shape of the monument is due to its location at the junction of two ancient roads, the Via Labicana and the Via Tiburtina. The fountain, which also doubled as a water-tower, was fed by the Aqua Julia. There is evidence to show that its brickwork was originally faced in marble and that the niches held pieces of sculpture.

In the background of Becker's drawing, to the right, can be seen the outlines of the church of Santa Croce in

Etienne Dupérac: *The 'Trophies of Marius'*

Gerusalemme and the arcades of the Aqua Claudia. The Church of Santa Croce in Gerusalemme has a distinguished history dating back to the time of Constantine, when sections of its fabric formed part of the Palatium Sessorianum, which was then the property of St Helena, the Emperor's mother. The original title of the church, Basilica Sessoriana, made reference to this pedigree, the great hall of the imperial palace having been converted into a basilica some time between 312 and 361. The church, which is reputed to contain relics of the true Cross brought back from the Holy Land by St Helena, was one of the seven pilgrim churches of Rome. It was substantially renovated by Pope Lucius II in 1144, who added the tall Romanesque campanile which survives to this day and is shown in Becker's view. Pope Benedict XIV commissioned a more comprehensive restoration and between 1741–44 the building received a thorough remodeling. The earlier structure was clad in a delightful Rococo façade but received a more Baroque interior, the work of Melchiore Passalacqua with the probable collaboration of Domenico Gregorini (*c*1690–1777).

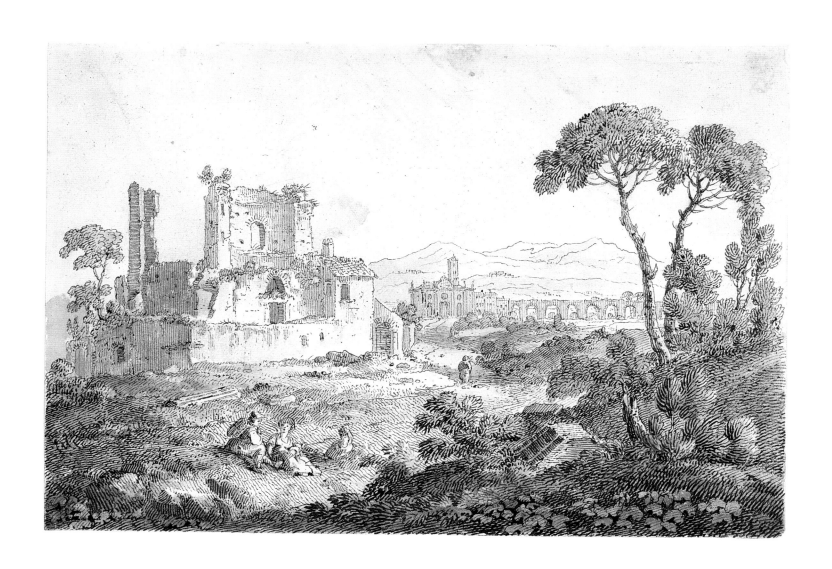

39 JACOB·FRANCKAERT the ELDER

ANTWERP c1550–1601 ROME

The 'Temple of Minerva Medica'

Pen and ink on laid paper: 237 × 378 mm

Signed, recto, bottom right, in ink: *Van franckaert*; inscribed, verso, bottom right, in pencil: 47

WATERMARK

CONDITION: good

BODART NO. 135

Well, I will tell you something, if you will love me: You have seen prints of the ruins of the temple of Minerva Medica; you shall only hear its situation, and then figure what a villa might be laid out there. 'Tis in the middle of a garden: at a little distance are two subterranean grottos, which were the burial-places of the liberti of Augustus. There are all the niches and covers of the urns with the inscriptions remaining; and in one, very considerable remains of an ancient stucco ceiling with paintings in grottesque...

Thomas Gray, *Letter* (16 April 1740)

THE 'Temple of Minerva Medica' on via Giolitti, close to Piazza Vittorio Emmanuele, is so called because it was supposedly here that the statue called the Giustiniani *Minerva*, now in the Vatican, was found (it was in fact found in the gardens of the convent of Santa Maria sopra Minerva by the Pantheon). The skeletal ruins of this imposing ancient rotunda stand in an area known as the Horti Liciniani, once the property of the Emperor Gallienus (253–68). However brick stamps found in the ruins indicate that its construction must date to the early fourth century. The design of the structure, of which the central unit measured 82 feet, consists of nine semicircular apses linked together to support a cupola ingeniously constructed of lightweight materials around a framework of brick ribs. Considered the most elaborate of late Roman rotundas, it is not known what particular purpose it served. The suggestion that it served as a *nymphaeum* is no longer accepted. It is more likely to have been a hall for banquets or ceremonial receptions. We know that in ancient times it was decorated with porphyry and mosaics. Its niches contained pieces of sculpture, some of which were discovered during the pontificate of Julius III (1550–55) and recorded by Pirro Ligorio. More recently, between 1875 and 1878, other important pieces were excavated from the ruins, including two statues representing Roman magistrates in the act of throwing the *mappa* to signal the start of the races in the Circus. Sixteenth-century drawings show the pavilion still more or less intact; by the early nineteenth century, however, the vault was near collapse. Attempts to prop it up unfortunately proved unsuccessful and in 1828 large sections of it came crashing down. The following year it suffered further damage when struck by lightning.

This attractive view represents the so-called temple with, in the left background, the remains of the Aqua Julia, constructed in 33 BC by Marcus Vipsanius Agrippa, the lifelong friend and supporter of Augustus. It is one of the small number of drawings which can confidently be attributed to Jacob Franckaert. Another drawing of the same scene, but from a somewhat different angle, is in the Rijksprentenkabinet in Amsterdam (inv. no. 64: 60; Boon 1978, no. 173). Also in pen and brown ink and measuring 176 × 265 mm, that sheet displays the same precise technical approach. So does another view of Rome by the artist, in the Louvre (inv. no. 19,885; Lugt 1968, no. 165), which represents a view of the Forum seen from a corner of the Palatine. A view of Monte Caprino (the Capitol) in the Kunstbibliothek in West Berlin (inv. no. 9668) is also attributed to Franckaert.

Van franckaert

40 LOUIS-GABRIEL BLANCHET

PARIS 1705–1772 ROME

The 'Temple of Minerva Medica'

Deux crayons on laid paper: 256 × 408 mm

Signed and dated, recto, bottom center, in brown ink: *Ls. Gel. Blanchet 1752* (the date may read: *1751*); indecipherable inscription, verso, top left, in pencil; mid left, in pencil (inscribed vertically): *Louis Gabriel Blanchet*

WATERMARK

CONDITION: fold mark down center of sheet

PROVENANCE: Thomas Hudson (Lugt 2432, recto, bottom center)

BODART NO. 103

Because this region bore the name 'Galluzze', certain writers of the sixteenth century were led to believe that these were the ruins of the Basilica of Caius and Lucius erected by Augustus; others for the same flimsiest of reasons imagined that it was the Temple of Hercules Callaicus, built by Brutus; others finally, after the discovery of the beautiful statue of Minerva with a serpent at her feet (which is now in the Braccio Nuovo of the Vatican Museum), believed it to be the Minerva Medica mentioned by the Regionaries, and thought it was a temple. But the form of the building is against this; it would be better to say that it resembled a hall, and it is impossible to believe that its date is far remote from that of Diocletian. It was perhaps a hall erected in the Licinian Gardens, which indubitably extended here. It cannot be allowed that the serpent at Minerva's feet has anything to do with medicine, since this reptile is the animal sacred to Minerva par excellence, as the eagle is to Jove and the gryphon to Apollo, etc, and especially to her in her capacity as tutelary deity of a city: in fact the Minerva Poliades and the Minerva of the Parthenon at Athens were represented by Phidias with a snake at their feet, and nobody will claim that these effigies of the goddess had anything to do with medicine...

This brick building is a decagon inside; from one corner to another the distance is 33 palms, making its circumference 330 palms. There were ten windows, and nine niches in which were statues, the tenth being the entrance. Not only the statues mentioned above, found here at various different times, viz. an *Aesculapius*, a *Pomona*, an *Adonis*, a *Venus*, a *Faunus*, a *Hercules*, an *Antinous*, but also other marbles found prove the magnificence of this building, that offers so many views suitable for painting. Its state of imminent ruin had moved the government to order the restoration of the vault, and preparations were already under way when, in 1828, the vault unexpectedly came down, flattening the wooden scaffolding that had been erected to hold it up.

Antonio Nibby, *Itinerario di Roma* (1830)

THIS representation of the 'Temple of Minerva Medica' is typical of the technique employed by Blanchet in so many of his Roman views. The signature is identical to that inscribed on the drawing of a *Woman seated by an altar* (dated 1753) in the Louvre. Other views of Rome by the artist are in the collection of Sir Brinsley Ford. Some more were offered for sale from the collection of the late Sir John and Lady Witt at Sotheby's (19 February 1987, lots 335–337). Another was sold at Sotheby's on 10 December 1968 (lot 190). The exhibition, *France in the Eighteenth Century*, held at the Royal Academy in 1968, contained three views by Blanchet (nos. 23–25).

L.^s Gel. Blanchet 1757

41 RICHARD WILSON

PENEGOES 1713?–1782 COLOMMENDY

Santa Maria Maggiore

Black chalk with stubbing and white highlights on gray-blue paper: 276 × 414 mm

Inscribed, recto, bottom left corner, in ink: *50 × (?)*; bottom center, in the hand of William Esdaile, in ink: *Wilson*; verso, top right, in ink: *St Mary Major*; bottom left corner, in ink: *1833 WE 50 Dr Munro's sale*; bottom center, in ink: *Wilson*; on front of mount, concealed beneath drawing, in Ashby's hand, in pencil: *R Wilson/Dr Munro, Esdaile &/Poynter coll^{ns}/Walker 3:3:0/oppe rg 808*; front of mount, top right, in ink: *Wilson*

Border of black chalk

WATERMARK

CONDITION: some bad staining, especially center and lower right

PROVENANCE: Dr Munro; William Esdaile 1758–1837 (Lugt 2617, recto, bottom right corner); Poynter; Walker

BODART NO. 322

On pase day is the stacion at seynt mari maior where seint gregori sang on the same day on whech a gret myracle fel there for whech myracle this stacion was sette there for evyr on this day. Thus sede we in seint gregori lif that on pase day he sang messe at this same cherch and all the puple devoutly herd his messe. So happed it at the last ende of masse whan he said *Pax domini sit semp[er] uobiscum* whilis the qweer was in silens an aungell with a lowd voys answerd and said *Et cum spiritu tuo*. No wondir thou[gh] this man were devoute in his writyng whan oure Lord had so grete tendirnesse ouyr him that he wold send aungell to do him servyse. For we rede eke that a nothir tyme an aungell ministered at his masse as is treded more largely in that capitle of seint sebastian.

John Capgrave, *Ye Solace of Pilgrims* (c1450)

This holy basilica was in ancient times the Temple of Juno, it was then built by Pope St Liberius after the famous miracle that took place on 5th August, when snow fell on the site where the church now is. The miracle is described in the readings given on the fifth day of the said month, when Our Lady of the Snow is commemorated. There are 40 columns of eastern granite to support the arches, and underneath the Altar of the Most Holy Crucifix there is an urn of porphyry containing the remains of Giovanni Patrizio of Rome, who was the owner of the land where the church was founded, and under the High Altar there is the body of the Apostle St Matthew. In one of the two ciboria is the cradle in which Our Lord lay, which is displayed on Christmas Day.

Pietro Rossini, *Il Mercurio Errante* (1693)

It was the first time I had seen Sta Maria [Maggiore], with its gay and merry front crowning the laughing Esquiline, the most cheerful of all the churches — and inside, its long perspective of columns, with the beautiful sober harmony of its colouring. There is such a brilliancy about the outside that it makes amends for the bad taste.

Florence Nightingale, *Letter* (27 December 1847)

If St John Lateran disappoints you internally, you have an easy compensation in pacing the long lane which connects

Wilson

it with Santa Maria Maggiore and entering the singularly perfect nave of that most delightful of churches. The first day of my stay in Rome under the old dispensation I spent in wandering at random through the city, with accident for my *valet-de-place*. It served me to perfection and introduced me to the best things; among others to an immediate happy relation with Santa Maria Maggiore. First impressions, memorable impressions, are generally irrecoverable; they often leave one the wiser, but they rarely return in the same form. I remember, of my coming uninformed and unprepared into the place of worship and of curiosity that I have named, only that I sat for half an hour on the edge of the base of one of the marble columns of the beautiful nave and enjoyed a perfect revel of — what shall I call it? — taste, intelligence, fancy, perceptive emotion? The place proved so endlessly suggestive that perception became a throbbing confusion of images, and I departed with a sense of knowing a good deal that is not set down in Murray ... The obvious charm of the church is the elegant grandeur of the nave — its perfect shapeliness and its rich simplicity, its long double row of white marble columns and its high flat roof, embossed with intricate gildings and mouldings. It opens into a choir of an extraordinary splendour of effect, which I recommend you to look out for of a fine afternoon. At such a time the glowing western light, entering the high windows of the tribune, kindles the scattered masses of colour into sombre brightness, scintillates on the great solemn mosaic of the vault, touches the porphyry columns of the superb baldachino with ruby lights, and buries its shining shafts in the deep-toned shadows that hang about frescoes and sculptures and mouldings. The deeper charm even than in such things, however, is the social or historic note or tone or atmosphere of the church — I fumble, you see, for my right expression; the sense it gives you, in common with most of the Roman churches, and more than any of them, of having been prayed in for several centuries by an endlessly curious and complex society.

Henry James, *Italian Hours* (1909)

THE beautiful basilica of Santa Maria Maggiore is one of the seven pilgrimage churches of Rome, the others being San Giovanni in Laterano (St John Lateran), St Peter's, San Paolo fuori le Mura, San Lorenzo fuori le Mura, Santa Croce in Gerusalemme and San Sebastiano. An old tradition, which can be traced back to Bartolomeo da Trento in the early thirteenth century, relates this venerable church to a foundation of Pope Liberius (352–66), built according to legend on the spot of a miraculous fall of snow on the night of 4–5 August 352. The legend recounts how this extraordinary event had been foretold in a dream to a wealthy and childless patrician named John and to Pope Liberius. Each had been instructed in his dream that a church was to be erected on the snow-covered spot. On visiting the summit of the Esquiline the following morning and finding that snow had indeed fallen, the Pope marked out in the fresh snow the outline of the new church, which was then constructed with funds donated by the pious John.

The best preserved of the four great patriarchal basilicas, Santa Maria Maggiore was in fact constructed during the pontificate of Sixtus III (432–40), most probably to celebrate the outcome of the Council of Ephesus in the year 431. This council upheld the divinity of Christ and proclaimed the Virgin Mary as *Theotokos* or Mother of God, repudiating the teaching of Nestorius that Christ assumed his divinity only at the moment of His baptism in the River Jordan. It may well be that Sixtus chose this particular spot for his basilica dedicated to the Virgin Mary not because of any miraculous event, but to counter the continuing popularity among the local female population of the nearby pagan sanctuary devoted to the mother-goddess Juno Lucina, which had been constructed in AD 373.

From examination of the fabric of the basilica it would seem that the entire building was erected during the lifetime of Sixtus III, though its great size might seem to deny this. The materials used, for the most part pillaged from older sites, and the manner of their application — old abused bricks bonded with mortar of almost identical thickness to the bricks themselves — indicate an early fifth century dating. The fabulous mosaics, illustrating 36 episodes from the Old Testament, arranged high up on the walls of the nave, also date to this time, though it may well be that they were not originally sited in their present location (their small size alone would seem to suggest this). On the triumphal arch above the high altar are a set of splendid mosaics of the same period celebrating the early life of Christ and emphasizing his divine nature in rebuttal of Nestorius's teachings. The apse behind the main altar was constructed dur-

ing restorations carried out by Nicholas IV (1288–92) and his successors and is more or less contemporary with that constructed at St John Lateran (see No. 37), which was demolished in 1886. The large monumental mosaics decorating the apse were completed in 1295 by Jacopo Torriti. Halfway down the nave, to the left, is the Sforza Chapel, begun in 1564 and completed in 1573. According to Vasari this chapel was erected according to designs supplied by Michelangelo. It exhibits the unusual feature of internal membering in travertine, a material almost exclusively used for the exterior of buildings. Further along the nave, to the left, is the Pauline Chapel, commissioned by the Borghese Pope, Paul V (1605–21), to match the earlier Sistine Chapel on the opposite side of the nave, erected by Domenico Fontana for Sixtus V (1585–90). The magnificent coffered ceiling above the nave, gilded with some of the first gold to have come from the New World, is reputed to be the work of Giuliano da Sangallo.

In the eighteenth century Pope Benedict XIV commissioned Ferdinando Fuga to erect a portico to the church and to carry out other restorations. Virtually all of the exterior of the building we see today is the work of Fuga in 1741–43, though the exterior of the apse was given its present appearance by Carlo Rainaldi during the papacy of Clement X (1670–76). One of the most remarkable aspects of Fuga's sensitive restoration of the interior is the manner in which he managed to retain its distinguished classical appearance. Indeed, it could almost be said that he improved its classical qualities, as he managed subtly to impart to its various components the correct proportions laid down by Vitruvius in his celebrated treatise on architecture.

The obelisk erected behind the apse of the basilica comes from the Mausoleum of Augustus. Brought to Rome some 80 years after the emperor's death in AD 14, it stood until at least the fourth century next to his tomb on the banks of the Tiber. Rediscovered in the fifteenth century, it was excavated in 1519 and left lying along via Ripetta. In 1587 Sixtus V instructed Domenico Fontana to remove it to its present location where it was erected with the same gear and tackle used to raise the obelisk from Caligula and Nero's Circus in front of St Peter's (see No. 2).

According to Farington (*Diary*, III, p.94), Wilson's decision to embark on a career as a landscapist was prompted by the 'warm approval' he received from Claude-Joseph Vernet. It was another French artist, however, who apparently influenced his choice of medium for his landscape sketches. During his second year in Rome Wilson started to draw with black chalk and stump on gray or buff paper and it is quite possible that he learned this technique from Louis-Gabriel Blanchet (*cf* No. 40). This view of Santa Maria Maggiore is related to a series of about 68 views of Rome mentioned by Wilson in a letter to Thomas Jenkins on 1 June 1754 (Ford 1948, pp.337–345). All of approximately the same dimensions, they were drawn for William Legge, the Earl of Dartmouth (1731–1801); all are signed on the mount or not at all and can be dated to 1754–55. They apparently repeat motifs which Wilson would have earlier executed on the spot and later used as the basis for an exercise in Claudean composition. David Solkin (1982, p.168) remarks that it is probably to drawings such as this that Farington referred when he said of Wilson's drawings that they had 'all the quality of his pictures except the color'.

42 *Attributed to*
M VAN OVERBEEK

ACTIVE 1650–*c*1680

The Baths of Diocletian

Pen and ink with bistre and gray wash with slight traces of black chalk on laid paper: 261 × 401 mm

Inscribed, recto, lower left, in brown ink: *Ruines des bains de diocletien;* verso, bottom left, in pencil: *1314*; inside of mount, just below right corner of drawing, in pencil: *1314/Mt 3.8.21/Patch on old Mt./(not Maretti's)/Mariette colln Mt cut away*

Border of dark brown ink

WATERMARK

CONDITION: good

PROVENANCE: Pierre-Jean Mariette, 1694–1774 (Lugt 1852, recto, bottom right corner)

BODART NO. 232

I live over a bathing establishment. Picture to yourself now the assortment of voices, the sound of which is enough to sicken one. When the stronger fellows are exercising and swinging heavy leaden weights in their hands, when they are working hard or pretending to be working hard, I hear their groans; and whenever they release their pent-up breath, I hear their hissing and jarring breathing. When I have to do with a lazy fellow who is content with a cheap rubdown, I hear the slap of the hand pummeling his shoulders, changing its sound according as the hand is laid flat or curved. If now a professional ball player comes along and begins to keep score, I am done for. Add to this the arrest of a brawler or a thief, and the fellow who always likes to hear his own voice in the bath, and those who jump into the pool with a mighty splash as they strike the water. In addition to those whose voices are, if nothing else, natural, imagine the hair plucker keeping up a constant chatter in his thin and strident voice, to attract more attention, and never silent except when he is plucking armpits and making the customer yell instead of yelling himself.

Seneca, *Moral Epistles* (1st century AD) (translated by N Lewis and M Reinhold)

The 12th, I walked up to Dioclesian's Bathes, whose ruines testifie the vastnesse of its original foundation and magnificence, as well as what M: Angelo tooke from the ornaments about it (by which 'tis sayd he restored the then almost lost art of Architecture) the excelency of the structure. This monstrous Pile was built by the Sweate of the Primitive Christians then under one of the 10 famous Persecutions.

Made out of one of these ruineous Cupolas onely, of imcomparable worke, is the Church cal'd st Bernardo: which is built in the just forme of an Urne with a Cover. Opposite to this is the Fontana delle Therme, otherwise cal'd Fons Felix, which has a *basso-relievo* in it of white-marble, representing Moses striking the rock which is adorn'd with Camels, Men, Women, children drinking, as big as life . . .

From this we bent towards Dioclesian's Bathes, againe, never satisfied with contemplating that moles, in which after an hundred & fifty [thousand] Christians were destined to burthens, building 14 years; he murthered them all; so as there had neede be a Monastery of Carthusians in memory of the cruelty: It is called Santa Maria degli Angeli, the Architecture M: Angelo's, & the Cloister incompassing walls in the ample garden . . .

John Evelyn, *Diary* (12 November 1644)

Opposite the station are the vast, but for the most part uninteresting remains of the Baths of Diocletian, covering a space of 440,000 square yards. They were begun by Diocletian and Maximian, about AD 302, and finished by Constantius and Maximus. It is stated by Cardinal Baronius, that 40,000 Christians were employed in the work; some bricks marked with crosses have been found in the ruins. At the angles of the principal front were two circular halls, both of which remain; one is near the Villa Strozzi, at the back of the Negroni garden, and is now used as a granary; the other is transformed into the church of S. Bernardo . . .

About 1520, a Sicilian priest called Antonio del Duca came to Rome, bringing with him from Palermo pictures of the seven archangels (Michael, Gabriel, Raphael, Uriel, Santhiel, Gendiel, and Borachiel), copied from some which existed in the church of S. Angiolo. Carried away by the desire of instituting archangel-worship at Rome, he ob-

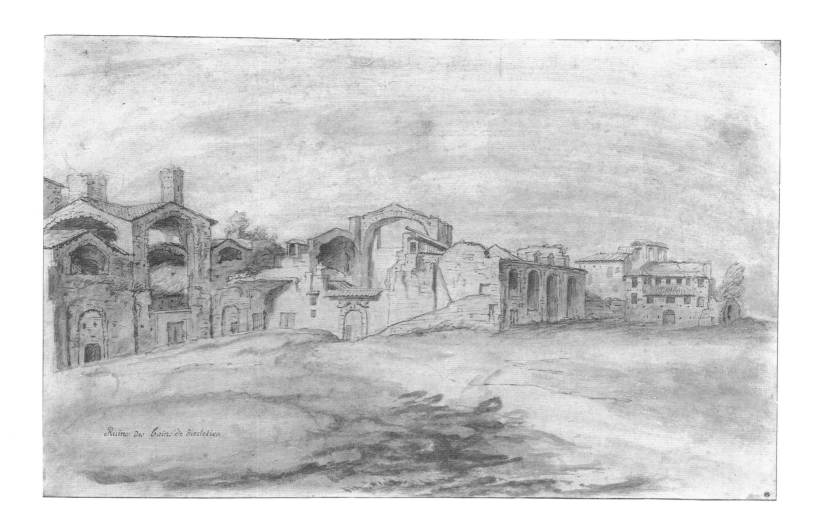

Ruines des bains de Diocletien

tained leave to affix these pictures to seven columns still standing erect in the Baths of Diocletian, which, ten years after, Julius III allowed to be consecrated under the title of S. Maria degli Angeli; though Pius IV, declaring that angel worship had never been sanctioned by the church, except under the three names mentioned in Scripture, ordered the pictures of Del Duca to be taken away. At the same time he engaged Michael Angelo to convert the great oblong hall of the Baths (Calidarium) into a church.

Augustus Hare, *Walks in Rome* (1893)

THE largest of Rome's great public baths, the Thermae Diocletiani were constructed between the years 298 and 306, under the supervision of Maxentius, joint Emperor with Diocletian, then resident in Nicodemia in Asia Minor. Altogether covering an area of 32 acres, these palatial public amenities could accommodate up to 3000 patrons at any one time, twice the number which those built by Caracalla were capable of handling. Like that great complex, the Baths of Diocletian were arranged according to the canon established by the earlier constructions of Nero, Titus and Trajan. Like its predecessors, the massive bulk of the building had two contrasting faces, a great exterior expanse of simple brick and a richly variegated and sumptuously decorated interior, with its bathhouse facilities and exercise halls generously complemented by libraries, concert halls, gardens adorned with fountains for relaxing and conversing, and exhibition pavilions for the appreciation of paintings and sculpture. Water was supplied by the Aqua Marcia. The baths must have suffered damage when Alaric sacked Rome in 410, though we know they were still in use at the time of Theodoric (died 526). It was only when the Ostrogoths, under Witiges, vandalized the aqueducts in 537, interrupting the water supply, that the baths were finally abandoned. The name of Rome's central railway station, Stazione Termini, is a reference, in corrupted form, to these great baths or *thermae*. The old name of Piazza della Repubblica, Piazza dell'Esedra, refers to the great portico, or *exedra*, which graced the south flank of the complex.

In 1091, Pope Urban II handed over the ruins of the Baths to St Bruno and his colleague Gavin to be turned into a monastery. In the sixteenth century Cardinal du Bellay, the French ambassador and friend of Rabelais, purchased a great part of the ruins as a site for his famous *vigna* or gardens (1535). On his death they passed into the possession of Carlo Borromeo, who in turn sold them to his uncle Pius IV. It was he who decided, at the instigation of a Sicilian named Antonio del Duca, a cleric passionately devoted to the veneration of angels, to convert the vast *tepidarium* into a church to be dedicated to Santa Maria degli Angeli. Pius IV chose the aged Michelangelo as the architect, who masterfully achieved the remodeling with the minimum of construction. Later, in 1749, Luigi Vanvitelli carried out an extensive rebuilding of the church, altering the main axis and converting the earlier nave into the new transept, adding eight new pillars to the existing eight granite columns which date from the erection of the Baths. The entrance to the church from Piazza della Repubblica is fronted by the inner walls of the original *caldarium*. The nearby church of San Bernardo (*c*1600) is also constructed from these ancient and venerable ruins, utilizing the original south-east corner tower of the perimeter wall which surrounded the baths. The Museo delle Terme, founded in 1889, housing one of the most important collections of classical art, is located to the right of Santa Maria degli Angeli, and occupies its place among the ruins converted by Michelangelo for the monks of the monastery attached to the church.

Bodart's attribution of this drawing to M van Overbeek is not convincing. He compares it to a number of drawings by the artist in the Louvre as well as in the Art Institute in Chicago (inv. no. 22. 5453) and elsewhere. The rather scratchy hatching evident in the shaded areas of this composition is not a feature of Overbeek's work. His assertion, also, that the inscription is similar to that found on drawings, attributed to this artist is not sustainable. See, for example, his sketch *Copper mills near Kingston, Surrey* in the British Museum (Stainton and White 1987, no. 121). That said, it is difficult to identify who is responsible for this composition and the author's identity remains a mystery.

The sheet bears the mark of the celebrated collector Jean-Pierre Mariette. Bodart has indicated that there is no record of the composition in any of the inventories of Mariette's extensive collection.

43 Attributed to
FEDERICO ZUCCARO

SANT'ANGELO IN VADO *c*1540–1609 ANCONA

The 'Frontispizio di Nerone'

Red chalk on laid paper, laid down: 126 × 185 mm

Inscribed on front of support, bottom left, in black ink: *Ruines du temple du Soleil dans le Jardin Colonna*; right corner, in ink; *Van Vitelli*; on back of mount, across top, in gray black ink: *Architrave Colossale provenant du temple du Soleil, construit/par Aurelien sur le Quirinal – Jardins Colonna*; indecipherable inscription, left center, in brown ink; bottom right, in brown ink: *Gasparo Van Witelli*; stamp of Léon Millet, bottom right; brief outline of head in brown ink on back of support, upper left center. Extensive inscription in brown ink(?) concealed beneath lining

Border of dark brown ink

CONDITION: good

PROVENANCE: Léon Millet, Paris

BODART NO. 328

This church ... was first built by Gregory in honour of St Agatha ... and perhaps he used for it remains of the antique buildings mentioned above, including part of the decoration of the very fine temple which is preserved in great part at the top of the hill I mentioned, and which, many say, the Emperor Aurelian dedicated to the sun. Remains of this temple may be seen in the place where the ruined tower is, that is commonly called the Torre Mesa, perhaps because it is in ruins; this tower, many have thought, was the Tower of Maecenas, which, I pointed out when I was describing the buildings of the Esquiline, was on that hill; and the reason why they see fit to say that this is the Tower of Maecenas is that they think that the Monte Cavallo and the Esquiline are one and the same hill, and have not trusted those writers who say that the frontispiece was once that of the Temple of the Sun. There have been many to spread the rumour, which is baseless, and to give out the notion that this frontispiece, which I am about to describe, belonged to the Golden House of Nero, and for that reason it is called the 'frontispiece of Nero'; and they have been able easily to induce others to share their opinion, because the remains of this work, which are of the greatest beauty, resemble those already described of the Golden House; and they are confirmed all the more in their opinion, by the sight all around it of magnificent walls and stairs, which originally led up from the spot now called the Elm of the Holy Apostle; and which pass behind the palace of the Most Illustrious Signor Marcantonio Colonna, a most noble gentleman, and worthy of his Roman origins ...

The Frontispiece of Nero's House

The stairs just mentioned, rising above the level of the windows, are indicated in our figure by the letter A, and by their sweep their size can be recognised. Whether this frontispiece belonged to the Temple of the Sun or the House of Nero, I do not now have to discuss; it is enough that from the few remains left it can be conjectured that the whole work must have been a rare thing in its perfection, for its magnificent order and its brilliant workmanship, as can be seen; and the building extended over as far as the *Horsemen* of Phidias and Praxiteles discussed above. But if I have to declare my own opinion, regardless of what the opinion of others may be, then I say that I do not believe that this ruin was the frontispiece of a temple, but rather that it belonged to a loggia, or courtyard, judging by the pier that remains, of the Corinthian order, which in its form corresponds to the columns which were near the Church of the Holy Apostle mentioned above; from which it may be deduced, that it served rather as the decoration of a loggia than as the frontispiece of a temple.

Bernardo Gamucci da San Gimignano, *Libri Quattro dell'Antichità della città di Roma* (1565)

THE ruins traditionally referred to as the Frontispizio di Nerone, and once believed to have been the spot from which Nero watched the burning of the city in 64, are now known to have formed part of the Temple of Serapis erected by Caracalla on the western corner of the Quirinal. This temple was among the largest structures built in imperial Rome and according to experts must have measured 770 × 320 feet in area. The great columns which graced its façade, twelve in number, had each a diameter of almost seven feet and were nearly 70 feet in height. One architectural fragment which has survived has been calculated to

weigh over one hundred US tons. A feature of the great building was the retaining wall erected at the western end of the complex, to which one ascended by the ramps of a monumental double stairway from the level of the Campo Marzio some 70 feet below. This type of building, set on a high hill and approached by a great sequence of stairs, recalls the Serapis of Alexandria, from which it probably derived, in part, its inspiration. Some of the motifs used in the decoration of the temple also recall eastern prototypes.

The remaining ruins of this great edifice are to be found in the gardens of the Palazzo Colonna and the nearby Università Gregoriana. According to ancient sources Justinian used a number of columns from the temple for the erection of Hagia Sophia in Constantinople. Part of the grandiose staircase survived to 1348, when it was removed by Lorenzo di Simone Andreozzo to be used for the staircase at Aracoeli (see No. 33). In the sixteenth century the plunder of the monument continued with renewed rapaciousness, sections of it being sold off by the Colonna to various bidders, mostly papal, for use in the construction of new buildings or the improvement of others. Portions of it went toward the building of the Palazzo Farnese, the Villa Giulia and Santa Maria Maggiore. The Colonna's own earlier appendage erected within the ruins and known as the Torre Mesa was itself demolished shortly after 1616 when it is last recorded in a drawing by Aloisio Giovannoli (c1550–1618). The tower was reputed to have earned its popular title after it had been half ('mezzo') knocked down in an attack by the Caetani, though it was also suggested that its name derived from Maecenas, the great patron of the arts during the reign of Augustus, who was once thought to have resided here. Another medieval legend relates that Virgil had an unfortunate amorous adventure beneath its walls. It is this ancient tower which in Federico's drawing abuts the surviving elements of the original Roman structure.

In the background can be seen the profile of the dome of Santissimo Nome di Maria adjacent to Trajan's Forum.

Bodart attributes this sheet to Federico Zuccaro who, though not a landscape artist by profession, did make landscape sketches from time to time. The drawing, according to Bodart, may most usefully be compared to four views of Rome at the University of Würzburg (Röttgen 1968, pp.298–302). Other landscape sketches by the artist are in the Louvre, the National Gallery of Scotland and the Nationalmuseum in Stockholm. Bodart cautions that the attribution is not definite and remarks that points of comparison may also be seen between this sheet and a landscape drawing at Windsor by Giovanni Antonio Canini (Blunt and Lester Cooke 1960, no. 99, illus.). Nicholas Turner (oral communication) has also expressed doubts about an attribution to Federico Zuccaro, stating that it is not stylistically close enough to the artist's known landscape sketches, not to mention the fact that the drawing itself seems somewhat tame and repetitive, and may possibly even be a copy, rather than an original. The same observation has been made by Philip Pouncey (letter to the author, 1987).

44 ETIENNE DUPERAC

PARIS 1525?–1604 PARIS

A View of Rome taken from the Roof of the Palazzo della Cancelleria

Pen and bistre ink, with faint traces of black chalk, on paper: 256 × 458 mm

Inscribed, recto, on two small strips of paper glued to sheet, top center, in brown ink: *Faict a Roma/au mois d'aout//le 9ᵉ Jour /1567;* inscribed, verso, bottom left, in brown ink: *E Perac* (?) (possibly *Peyrac*); lower left center, in indelible pencil (blue), diagonally, upside down: *Peyrac;* bottom left corner, in pencil: *656;* also: *WC;* top left, in pencil: *Sotheby sale (of) 10.XII 1920/lot 4(1)3 £3:6:0*

CONDITION: prominent fold mark down the center, staining, edges damaged

PROVENANCE: Benno Geiger, Vienna

BODART NO. 131

BY climbing the campanile of San Lorenzo in Damaso and surveying the view before him, Thomas Ashby (1924, pp.429–459) determined that the present panorama, executed in 1567, was drawn from the roof of the Palazzo della Cancelleria. An important document for our knowledge of sixteenth-century Rome, it corroborates information supplied by other northern artists active in Rome in the latter half of the century, including Anton van den Wyngaerde, who made a view looking back over the city from the garden of the Palazzo Colonna.

There are other views of Rome by Dupérac in the Louvre. A drawing of Tivoli, dated May 1568, which was sold along with the present sheet at Sotheby's (7–10 December 1920, lot 413) is now in the British Museum.

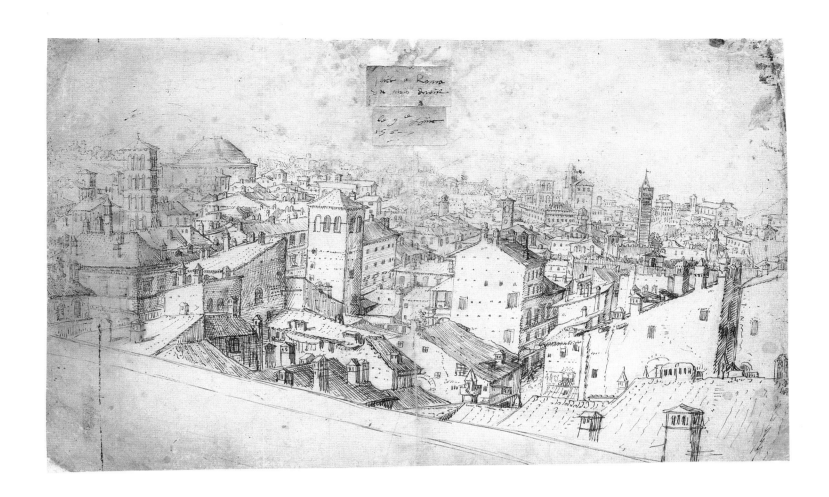

45 ELIZABETH SUSAN PERCY

ENGLISH c1778–1847

Trinità dei Monti

Graphite with gray and pale blue wash and some brown ink:
245 × 173 mm

Inscribed, verso, lower left center, in black ink: *on mount / San Trinita del Monte / from Marguntta's (?) Hotel / 21 March / (1803)*

CONDITION: tear mark on left side, just above center

BODART NO. 234

The stair of the Trinità dei Monti, recently constructed on the hill, with an old legacy of a French royal accountant . . . is a rotten piece of work: part of it fell down last winter during a downpour . . .

Baron Montesquieu, *Voyage en Italie* (1728–29)

One Richard O'Mooney, an Irishman, was found this morning dead, at the bottom of the Wall that supports the Terras of the Trinità de'Monti — his legs and Arms broken & scull fractured — supposed to have fallen from the top in the night. NB he was at the Coffeehouse the Even'g before.

Thomas Patch, *Memoirs* (11 July 1777)

A proposal had been made to erect an obelisk in front of the Church of Trinità dei Monti, which was unpopular with the people because the piazza was too small, and to raise it to the proper height, the little obelisk would have to be set on a very high pedestal. This had given someone the idea of wearing a cap shaped like a huge white pedestal with a tiny red obelisk on top. The pedestal bore an inscription written in large letters, but probably only a few people could guess what it meant.

Johann Wolfgang von Goethe, *Italian Journey* (1786–1788) (translated by W H Auden and E Mayer)

So I went home to bed, but as I came to the end of the long dark street which led to my earthly bed, I saw the Obelisk of the Trinità, high above the city raising its tall head to heaven, and though the clouds had gathered and almost overshadowed it out of my sight, I could still see its spectral form, as it had stood for thousands of years in different parts of the earth, and shall for thousands more, its secret undiscovered, its mystery unveiled, but still pointing to the infinite, as if it would say, There will all things be known — and I thought, Man has created thee indeed after his own image, O Obelisk, as thou art, so is he.

Florence Nightingale, *Letter* (17 February 1848)

THE present composition shows Santa Trinità dei Monti from a somewhat unusual angle from via di Sebastianello, a sidestreet just off Piazza di Spagna towards Piazza del Popolo. The view represents the tiny Sebastianello in the lower half, with the church and convent of Santa Trinità dei Monti in the upper half, together with the obelisk which stands before the church.

The great niche known as the Sebastianello is in the end wall of the eponymous street, where it forks to lead to Trinità dei Monti on the right and the Villa Medici to the left. In the middle of the sixteenth century there was a small church set into the sustaining wall of the Pincio at this point. Its presence is recorded in the maps produced by Pinard (1553) and Cartaro and Tempesta (1593). In Falda's map of 1676, however, the location is designated 'Il Nicchione'. The great niche which we see today, and which was drawn by Lady Elizabeth Percy, was erected in 1733 following the collapse of the sustaining wall in 1728. It was designed by Filippo Raguzzini (c1680–1771) whose talent for creating theatrical streetscapes is best illustrated by his design for Piazza di Sant'Ignazio (1727–28). The niche originally exhibited a painting of St Sebastian. Today it is decorated by an Early Christian sarcophagus which dates to the fourth century.

The church and convent of Santa Trinità dei Monti, which dominate the upper portion of the drawing, reputedly owe their foundation to the prediction made by St Francis of Paola, founder of the order of Minim Friars, when passing through the city on his way to the court of Louis XI in France, that a convent of his followers would one day rise upon the Pincio. Following the death of Louis XI (1461–83), Charles VIII of France, himself a great admirer of

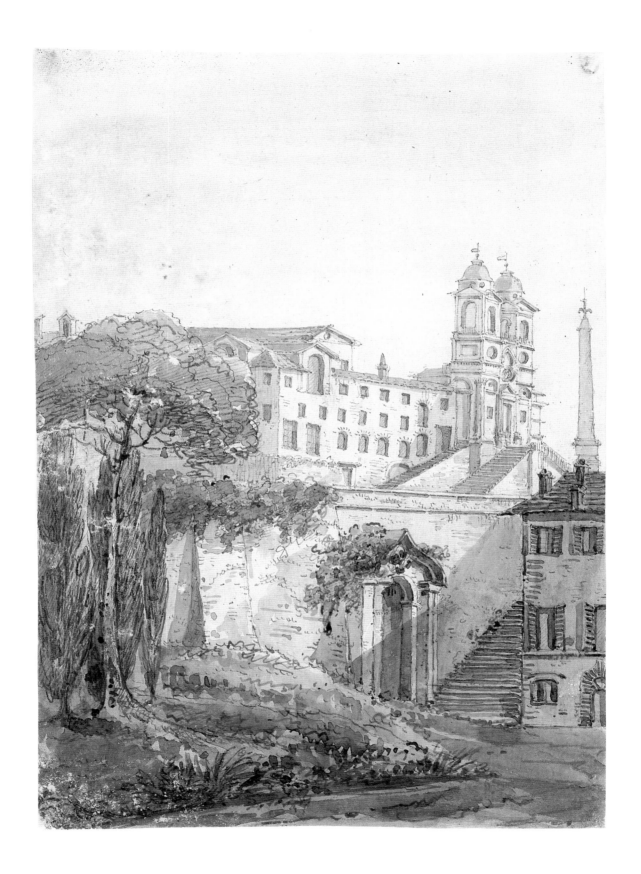

the saintly Francis, ordered his ambassador in Rome to purchase property as a site for a church and convent for the Minim Friars. With the acquisition of a *vigna* which had belonged to Daniele Barbaro, work was ready to begin on the project, which would serve as a hospice for French pilgrims to Rome. Begun in 1493, the construction proceeded very slowly despite assistance from succeeding French monarchs and from Pope Julius II. Only in 1585 was it ready to be consecrated, the façade having been erected about 1570 by Carlo Maderno. The twin campanili which crown the single-order façade were completed in 1584 by the Florentine architect Antonio Ilarione Ruspoli. The double ramp staircase which gives access to the church was designed by Domenico Fontana for Sixtus V in 1587. The interior of the church contains important frescos by Daniele da Volterra (1509–66), Perino del Vaga (1501–47) and Taddeo Zuccaro (1529–66). The convent contains frescos by Andrea del Pozzo and Charles Clérisseau.

The small, 46 foot high Egyptian obelisk which rises in the little square before the church may have been erected originally on the southern slopes of the Pincio by the Emperor Gordian III (238–44), in an area which had been occupied by the Gardens of Sallust. After it had fallen, it remained in its original location until 1733 when Clement XII planned to move it to the Lateran. It was eventually decided, however, to place it in Piazza della Trinità dei Monti, where it was erected between 14 March and 20 April 1789. The apex of the obelisk is surmounted by a bronze heraldic ornament sustaining a cross which reputedly contains relics of the true Cross, St Joseph, St Francis of Paola, Pius V and the Apostles Peter and Paul. As indicated in the inscription, the present representation of Trinità dei Monti was drawn from the Hotel Margutta situated in the artists' quarter close to the Piazza di Spagna. In the sixteenth century special tax concessions were offered to artists to come and live in this area, a practice which was renewed and curtailed from time to time as the authorities thought fit. In nearby vicolo Alibert, an English academy was established in the eighteenth century to assist with the education of British artists in Rome. In 1797 a campaign was launched, with the support of Sir William Hamilton, to improve the academy and formalize its organization. The academy later moved to via Margutta no. 53. Among those who frequented its classes were Henry Raeburn, George Romney and Sir Thomas Lawrence. It is not known if ladies were admitted to the classes.

46 Artist using the monogram A B

Active 1723–1745

Trinità dei Monti and the Villa Malta

Red chalk and slight traces of black chalk on white paper, laid down:
275 × 416 mm

Inscribed, verso, bottom left (visible against light), in ink: *Veduta
(della) Ternita / a de Monti / del Palazzo di Monte . . . Cavallo luglio
1740 AB*; the previous inscription is traced on the back of the
support, in pencil: *Veduta Ternita / a di Monti / del Palazzo di Monte
Cavalo (Luglio) 1740 AB*

WATERMARK on support

CONDITION: some lacunae, bottom left corner and center

PROVENANCE: Jonathan Richardson Jr. (Lugt 2170[?], recto, bottom
right corner); Robert Udny 1722–1802 (Lugt 2248, pasted to front
of support, bottom right corner)

BODART NO. 204

Here many Young Peoplle study Landscape — I think I may
say without Vanity that I am the best Landscapepainter in
Rome. I have taken a very handsome Lodging on the
Trinita del Monte on one of ye Finest Situations about
Rome it commands almost the whole City of Rome besides
a good deal of ye Country. The Famous Villa Madama
(Where Mr Wilson took his View of Rome from which I
always thought his best Picture) comes into my View. I
shall have the finest opportunity of painting Evening Skies
from my Painting-Room that I could almost wish, — surely I
shall be inspired as I am going to live in the Palace of the
late Queen [i.e. Maria Casimira Sobieska, Queen of Poland],
and the same Apartments that Vernet had (when he was
here), and within 80 or 100 yards of ye House where those
Celebrated Painters Nicolo and Gaspar Poussin lived! I am
to pay 6£ a year for my Lodgings, and I can have them
furnished for 4£ a year more as well as I shall desire.

Jonathan Skelton, *Letter* (11 January 1758)

The sight of so many banalities had spoiled Rome for me.
My eyes needed a window from which to overlook the
town. I was at the foot of the Pincio: I climbed the
enormous staircase of Trinità dei Monti, which Louis XVIII
has just magnificently restored, and I took lodging in the
house where Salvator Rosa once lived, in via Gregoriana.
From the table where I write I can see three quarters of
Rome; opposite me, on the other side of the city, rises
majestically the dome of St Peter's. In the evening, when
the sun sets, I see it through the windows of St Peter's, and
half an hour later that admirable cupola is silhouetted
against the pure orange of the dusk, crowned above by the
first few stars that are beginning to appear.

Nothing on earth can be compared to it. The soul is
melted and uplifted, a tranquil contentment pervades it. But
it seems to me that to respond adequately to these sens-
ations you have to have loved and known Rome for a long
time. A young man who has never known unhappiness
would not be able to appreciate them.

Stendhal, *Voyages en Italie* (early 19th century)

From the late sixteenth century onward the area about the Piazza di Spagna and Trinità dei Monti was popular with artists both as a scenic location worthy of study and as a place of residence. From time to time special tax incentives were awarded to foreign artists to settle in the locality, and it became a mecca for British artists particularly in the eighteenth century. One street in the area is in fact called via degli Artisti.

In the view described by A.B. there are several identifiable buildings with documented associations with artists, though other less distinguished edifices also housed painters, sculptors and writers — notably some of the houses along via Gregoriana and via Sistina. The two towers of the Villa Medici, constructed for Cardinal Giovanni Ricci da Montepulciano in 1564 using the existing fabric of a villa belonging to Cardinal Marcello Crescenzi, are just visible rising up in the center of the composition. Velázquez stayed here during his brief trip to Rome in the mid-seventeenth century and sketched its charming gardens. In 1803 it became the property of the Académie de France, the training center for French artists in Rome. The Villa Malta, which probably derives its name from the residence there of the Maltese ambassador, Lauro Bailli de Breteuil, also has a distinguished history, being at one time occupied by the Lukasbrüder, the community of German artists established in Vienna in 1809 by Friedrich Overbeck and Frans Pforr. These artists, also known as the Nazarenes, settled in the Villa Malta following their move to Rome in 1810, later moving to the nearby convent of Sant'Isidoro, the Roman house of the Irish Franciscans, which had been suppressed by the French régime. Just below the twin bell towers of the church of Santa Trinità, forming the wedge which divides via Sistina and via Gregoriana, is the Palazzo Zuccari, the splendid residence built by the artist Federico Zuccaro on land he had purchased there in April 1590. It was for a time the home of the Accademia di San Luca. Among the artists who resided there were Joshua Reynolds (1752–53) and Jacques-Louis David (1784).

For commentary on the authorship of this drawing see No. 14.

47 ELIZABETH SUSAN PERCY

ENGLISH c1778–1847

The Pincio and the Piazza del Popolo

Graphite with light gray wash: 166 × 242 mm

Inscribed, recto, bottom left corner, in graphite: *Rome / Ville Madama / e Melina(?) / 20 March / 1803*; verso, right center, in blue ink: *Rome from Margutta's Hotel / 20 March*

CONDITION: light staining on upper quarter of drawing

BODART NO. 235

Opinions differ about the name of this Piazza among the authorities. Andrea Fulvio, a scholar of the time of Pope Leo X, held that it was named after 'popolo' meaning the tree poplar, in Latin *populus*, this being the species of tree with which the wood around Augustus's Mausoleum was planted. Others with greater plausibility have derived the name from the church dedicated to the Virgin which was founded by Paschal II in 1099 at the behest of the 'Popolo Romano' in the ruins of the tomb of Domitian. Others claim that it was so called from the diversity of peoples that entered the city through this way. But it is easier to believe that the name commemorated the woods and park Augustus placed around his Mausoleum, which were intended, according to Suetonius, for the uses of the 'people' . . .

In the middle of the great open space, visible from three very long and broad streets, is the Obelisk which Augustus brought to Rome and placed as a monument in the Circus Maximus, after he had conquered Egypt. The obelisk was the work of Pharaoh Semnesertes, who had it carved, according to Pliny, during the time when Pythagoras was in Egypt.

In 1589 Sixtus V of happy memory had it removed from the ruins of the Circus and erected in this much frequented spot by Domenico Fontana, whose fame will be everlasting for having revived the skill possessed by the ancients of raising heavy weights.

Giuseppe Vasi, *Delle Magnificenze di Roma Antica e Moderna* (1747)

Nothing can give a finer idea of the grandeur of Rome than this first sight of the town; but one must always look straight ahead — not to the right or the left hand of the square; if you do so you will see on the right hand only some ugly large barns, and on the left the church of Santa Maria, a poor building, and near it a row of very small buildings, so that, although the Piazza del Popolo contains some fine things, it can scarcely be called a very beautiful one. Such contrasts are common here: it is either palace or hovel. A splendid building is often surrounded by a hundred little cabins — some fine streets, endless in length, admirably laid out, and generally terminated by a fine prospect, enable one to find one's way in the midst of blind alleys, narrow lanes, and cross-roads. Nothing is more easy than to have a general idea of the town, nothing more difficult than to know it in detail. It makes one think that Rome is still suffering from its burning by the Gauls, and that when it was being rebuilt after the fire every person put up his dwelling in the first vacant space that came to hand.

Président de Brosses, *Letters* (1739) (translated by Lord Ronald Sutherland Gower)

THE western slope of the Pincio gives onto the Piazza del Popolo, a large public square just inside the Porta del Popolo. In Roman times this was the location of the Porta Flaminia, the gate set into the great wall built by Aurelian, which led out of the city along the Via Flaminia towards Tuscany and the transalpine provinces. In the sixteenth century the area inside this gate, which was still the principal entrance to the city for travelers arriving from northern regions, was still very much a shambles, unpaved and possessing little or nothing with which to impress the new arrival.

It was Pope Pius IV who made the first substantial contribution towards rectifying this all too evident shortcoming when he commissioned the restoration of the ancient gateway, a task he entrusted in 1561 to Nanni di Baccio Bigio. Later in the century the area was further embellished

Rome
Ville Madam
e Quirina
20 March

Giuseppe Vasi: *Piazza del Popolo*

when Sixtus V instructed his architect Domenico Fontana to erect in the center of the old square the Egyptian obelisk which had lain forgotten in the ruins of the Circus Maximus (*cf* No. 16). This task was completed in 1589, when the obelisk was set on a foundation of 33 blocks of travertine pillaged from the remains of the Septizonium (*cf* No. 19). In the seventeenth century, the newly elected Pope Alexander VII quickly set about preparing the square for the imminent arrival of Queen Christina of Sweden, who in 1654 had abdicated her throne to embrace the Catholic faith. Among the works carried out to prepare the city for the momentous occasion was the decoration of the inner façade of the gate, a project entrusted to Gianlorenzo Bernini, who crowned the entrance with scrolls and the family insignia of the pontiff. Just a few years later, Alexander sought to improve

the setting further when he commissioned Carlo Rainaldi to design the twin churches of Santa Maria di Monte Santo and Santa Maria de'Miracoli, which are set into the southern corner of the square, between the three axial routes which lead away into different parts of the city: via del Babuino, via del Corso and via della Ripetta.

The Piazza derives its name from the Church of Santa Maria del Popolo, one of the most important of all the great Roman churches, with fantastic art treasures decorating its interior, including works by Pintoricchio, Raphael, Bernini and Caravaggio. The first record of a church on this site, which was reputed to be built over the tomb of Nero, dates to 1099. The church was erected at the expense of the Roman people and subsequently was given the title Sancta Maria Populi Romani.

48 GIUSEPPE VALADIER

ROME 1762–1839 ROME

Scheme for the layout of the Pincio

Pen and brown ink with watercolor: 392 × 607 mm

Inscribed, recto, bottom right corner, in pencil: *60*; bottom left corner, in pencil: *13*; verso, lower right, in pencil: *Progetto per il Pincio? / Paolo*; bottom left, in pencil: *13/18*; top right, in pencil: *ASBI*

CONDITION: some repaired damage, top left corner. Some staining and foxing. Fold mark down center

BODART NO. 310

The Pincian Hill is the favourite promenade of the Roman aristocracy. At the present day, however, like most other Roman possessions, it belongs less to the native inhabitants than to the barbarians from Gaul, Great Britain, and beyond the sea, who have established a peaceful usurpation over whatever is enjoyable or memorable in the Eternal City. These foreign guests are indeed grateful, if they do not breathe a prayer for Pope Clement, or whatever Holy Father it may have been, who levelled the summit of the mount so skilfully, and bounded it with the parapet of the city-wall; who laid out those broad walks and drives, and overhung them with the deepening shade of many kinds of tree; who scattered the flowers of all seasons, and of every clime, abundantly over those green, central lawns; who scooped out hollows, in fit places, and, setting great basins of marble in them, caused ever-gushing fountains to fill them to the brim; who reared up the immemorial obelisk out of the soil that had long hidden it; who placed pedestals along the borders of the avenues, and crowned them with busts of that multitude of worthies — statesmen, heroes, artists, men of letters, and of song — whom the whole world claims as its chief ornaments, though Italy produced them all. In a word, the Pincian Garden is one of the things that reconcile the stranger (since he fully appreciates the enjoyment, and feels nothing of the cost) to the rule of an irresponsible dynasty of Holy Fathers, who seemed to have aimed at making life as agreeable an affair as it can well be.

Nathaniel Hawthorne, *The Marble Faun* (1859)

On the left side of the piazza rises the Pincio, which derives its name from the Pinci family, who had a magnificent palace there. The terraces are adorned with rostral-columns, statues, and marble bas reliefs, interspersed with cypresses and pines. A winding road, lined with mimosas and other flowering shrubs, leads to the upper platform, now laid out in public drives and gardens, but, till *c*1840, a deserted waste, where the ghost of Nero was believed to wander in the Middle Ages...

Here the band plays every afternoon except Friday, when immense crowds often collect, showing every phase of Roman life. It is on Sunday especially that the Pincio may be seen in what Miss Thackeray calls 'a fashionable halo of sunset and pink parasols'; but all begin to disperse as the

Ave-Maria bell rings from the churches, either to descend into the city, or to hear Benediction sung by the nuns in the Trinità de'Monti.

Augustus Hare, *Walks in Rome* (1893)

DESPITE several campaigns of activity in the sixteenth and seventeenth centuries (see No. 47), the problem of what to do with the corner of Piazza del Popolo which abutted the western slope of the Pincio, or with the opposite corner towards St Peter's, or indeed how to integrate all the previously created elements into one complete design, remained. It was not until the end of the eighteenth century that this problem was finally tackled, when the architect Giuseppe Valadier was invited to make designs for the layout of the square. Valadier's first ideas for the systematization of the Piazza date to the 1790s and he was to continue his involvement with the project, on and off, for the next 30 years, as the various proposed arrangements were debated, rejected and again resubmitted. Apart from the purely architectural problems and disagreements, progress on the project was held up by the tumultuous political life of the city at this time, and the comings and goings of the French army of occupation. In 1812 Valadier submitted a new plan for the development of the Piazza, which, though eventually abandoned, did contain the basic elements which were to be used in the final layout, namely the employment of a semicircular exedra to define the corner towards St Peter's and the terracing of the slopes ascending to the Pincio, with the insertion of ramps to facilitate traffic. Some time later the official architects of the Napoleonic régime, Louis-Martin Berthault and Guy de Gisors, made further adjustments to the design developed by Valadier and the go-ahead was given for work at last to begin. Political developments again overtook the scheme, however, as the French occupation collapsed and Rome again came under papal rule. Pius VII returned to Rome in April 1814, shortly after which time he reappointed Valadier to the scheme. Valadier's new plans, which included only minor alterations to the designs developed by Gisors and Berthault, soon received papal approval and the final development went ahead in January 1816.

This is one of three drawings in the Ashby collection (nos. 309–11), which are believed to be related to Valadier's proposed plans for the Pincio. Certainly the general disposition of the various elements would seem to fit comfortably atop the existing arrangement abutting the Piazza del Popolo. Elisabeth Kievan at the Biblioteca Hertziana has pointed out, however, that before the design can be positively linked to the Pincio project, further examination of the evidence is required. She has remarked that the overhung terraces and the inclusion of features more consistent with garden architecture would suggest that the design could possibly be for a garden terrace, for example at the Orti Farnesiani on the Palatine, where again the design would sit nicely on top of the restored structures of Vignola. The style of the drawing is consistent with the technique of Valadier and the attribution would seem correct, though its authorship has been called into doubt by Elisa Debenedetti (1985, no. 140). Other drawings relating to the landscaping of the Pincio are in the Accademia di San Luca.

49 'GIMELLY'

ENGLISH, active in ROME 1792

Monte Mario

Pen and ink with watercolor on white card: 568 × 795 mm

Inscribed on *passepartout*, below drawing, center, in display characters, in brown ink: *VEDUTA DI MONTE MARIO*; below drawing, left corner, in ink: *Eques Gimelly Anglus delin: – Et pinxit Rome An: MDCCXCII*; inscribed on back of support, bottom left, in pencil: *13/18*; left side, in pencil: *1417*; upper left side, in pencil: *iii:* top center, in pencil: *iii(161)*; top right, in pencil: *Ashby/12*

CONDITION: torn on right edge and lower center

BODART NO. 138

The only place where the City is not walled today is from the Porta del Popolo to down beneath the Castel Sant' Angelo and the Porto di Ripetta, because here it is defended by the fort of Sant'Angelo. It was Aurelian who resolved, in order that the many proud and magnificent buildings which covered the Campo Marzio should not be exposed to the outrages of the enemy, to enclose it within strong walls. He was encouraged to do so by the Colle degli Ortoli, which surrounds a good part of it, and curves where the Porta del Popolo now is towards the Tiber, making a natural entrance. Conveniently it embraced the entire park with which Augustus had surrounded his Mausoleum, the furthest outlying of the sumptuous buildings of the Campo Marzio.

That there was also in ancient times a quay here, as there is today, I think can be stated as a fact, following Nardini, who writes that Rome had two quays: one, for the boats which came up from the sea, which was beneath the Aventine; and another for boats plying the river inland, which, while there was only one bridge, the Sublicius, was near the saltworks; but as new bridges were built, the inland terminus had to be moved further and further upstream, and in Livy's time, because the Pons Triumphalis barred passage, the landing was certainly between that bridge and what is now the church of San Rocco on the Campo Marzio, used by the Romans for the military exercises with which they were constantly occupied. Tacitus gives confirmation of this, when he narrates that Sillanus, coming down the Tiber to Rome from Narni with his wife Plancina, disembarked at the Tumulus Caesarum, that is the Mausoleum of Augustus, of which the remains are still to be seen behind the church of San Rocco; from which it may be deduced that in those days, just as now, victuals from the Sabine hills were unloaded here, at the Sbarco.

Opposite the boatsheds, in the area beside the Castel Sant'Angelo, was the Campo Quinzio, which Pliny says was in the area of the Vatican; however Donati and others, of different opinion, place it outside the Porta Portese; but since that place is so close to the old city, it is not likely that the Meadows of Quintius can have been there, as the perspicuous Nardini observes. In our time a little market-hall, called the Porto di Ripetta, was built by Clement XI most usefully and appropriately, to the design of Alessandro Specchi; he also provided accommodation for the officials and ministers of the landing-place, and desired that on two columns should be marked the heights of the floods of the Tiber over the years.

Giuseppe Vasi, *Delle Magnificenze di Roma antica e moderna* (1756)

Monte Mario: a hill to the north-west of Rome, a little beyond the Vatican, an extension of the Janicular, under which name it was once included, like the Vatican hill. The name it bears today has nothing to do with the antique Marius the Consul, but comes from a certain Mario Millini, who lived in the time of Sixtus IV, and who had on this hill a fine house that still belongs to the family. On the hill there is also a church dedicated to the Holy Cross, which Pietro Millini had built about 1470; and a Church of the Rosary served by Dominicans from houses in Lombardy, which was built by the famous Giovan Vittorio de'Rossi, who chose to transfigure himself into Giano Nicio Eritreo, which means the same thing in Greek. The convent was restored by Pope Benedict XIII, who was a Dominican and who used to lodge there sometimes.

Joseph-Jérome Lefrançois de Lalande, *Voyage d'un François en Italie fait dans les Années 1765 & 1766*

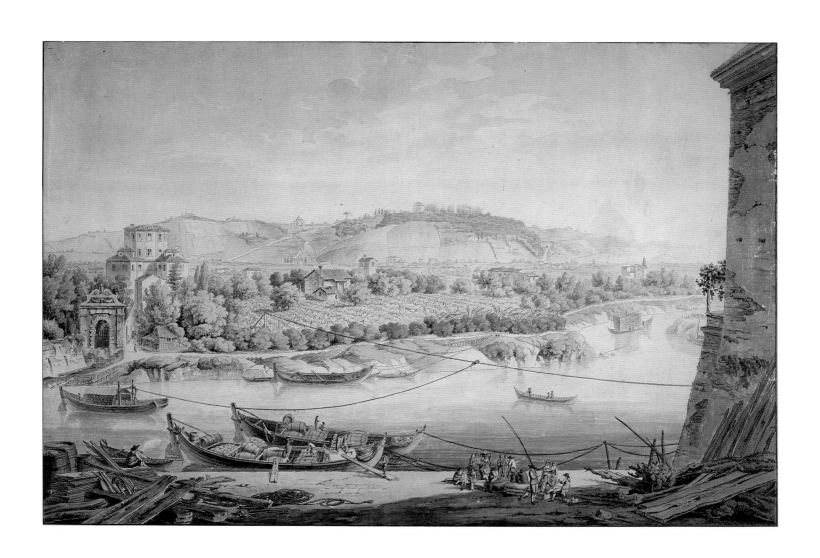

GIMELLY'S watercolor shows a view across the Tiber, from the Porto di Ripetta towards the hill of Monte Mario in the distance. Up until the sixteenth century there was a primitive landing ground on this spot for travelers and supplies from Tuscany. Given that the family palace of the Borghese is only a short distance away, it is not surprising that Pope Paul V (1605–21) sought to improve the facilities and embellish the area during his pontificate by establishing a new port along the river close to the existing landing point. Known as the Porto di Legno or Legnara, the small port, finished in 1614, was, among other things, used as the principal location for the unloading of firewood (note the barges of wood floating down the river in the distance). This facility was further improved and embellished during the pontificate of Clement XI, who employed Alessandro Specchi (1668–1729) to design a new harbor.

Specchi's beautiful port was one of the most graceful constructions of its period, involving a complex design for the layout of the steps leading to the landing point, arranged according to a layout made up of contrasting curves and counter-curves. Work on the port was completed with remarkable speed, beginning in July 1703 and finishing in May 1704, using travertine which had been quarried from the Colosseum. The port remained one of the most popular and attractive Roman landmarks until the new embankment along Lungotevere was constructed, provoking its destruction in 1874. Some years later a hideous iron bridge was erected across the Tiber at this spot. This was replaced in 1901 by the present Ponte Cavour.

Across the river in Gimelly's view, behind the monumental entrance gate along the river, can be seen the Villa Altoviti in the Prati di Castello. This villa, which was the property of the great Florentine banking and trading family, dated back to the sixteenth century (the *vigna* of the Altoviti family is marked at this location in Leonardo Bufalini's map of Rome dated 1551). The family palace was constructed just across the river, at the city end of the Ponte Sant'Angelo. Sadly, the villa was demolished in 1888 to make way for the ponderous Palazzo della Giustizia. The palace was pulled down a short while earlier to facilitate work on the construction of the Tiber embankment. In the distance, in the saddle of the outline of Monte Mario, can be seen the church of Santa Maria del Rosario, originally built in 1628–29 and later extensively remodeled in 1659 according to the designs of Camillo Arcucci. Crowning the summit is the Villa Mellini, which now functions as a metereological station and observatory and houses an astronomical museum.

The author of this large and competent view is unknown. Despite the signature 'Eques Gimelly Anglus' it has not proved possible to identify the personality behind the work, who apparently was an Englishman of some status visiting Rome in 1792. It may be noted that Gimelly is not a very common name and it is just possible that the author of this piece was in some way related to the artist H Gemell or Gemelli who is known to have painted a portrait of Robert Johnston of Hilton, dated 1723, which is in the collection of Hopetoun House, Linlithgow.

50 JACOB VAN DER ULFT

GORINCHEM 1627–1689 NORDWIJK

A View of the Walls of Rome

Pen and ink with bistre wash on laid paper: 119 × 212 mm

Inscribed on front of mount, below right corner of drawing, in pencil: *J. de Bisschop/1646–1686*, top right corner, in pencil: *1441*; on strip of old paper pasted to front of mount, below drawing, in brown ink: *Mure di Roma. 1674*; inscribed, verso, top left, in pencil: *34*; bottom left, in pencil (very faint): *V D Ulft* (?)

WATERMARK

CONDITION: the drawing has been cut into two pieces

BODART NO. 304

The thickness of the wall should, in my opinion, be such that armed men meeting on top of it may pass one another without interference. In the thickness there should be set a very close succession of ties made of charred olive wood, binding the two faces of the wall together like pins, to give it lasting endurance. For that is a material which neither decay, nor the weather, nor time can harm, but even though buried in the earth or set in the water it keeps sound and useful forever. And so not only city walls but substructures in general and all walls that require a thickness like that of a city wall, will be long in falling to decay if tied in this manner.

The towers should be set at intervals of not more than a bowshot apart, so that in case of an assault upon any one of them, the enemy may be repulsed with *scorpiones* and other means of hurling missiles from the towers to the right and left. Opposite the inner side of every tower the wall should be interrupted for a space the width of the tower, and have only a wooden flooring across, leading to the interior of the tower but not firmly nailed. This is to be cut away by the defenders in case the enemy gets possession of any portion of the wall; and if the work is quickly done, the enemy will not be able to make his way to the other towers and the rest of the wall unless he is ready to face a fall.

The towers themselves must be either round or polygonal. Square towers are sooner shattered by military engines, for the battering rams pound their angles to pieces; but in the case of round towers they can do no harm, being engaged, as it were, in driving wedges to their centre. The system of fortification wall and towers may be made safest by the addition of earthen ramparts, for neither rams, nor mining, nor other engineering devices can do them any harm.

Vitruvius, *On Architecture* (early 1st century AD) (translated by M H Morgan)

But, whatever confidence might be placed in ideal ramparts, the experience of the past, and the dread of the future, induced the Romans to construct fortifications of a grosser and more substantial kind. The seven hills of Rome had been surrounded by a successor of Romulus with an ancient wall of more than thirteen miles. The vast inclosure may seem disproportioned to the strength and numbers of the infant state. But it was necessary to secure an ample extent

of pasture and arable land against the frequent and sudden incursions of the tribes of Latium, the perpetual enemies of the republic. With the progress of Roman greatness, the city and its inhabitants gradually increased, filled up the vacant space, pierced through the useless walls, covered the field of Mars, and, on every side, followed the public highways in long and beautiful suburbs. The extent of the new walls, erected by Aurelian, and finished in the reign of Probus, was magnified by popular estimation to near fifty; but is reduced by accurate measurement to about twenty-one miles. It was a great melancholy labour, since the defence of the capital betrayed the decline of the monarchy. The Romans of a more prosperous age, who trusted to the arms of the legions the safety of the frontier camps, were very far from entertaining a suspicion that it would ever become necessary to fortify the seat of empire against the inroads of the barbarians.

Edward Gibbon, *The Decline and Fall of the Roman Empire* (1776–1788)

IF we accept the accounts of the classical authors then it can be determined that Rome has been fortified by protective walls on at least seven different occasions. The earliest walls were those reputed to have been erected by Romulus, the most recent those constructed by the Italian government in the nineteenth century.

The walls raised up during the early history of Rome were no different from those set up by the rulers of neighboring cities. Times were turbulent and the balance of power delicate and walls were an essential part of every city's defensive strategy. With the tremendous expansion of Rome's military power, however, the first city of the Empire soon achieved an unassailable position among its neighbors and walls became more or less superfluous. By the third century AD, however, the situation had changed again, with the intrusion of armies from north of the Alps into the Po Valley, and a new, more defensive strategy was deemed advisable. The Emperor Aurelian (270–75) undertook the task of securing Rome's defensive perimeter, building a great wall about the city — the kind of project which heretofore had been applied only in territories on the remote borders of the empire.

The wall constructed by Aurelian is the most celebrated of the defensive rings thrown about the city down through its history. It was begun by the Emperor in 271 and was well advanced at the time of his assassination in 275. This rapid rate of construction would seem to indicate an air of urgency, and excavations have shown that the engineers in charge did not bother to demolish all the existing buildings in its path but chose instead to incorporate them into the structure. When finished the fortifications circled the city in a ring some 12 miles in length. The base of the wall measured almost 12 feet in thickness and nearly 25 feet in height. To strengthen the defences square towers were inserted at regular intervals of about 100 feet. Vitruvius had recommended that defensive towers in walled fortifications should be no further than the flight of an arrow from any assailant. Altogether there were 381 towers in the circuit, although of these only one, close to the Porta Salaria, has survived to modern times. To control access to the city a series of 18 fortified gates were erected. The walls constructed by Aurelian were later extensively reworked by Honorius and Arcadius during the years 401–02 as the threat of attack from the marauding Gothic armies became ever more menacing. The campaign of renewal principally involved raising the wall to about double its previous height, improving the watch-towers and strengthening the great gates. The gates were eventually breached, however, just eight years later, when Alaric entered the city in 410.

Aurelian's wall, nonetheless, continued to act as the principal defensive barrier for the security of the city down to the year 1870.

The present representation of the walls of Rome is very similar to another view of the same subject in the print room of the Rijksmuseum (inv. no. A 4429, 136 × 210 mm) which carries an identical inscription '*Mure di Roma 1674*'. Bodart notes that the Amsterdam sheet repeats a composition by Jan de Bisschop in the Fondation Custodia in Paris (Van Hasselt and Blankert 1966, p.20, no. 8, pl.xxxii). He believes that Van der Ulft may have sketched these compositions after he had come into the possession of some of De Bisschop's material after the latter's death in 1671. (For De Bisschop and Van der Ulft, *cf* also No. 5.)

51 FERDINAND BECKER

BATH, late 18th century – 1825 BATH

The Arch of Drusus and the Porta San Sebastiano

Pen and gray ink wash: 286 × 420 mm

Inscribed, recto, across bottom center, in ink: *L Arc de Claudius Drusus et Porte de S Sebastiano at Rome*; verso, lower left, in Ashby's hand(?), in pencil: *Arch of Claudius Drusus & St. Sebastian's Gate / at Rome*; upper right center, in Ashby's hand(?), in pencil: *46*

CONDITION: slight foxing

BODART NO. 43

...Reaching the paved road again, I kept on my course, passing the tombs of the Scipios, and soon came to the gate of San Sebastiano, through which I entered the Campagna. Indeed the scene round was so rural, that I had fancied myself already beyond the walls. As the afternoon was getting advanced, I did not proceed any farther towards the blue hills, which I saw in the distance, but turned to my left, following a road that runs round the exterior of the city walls. It was very dreary and solitary, – not a house on the whole track, with the broad and shaggy Campagna on one side, and the high, bare wall, looking down over my head, on the other. It is not, any more than the other objects of the scene, a very picturesque wall, but is little more than a brick garden-fence seen through a magnifying glass, with now and then a tower, however, and frequent buttresses, to keep its height of fifty feet from toppling over...

Nathaniel Hawthorne, *Passages from the French and Italian Notebooks* (*c*1871)

The Arches of Trajan and Verus, which crossed the road within the walls, have been destroyed, but just within the gate still stands the Arch of Drusus. On its summit are the remains of the aqueduct by which Caracalla carried water to his baths. The arch once supported an equestrian statue of Drusus, two trophies, and a seated female figure representing Germany.

The Arch of Drusus was decreed by the Senate in honour of the second son of the empress Livia, by her first husband, Tiberius Nero. He was father of Germanicus and the Emperor Claudius, and brother of Tiberius. He died during a campaign on the Rhine, BC 9, and was brought back by his step-father Augustus to be buried in his own mausoleum. His virtues are attested in a poem ascribed to Pedo Albinovanus...

The Porta San Sebastiano has two fine semicircular towers of the Aurelian Wall, resting on a basement of marble blocks, probably plundered from the tombs on the Via Appia. Under the arch is a Gothic inscription relating to the repulse of some unknown invaders.

It was here that the Senate and People of Rome received in state the last triumphant procession which has entered the city by the Via Appia, that of Marc Antonio Colonna, after the victory of Lepanto in 1571. As in the processions

of the old Roman generals, the children of the conquered prince were forced to adorn the triumph of the victor, who rode into Rome attended by all the Roman nobles 'in abito di grande formalità', preceded by the standard of the fleet.

Augustus Hare, *Walks in Rome* (1893)

THE Arch of Drusus, spanning the Via Appia where it left the city, was probably constructed as a support for the passage of the Aqua Antoniniana to the Baths of Caracalla (211–16), though it has also been suggested that it dates to the time of Trajan (98–117) or possibly Lucius Verus (161–69). Before the erection of the neighboring Porta Appia, it doubled as a monumental entrance to the city.

Partially obscured by the Arch of Drusus in Becker's drawing is the Porta San Sebastiano, the most imposing and best preserved of all the gates piercing the Aurelian Walls. Its present appellation, which was used for the first time on the occasion of Charles V's triumphal entry in 1536, derives from the nearby church dedicated to the third-century saint martyred under Diocletian. Its original name, the Porta Appia, was derived, like those of many of the old Roman gates, from the name of the road which passed through it, the Via Appia. The gate was initially made up of two arches surmounted by a windowed attic and parapet flanked by two towers. It has undergone many modifications, most notably the heightening and expansion of the two towers and the reduction of the entrance to one archway. The most extensive remodeling occurred in the fifth and sixth centuries when it was rebuilt by Honorius (395–423), who enclosed the reshaped towers in squared marble revetments, later modified by restorations carried out by both Belisarius and Narses in the following century. Inside the gate is the incised figure of an angel accompanied by a curious inscription in medieval Latin recording the victory achieved here on 29 September 1327 against Robert d'Anjou. In the present century the interior of the gate was again restored and the towers served temporarily as office accommodation. The gate now houses the Museo delle Mura.

52 LOUIS VINCENT

VERSAILLES 1758–?

The Porta San Paolo

Pen and gray wash on laid paper: 371 × 259 mm

Inscribed, front of mount, lower left corner, dark brown ink: *L Vincent f. a Rome*; top of mount, in pencil: *1/3*; reverse of mount, center left, in pencil: *oppe 303 / Bristol / . . . 5/–*; lower center, in pencil: *Porta S. Paolo / Copied from Overbeke – 123*. Other marks or inscriptions indecipherable

Border of dark brown ink.

CONDITION: good

BODART NO. 314

To go to San Paolo fuori le Mura, one of the largest of the ancient churches in the suburbs of Rome, one has to leave the city by the gate of the same name, which has replaced the Tregemina, situated a little closer to the Tiber, and so called because it was the gate from which the Three Horatii sallied forth to combat the Three Curiatii. The stretch of ancient wall that extends beside the gate is from the circumvallation of Aurelian. Nearby, on the right as you leave Rome, in the middle of the wall is the Tomb of C Cestius, prefect of the Epulones. It is a four-sided pyramid, all in marble, with an inscription on the city side and another on the country side. One enters the interior through a low door, which gives on to a dark, low corridor about 20 paces long, at the end of which is the oblong burial chamber. In this chamber was the funeral urn, of which the subsequent fate is unknown.

Marquis de Sade, *Voyage d'Italie* (1775–1776)

Yesterday the city was in feverish agitation. There were two reasons: the rumour that there would be an insurrection that evening and the defensive measures taken by the general command. Last night trenches had already been dug at all the gates. I was at Porta del Popolo and at Porta Angelica to lend a hand in these tasks, which reminded me of the Middle Ages, when city gates were quite often barricaded in this way. The people looked on at the work in the rain, passionately, since here everything, including the tragic, is a matter of theatre. A communication from the police authority announces that from today the following gates will be closed altogether: Maggiore, San Lorenzo, Salaria, San Pancrazio, San Sebastiano, San Paolo.

Ferdinand Gregorovius, *Roman Diaries* (23 October 1867)

THE old Porta Ostiensis, renamed the Porta San Paolo as it led to the great basilica of San Paolo fuori le Mura, is one of the best preserved of the ancient Roman gates. Constructed in the seventh decade of the third century AD, it was one of the gates inserted into the great defensive wall with which Aurelian had encircled the city. Its function was to defend and control access to the city by those arriving from Ostia and the sea along the Via Ostiensis. Its original design, with two archways through which traffic could pass, underwent two major modifications, first during the reign of Maxentius (306–12) and later during that of Honorius (395–423). During the reign of Maxentius additional new walls were added on the inner side which, as they came together in a kind of pincer movement, formed a sort of courtyard with twin archways echoing the existing configuration. As indicated by the monograms carved on the keystone of the arch, it was during the reign of Honorius that the twin archways on the outside of the gate were reduced to one and the semicircular towers raised. It was through this gate that Totila re-entered the city in 549. It now houses the Museo della Via Ostiense.

The present view shows one of the inner archways with its medieval additions. The *edicola* built into the wall above the gate shelters an image of St Peter which replaces an earlier one devoted to St Paul. To the right can be seen the Pyramid of Cestius.

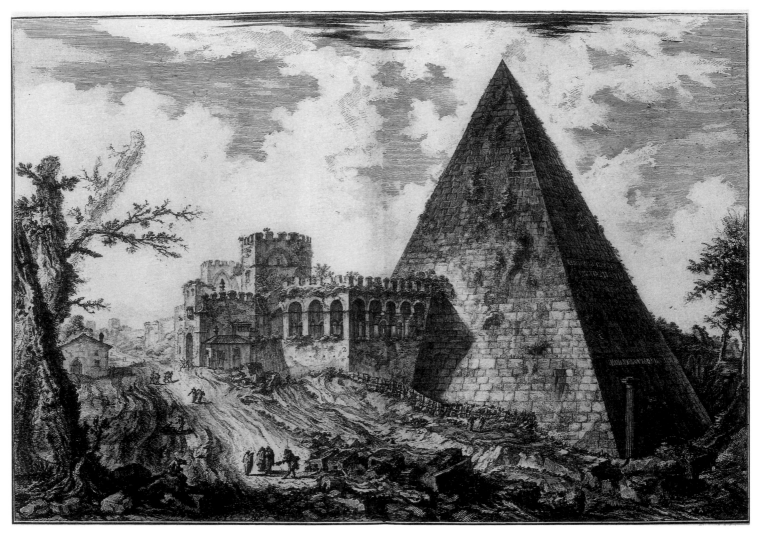

Giovanni Battista Piranesi: *The Pyramid of Caius Cestius*

Bodart attributes this drawing to the little known Louis Vincent on the basis of the inscription '*L. Vincent f. a Rome*' on the old mount, though he disputes the assertion that Vincent made the sketch in Rome, stating that it repeats the design of an engraving of the scene made by Bonaventure van Overbeck (1660–1706) in *Les restes de l'ancienne Rome* *recherchez avec soin ... par feu Bonaventure d'Overbeke*, The Hague 1712 (p.23, pl. 12). Bodart notes that a view of the Villa Borghese by Vincent was sold in Paris in 1925. Jean-Pierre Cuzin (oral communication), who has seen a photograph of the present sketch, believes the old attribution to Vincent may be correct.

53 FERDINAND BECKER

BATH, late 18th century – 1825 BATH

The Protestant Cemetery

Pen and gray ink wash with traces of black chalk: 325 × 340 mm

Inscribed, recto, across bottom, in black ink: *Sepulchre of Caius Cestius and Burying ground of the English at Rome near la porta . . . Paolo*; verso, lower center, in Ashby's hand(?), in pencil: *Tomb of Caius Cestius & English Burying ground at Rome*; center right in Ashby's hand (?) in pencil: *36*

WATERMARK

CONDITION: some patches of staining, especially across the top, slight tear in bottom right corner

BODART NO. 46

The cemetery is an open space among the ruins, covered in winter with violets and daisies. It might make one in love with death to think that one should be buried in so sweet a place.

Percy Bysshe Shelley, preface to *Adonais* (1821)

Or go to Rome which is the sepulchre
O! not of him, but of our joy: 'tis nought
That ages, empires, and religions there
Lie buried in the ravage they have wrought;
For such as he can lend, — they borrow not
Glory from those who made the world their prey;
And he is gathered to the kings of thought
Who waged contention with their time's decay,
And of the past are all that cannot pass away.

Go thou to Rome, — at once the Paradise,
The grave, the city, and the wilderness;
And where its wrecks like shattered mountains rise,
And flowering weeds, and fragrant copses dress
The bones of Desolation's nakedness
Pass, till the Spirit of the spot shall lead
Thy footsteps to a slope of green access
Where, like an infant's smile, over the dead
A light of laughing flowers along the grass is spread.

And gray walls moulder round, on which dull Time
Feeds, like slow fire upon a hoary brand;
And one keen pyramid with wedge sublime,
Pavilioning the dust of him who planned
This refuge for his memory, doth stand
Like flame transformed to marble; and beneath,
A field is spread, on which a newer band
Have pitched in Heaven's smile their camp of death
Welcoming him we lose with scarce extinguished breath.

Here pause: these graves are all too young as yet
To have outgrown the sorrow which consigned
Its charge to each; and if the seal is set,
Here, on one fountain of a mourning mind,
Break it not thou! too surely shalt thou find
Thine own well full, if thou returnest home,
Of tears and gall. From the world's bitter wind
Seek shelter in the shadow of the tomb.
What Adonais is, why fear we to become?

Percy Bysshe Shelley, *Adonais: An elegy on the death of John Keats* (1821)

I recently spent an afternoon hour at the little Protestant cemetery close to St Paul's Gate, where the ancient and the modern world are insidiously contrasted. They make between them one of the solemn places of Rome — although indeed when funereal things are so interfused it seems ungrateful to call them sad. Here is a mixture of tears and smiles, of stones and flowers, of mourning cypresses and radiant sky, which gives us the impression of our looking back at death from the brighter side of the grave. The cemetery nestles in an angle of the city wall, and the older graves are sheltered by a mass of ancient brickwork, through whose narrow loopholes you peep at the wide purple of the Campagna. Shelley's grave is here, buried in roses — a happy grave every way for the very type and figure of the Poet. Nothing could be more impenetrably tranquil than this little corner in the bend of the protecting rampart, where a cluster of modern ashes is held tenderly in the rugged hand of the Past. The past is tremendously embodied in the hoary pyramid of Caius Cestius, which rises hard by, half within the wall and half without, cutting solidly into the solid blue of the sky and casting its pagan shadow upon the grass of English graves — that of Keats,

among them — with the effect of poetic justice. It is a wonderful confusion of mortality and a grim enough admonition of our helpless promiscuity in the crucible of time. But the most touching element of all is the appeal of the pious English inscriptions among all these Roman memories; touching because of their universal expression of that trouble within trouble, misfortune in a foreign land.

Henry James, *Italian Hours* (1909)

THE Protestant Cemetery is the burial place of non-Catholics and members of the Orthodox Church. Located close to the Aurelian Wall, in the shadow of the Pyramid of Caius Cestius, its history as a burial ground for non-Catholics in Rome goes back to 1726 and possibly earlier. Sacheverell Stephens, who was in Rome *c*1740, wrote:

The city wall joins to both sides of the pyramid, and seems to divide it in the middle, so that one part stands within, and the other without the city; at the front of it they bury the English Protestants that die in Rome, but even if they are of rank and distinction, they are allowed no monuments; they were till lately buried with the excommunicated whores, but since the Chevalier de St George has resided at Rome, he has prevailed with the Pope that they may be buried near this monument; however the common pathway is over the place where they are interred, which plainly shows what great regard they have for us hereticks.

As mentioned by Stephens, prohibition on the erection of monuments to the memory of the dead continued for a long time — until around 1775, when the Marquis de Sade counted three graves with small marble tombstones carrying inscriptions.

Among those interred in this picturesque setting is the great English poet John Keats (1795–1821), who lies close by his faithful friend, the artist Joseph Severn (1793–1879). The inscription on his grave reads:

This grave contains all that was mortal of a young English poet, who, on his death-bed, in the bitterness of his heart at the malicious powers of his enemies, desired these words to be engraven on his tombstone: Here lies one whose name was writ in water. February 24, 1821.

In another part of the cemetery lies the heart of Percy Bysshe Shelley (1792–1822), placed there by his friend Edward John Trelawny (1792–1881) following his death by drowning off Leghorn, his body having been burnt upon the shore at Lerici. Also buried in these grounds are Julius A Walter von Goethe, the son of the celebrated German poet, Antonio Gramsci, the great Italian politician, as well as the father of Thomas Ashby.

The pyramid which dominates the middle ground of Becker's composition is the funerary monument of Caius Cestius, described in the inscription incised on both its eastern and western faces as *C(aius) Cestius L(uci) f(ilius) Epulo, Pob(liliae tribu), praetor, tribunus plebis, (septem)vir epulonum* (Caius Cestius Epulone, son of Lucius, of the tribe of Poblilia, praetor, tribune of the plebs, member of the College of the Septemviri Epulones). Despite the inscriptions it has not, however, proved possible to determine with certainty the identification of its author, who must have been a person of considerable wealth. It has been proposed that the Cestius in question is to be recognized as the homonymous praetor of 44 BC, who died in 12 BC. The date of the monument, inspired by Egyptian models (as was the now lost pyramid known as the Meta Romuli in the Vatican), can certainly be placed between 18 BC and 12 BC. Measuring 97 feet around its base and 119 feet in height, according to the inscription it took just 330 days to build.

Behind the Pyramid can be seen remnants of the Aurelian wall with the towers of the Porta San Paolo to the left.

54 ANONYMOUS

DUTCH, 17th century

The Nympheum called the Grotta della Ninfa Egeria

On the verso, a faint sketch in black chalk representing classical ruins
Brush and wash with faint traces of black chalk on laid paper:
259 × 399 mm

Inscribed, recto, bottom right (cut), in an old hand, in brown ink: *Jo. Both.*; verso, top right, in pencil: *J. Both*; top left, in ink: *ª/ₑ f 025*, repeated top left corner, in black chalk (?); bottom left, very faint, in pencil: *Breenberg*; on inside of mount, bottom right, in pencil: *1177*

WATERMARK

CONDITION: good

BODART NO. 105

Where the Caffarella is today there is a fountain of the clearest water, which was called the Fountain of the Vestal Virgin Egeria. Numa Pompilius was greatly devoted to her, and according to her wish dedicated it to the Camenae [or Muses]. He ordered the Vestals to draw the water for their service at the sacrifices from here, and there is there the statue, now headless, in marble, of the goddess Egeria, as well as a great ancient arch decorated with stuccoes, so it is evident that it was a very noble place. Here the Roman people celebrate all the festivities of the month of May, with great parties and much joy, and a great throng of people in Bacchic mood.

Pietro Rossini, *Il Mercurio Errante* (1693)

Fountain of the Nymph Egeria, a kind of grotto in the side of a hill of arched mason work. This was the favorite retreat of Numa Pompilius to enjoy the coolness of the grotto and the delightful groves by which it was surrounded – The water is pure and limpid – The grotto highly picturesque – The statue is much mutilated. I, however, on the first glance perceived that the cumbent statue of the nymph as it is generally called was nothing more or less than the strapping carcass of a man – such are the errors into which these antiquarians are forever running.

Washington Irving, *Journals and Notebooks* (4 April 1805)

The passion for marking every Roman stone with a famous name led many learned men of those times to call this nympheum the Cave of the Nymph Egeria, or Fountain of Egeria, which in fact, as was indicated at its proper place, was situated a long way from here, that is, as Juvenal and Symmachus testify, near the Porta Capena in the valley between the Caelian and the Monte d'Oro, near the road which in Juvenal's time led from Rome to Baia, and was the Via Appia as far as Sinvessa, and from then on the Domitiana or Campana. Quite apart from these authorities, the ancient statue that is still to be seen at the back of the nympheum, though headless, is evidently that of a man, and by his figuration and drapery there is no doubt but that it represents a young river or stream, something quite different from a nymph. It seems right, however, to recognise this picturesque ruin as a nympheum, as one of those buildings the ancients dedicated to springs, rivers, waternymphs, to the never-ceasing supply of water, and which are so frequently met in ancient country estates: there are two very fine and large ones near Lake Albano which belonged to Domitian's villa. The statue of a young man at the back of the nympheum is indeed that of the local spring, perhaps of the Almone to which this spring is tributary.

Antonio Nibby, *Itinerario di Roma* (1830)

The ablest preceptors of Greece and Asia had been invited by liberal rewards to direct the education of young Herod. Their pupil soon became a celebrated orator, according to the useless rhetoric of that age, which, confining itself to the schools, disdained to visit either the forum or the senate. He was honoured with the consulship at Rome; but the greatest part of his life was spent in philosophic retirement at Athens, and his adjacent villas, perpetually surrounded by sophists, who acknowledged, without reluctance, the superiority of a rich and generous rival. The monuments of his genius have perished; some considerable ruins still preserve the fame of his taste and munificence; modern travellers have measured the remains of the stadium which he constructed at Athens. It was six hundred feet in length, built entirely of white marble, capable of admitting the whole body of the people, and finished in four years, whilst Herod was president of the Athenian games. To the memory of his wife Regilla, he dedicated a theatre, scarcely

paraalleled in the empire: no wood except cedar, very curiously carved, was employed in any part of the building.

Edward Gibbon, *The Decline and Fall of the Roman Empire* (1776–1788)

To the ancient Romans Egeria was the nymph or goddess of the fountains. Together with Virbius she was revered at Diana's grove at Ariccia. The lake of Nemi was also considered sacred to her. She was reputed to have been the consort of Numa Pompilius, the mythical king of Rome who succeeded Romulus. According to legend she advised Numa on matters of state and law. In deference to this fable the word Egeria in English means a female advisor or companion. Another aspect of the myth of Egeria was her protection of pregnant women; she was believed to assist in bringing the baby safely from the womb. When Egeria died Diana is said to have changed her into a spring which remained sacred. In Rome she was revered in the grove of the Camenae, located outside the Porta Capena, to the south of the Caelian Hill. This grove had a spring and it was from this well that the Vestal Virgins drew the water which they used in their ceremonies.

With the passage of time the location of the grove and spring was forgotten and there was considerable confusion as to its exact whereabouts. In the seventeenth century the ruined fountain which lies not far from Sant'Urbano was erroneously identified as the celebrated place sacred to the nymph. This crumbling ruin, however, has nothing whatsoever to do with Egeria, and was in fact built as part of the garden apparatus of a villa which belonged to Herod Atticus. Part of this garden was consecrated to the memory of his wife Regilla who died when pregnant with their fifth child. Herod was suspected of having caused his wife's death and when cleared of this accusation set about establishing a funerary cult to her memory, which consisted chiefly in the 'Triopio' which he laid out in the gardens of his suburban villa. The supposed fountain of Egeria undoubtedly formed part of the complex dedicated to the memory of Regilla. The recumbent headless figure reposing there most probably represents the local river god.

The original Fountain of Egeria was in fact located where the grounds of the Villa Celimontana now stand, close by the Baths of Caracalla and the church of Santa Maria in Domnica. It was there that Numa is reported by the classical authors to have held his nocturnal meetings with the nymph Egeria.

55 JAMES BRUCE OF KINNAIRD

KINNAIRD 1730–1794 KINNAIRD

The Nympheum called the Grotta della Ninfa Egeria

Pen and ink with watercolor and wash on laid paper: 495 × 668 mm (image 407 × 624 mm)

Inscribed, recto, bottom right corner, in ink: *J:B 1764–*; bottom center, probably in the artist's hand, in ink: *Grotto of the Nymph Egeria near Rome*; verso, bottom left center, in pencil: *Oppe Reg: 544 Puttich 10/–*

WATERMARK

CONDITION: glue stains around the edges

BODART NO. 110

However, the sufferings of others had no power to lessen Egeria's grief. Prostrate at the foot of the mountain, she melted away in tears, until Phoebus's sister, moved by the devoted affection of the mourning wife, turned her body into a cool spring, and dissolved her limbs into everlasting tears.

Ovid, *Metamorphoses* (about the time of the birth of Christ) (translated by MM Innes)

Egeria! sweet creation of some heart
Which found no mortal resting-place so fair
As thine ideal breast; whate'er thou art
Or wert, – a young Aurora of the air,
The nympholepsy of some fond despair;
Or, it might be, a beauty of the earth,
Who found a more than common votary there,
Too much adoring; whatsoe'er thy birth,
Thou wert a beautiful thought, softly bodied forth.

The mosses of thy fountain still are sprinkled
With thine Elysian water-drops; the face
Of thy cave-guarded spring, with years unwrinkled,
Reflects the meek-eyed genius of the place,
Whose green, wild margin now no more erase
Art's works; nor must the delicate waters sleep,
Prisoned in marble; bubbling from the base
Of the cleft statue, with a gentle leap
The rill runs o'er, and round, fern, flowers, and ivy creep
Fantastically tangled.

Lord Byron, *Childe Harold's Pilgrimage* (1812)

THE present drawing, executed during Bruce's short stay in Italy, has the amateurish charm of many pieces executed by foreign travelers, many of whom took drawing lessons to improve their art. Bruce employed the Bolognese artist Balugani to give him instruction and to assist with documenting the various monuments he visited on his travels. The present sketch would seem to owe little to Balugani, however, and has a quality not unlike that of the sketches by Richard Colt Hoare (*cf* Nos. 79 and 80), who, like Bruce, had ambitions to publish the reports of his travels. An album of drawings by Bruce, of similar dimensions to the Ashby sheet, is at Windsor Castle (Oppé 1950, p.30, no. 94, figs. 35–38).

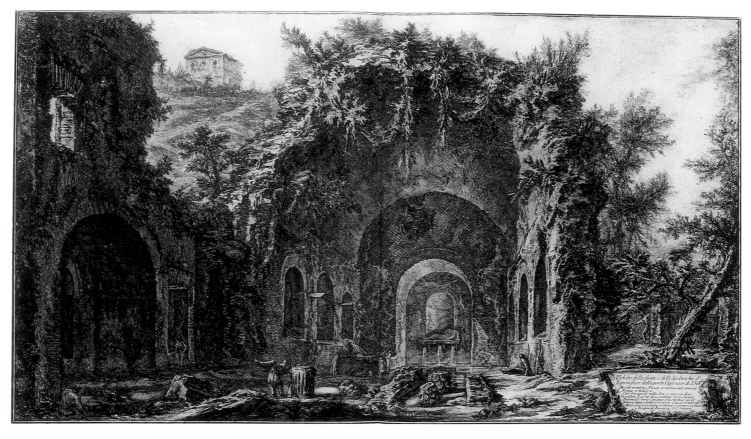

Giovanni Battista Piranesi: *The Nympheum called the Grotta della Ninfa Egeria*

56 CARLO LABRUZZI

ROME 1748–1817 PERUGIA

The Villa Pamphili

Pen and ink with bistre wash with traces of black chalk on laid paper: 395 × 480 mm

Inscribed, verso, bottom center, in pencil: *Villa Pamfili*; below former inscription, in Ashby's hand, in pencil: *These 6 with 8 AB's at Sotheby's / for 2.10.0 Mar / 21*

Ink border

WATERMARK

CONDITION: tear mark, top left center. Fold mark down center

BODART NO. 165

The Pamphili Garden, laid out splendidly by the homonymous Prince; called Bel Respiro; at San Pancrazio. The palace is adorned with a frieze outside, with low reliefs and ancient statues; on the first storey the vaults are adorned with the most elegant stuccoes by Algardi; among the statues above are *Andromeda with Perseus*, in half relief; *Hermaphroditus*, standing, and other statues of empresses and deities, of astonishing antique workmanship; pictures by Annibale Carracci, Guercino, Guido Reni, Caravaggio and other first-class artists.

Giovanni Pietro Bellori, *Nota delli Musei, Librerie, Galerie... di Roma* (1664)

Leaving the Castle of St Angelo, we drove, still on the same side of the Tiber, to the Villa Pamfili, which lies a short distance beyond the walls... At the portal of the villa we found many carriages waiting, for the Prince Doria throws open the grounds to all comers, and on a pleasant day like this they are probably sure to be thronged. We left our carriage just within the entrance, and rambled among these beautiful groves, admiring the live-oak trees, and the stone pines, which latter are truly a majestic tree, with tall columnar stems, supporting a cloud-like density of boughs far aloft, and not a straggling branch between them and the ground. They stand in straight rows, but are now so ancient and venerable as to have lost the formal look of a plantation, and seem like a wood that might have arranged itself almost of its own will. Beneath them is a flower-strewn turf, quite free of underbush. We found open fields and lawns, moreover, all abloom with anemones, white and rose-coloured and purple and golden, and far larger than could be found out of Italy, except in hot-houses. Violets, too, were abundant and exceedingly fragrant; when we consider that all this floral exuberance occurs in the midst of March, there does not appear much ground for complaining of the Roman climate; and so long ago as the first week of February I found daisies among the grass, on the sunny side of the Basilica of St John Lateran. At this very moment I suppose the country within twenty miles of Boston may be two feet deep with snow, and the streams solid with ice.

Nathaniel Hawthorne, *Passages from the French and Italian Note Books* (1858)

THE Villa Pamphili, also known as the Belrespiro, with a perimeter stretching to 6 miles, is the largest park in Rome. Its origins date back to 1630, when Pamphilo Pamphili purchased a small *vigna* on the Janiculum, just outside the Porta San Pancrazio. With the election of Giambattista Pamphili to the papacy in 1644 (taking the name Innocent X), Prince Camillo Pamphili set about expanding and aggrandizing the family property. A new *casino* was designed and elaborate plans were made for the layout of the gardens. Both undertakings were developed simultaneously between 1645 and 1648, at the end of which time the Casino was more or less completed, though work on the gardens continued on for another four years.

The question of the design of the new Casino has given rise to some controversy. The sculptor Alessandro Algardi (1598–1654) was placed in charge of the overall project. In designing the structural details he is thought to have been guided by Carlo Rainaldi (1611–91), the family architect. The artist Giovanni Francesco Grimaldi (1606–80), who also has claims for some parts of the design, is thought to have assisted Algardi with the administration of the construction. As at the Villa Borghese, the Casino was designed not as a residential block, but as a pleasure-house intended for relaxing and entertaining. Its most obvious function was to hold the family's collection of sculpture and paintings. From Falda's engraving of the Casino it would appear that the large central block which rises in the center of Labruzzi's composition was intended to be flanked by side wings which were never realized. The interior of the completed Casino contains stucco reliefs designed by Algardi, with frescos by Giovanni Francesco Grimaldi. The old *casino*, which had sleeping quarters, was retained and refurbished.

The gardens which surround the villa were laid out in a combination of formal plots embellished with grottos, fountains and pieces of sculpture, many of which were damaged in the early 1970s when the villa was opened up to the public. As at the Villa Borghese, the grounds close to the Casino were planted with formal gardens, which dominated both the front and rear perspectives. Originally the layout was severely geometrical, but in the late eighteenth century elements of the French tradition of *broderie* were introduced – which here took the form of representing the heraldic devices of the Pamphili and Doria in trimmed hedgerows. (In the 1760s, when the male line of the Pamphili family died out, the property passed through the female line into the possession of the Doria family from Genoa.)

In the summer of 1849 the villa suffered some damage during the attack on the newly declared Roman Republic by the invading French troops, led by General Oudinot. A fierce battle raged round the nearby Villa Corsini, which was itself completely destroyed during the struggle for this important strategic position overlooking the city.

Apart from this, and Nos. 57, 68 and 70, the Ashby collection holds six other works by Carlo Labruzzi (nos. 163, 166, 167, 169, 171 and 172).

57 CARLO LABRUZZI

ROME 1748–1817 PERUGIA

Gardens of the Villa Borghese

Pen and ink with brown wash and light traces of black chalk:
418 × 492 mm

Inscribed, recto, bottom center, below ink border, in ink: *Veduta di
Villa Borghesi*—; verso, bottom left, in pencil: *C. Labruzzi*

Border of ink

WATERMARK

CONDITION: some slight staining in sky

LITERATURE *Villa Borghese* 1966, cat. no. 45

BODART NO. 164

The Villa Borghese at the Porta Pinciana, a magnificent
building created by the homonymous Cardinal Scipione.
The block is richly adorned on all four sides with antique
reliefs and statues, while inside, among the most famous are
the *Silenus* with the infant Bacchus, whom he holds in his
arm; the *Gladiator*; the *Seneca* in his bath; the porphyry *Juno*;
Cupid riding a centaur; *Hermaphroditus* reclining; the little
Faun, playing the flute; and among the modern works the
metamorphosis into a laurel of *Daphne*, pursued by Apollo,
by Gianlorenzo Bernini. In the villa are also the most
beautiful pictures, and in particular the *Deposition of Christ*
by Raphael in his early style, and *St Anthony* tempted by
demons in a small engraving by Annibale Carracci.

Giovanni Pietro Bellori, *Nota delli Musei, Librerie, Galerie . . . di Roma*
(1664)

This day the Prince Borghese threw open his Park &
Gardens where all the idle of Rome might be amused in the
true stile of the Bartholomew fair in Smithfield — The prin-
cipal Machine & which was intended for the gentealer sort,
was an immense large horizontal Wheel — put in Motion by
a number of People placed in the Center for that purpose —
On the Circumference were alternately fixed large wooden
horses & chairs — the one for the Ladies, the other for the
Gentlemen — just without the Circumference of the Wheel
was fixed a Post, on the top of which was a small brass ring,
for those who entered the Lists, to carry off on the point of
their Lance or javelin — It was so contrived that when one
Ring was taken off, another immediately dropp'd in its
place & those who bore off the greatest number were the
Conquerors of course — It must be owned that the Officers
of his Holiness's Guards exerting themselves with a becom-
ing Emulation, & great adroitness on the Occasion nor
could their becoming gravity & self-complacency be ex-
ceeded by the heroic knight of La Manca —

Thomas Jones, *Memoirs* (14 October 1779)

He who loves the beauties of simple nature, and charms of
neatness, will seek for them in vain amidst the groves of
Italy. In the garden of the Villa Pinciana, there is a plant-
ation of four hundred pines, which the Italians view with
rapture and admiration: there is likewise a long walk of
trees, extending from the garden-gate to the palace; and
plenty of shade, with alleys and hedges in different parts of
the ground: but the groves are neglected; the walks are laid
with nothing but common mould or sand, black and dusty;
the hedges are tall, thin and shabby; the trees stunted; the
open ground, brown and parched, has scarse any ap-
pearance of verdure. The flat, regular alleys of evergreens
are cut into fantastic figures; the flower gardens embell-
ished with thin cyphers and flourished figures in box, while
the flowers grow in rows of earthen-pots, and the ground
appears as dusky as if it was covered with the cinders of a
blacksmith's forge. The water, of which there is great
plenty, instead of being collected in large pieces, or con-
veyed in little rivulets and streams to refresh the thirsty
soil, or managed so as to form agreeable cascades, is
squirted from fountains in different parts of the garden,
through tubes little bigger than common glyster-pipes. It
must be owned indeed that the fountains have their merit in
the way of sculpture and architecture; and that there is a
great number of statues which merit attention: but they
serve only to encumber the ground, and destroy the effect
of rural simplicity, which our gardens are designed to pro-
duce. In a word, here we see a variety of walks and groves
and fountains, a wood of four hundred pines, a paddock
with a few meagre deer, a flower-garden, an aviary, a
grotto, and a fish pond; and in spite of all these particulars, it

is, in my opinion, a very contemptible garden, when compared to that of Stowe in Buckinghamshire, or even to those of Kensington and Richmond.

Tobias Smollett, *Travels through France and Italy* (1766)

You could spend entire afternoons here looking at the evergreen oaks, at the faint bluish tint of their foliage, at their trunks, as thick as English oaks; there is an aristocracy here as there is there, only here the owner of a great patrimony may keep his unproductive trees from the axe. Nearby, the umbrella pines bear up their canopy as straight as columns against the serene blue sky: the eye cannot fail to be fascinated by the unfolding and interpenetrating ranks and rows of stems, by the tremors that flutter them, by the gracious bowing of their noble heads standing free in the open air. At intervals, poplars red with buds raise their shaking tips from their midst. Slowly the sun sinks; shafts of bright light illuminate their half-white trunks, or the sloping lawns full of flowering daisies. The sun sinks further, and the windows of the villa flash; a strange red light hovers about the heads of the statues, and there is a distant strain of an air by Bellini, a faint music that reaches one between the intervals of breeze.

Hippolyte Taine, *Voyage en Italie* (1865)

Rome is burning with the heat: really terrible: but at 4.30 I am going to the Borghese, to look at daisies, and drink milk: the Borghese milk is as wonderful as the Borghese daisies. I also intend to photograph Arnaldo. By the way, can you photograph cows as well? I did one of the cows in the Borghese so marvellous that I destroyed it: I was afraid of being called a modern Paul Potter. Cows are very fond of being photographed, and, unlike architecture, don't move.

Oscar Wilde, *Letter* (21 April 1900)

HIGH on the Pincian Hill, just outside the Porta Pinciana, is the Villa Borghese, the seventeenth-century estate created by Scipione Borghese, the favorite nephew of Pope Paul V (1605–21). Shortly after the election of his uncle to the papacy, Scipione Borghese (1576–1633) set about buying land in this area, adjacent to the family *vigna*, with the intention of creating there an extensive suburban park with a non-residential *casino* set within its landscaped gardens. The layout of these gardens would seem to derive its inspiration from the great villa Hadrian had built at Tivoli *c*134. Their organization, part of which was the work of Girolamo Rainaldi (1570–1655), was neither purely formal nor natural, but rather a combination of both, with the formal element principally arranged about the Casino and in pockets here and there about the outer, more naturally arranged plots.

In his book about the villa published in 1700, D Montelatici described how the original layout of the garden, considerably altered by later interventions, was organized into four main sections which displayed a gradual progression from the more formal Baroque design to a more or less natural parkland. In these gardens visitors could wander about and enjoy the many delights offered by the apparently haphazard arrangement, which included, in the area close to the Casino, parterres, *giardini segreti* with beds of exotic flowers, orange trees, garden pavilions and an aviary. Beyond this were the more naturally planted spaces with meadows and clumps of trees and a lake with two tiny islands, and enclosures for wild animals such as deer, Indian sheep, ostriches and even lions (a merchant from Tunis had presented Cardinal Scipione with a lion, a leopard and two camels). Beyond this again was the outermost corner, located towards the Piazza del Popolo, which consisted chiefly of vegetable plots and flower beds. By 1650 the perimeter of this magnificent park had grown to two and a half miles.

Cardinal Borghese chose Flaminio Ponzio (*c*1560–1613) as the architect for his new villa. Ponzio, however, did not live to see the completion of his designs. On his death his place was taken by the Flemish-born architect Jan van Santen, called Vasanzio (*c*1550–1621), who was involved chiefly with the decoration of the building. The construction proper had been more or less finished by 1616. The design of the Casino is modeled on the type of *villa suburbana* established by Baldassare Peruzzi with the Villa Farnesina almost exactly a century earlier. Unlike the Farnesina, however, the projecting wings of the Borghese do not extend forward to enclose part of the forecourt, but are joined by a loggia which spans the façade. A feature of the garden

PALAZZO DELLA VILLA BORGHESE FVORI DI PORTA PINCIANA ARCHITETTVRA DI GIOVANNI VANSANZIO FIAMMINGO

Scala di palmi 100

Gio·Iac·Rossi le stampa in Roma alla pace cõ pri·del S·P·

Giovanni Battista Falda: *The Villa Borghese*

façade are the two large towers which help to animate the design and give it a somewhat rustic appearance. The walls of the façade were decorated with classical friezes and busts. As stated earlier, the Casino Borghese was designed to serve not as a residential unit but as a place of entertainment, complete with an art gallery and library.

Down through the centuries both gardens and Casino have experienced many changes and greatly altered their original appearance. In the 1770s the British landscape artist Jacob More, whose compositions were favorably compared to those of Claude, was requested to redesign some areas of the garden with the assistance of Giulio Camporese. Other important works were carried out under the supervision of Antonio Asprucci. At about the same time substantial changes were made to the interior of the Casino, notably the magnificent frescoing of the vault of the *salone* by Mariano Rossi in 1782. In 1902 the villa was purchased for the state, along with its fabulous collection of paintings and sculptures, including masterpieces by Raphael, Bernini, Caravaggio and Canova. The garden is now a public park and the Casino a museum.

According to Bodart, this view by Labruzzi shows part of the gardens towards the Piazza di Siena. Bodart also notes that the Villa Borghese inspired another work by Labruzzi, a canvas showing a replica of the Temple of Faustina in the grounds of the Villa, exhibited in Rome in 1966 (*Villa Borghese* 1966).

58 JOHN SMITH called WARWICK SMITH

IRTHINGTON 1749–1831 LONDON

A View of the Via Flaminia

Watercolor: 108 × 176 mm

Inscribed, front of mount, bottom right, in pencil: *John 'Warwick' Smith*; bottom left, in pencil: *1597*; bottom right, in pencil: *18/–*; and: *21/–*; and: *Rome*

CONDITION: good

BODART NO. 299

This small but elegant church was built and dedicated to St Andrew by Julius III, in remembrance of a stroke of fortune that befell him before he became Pope. Giacomo Barozzi da Vignola, the architect, provided it with a beautiful façade of *peperino*, set off with Corinthian pilasters; and it is held to be one of the best and most intelligently designed buildings of modern Rome. It has an oblong interior, again with Corinthian pilasters, and an oval dome. The frescoes in the chapel of St Andrew and on the walls are by Francesco Primaticcio, the pupil of Giulio Romano.

Mariano Vasi, *Itinerario istruttivo di Roma* (1814)

About a mile further on on the left is the small church built by Julius III to the Apostle St Andrew, in remembrance of his delivery from the hands of imperial troops in 1527, on the feast-day of the saint. The architecture is by Giacomo Barozio da Vignola, and is one of the most classically correct buildings of modern Rome. It had been abandoned for some time but is now being restored, with strict regard for the original design.

Antonio Nibby, *Itinerario di Roma* (1830)

THE small church of Sant'Andrea on the Via Flaminia, just beyond the Porta del Popolo, was erected in 1554 for Pope Julius III. In a sense it may be considered to have formed part of the nearby villa erected by Julius III just a short distance outside the Porta del Popolo. This great suburban villa was constructed by the Pope in the grounds of an earlier, smaller property which he had inherited from his uncle, Cardinal Antonio Ciocchi. Julius chose Giacomo Barozzi da Vignola as architect for this important project, though the sculptor Ammanati and the artist Vasari also contributed to the design. Vignola was also assigned the responsibility of designing the small church which was to be dedicated to the Apostle St Andrew.

Julius's decision to dedicate a church to St Andrew is reputedly due to the fact that he won his freedom from the Imperial forces which had sacked Rome so brutally in 1527 on the saint's feast-day (30 November). Though the church is of small dimensions its organization is of some importance in the development of Baroque architecture. The fundamentals of its design involve the placement of a domed cylinder on to a cubed base. The elements of this arrangement derive from the models supplied by such classical remains as the tomb of Cecilia Metella on the Via Appia. Vignola, however, modified the proportions, turning the domed cylinder into an elliptical shape and stretching the square base to a rectangle. This formula of an elliptical dome over a rectangular base was to become one of the favorite motifs of Baroque architecture. Vignola himself developed the design a step further in 1573 with his plans for the small church of the confraternity of Sant'Anna dei Palafrenieri in the Vatican, in which the floor plan also is laid out in an elliptical form.

When built, Sant'Andrea in Via Flaminia presented the viewer with a very different impression than in the late eighteenth century when 'Warwick' Smith painted it, as it was then set in a wooded landscape, with an exquisite laurel grove adjoining it. The young Bolognese artist Pellegrino Tibaldi received one of his first commissions in Rome for the decoration of the interior.

This composition shares the same qualities as its companion (No. 28) showing the Temple of Venus and Rome and must have been done at about the same time. The source of the design is apparently an engraving by the French artist Jérôme-Charles Bellicard (1726–86), published in 1750 under the title '*Tempio di S Andrea nella Via Flaminia*' (*Piranesi et les Français* 1976, fig. 118 bis).

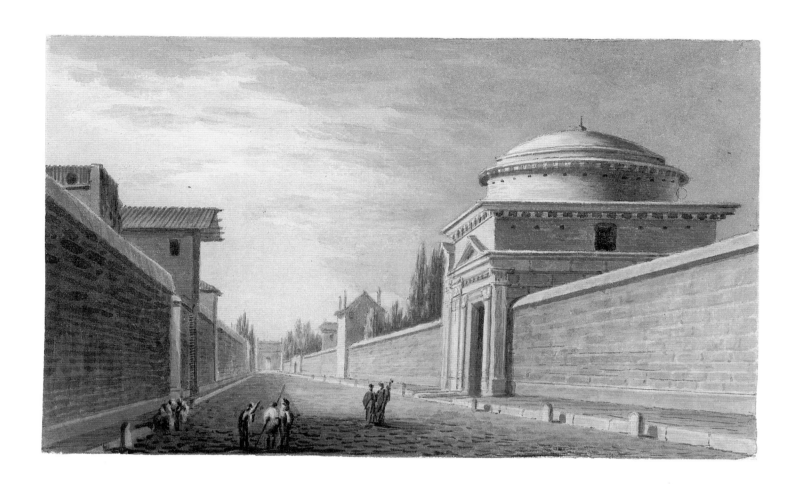

Attributed to

THEODOOR WILKENS

DUTCH *c1675–1748*

The Ponte Milvio

Pen and ink with colored wash on laid paper: 377 × 524 mm

Inscribed, verso, on modern label glued vertically to sheet, typed in blue ink: *Five large Italian Views, in pen & watercolour. Dated 1716.*; on the same strip in pencil, preceding and following the above inscription: *169 . . . 12/6.*; bottom center, in pencil: *Ponte Molle*; bottom left, in brown ink: *No 6*

Border of brown ink

CONDITION: good

BODART NO. 1

Of the dyvers briggis in rome schul we make but schort processe for it is a mater of no grete charge. The first brigg is *pons milvius* of whech I spak be fore whech stant more than a myle fro the north pate of rome and there goo men ouyr tibur that schul to peruse goo or ellis to venyce. It had summe tyme grete touris and mech housyng a boute it as the name of it soundith yet, for milvius is as mech to say as a thousand and be cause the romanes wold not her enmyes schuld entre with inne her wateris yerfor had thei there as it is seyd a thousand assigned to kepying of this brigg.

John Capgrave, *Ye Solace of Pilgrims* (c1450)

You may guess what I felt at first sight of the city of Rome, which, notwithstanding all the calamities it has undergone, still maintains an august and imperial appearance. It stands on the farther side of the Tyber, which we crossed at the Ponte Molle, formerly called Pons Milvius, about two miles from the gate by which we entered. This bridge was built by Aemilius Censor (M Aemilius Lepidus, censor in 179 BC) whose name it originally bore. It was the road by which so many heroes returned with conquest to their country; by which so many kings were led captive to Rome; and by which the ambassadors of so many kingdoms and states approached the seat of the empire, to deprecate the wrath, to sollicit the friendship, or sue for the protection of the Roman people. It is likewise famous for the defeat and death of Maxentius who was here overcome by Constantine the Great . . . Nothing of the antient bridge remains but the piles; nor is there anything in the structure of this, or of the other five bridges over the Tyber, that deserves attention. I have not seen any bridge in France or Italy, comparable to that of Westminster, either in beauty, magnificence, or solidity; and when the bridge at Black-Friars is finished, it will be such a monument of architecture as all the world cannot parallel.

Tobias Smollett, *Travels through France and Italy* (1766)

THE Ponte Milvio, renowned as the site of Constantine's victory over Maxentius in 312, was erected at the point where the Via Flaminia met the Tiber. The Via Flaminia, constructed in 220 BC by the consul Gaius Flaminius, left Rome by the Porta Ratumena and ran for 195 miles to Rimini on the Adriatic coast. The original bridge, almost certainly in wood, must date to the time of Flaminius. The stone replacement, parts of which are still preserved in the existing structure, dates to 109 BC, when the censor M Aemilius Scaurus had it rebuilt. Since that time it has been subject to many interventions, more indeed than any other Roman bridge, as it has been fortified, damaged and repaired on many occasions.

Early restorations had been carried out by Narses (died c573), and again in 1149. Nicholas V (1447–55) had the bridge repaired after it had been damaged in 1405 during the revolt against Innocent VII. The tower which is shown protecting the approaches to the bridge from the right bank was constructed by Calixtus III (1455–58) in the mid-fifteenth century. It was replaced in 1805 when Valadier was commissioned to restore the fabric. Also at this time the wooden walkway leading on to the bridge from the left bank was removed. The bridge itself was badly damaged in 1849 when, to halt the advance of the French troops, one of the central arches was blown up by the Garibaldini. It was again renovated in 1871 and most recently in 1982–84, from which time it has been closed to vehicular traffic. The *edicola* which is visible above the large arch to the right carried an image of the Virgin.

See No. 62 for commentary on the attribution of this composition to Theodoor Wilkens.

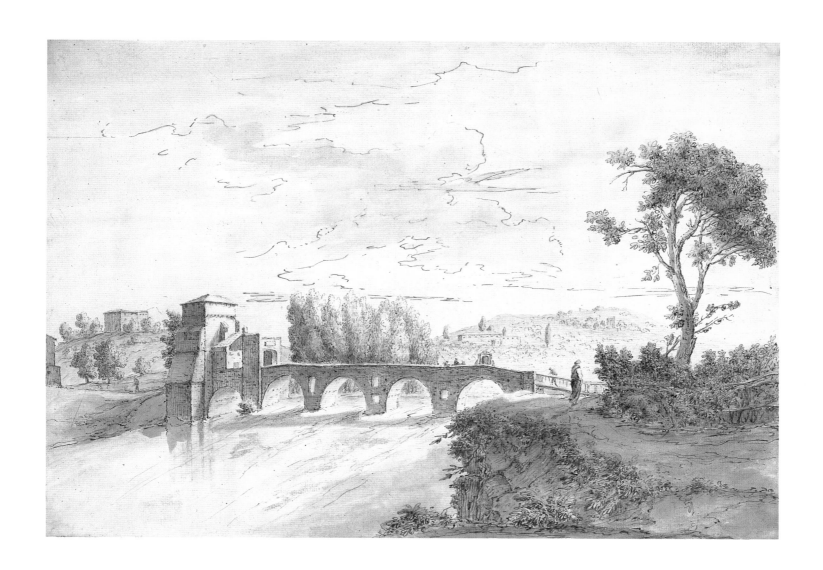

60 WILLIAM MARLOW

SOUTHWARK 1740–1813 TWICKENHAM

The Ponte Milvio

Black chalk with pen and ink and watercolor, laid down: 241 × 376 mm

Inscribed, verso, upper left, in dark brown ink: *1674/W Marlow/Ponte Molle.*

Border of black chalk. Remains of *passepartout* on recto with glue marks and remains of paper

WATERMARK

CONDITION: torn, lacuna in top left corner. Irregularly trimmed along bottom edge

BODART NO. 186

MICHAEL Liversidge, at the University of Bristol, has very kindly confirmed the attribution of this drawing to Marlow. He sees it as entirely typical of the artist's pen outline studies, sometimes executed in gray ink or occasionally in light watercolor washes, and believes the present piece possibly to have been preparatory for a finished watercolor or oil-painting. He has also remarked that a very large number of Marlow drawings went for sale at Christie's on 14 July 1987 (lot 30). Included among the Marlow sketches in this sale was another view of the Ponte Milvio. The original attribution to Marlow of the present drawing is due to an inscription on the verso of the sheet.

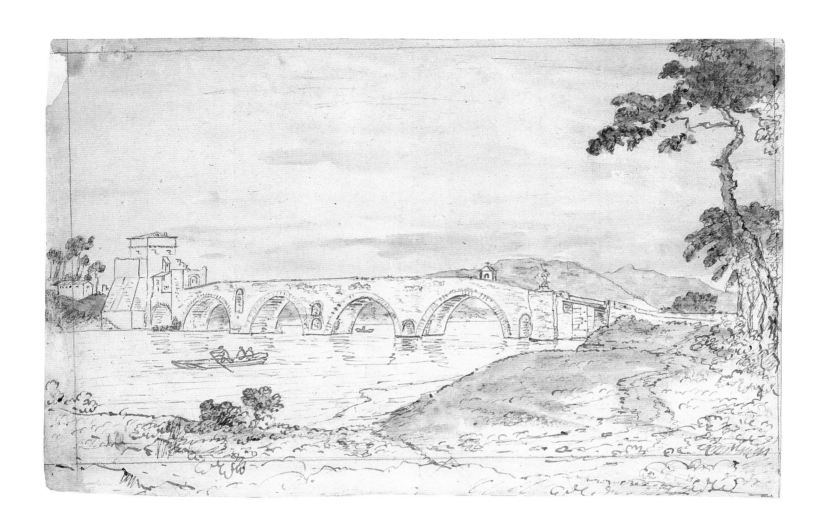

61 RICHARD WILSON

PENEGOES 1713?–1782 COLOMMENDY

Rome viewed from the Ponte Milvio by moonlight

Black chalk with white highlights on paper laid down: 266 × 406 mm

Inscribed, verso, upper right center, in ink: *Study made at Rome Richard Wilson's* / *Casa Madama* / *S¹ Peters etc etc in the distance;* lower right, in pencil: *1397 / Levin 10/–*

WATERMARK

CONDITION: fair

BODART NO. 321

To come again on Rome, by moonlight, after such an expedition, is a fitting close to such a day. The narrow streets, devoid of footways, and choked, in every obscure corner, by heaps of dunghill-rubbish, contrast so strongly, in their cramped dimensions, and their filth, and darkness, with the broad square before some haughty church: in the centre of which, a hieroglyphic-covered obelisk, brought from Egypt in the days of the Emperors, looks strangely on the foreign scene about it; or perhaps an ancient pillar, with its honoured statue overthrown, supports a Christian saint: Marcus Aurelius giving place to Paul, and Trajan to St Peter. Then, there are the ponderous buildings reared from the spoliation of the Coliseum, shutting out the moon, like mountains: while here and there, are broken arches and rent walls, through which it gushes freely, as the life comes pouring from the wound. The little town of miserable houses, walled, and shut in by barred gates, is the quarter where the Jews are locked up nightly, when the clock strikes eight – a miserable place, densely populated, and reeking with bad odours, but where the people are industrious and money-getting. In the day-time, as you make your way along the narrow streets, you see them all at work: upon the pavement, oftener than in their dark and frouzy shops: furbishing old clothes, and driving bargains.

Charles Dickens, *Pictures from Italy* (1846)

THIS view of the Ponte Milvio, with St Peter's and the Vatican in the distance, is one of a series of drawings related to the composition of one of Wilson's large Roman paintings (*Rome and the Ponte Molle*, signed and dated 1754, National Museum of Wales). David Solkin (1982, no. 71) has remarked how Wilson, inspired by the prototypes of Claude Lorrain, has taken some liberties with his subject and arranged the scenery to suit his liking, putting together a view which, though quite plausible, is not in fact possible. This observation confirms the remarks made by Joseph Farington who observed 'Wilson when he painted views seldom adhered to the scene as it was' (*Diary*, V, p.107; 15 December 1808). The Ashby drawing, together with two other full sketches of the scene, explores the variety of light effects which enhance the poetic character of the image. One of these drawings (Huntington Library, California) illustrates the view in a neat crisp style, where the effect is concentrated on form and texture, rather than on the suggestive nocturnal lighting. In the other drawing (collection of the Earl of Cawdor, Stackpole Court) the artist has used copious amounts of white highlighting to achieve the moonlit atmosphere. The Ashby drawing is possibly the freest of the three sketches in terms of technique, though with less highlights than the Stackpole Court image. A reworked version of a detailed sketch for the broken Ionic capitals set in the center foreground is in the collection of Sir Brinsley Ford in London (Ford 1951, no. 15; Solkin 1982 no. 26).

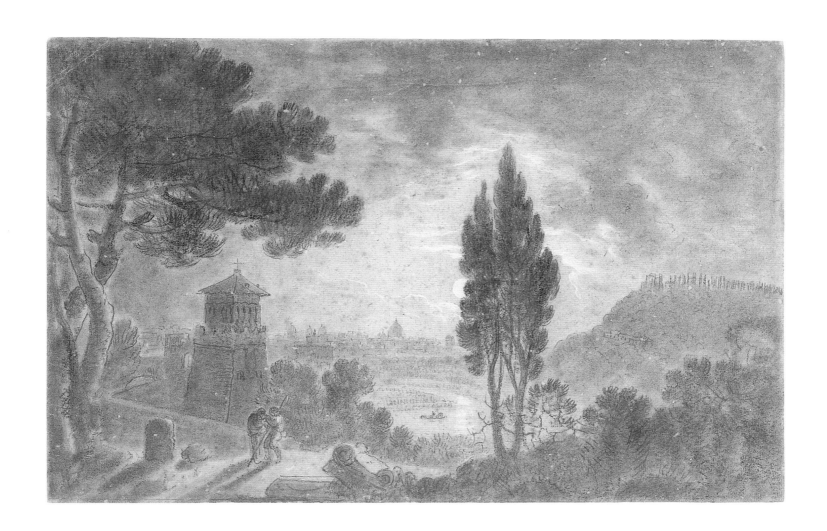

62 *Attributed to*
THEODOOR WILKENS

DUTCH *c*1675–1748

View of the Tiber close to the Fountain of the Acqua Acetosa

Pen and brown ink with colored wash and watercolor on laid paper: 376 × 520 mm

Inscribed, recto, top center, in brown ink: *Veduta dalla Fontana d'aqua acetosa verso il Ponte Milvio/nella campagna di Roma 13 Giugno 1716.*; verso, lower center, in an old hand, in brown ink: *Veduta dalla fontana d'Acqua acetosa verso il Ponte Milvio nella Campagna di Roma 13. Giug°. 1716.*; bottom center, in brown ink: *n° 6*; running vertically on right side, labelled strip typed in blue ink: *Five large Italian Views, in pen and watercolour. Dated 1716.*; in pencil, preceding and following the above inscription: *169 . . . 12/6.*

Border of dark brown ink

CONDITION: good

BODART NO. 2

Acqua Acetosa is a fountain two miles from the Porta del Popolo, of which the water is meant to be medicinal. One gets there by a road close by the Villa Papa Giulio, which leads to a square; one passes under a dark arch where there is an image of the Virgin very devoutly worshipped, and one is there. The fountain is embellished with a fine façade put up by Alexander VII, which is by Bernini, and has the following inscription: *Alex. VII P.M. ut acidulae salubritatem nitidius hauriendi copia & loci amoenitas commendaret, repurgato fonte, additis ampliore aedificatione salientibus, umbraque arborum inducta, publicae utilitati consuluit A.S.* MDCLXI [Alexander VII Supreme Pontiff, having regard to public utility, in order to enhance the health-giving quality of the mineral water by a clear and abundant draught and a delightful setting, cleansed the source, added outlets, enlarged the fountain and planted shady trees in the Year of the Saviour of the World 1661]. The water of the fountain is purgative, as is the sediment if it is distilled; it derives its taste and powers from soluble calcareous elements in the local *pozzolano*.

Joseph-Jérome Lefrançois de Lalande, *Voyage d'un François en Italie fait dans les Années 1765 & 1766*

Tischbein has left; his studio has been cleaned and tidied, so that I am enjoying living in it. At this season a pleasant refuge is an absolute necessity. The heat is terrific. I get up at dawn and walk to the Acqua Acetosa, a mineral spring about half an hour's walk from the Porta del Popolo, where I live. There I drink the water, which tastes like a weak *Schwalbacher*, but is very effective. I am home again by eight, and set to work in whatever way the spirit dictates.

Johann Wolfgang von Goethe, *Italian Journey* (5 July 1787) (translated by W H Auden and E Mayer)

On the right of the palace is an arch, called the Arco Oscuro, beyond which, after a mile or so, you reach a spring of mineral water, called the Acetosa after its vinegary taste. Alexander VII adorned it, as you see it today, to a design by Bernini.

Antonio Nibby, *Itinerario di Roma* (1830)

Close to the Villa Papa Giulio is the tunnel called Arco Oscuro, passing which, a steep lane, with a beautiful view towards St Peter's, ascends between the hillside of the Monte Parione, and descends on the other side (following the turn to the right) to the Tiber bank, about two miles from Rome, where is situated the Acqua Acetosa, a refreshing mineral spring like seltzer water, enclosed in a fountain erected by Bernini for Alexander VII. There is a lovely view from hence across the Campagna in the direction of Fidenae (Castel Giubeleo) and Tor di Quinto.

Augustus Hare, *Walks in Rome* (1893)

T HE fountain of the Acqua Acetosa, located about a mile upstream from the Ponte Milvio, was a popular haunt for Romans both for the quality of its somewhat acid-tasting yet salubrious water and for the natural beauty of the surrounding countryside, which had earned the locality the appellation Valle del Pussino, or Poussin's Valley, it had featured in so many of the French artist's pictures. These natural attractions were enhanced in 1631 when Paul V commissioned Vasanzio to construct a modest fountain there bearing the inscription: *Quest'acqua salutare fa bene ai reni, allo stomaco, alla milza ed al fegato, ed è utile a mille mali* [This health-giving water is good for the kidneys, the stomach, the spleen and the liver, and is effective against a

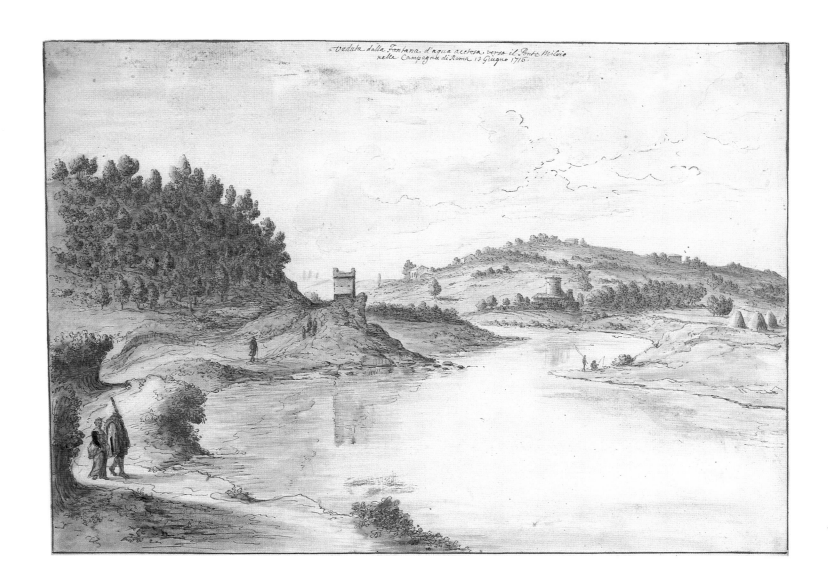

Veduta della Fontana d'aqua acetosa verso il Ponte Milvio
nella Campagna di Roma 13 Giugno 1715.

thousand ills]. Between 1660 and 1662 a new fountain, commissioned by Alexander VII, was erected according to the designs drawn up by Andrea Sacchi (and not Bernini as stated erroneously in many early guides). This fountain exists to the present day.

According to Bodart the circular tower located on the right bank of the river is the Tor di Quinto, probably so called because it was five miles distant from Rome, though it is also conjectured that it is named after Titus Quinctius Cincinnatus who is reputed to have retired to this spot in 439 BC having fought the Volsci and the Aequi then threatening the city. The origins of the Tor di Quinto must date back to the time of Pope Adrian I (772–95), when it would have served to defend the road to Rome, protecting both the city and the church beside it. The Tor di Quinto, however, is known to have been rectangular in shape whereas the present structure is circular. Almost certainly the round tower represented in the present view is the Torre Lazzaroni, erected over the remains of an old Roman tomb. In the sixteenth century it was known as the Torre de'Massimi. The area also possessed other towers; in 814 Leo IV had a series of towers built at regular intervals in this locality to provide extra protection for the city. These were later abandoned and eventually most of them disappeared or were incorporated into subsequent structures.

The small rectangular edifice perched on the outcrop above the left bank of the river may be identified as a small votive chapel. The tiny structure is represented in views of this scene by other artists, including Claude, Breenbergh and Richard Wilson.

In Bodart's catalogue of the Ashby collection, this drawing and its two companions (No. 59, Bodart no. 1, and Bodart no. 3) were attributed to John Alexander (c1690–1765), an English artist who traveled to Italy around 1711–14 and remained there till 1719. However, the proposal that these three compositions are by the same hand as the signed drawing by Alexander in the British Museum (inv. no. 1869–6–12–581), depicting Santa Croce in Gerusalemme, cannot be sustained. The works are quite different stylistically as well as carrying inscriptions which are patently in a different script. An Zwollo has made the suggestion (oral communication) that the three views are all by the little known Dutch artist Theodoor Wilkens, who was active in Rome between 1710 and 1717. Comparison with the known works of the artist, particularly with some of his compositions in the Staatliche Museen in West Berlin and the Statens Museum in Copenhagen (see Zwollo 1973 figs. 107, 108) is enlightening and would appear to confirm that Wilkens is indeed responsible for the Ashby views. The Wilkens material has the same scratchy penwork, similar figure types, and, according to Zwollo, the same unusual coloring in some instances. They also bear rather lengthy inscriptions in a like hand.

63 CLAUDE GELLEE *called* CLAUDE LORRAIN

CHAMAGNE *c*1602–1682 ROME

The Ponte Salario

Pen and brown ink with gray-light brown wash on paper, laid down: 184 × 317 mm

Inscribed on back of mount, in Ashby's hand, in pencil: *Meatyard 16.VII 20. £2:13:0 / Ponte, Nomentano*; on front of windowed mount, bottom right, in pencil: *cat* – *Breenberg* – *Fairfax Murray Coll.* – *S 5521 – 3/10–*

CONDITION: some stain marks along the top of the drawing

PROVENANCE: Fairfax Murray; Adolphus Frederick, Duke of Cambridge, 1774–1850 (Lugt 118; collection sold London, Sotheby's 28 November 1904)

BODART NO. 182

In any case, this was the year [361 BC] in which the Gauls encamped at the third milestone on the Salarian road, beyond the bridge over the Anio. The dictator, having, by reason of the Gallic rising, proclaimed a suspension of the courts, administered the oath to all of military age. Then marching out of the City with a great army he pitched his camp on the hither bank of the stream. There were frequent skirmishes for the possession of the bridge, and yet, so evenly matched were their forces, it could not be determined who were masters of it. Then a Gaul of extraordinary size advanced upon the empty bridge, and making his voice as loud as possible, cried out, 'Let him who Rome now reckons her bravest man come out and fight, that we two may show by the outcome which people is the superior in war.'

Livy, *History of Rome* (early 1st century AD)
(translated by B O Foster)

About two miles northward of the Pons Nomentanus is the Pons Salarius, Ponte Salario, remarkable for the well known combat between Manlius Torquatus and the gigantic Gaul, as also for the neighbouring encampment of Hannibal, when he approached the city, and by threatening Rome itself hoped to terrify the consuls and induce them to raise the siege of Capua. The traveller may then return by the Via Salaria and re-enter the city by the gate of the same name.

The Rev John Chetwode Eustace, *A Tour through Italy* (1813)

The Ponte Salario by which the road crossed the Anio has been thrice destroyed in comparatively modern times, and little of the ancient structure now remains except the greater portion of the small arches on each side. It was cut in 1849 for a length of 15 metres by the French in their attack on Rome (*Rapport de la Commision Mixte pour constater les dégâts, etc.* [Paris, 1850], 42). A photograph of it after it was blown up in 1867 is given in Lanciani's *Destruction of Ancient Rome*, p. 149, fig. 26. Canina (*Edifizi*, VI, tav. 178) gives views of it. It had one central arch and two smaller side-arches of tufa with voussoirs of travertine. The parapets, which were thrown into the river in 1798, bore the inscription of Narses, who restored the bridge under Justinian in AD 565 (C.I.L. vi, 1199). On the left of the road a little beyond the bridge is a large tomb of tufa concrete (the facing of rectangular blocks of stone has disappeared) with

a chamber in the form of a Greek cross and a mediaeval tower above. The staff map marks ruins on the right also, but the loose blocks in the field at this point belong to the old bridge.

Thomas Ashby, *The Roman Campagna in Classical Times* (1927)

THE Via Salaria, said by Pliny to derive its name from the salt trade which passed this way from Ostia to the north, crosses the Aniene river about two miles north of Rome. The original Roman structure, probably of wood, can be dated at least as early as the fourth century BC, and almost certainly its origins go back further still. The later stone fabric, of which some remnants still remain, was most probably constructed during the late Republican period. That particular structure had a long and chequered history. Badly damaged by Totila in 544, it was rebuilt by Justinian's great general, Narses, in the year 565. His contribution was recorded in inscriptions carved on the two balustrades:

Narses vir gloriosissimus... after his victory over the Goths... and having re-established the freedom of Rome and of all Italy, restored the bridge of the Via Salaria which had been destroyed as far as the water by the infamous Totila, and having cleared the river-bed arranged it in such a manner that it was better than it had ever been.

The defensive tower which dominated the northern end of the bridge may have been put there by Narses, though it has also been proposed that it was a later addition put in place by the Longobards in 728 when they came to assist Gregory II in his struggle with Paolo Patrizi. In December 1798 the bridge was badly damaged by the retreating French troops. It was practically demolished some 30 years later in 1829 when its defensive tower was razed. Damaged again in 1849, it was finally destroyed on 29 October 1867, when the pontifical army blew it up to defend Rome against Garibaldi who was then advancing on the city from Monte Rotondo. The modern structure was erected in 1874.

This drawing bears a traditional attribution to Claude, under whose name it was catalogued when in the possession of the noted collector Fairfax Murray. Marcel Roethlisberger, though he only knew the composition from a reproduction, accepted this attribution in his monograph on the artist's drawings (Roethlisberger 1968, no. 166), stating that the same motif, in an extended landscape, appears on a large pen drawing in Rotterdam by an imitator of Claude (*ibid*, no. 405). Michael Kitson (oral communication) also accepts Claude's authorship, though he, too, only knows the piece from reproductions. Bodart notes that Ashby considered the drawing to be by Bartholomeus Breenbergh. Roethlisberger dates the sketch to 1635–40.

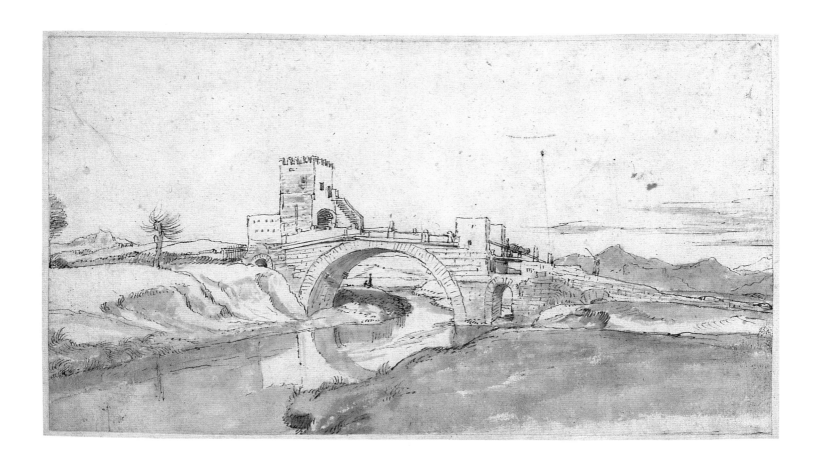

64 ANONYMOUS

18th Century

Sant'Agnese fuori le Mura and Santa Costanza

Verso: another view of the same scene, inverted, in black chalk and partially worked in pen and brown ink

Black chalk with pen and brown ink on laid paper: 129 × 226 mm

Inscribed, recto, bottom right, only partially legible, in ink: *N91…*; verso, top right corner, in ink: *664*

WATERMARK

CONDITION: lacunae, top left corner. Some staining

BODART NO. 421

Without the gate, as it is now called, of Santa Agnesa, and by the antients Viminalis, from the name of the hill where it is placed, the following temple is to be seen pretty intire, which is dedicated to Santa Agnesa.

I believe that it was a sepulchre, because there was a very large case of porphyry found in it, very beautifully carved with vines, and little children gathering grapes; which has made some believe it was the temple of Bacchus. And because it is common opinion, and now serves for a church, I have placed it among the temples.

Before its portico the vestigia of a court are to be seen, of an oval form, which I believe was adorned with columns, and niches in the intercolumniations, which must have been for its statues.

The loggia of the temple, by what is to be seen of it, was made of pilasters, and had three openings. In the inward part of the temple there were columns placed two and two, which supported the cuba.

All these columns are of granate; and the bases, the capitals, and the cornice of marble. The bases are in the Attick manner. The capitals are of the Composite order, very beautiful, and have some leaves which project from the rosa, from which the voluta's seem to spring very gracefully. The architrave, the frize, and cornice are not very well wrought; which makes me believe that this temple was not made in good times, but in those of the latter emperors. It is very rich with works, and with various compartments; part of them of beautiful stones, and part of

Mosaick work, as well in the pavement, as in the walls, and in the vaults.

Of this temple I have made three plates.

Andrea Palladio, *Quattro Libri dell'Architettura* (1570) (translated by Isaac Ware)

LIKE St John Lateran and Santa Croce in Gerusalemme, the basilica of Sant'Agnese fuori le Mura and the round church of Santa Costanza were imperial foundations dating back to the time of Constantine and his family. Located outside the city, just off the Via Nomentana, they were erected near the burial ground in which the body of the young martyr Agnes had been interred.

Sant'Agnese was erected in the year 342 by Constantina, the eldest daughter of the Emperor. The structure, which now lies in ruins, was sited, not above the tomb of the martyr, but close by, as was the early practice (exemplified by San Lorenzo and San Sebastiano. St Peter's, built directly above the tomb of the Apostle, broke with contemporary custom). The skeletal apse of this venerable structure (300 by 130 feet), with its great fan-like arrangement of buttresses, stands to the south of the replacement basilica constructed by Pope Honorius (625–38), after the Constantinian fabric had already required substantial repairs during the pontificate of Symmachus (498–514). It is interesting to note that old guides considered the ruins of the Constantinian basilica to be the remains of a hippodrome or circus.

The new basilica put up by Honorius, who was tireless in his enthusiasm for the restoration of the Early Christian churches, was placed above the *martyrium* of the saint, and its construction was paid for by the Church. Repairs were made necessary in 775 following the attack on Rome by Astolfo and his army. The church was further damaged in 1241 by the forces of the Emperor Frederick II; restoration was carried out by Pope Alexander IV (1254–61). More work was commissioned by Cardinal Giuliano della Rovere, the future Pope Julius II, in 1479. Further repairs were required in the wake of the sack of Rome in 1527 and again in 1720. Sant'Agnese was again restored by Pope Pius IX in 1856. An interesting feature of this basilica is the *matroneum*, a gallery accommodating the female worshippers. A splendid mosaic depicting St Agnes standing between two popes, Honorius and Symmachus (?), decorates the apse.

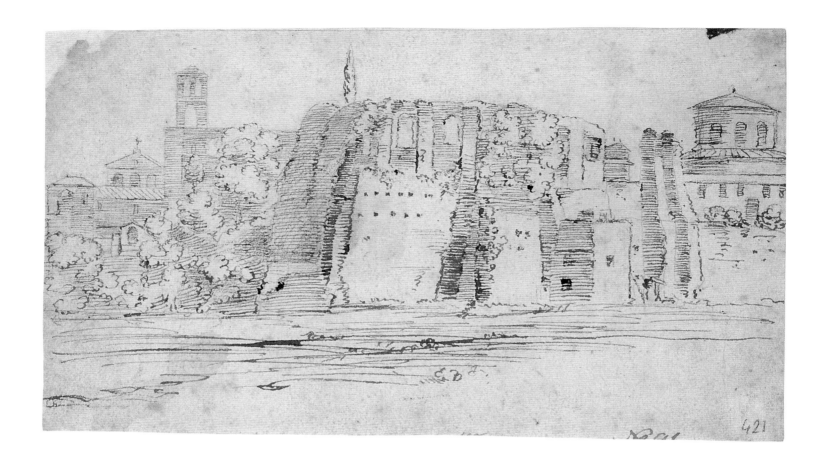

421

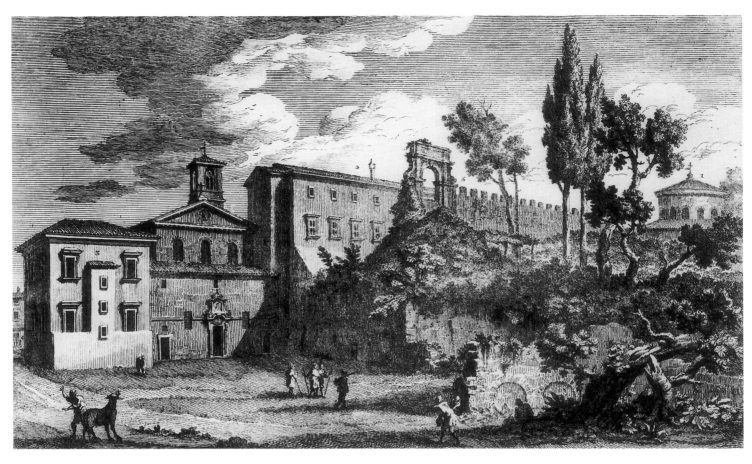

Giuseppe Vasi: *Sant'Agnese fuori le Mura and Santa Costanza*

The circular mausoleum of Santa Costanza, which is shown to the right of the composition in this anonymous drawing, was built between 337 and 354 as a sepulchral chapel for Constantine's two daughters, Constantina and Helena, wife of Julian the Apostate. It is an impressive building consisting of a central, domed space, 37 feet in diameter, which rests on a colonnade of twelve coupled granite columns. This in turn is surrounded and buttressed by a barrel-vaulted ambulatory exquisitely decorated with fourth-century mosaics, which, though pagan in form, are Christian in their symbolism. The grapevine motif running through them led early scholars to believe that the building was dedicated to Bacchus, though it is almost certain that the symbolism is Eucharistic. The mosaics originally in the vault and the marble decoration of the walls have been lost. The mausoleum was most probably used as a baptistery for nearby Sant'Agnese during the Middle Ages. It was converted into a church in 1254.

It was in Santa Costanza that the fraternity of Netherlandish artists known as the Schildersbent, founded in 1623 and disbanded in 1720, used to meet for their outlandish rituals and festivities, considered by contemporaries to have bordered on the sacrilegious. The magnificent antique sarcophagus of the Mausoleum, since removed to the Vatican, was used as a makeshift altar for their bizarre ceremonies.

This drawing shows the Honorian basilica to the left, the ruins of the original Constantinian construction in the center and Santa Costanza to the right. Though of interest from a topographical point of view, the drawing displays little artistry. It would seem to date from the eighteenth century.

65 ANONYMOUS

16th century

An unidentified Roman tomb, with ground plan

Pen and ink: 392 × 206 mm
Inscribed, verso, in ink: 49:
WATERMARK
CONDITION: some staining
BODART NO. 334

For which Reason, as I had always the highest Esteem for the Prudence of our Ancestors in all their Institutions, so I particularly commend them for that Custom of theirs, whereof we shall speak immediately, by which, though in it they aimed at much greater Ends, they afforded so much Recreation to Travellers. It was a Law of the twelve Tables, that no dead Body should be interred or burnt within the City, and it was a very ancient Law of the Senate that no Corpse should be interred within the Walls, except the Vestal Virgins, and the Emperors, who were not included within this Prohibition. Plutarch tells us, that the Valeri and the Fabricii, as a Mark of Honour, had Privilege to be buried in the Forum; but their Descendants, having only set their dead down in it, and just clapt a Torch to the Body, used immediately to take it up again to bury it elsewhere; thereby shewing that they had such a Privilege, but that they did not think it decent to make use of it. The Ancients therefore chose their Sepulchres in convenient and conspicuous Places by the Side of Highways, and embellished them, as far as their Abilities and the Skill of the Architect would reach, with a perfect Profusion of Ornaments. They were built after the noblest Designs; no Columns or Pilasters were spared for, nor did they want the richest Incrustations, nor any Delicacies that Sculpture or Painting could afford; and they were generally adorned with Busts of Brass or marble finished after the most exquisite Taste: By which Custom how much that prudent People promoted the Service of the Commonwealth and good Manners, would be tedious now to recapitulate. I shall only just touch upon those Points which make to our present Purpose. And how, think ye, must it delight Travellers as they passed along the Appian Way, or any other great Road, to find them full of a vast Number of Tombs of the most excellent Workmanship, and to be every Moment picking out some more beautiful than the rest, and observing the Epitaphs and Effigies of the greatest Men? Do you not think that from so many Monuments of ancient Story, they must of Necessity take continual Occasion to discourse of the noble Exploits performed by those Heroes of old, thereby sweetning the Tediousness of their Journey, and exalting the Honour of Rome, their native City? But this was the least of the good Effects which they produced; and it was of much more Importance that they conduced not a little the Preservation of the Commonwealth, and of the Fortunes of private Persons. One of the chief Causes why the Rich rejected the Agrarian Law, as we are informed by the Historian Appian, was because they looked upon it to be an Impiety to suffer the Property of the Tombs of their Forefathers to be transferred to others. How many great Inheritances may we therefore suppose them to have left untouched to their Posterity, merely upon this Principle of Duty, Piety or Religion, which else would have been prodigally wasted in Riot and Gaming? Besides that those Monuments were a very great Honour to the Name of the City itself, and of a great Number of private Families, and was a constant Incitement to Posterity to Imitate the Virtues of those whom they saw so highly revered. Then again, with what Eyes think you, whenever such a Misfortune happened, must they behold a furious and insolent Enemy ransacking among the Sepulchres of their Ancestors? And what Man could be so base and cowardly, as not to be immediately inflamed with Rage and Desire of revenging such an Insult upon his Country and Honour? And what Boldness and Courage must Shame, Piety and Grief stir up in the Hearts of Men upon such an Occasion? The Ancients therefore are greatly to be praised; not that I presume to blame the present Practice of burying our Dead within the City, and in Holy Places, provided we do not lay them in our Temples . . . so as to pollute the most sacred Offices with the noisome Vapours of a rotting Corpse. The Custom of burning the Dead was much more convenient.

Leon Battista Alberti, *The Ten Books of Architecture* (mid-15th century)
(translated by Giacomo Leoni)

As soon as we have crossed the Almo, the series of tombs on each side of the Via Appia begins to be prominent. We first see a huge mass of concrete on the left, which is generally attributed to Geta; and a similar mass on the right, with an internal chamber, which is usually called the tomb of Priscilla, the wife of Abascantus, freedman of Domitian. The grounds for these attributions are in both cases insufficient.

At the second mile, according to Pliny the Elder, was situated the *Campus Rediculi*, where a pet crow of Tiberius was buried, and there is every likelihood that it was connected with the *fanum Rediculi*, the sanctuary of the divinity who, it was believed, caused Hannibal to turn back from his advance on Rome.

On the left is the church of *Domine Quo Vadis?* which takes its name from the well known legend that St Peter, flying from Rome, met Our Lord, and asked him the question. Our Lord replied, *Vado iterum crucifigi*, and St Peter returned to the city to meet his death. A paving stone on the road, with the imprint of Our Lord's footsteps (as is believed) is still preserved in the church. The legend can be traced back as far as the third century, and was accepted as genuine by St Ambrose.

Thomas Ashby, *The Roman Campagna in Classical Times* (1927)

I N classical times the great roads leading out of Rome presented a vastly different appearance to the traveler than they do today. In Republican and imperial times these routes were popular sites for the villas of wealthy patrician families. Sometimes vast villas were established, not simply as luxurious retreats away from the noisy and unsalubrious air of the city, but frequently as working farms earning income from the production of foodstuffs for the nearby metropolis.

In Roman law it was forbidden to bury the dead inside the city and as a consequence another feature of the main roads was the great number of tombs which were erected along their length; these began just beyond the city gates and continued several miles out into the countryside, although it should be remembered that the more humble communal cemeteries known as *colombaria* were also to be found at intervals among them. Frequently, many of the most imposing tombs were erected close to the site of the family estate. The catacombs, famous as the burial grounds and meeting places of the early Christians, were part of this tradition and in fact were used by all of the community, pagans, Jews and Christians alike.

The Via Appia is the only Roman road which still retains some semblance of its original appearance, with the ruins of many of its varied tombs still visible along the first 10 miles of its length. Built in 312 BC, it was the first Roman road to be named after the man who commissioned it, the Censor Appius Claudius Cecus. Early highways had been called after their town of destination, such as the Via Ostiensis, or the trade which they supported, like the Via Salaria, which carried the traffic of salt. Originally the Via Appia went only as far as Capua; later works, however, extended its length to Brindisi.

The subject of this composition has not been identified and it cannot yet be determined whether or not the view illustrates a real Roman tomb, since destroyed, or some artist's or architect's invention. The structure represented is close in style to a number of ancient monuments which line the route of via Appia Antica, notably the ruin of the building known as the Temple of the Deus Rediculus, though the design in fact resembles even more closely that of the two unnamed monuments simply identified as Tombs nos. 71 and 74 in the census of the Appian monuments currently being compiled (information courtesy of the staff of the Biblioteca Hertziana; see Burns 1983, note 26).

66 *Attributed to*

JACQUES-FRANÇOIS AMAND

PARIS 1730–1769 PARIS

The Sedia del Diavolo

Black chalk on laid paper: 232 × 377 mm

Inscribed on back of mount, upper left center, in pencil: *1880*

WATERMARK

CONDITION: good

BODART NO. 123

Whether it be most adviseable to build a Sepulchre which we would have, if possible, endure to Eternity, of noble or mean Materials, is not thoroughly determined, upon Account of the Danger of their being removed for their Value. But the Beauty of its Ornaments, as we have observed elsewhere, is extremely effectual to its Preservation, and to securing the Monument to Posterity. Of the Sepulchres of those great Princes *Caius Caligula*, and *Claudius Caesar*, which no doubt must have been very noble, nothing now remains but some small square Stones of two Cubits broad, on which their Names are inscribed; and if those Inscriptions had been cut upon larger Stones, I doubt not they too would e'er now have been carried away with the other Ornaments. In other Places we see Sepulchres of very great Antiquity, which have never been injured by any body, because they were built of common Chequerwork, or of Stone that would not adorn any other Building, so that they were never any temptation to Greediness.

Leon Battista Alberti, *The Ten Books of Architecture* (mid-15th century) (translated by Giacomo Leoni)

On the left-hand side of the road, some 200 yards away in the valley, is the tomb known as the Sedia del Diavolo, a very fine specimen of work of the second or third century AD consisting of two chambers one above the other, the upper one with fine ornamental brickwork.

Thomas Ashby, *The Roman Campagna in Classical Times* (1927)

THE monument commonly known as the Sedia del Diavolo is located about three miles beyond the city, in Piazza E Callistio, just off the ancient Via Nomentana, which like all the other great Roman roads had a number of tombs sited along its course. Its name is seemingly derived from its ruined shape, which in ages past, because of its location and seat-like form, excited the imagination of travelers who considered it a sinister remnant of the cruel days of pagan Rome. The two-storied tomb (which Bodart mistakenly identified as part of the Gordian complex along the Via Prenestina) has been dated to the middle of the second century AD.

Previously attributed to the artist Jean Chauffourier (1679–1757), who gave instruction to Mariette in the art of drawing, this composition, and its companion presenting a view of the Torre degli Schiavi (No. 67) are here given to the artist Jacques-François Amand, active in Rome from 1759 to 1763. Bodart's view that both these drawings share the same stylistic characteristics as the Chauffourier sketches in the Louvre (Guiffrey and Marcel 1909, III, nos. 2252–2254) does not stand up to scrutiny, though there are some points of comparison which might suggest the name of Chauffourier, particularly the figure style. An attribution to Amand, proposed by Jean-Pierre Cuzin (letter to the author, 1987), is much more convincing if not altogether conclusive. Certainly, the overall effect is more typical of Amand, with strong emphatic lines employed to model forms and spikey foliage used to animate the foreground. Chauffourier's work is much more even and controlled by comparison, with the shading and modeling achieved by neat repetitive strokes. Chauffourier's figures, though they share a pedigree with those populating Amand's compositions, do not have the same almost spectral quality. The Louvre has 16 drawings by Amand, ten of which were once in the collection of Mariette (see *Dessins Français du XVIIIᵉ siècle* 1967, nos. 81–82).

67 Attributed to

JACQUES-FRANÇOIS AMAND

PARIS 1730–1769 PARIS

The Torre de' Schiavi

Black chalk on paper: 232 × 377 mm

Inscribed, verso, bottom left, in pencil: *Hubert Robert*; in corner: *3/10/-*; on front of mount, bottom right, in pencil: *Hubert Robert*; bottom right corner, in pencil: *3/10/-*; reverse of mount, bottom center, in pencil: *Meatyard 16.vii.20 £2:15:0*

WATERMARK

CONDITION: good

BODART NO. 122

Not far from the Porta Labicana, now called Maggiore, there are many ancient tombs in the countryside, and among them a round shrine known vulgarly as the Torre de' Schiavi. It is very well built and well designed; once upon a time the whole ceiling was painted with beautiful figures, but these cannot now be made out because of the smoke [of the fires] of the shepherds, who here take refuge with their flocks. In other buildings nearby there are traces of stucchi of an excellent taste, or the panelling for them. Some remains of painting have been retrieved from the ruins, notably a little picture in the Palazzo Farnese showing two *putti* playing with a mask in amongst a twining pattern.

Giovanni Pietro Bellori, *Nota delli Musei, Librerie, Galerie... di Roma* (1664)

THE group of imposing buildings located about two and a half miles from the Porta Maggiore along the Via Prenestina is commonly identified as the Villa of the Gordiani, a family which gave Rome three emperors during the second quarter of the 3rd century AD. The complex, which extends for nearly a mile along the beautifully preserved old Roman road with its polygonal basalt paving, in ancient times was compared to the magnificent Villa of Hadrian at Tivoli, on account of its sheer dimensions, and its ostentatious display of wealth and luxury. Precisely how much of this vast park of ruins actually formed part of the Villa of the Gordiani is debatable. The structures which remain would seem to date mostly from the second to the fourth century, though there are some which may be dated to the late Republican period.

The most impressive of all these ruins is the rotunda generally known as the Torre de'Schiavi, so called after the family which owned it during the sixteenth century. This ruin, because of its marvelous design and informative state of preservation, was a popular subject for archaeologists to study and for artists to sketch. It originally constituted a two-storey structure formed of a cylindrical drum 56 feet in diameter surmounted by a dome. The lower section was a sort of crypt organized in a sequence of curved and rectangular niches arranged about the perimeter walls. As can be seen from the drawing, the upper section also had a sequence of niches which were lit by four great circular openings. The large gaping hole in the edifice before which one can detect a mass of rubble is where the magnificent portico must have stood. This may have had a vaulted, centrally arched form in place of the more conventional flat architrave. According to the nineteenth-century archaeologist Antonio Nibby the rotunda might have functioned as a *heroön* with the ashes of the deceased placed in the crypt and their statues placed in the niches above. In the Middle Ages the building was used as a church, possibly dedicated to St Andrew. Tile stamps indicate that the structure must date to about AD 300.

For discussion arguing the attribution of this drawing to Jacques-François Amand see No. 66.

68 CARLO LABRUZZI

ROME 1748–1817 PERUGIA

The Ponte Lucano, near Tivoli

Black chalk with ink and colored washes, on gray paper, laid down: 372 × 601 mm

Inscribed on front of support, bottom right, in ink: *Vue de Ponte-Lugano avec le Tombeau de / Plautius pres de Tivoli*; on back of support, bottom left, in pencil: *Meatyard 16. VII. 1920 £2:13:0*; top left, written vertically, in pencil: *Plautius*; on front of windowed mount, bottom right, in pencil: *Original drawing by C. L. Clerisseau / 1722–1820*; bottom right, in pencil: *. . . 3/10/–*; printed label pasted to center of mount: *VUE DU PONTE-LUGANO AVEC LA TOMBEAU DE PLAUTIUS DE TIVOLI*

CONDITION: slight discoloration in sky, with some light foxing

BODART NO. 170

To go to Tivoli, which is six leagues east of Rome, one leaves by the Porta di San Lorenzo; one twice crosses the Teverone, formerly the Anio, a river celebrated in the history of Rome — there are actually four bridges over this river: the Ponte Salario, on the ancient via Salaria; the Ponte Lamentatno, formerly the Pons Nomentanus, on the Via Nomentana; the Ponte Mamolo; and the Ponte Lucano, which are both on the Via Tiburtina, or the road to Tivoli . . .

The Ponte Lucano, which is 15 miles from the Porta di San Lorenzo, derives its name from having been built after the victory of the Romans over the Lucanians; it was rebuilt by Tiberius Plautius, who accompanied the emperor Claudius on his expedition against Great Britain; the inscription can be found in Gruter's compilation.

Joseph-Jérome Lefrançois de Lalande, *Voyage d'un François en Italie fait dans les Années 1765 & 1766*

This magnificent tomb was raised by the Plautii, a family of great honour in the Republic and under the Emperors. It is built of Tivoli stone, called travertine, in the form of a round tower, with the entablature at half its height, and it resembles the Tomb of Cecilia Metella. Subsequent to the construction of the round part, the tomb was encircled by another structure, of which the part that looked on to the road still remains, and enables one to see that it was decorated with half-columns between which there were inscriptions. Two of these survive intact: one of M Plautius the Consul and Septemvir of the Epulones, distinguished for his exploits in Illyrium; the other of Ti Plautius Silvanus, whose honours included that of accompanying the Emperor Claudius on his expedition to England. The work that can be seen at the top of the building shows that it served as a defensive tower during the civil wars of the Dark Ages; this was done by Paul II.

Antonio Nibby, *Itinerario di Roma* (1830)

Of all glorious things here I think a ride on the Campagna in the morning or the evening sun is the most beautiful. There one has Rome and Italy, the past and the present, all to oneself. There the old poetic mountains breathe inspiration around. There one sees the aqueducts in their grandeur and beauty, and the ruins stand out on the landscape without being wedged in by a dozen dirty houses, or guarded by a

chorus of filthy beggars. The whole country lies open, unfenced and uncultivated, and as one rides from hill to hill, the scene changes with the ground and St Peter's or the Lateran, an aqueduct or a tomb, Mt Albano and Frascati or Soracte and Tivoli almost bewilder one with their different charm. The Campagna is now green and fresh, the flowers are blooming on it and the poppies are redder than blood: the little lizards fly about with their green backs that glitter in the sun, and when one is glowing with the heat after a quick gallop, there's always a pleasant breeze to comfort one. This is the Rome which delights me, and in all Europe as yet I've seen nothing so beautiful and so pleasant.

Henry Adams, *Letter* (17 May 1860)

ALONG the old Via Tiburtina, not far from Tivoli, is the Ponte Lucano, one of the most picturesque relics of classical times. The well-preserved bridge, with the tomb of the Plautii standing alongside it, has been a popular motif for artists down through the centuries. Originally made up of five arches (the fifth arch now lies buried), it spans the river Aniene, and derives its name from the adjacent family mausoleum of M Plautius Silvanus, who served as consul with Augustus in the year 2 BC. His name and that of other members of his family (including A Plautius Urgulnius and P Plautius Pulcher) were recorded on inscribed plaques, now disfigured, on the projecting front, which was originally decorated with Ionic pilasters. In the Middle Ages the tomb was adapted as a stronghold and fortified to control access to the bridge. Early in the twelfth century papal envoys from Tivoli met the Emperor Frederick Barbarossa here and here also Barbarossa parleyed with Pope Adrian IV. In the mid-twelfth century, when Innocent II (1130–43) won sovereignty over the area, the bridge was controlled by an attachment of Roman troops. The crenellated fortifications crowning the tower were probably added by Pope Paul II (1464–71). The tomb dates to about AD 15 and is built close to the remains of a villa, quite likely a property of the Plautii.

Like the Ponte Salario, the Ponte Lucano has suffered much damage down through its history and has, in consequence, been repaired and restored many times, altering its original appearance. It was broken down by Totila when he was encamped at Tivoli and later restored by Narses. It was repaired again in the fifteenth century and in 1856 the complete bridge was restored.

The present view of the Ponte Lucano is one of two by Labruzzi in the Ashby collection. The other representation of the scene, though somewhat smaller (355 × 494 mm), is very similar compositionally, but has different staffage. It shows less color than the present sheet, being simply in pen and wash, and may conceivably have been preparatory for an engraving.

69 LOUIS CHAIX or CHAYS

MARSEILLE *c*1740–1810 PARIS

View of Tivoli

Black chalk on paper: 176 × 325 mm

Inscribed on front of mount, bottom right, in brown ink: *Tivoli avant l'eboulement de 1825*

WATERMARK

CONDITION: good

PROVENANCE: Léon Millet, Paris (stamp on verso of drawing, bottom left corner, with the date: *11 Novembre 1897*)

BODART NO. 124

Here on the verge of the abyss, with coloured cloths hanging over its parapet-wall, as we have so often seen it in pictures, stands the beautiful — the most beautiful — little building which has been known for ages as the Temple of the Sibyl. It was once encircled by 18 Corinthian columns, and of these 10 still remain. In its delicate form and its rich orange colour, standing out against the opposite heights of Monte Peschiavatore, it is impossible to conceive anything more picturesque, and the situation is sublime, perched on the very edge of the cliff, overhung with masses of clematis and ivy, through which portions of the ruined arch of a bridge are just visible, while below the river foams and roars. Close behind the circular temple is another little oblong temple of travertine with Ionic columns, now turned into the Church of S. Giorgio. Those who contend that the circular temple was dedicated to Vesta, or to Hercules Saxonus, call this the Temple of the Sibyl: others say it is the Temple of Tiburtus, the founder of the city. Others, that it was built in honour of Drusilla, sister of Caligula. We know from Varro that the 10th and last of the Sibyls, whose name was Albunea, was worshiped at Tivoli, and her temple seems to be coupled by the poets with the shrine of Tiburtus above the Anio.

Augustus Hare, *Days near Rome* (1875)

In the lower part of the picturesque mediaeval town, then, we have to seek the site of this great sanctuary. But more famous still are the two small temples — one circular with Corinthian columns, the other rectangular with Ionic columns — which stand at the top of the town, on a rock above the old waterfall of the Anio. The rock would probably have been eaten away by now had not Gregory XVI had a new channel made to carry off the river further away from the town, out of danger.

The two temples are traditionally attributed to Vesta and the Sibyl of Tibur — for Varro adds Albunea, a water goddess worshipped on the banks of the Anio, to the nine Sibyls of whom the Greek writers speak . . .

This lofty point, well defended by the Anio, must have been the citadel of the ancient city, though the lines of its walls cannot be traced by any actual remains. It was founded, according to tradition, by Tiburtus, Corax, and Catillus, grandsons of Amphiaraus of Argos, and the last has given his name to the Monte Catillo above the modern railway station. This hill Turner, among others, climbed for a view of the town and the deep gorge of the river. Tivoli is on the edge of the Sabine mountains, guarding the pass to the upper valley of the Anio and the interior of the complicated mountain system which forms the backbone of the peninsula and extends uninterruptedly as far as the Adriatic. It must, in the days of its independence, have been a very powerful city, with roads leading to the outlying forts by which its sway was maintained.

It came into collision with the Romans in the fourth century BC, and thrice the latter were able to celebrate triumphs over it; but it did not lose its independence, more wisely becoming an ally of Rome. In the latter centuries of the Republic, and under the Empire, it was a favourite summer resort, and both Augustus and Maecenas had villas here, and — though it may be disputed by some — I think Horace also.

Thomas Ashby, *The Roman Campagna in Classical Times* (1927)

WITH its magnificent elevated site on the acropolis overlooking the rumbling cascade of the river Aniene, the so-called Temple of the Sibyl at Tivoli has become one of the most famous of all Roman ruins. The remains of this beautiful marble building have fascinated artists, archaeologists and tourists down through the centuries. Despite all the attention lavished upon it, however, its origins and

meaning still pose many problems for students of classical culture.

It has been suggested that the site on which the temple stands was conceived as a sacred landscape garden, a convention first mentioned by Cicero (106–43 BC) in his letters to Atticus, in which nature, local legend and religious shrines were intermingled. The building itself is circular in shape, with a peristyle of 18 marble columns, of which just ten remain. The columns, which had Corinthian capitals, stand on a high base and support a finely carved trabeation decorated with ox-heads and festoons. Of the damaged inner *cella*, the door and one of the two windows remain. The temple has been dated variously to around the second or first century BC, with one recent suggestion that its construction may in some way have involved L Gellius Poplicola, who was consul in 72 BC. The inside of the architrave contains a carved inscription bearing the name 'L Gellio'.

It is not known to which deity the temple was dedicated, and it has been known under various titles, notably the Temple of Vesta, the Temple of the Sibyl and the Temple of Hercules Subsaxanus. During the Middle Ages the temple was converted into a church (already by 978 it was referred to as Santa Maria Rotonda), a use which undoubtedly contributed to its preservation. In 1828, when the ruin no longer had any religious function and had become the property of the local hosteller, it was reputedly offered for sale to the Earl Bishop of Derry who intended to take it back to his estate in Ireland and re-erect it on an equally imposing site along the Irish coast.

In this view of the acropolis at Tivoli, the artist has chosen a dramatic low angle of view, with the small rectangular temple partly obscuring its more famous circular companion. Of the two, the square temple, shown here as a church, is the older. Its design and method of construction indicate a dating of about the middle of the second century BC, some 50 years or more older than the Temple of the Sibyl. It was probably dedicated to Tiburnus, the legendary founder of the city. It functioned as a church in medieval times, when it was dedicated to St George, a usage which ceased only in 1884.

Bodart attributes this fine drawing to Louis Chaix on the basis of a comparison with drawings conserved in the Kunstbibliothek in West Berlin, where there are over 50 sketches by the artist. He notes particularly the relationship between the Ashby sheet and a view of Tivoli (inv. no. HDZ 3045, Berckenhagen 1970, p.395), which includes part of the same scenery. He remarks also on the particular manner used by Chaix to delineate foliage in a neat crisp pattern. The Kunstbibliothek drawings include other views of Tivoli by the artist. The attribution is quite convincing and Jean-Pierre Cuzin (letter to the author, 1987) believes it may be correct. One should bear in mind, however, that the young French artists studying in Rome at this particular time worked very closely together and copied each other frequently, rather like the young Dutch and Flemish artists of the late sixteenth century (*cf* No. 24). The colleague to whom perhaps Chaix was closest was Joseph Benoît Suvée, and there are drawings which document their sketching trips into the Campagna together (Méjanès 1976). The drawings of the two are sometimes confused and caution is advised in determining which hand is responsible for many of the compositions ascribed to either. The present view of Tivoli is no exception.

70 CARLO LABRUZZI

ROME 1748–1817 PERUGIA

The 'Temple of the Sybil' at Tivoli

Pen and brown ink with gray wash on laid paper: 380 × 500 mm

Inscribed, recto, bottom left center, in dark ink (below border):
Tempio della Sibilla in Tivoli; verso, bottom left, in pencil: *C. Labruzzi.*

Border of very dark brown ink

WATERMARK

CONDITION: some very faint staining

BODART NO. 168

Instead of breathing the pure air on the gentle rising Hills of Croomehurst, or on the level plains of Croydon and Beddington, with those agreeable young Ladies your neighbours: I now sit in the murk[y] Caves and gloomy Woods admiring Thundering Cascades of Tivole bounding o'er lofty[?] Rugged Rocks whose spirey points seem ready to pierce the Clouds. This antient City of Tivole I pla[i]nly see has been ye only school where our two most celebrated Landscape Painters Claude and Gasper studied. They have both taken their Manners of Painting from hence. I see at the same time that one was as strict an imitator of Nature as the other. On one side of this place, from ye very spacious even top of a high Mountain one may behold many of those pleasing Compositions of Claude Lorrain in the Campagnia of Rome, with that City about 18 miles distant towards which place the Anio winds its way thro' the Campagnia from hence. [On] the other side you would be su[r]prized with all the most noble Romantic wildness of Gasper Poussin. I have been here about a fortnight and I intend to stay a week longer. The first week I spoiled almost all my drawings, this wild nature being a new kind of study to me: this week I have succeeded tolerably well.

Jonathan Skelton, *Letter* (23 April 1758)

As soon as the sun came up, I opened my windows. My first view of Tivoli, in the darkness, was fairly accurate; but the waterfall seemed small to me and the trees which I had thought to have seen were non-existent. A huddle of peasant houses rose on the other side of the river; mountains enclosed the scene on every side; the temple of Vesta, overlooking the Cave of Neptune, was four paces from me; my spirits rose. Immediately above the fall, a troop of cows, donkeys and horses straggled along a sandbank: they all advanced a step or two into the Teverone, lowered their heads, and drunk peaceably from the stream of water which ran like lightning in front of them, precipitating into the abyss. A Sabine peasant, dressed in a goatskin and carrying a kind of chlamys wrapped round his left arm, leant on his staff and watched his herd drink — their immobility and silence contrasted with the movement and noise of the waters.

After I had eaten, my guide arrived, and I went with him to stand on the bridge of the cascade: it was like seeing the

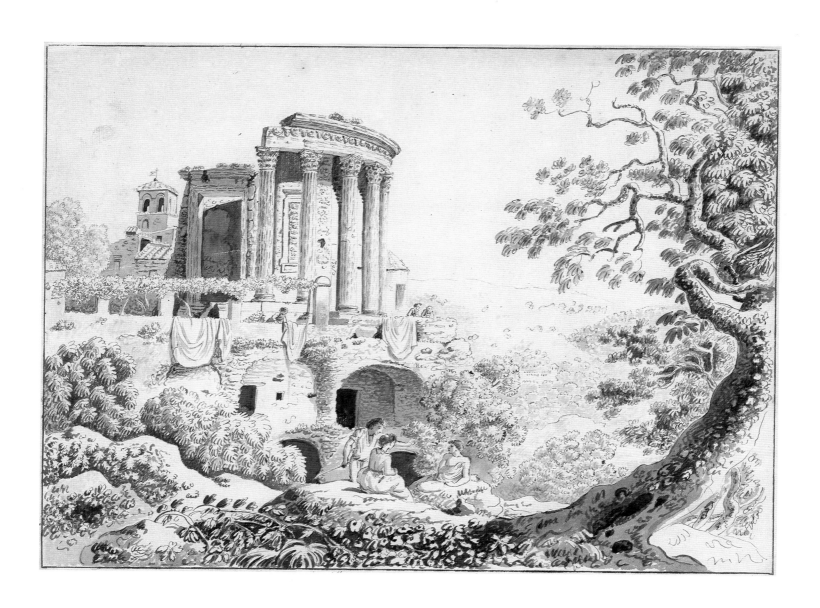

falls at Niagara. From the bridge we went down to the Cave of Neptune, so called, I believe, by Vernet. The Anio, after its first rush under the bridge, is engulfed among the rocks and then re-appears in this cave, then cascades in a second fall to the Cave of the Sirens.

The basin of the Cave of Neptune is shaped like a cup; I saw doves drinking there. A dovecot in the hollow of the rock, rather more like the eyrie of an eagle than a pigeon's nest, offered a treacherous lodging for these birds: they believed themselves safe in such an apparently inaccessible place, and made their nest; however, there was a secret path to the place, and in the night a thief carried off the fledglings who slept without fear through the noise of the waters under the wing of their mother. *Observans nido... implumes detraxit.* [Seeing them in their nest... he snatches the fledglings. Virgil, *Georgics*.]

Vicomte de Chateaubriand, *Voyage en Italie* (11 December 1803)

Yesterday I went with Cranch & Smith & Wall to Tivoli. I cannot describe the beauty of the Cascade nor the terror of the Grotto nor the charm of the iris that arched the torrent. The Temple of Vesta is one of the most beautiful ruins & in a chosen place. The whole circuit of about four miles which we make with the Cicerone, showed everywhere a glorious landscape. All was bright with a warm sun. The ground was sprinkled with gay flowers, & among others that pink thing with a spicy smell we used to call 'Rabbit's ears'. Then there was the great aloes with its formidable fleshy spine growing about, & (which is a rare sight) one of these plants was in bloom. We found the remains of the villa of Catullus, then the reputed site of the house of Horace, & hard by, the arched ruins of the Villa of Q[uintilius] Varus. Here, too, they say, M[a]ecenas lived; & no wonder that the poet & patron should have come to this fair specular mount escaping from the dust of the Capitol. The Campagna lies far & wide below like a sea.

Ralph Waldo Emerson, *Journals* (20 April 1833)

Dear people I left off at Tivoli, but it is so impossible to describe the scenery. What a glorious walk we had the next morning on the opposite side of the hill from Tivoli, all round by the villas of Catullus and Sallust, and Varus, over against Maecenas with his arches and the Cascatelle, which do not fall like other cascades, but come leaping and spouting and gushing forth over the rock, sometimes in such a hurry as if careless and headlong they would enter upon life, sometimes slowly and majestically. I had my eyes fixed upon one of these Cascatelle for a long time, when oh wonder, I really saw, I thought, the sacred fire blazing in a little cave close by. I looked, and rubbed by eyes [sic], I could hardly believe them. I thought I was dreaming, but there it was, flickering, but with a constant light, just as a sacred fire should be. I soon saw it was a forge, but in such a spot in a little unhewn hollow in the rock, close under the Cascatelle and with no human being visible.

Florence Nightingale, *Letter* (9 December 1847)

ANOTHER image of the 'Temple of the Sibyl' by Labruzzi was published by Giuseppe Petrocchi (1976). That view, which gives a very similar perspective of the monument, is executed in pen and wash and measures 600×400 mm. Yet another very similar image, dated 1782, was illustrated in *The Burlington Magazine* in March 1978. In the National Gallery of Canada at Ottawa there is a view of the Temple seen from a somewhat lower angle of view, a perspective repeated in a large finished watercolor which went on sale at Christie's on 15 June 1976 (lot 242). Another variant was sold at Karl von Faber, Munich, on 10/11 December 1969 (lot 308, illus.).

71 ALBERT CHRISTOPHE DIES

HANOVER 1755–1822 VIENNA

The Cascade at Tivoli with the Ponte San Rocco

Pen and brown wash, with slight traces of black chalk, on paper, laid down: 591 × 480 mm

Signed and dated, verso, bottom left, in ink: *A.C. Dies .f. Tivoli 1785*; inscribed verso, bottom center, in pencil: *A.C. Dies = see the other*; underneath also in pencil: = *collection de vues Pittoresques 56 / (which is signed and dated A.C. Dies f. Romae. 1795)*

WATERMARK

CONDITION: good

BODART NO. 128

Having gratified our curiositie with these artificial miracles [fountains of the Villa d'Este], and din'd, we went to see the so famous natural precipice and cascade of the river Anio, rushing down from the mountaines of Tivoli, with that fury that, what with the mist it perpetualy casts up by the breaking of the water against the rocks, and what with the sun shining on it and forming a natural Iris, the prodigious depth of the gulph below, it is enough to astonish one that lookes on it. Upon the sumite of this rock stand the ruines and some pillars and cornishes of the temple of Sibylla Tybertina, or Albunea, a round fabric, still discovering some of its pristine beauty. Here was a great deal of gunpowder drying in the sun, and a little beneath, mills belonging to the Pope.

John Evelyn, *Diary* (6 May 1645)

From whence we shall proceed to the garden, containing two millions of superfine laurel hedges, a clump of cypress trees and half the river Teverone, that pisses into two thousand several chamberpots. Finis. — Dame Nature desired me to put in a list of her little goods and chattels, and as they were very small, to be very minute about them. She has built here three or four little mountains and laid them out in an irregular semi-circle; from certain others behind, at a greater distance, she has drawn a canal, into which she has put a little river of hers, called Anio; she has cut a huge cleft between the two innermost of her four hills, and there she has left it to its own disposal; which she has no sooner done, but, like a heedless chit, it tumbles headlong down a declivity fifty feet perpendicular, breaks itself all to shatters, and is converted into a shower of rain, where the sun forms many a bow, red, green, blue and yellow. To get out of our metaphors without any further trouble, it is the most noble sight in the world. The weight of that quantity of waters, and the force they fall with, have worn the rocks they throw themselves among into a thousand irregular craggs, and to a vast depth. In this chanel it goes boiling along with a mighty noise till it comes to another steep, where you see it a second time come roaring down (but first you must walk two miles farther) a greater height than before, but not with that quantity of waters; for by this time it has divided itself, being crossed and opposed by the rocks, into four several streams, each of which, in emulation of the great one, will tumble down too; and it does tumble down, but not from an equally elevated place; so that you have at one view all these cascades intermixed with groves of olive and little woods, the mountains rising behind them, and on the top of one (that which forms the extremity of one of the half circle's horns) is seated the town itself. At the very extremity of that extremity, on the brink of the precipice, stands the Sybil's temple, the remains of a little rotunda, surrounded with its portico, above half of whose beautiful Corinthian pillars are still standing and entire; all this on one hand. On the other the open Campagna of Rome.

Thomas Gray, *Correspondence* (20 May 1740)

ALBERT Christophe Dies here gives a glimpse of the famed Tivoli waterfall through the arch of the Ponte San Rocco. This sixteenth-century bridge, which spanned the great gorge with its picturesque grottos cut out of the rock by the sheer force of the waters, collapsed on 7 January 1808 when a torrential winter flood devastated much of Tivoli, carrying away 20 houses into the abyss below. The damage done at this time was such as to prompt the authorities to consider diverting the course of the Aniene river, for fear that it would engulf the town in an even greater

Luigi Rossini: *The Ponte San Rocco at Tivoli*

catastrophe at some later date. Between the years 1825 and 1836 the engineer Folchi drove two shafts (290 and 300 yards respectively) through the rock of Monte Catillo to reduce the pressure of the water and avert the threat of further floods. The ruined Ponte San Rocco was for some time replaced by a wooden structure until the Ponte Gregoriano was constructed by Pope Gregory XVI in the years 1831–46. The great flood of 1808 had its counterpart in antiquity, in AD 105, when the swollen river had carried away all before it.

This drawing of the Ponte San Rocco probably served as the preparatory study for the artist's print of the same subject published in *Vues Pittoresques de l'Italie* (pl. 26). In the engraving, Dies added the figure of an artist sketching beneath the shade of a parasol in the lower right corner of the composition.

72 *Attributed to*

WILLEM VAN NIEULANDT

ANTWERP 1584–1635/36 AMSTERDAM

View with the 'Temple of the Sybil' at Tivoli

Pen and ink with brown and indigo wash on laid paper:
299 × 414 mm

Inscribed (signed?), recto, bottom right corner, in brown ink: *A Nulant fe*; verso, upper center, in brown ink: *a a*; bottom left, in brown ink: *40*; illegible inscription, bottom right, in ink (a three-figure number crossed out)

WATERMARK

CONDITION: fold marks both vertically (center) and horizontally (near bottom)

BODART NO. 219

WHILE admitting difficulty in determining the authorship of a great many drawings of the early seventeenth century showing Roman ruins, on account of our inadequate knowledge of the period, Bodart assigns the present capricious view of the Temple of the Sibyl at Tivoli to Adrian van Nieulandt. This he does primarily on the basis of its signature, acknowledging that his brother Willem van Nieulandt, who had certainly been to Rome, often included the motif in many of his landscapes, whereas Adrian, who specialized in history paintings and still lifes and who may never have visited Italy, would hardly ever have had occasion to paint this motif. While the design reproduces almost exactly the composition of a painting attributed to Willem, exhibited in Delft in 1977 (*Oude Kunst en Antiekbeurs*, no. 61, 490 × 660 mm, illus), it still cannot be determined with certitude whether or not Willem was its author, as the design lacks the tension and energy one normally associates with an original drawing by an artist, and it may be that the sheet is a copy, conceivably by Adrian, though this is unlikely. Certainly, it is not from nature, as the scene represented is made up of a combination of different motifs including, besides the temple at Tivoli, possibly elements from the Forum of Nerva. Bodart cites a painting attributed to Willem van Nieulandt sold in Berlin in 1962 (Spike sale, 5 April 1962, lot no. 145) which reproduces the composition in reverse.

A. Anland fe.

73 SIMONE POMARDI

MONTEPORZIO CATONE 1760–1830 ROME

Palestrina

Black chalk with charcoal on white paper, laid down: 365 × 530 mm
Signed, recto, bottom left corner, in black chalk: *Pomardi*; inscribed, recto, top center, in sky, in black chalk: *Prenes . . .*; on hill: *Sasso b*; lower down: *Sasso ed erbe . . .*
CONDITION: some foxing
BODART NO. 284

On 11th June we were at Palestrina, once the fief of the Colonna, now of the Barberini. It is the famous spot where the Romans raised a temple to Fortune, for consultation of the oracle — a grandiose temple, which occupied almost the entire area of the present city. On its foundations and the ruins of its superstructure the Palazzo Barberini has been built, where originally the plan must have been semicircular. It preserves a mosaic of Greek workmanship, one of the most important antiquities to have survived. The ancients did not have available for their mosaics as many colours as we do, and were not so adept in the handling of light and shade. At Palestrina there are several passable roads, some well-built houses, and two or three thousand inhabitants. It has beautiful country, with vines and fruit-trees.

Baron Montesquieu, *Voyage en Italie* (June 1729)

Praeneste enjoyed a considerable share of celebrity, from its magnificent Temple of Fortune. The whole extent of the modern town exhibits traces of ruins, all of which have been identified with this structure. The most perfect remains now existing may be seen at the Seminario, from whence the beautiful mosaic pavement, transported to the Barberini palace at Rome, was taken. I was shown a square niche, ornamented with a Doric frieze, which is said to have contained the altar of the goddess. Opposite the Palazzo Barberini I noticed the fragment of an ancient inscription, of which I could only distinguish the letters RESTIT. From the church of St Pietro, there is the most delightful view imaginable, of the sea and the whole circumjacent country.

The church contains a fine inscription, and a good picture, by Pietro da Cortona.

Sir Richard Colt Hoare, Bart, *A Classical Tour through Italy and Sicily* (1819)

The princely families of Rome, who derive their titles from the feudal towns which once they ruled over among the mountains, have villas or castles here and there, where they sometimes spend a few days or weeks in the summer. Many of these old castles and palaces are ruined, but some of them are still habitable. One of the finest of them is the Barberini Palace at Palestrina, which was built in the 15th century upon the ruins of the ancient Temple of Fortune. On the floor of a hall in this palace is the celebrated mosaic which has afforded so much scope to the speculation of antiquaries, and of which the family have lately printed an elaborate description with plates. For a long period this noble palace was deserted by the family, but within the last two or three years the present prince has passed his summer *villeggiatura* there, and occupied himself with excavating some of the Etruscan tombs in the vicinity.

William Wetmore Story, *Roba di Roma* (1871)

But this is not the chief title of Praeneste to fame. In early times it was chiefly celebrated as a stronghold; and from its citadel, now Castel San Pietro, on a limestone rock high above the modern town, defended by massive Cyclopean walls of large limestone blocks, two long walls descended and enclosed a roughly triangular space between them. The wealth of the rulers of this city is shown by the magnificence of the tombs of the seventh century BC which have been found in the lower ground below the town. Such tombs as the Barberini and the Bernardini, the contents of which are to be seen in the museum of the Villa di Papa Giulio and the Collegio Romano in Rome, show that these princes acquired their artistic treasures, with their strong Oriental characteristics (some are actually of Eastern origin and some of local workmanship), if not from Etruria itself, at any rate from the same sources as those which supplied the lords of Caere in Southern Etruria; while the bronze toilet chests, the so-called *cistae*, of the fourth and third centuries BC, reveal an important renaissance of art in the beauty of their engravings.

Thomas Ashby, *The Roman Campagna in Classical Times* (1927)

THE modern town of Palestrina sits on the ruins of its illustrious Roman predecessor, Praeneste, on the slopes of Monte Ginestro south-west of Rome. Its venerable history can be traced back at least to the eighth century BC. According to local legend it was founded by Caeculus, the son of Vulcan, who was conceived when a spark fell into the lap of the sister of the Fratres Delpidii. He is reputed to have attracted people to Praeneste from the surrounding areas by holding games. Another legend relates that the town was founded by Telegonus, the son of Circe and Ulysses, who was instructed by an oracle to found a city in a place where he would come across people dancing and wearing wreaths, which is reputedly just what he found at Praeneste.

The classical historians described Praeneste as a colony of Alba Longa and a member of the Latin League. In its heyday it won enormous fame as the site of the vast temple dedicated to Fortuna Primigenia, which ranks among the greatest monuments of ancient history. An important oracle, much consulted during the First Punic War, was attached to the temple. The oracle used lots picked by children as its means of divination. In 270 BC a lot fell from the bundle with the message 'Mars shake your spear', warning the Romans of the approaching War. The cult of Fortuna Primigenia endured until the fourth century AD. Remains of the temple with its massive arcades, arranged on the slopes of the hill where the modern town now stands, can be discerned in Pomardi's drawing. Excavated in 1952–55, the great temple has been dated to about 150 BC, or perhaps a little later.

The medieval history of the town was bloody, as various feudal lords fought for its possession. The Conti, who were its first rulers, were succeeded in 1043 by the Colonna who remained its overlords on and off for the following 600 years, eventually selling off the title to Carlo Barberini in 1630 for 775,000 scudi. The Palazzo Barberini, begun by Francesco Colonna towards the end of the fifteenth century, dominates the town today much as it did when Pomardi made his sketch. The Palace, which is now a museum, contains important archaeological exhibits, including the celebrated mosaic of the Nile, taken from the Sala Absidata of the temple. The ruins of the old Colonna stronghold, the Castel San Pietro, demolished by Cardinal Vitelleschi in 1436, can be seen near the summit of the hill. The cathedral of Sant'Agapito, with its pointed bell tower, is visible towards the bottom of the town. The remains of the third-century saint were translated here in 898. At the beginning of the twelfth century the structure was expanded and the bell tower added. The building was again extensively reworked in the fifteenth century. It is built upon the ruins of an ancient edifice, possibly the Iunonarium. The composer Giovanni Pierluigi da Palestrina (died 1594), master of counterpoint, was born here.

The technique of this interesting drawing by Pomardi is similar in many ways to that of his contemporary, the Dutchman Hendrik Voogd, who is represented in the Ashby collection by three views in and around Rome (nos. 315–17). An extensive View of Tivoli by Pomardi, signed and dated 1796 (635 × 950 mm), was sold at Christie's in 1983 (23 June). Another fine view of Tivoli by Pomardi was sold at the same venue in 1985 (2 July, lot 86).

74 *Artist using the monogram* AB

Active 1723–1745

View of the Villa Aldobrandini at Frascati

Red chalk on laid paper, laid down: 275 × 429 mm

Autograph inscription on verso, bottom left (visible against the light), in ink: *Veduta del Palazzo di Belvedere di Frascati 1741 AB*; also on verso, slightly lower, in ink: *W*; this inscription is repeated (by Jonathan Richardson Junior?) on the reverse of the support, top center, in ink: *Veduta del Pallazo di Belvedere (del Principe Pamfilio) a Frescati 1741: W. circa 12 miglia di Rᵃ*

CONDITION: Some slight staining top right and center, close to left border

PROVENANCE: Jonathan Richardson Jr 1694–1771 (Lugt 2170 [?], recto, bottom right corner)

BODART NO. 205

We tooke coach, and went 15 miles out of the Cittie to Frescati, formerly Tusculanum, a villa of Cardinal Aldobrandini, built for a country-house, but surpassing, in my opinion, the most delicious places I ever beheld for its situation, elegance, plentifull water, groves, ascents, and prospects. Just behind the palace (which is of excellent architecture) in the center of the inclosure rises an high hill or mountaine all over clad with tall wood, and so form'd by nature as if it had been cut out by art, from the sum'it whereof falls a cascade, seeming rather a greate river than a streame precipitating into a large theatre of water, representing an exact and perfect rainebow when the sun shines out. Under this is made an artificiall grott, wherein are curious rocks, hydraulic organs, and all sorts of singing birds moving and chirping by force of the water, with several other pageants and surprising inventions. In the center of one of these roomes rises a coper ball that continually daunces about 3 foote above the pavement by virtue of a wind conveyed secretely to a hole beneath it; with many other devices to wett the unwary spectators, so that one can hardly step without wetting to the skin. In one of these theaters of water is an Atlas spouting up the streame to a very great height; and another monster makes a terrible roaring with an horn; but above all, the representation of a storm is most naturall, with such fury of raine, wind, and thunder, as one would imagine ones self in some extreame tempest. The garden has excellent walkes and shady groves, abundance of rare fruit, oranges, lemons, &c, and the goodly prospect of Rome, above all description, so as I do not wonder that Cicero and others have celebrated this place with such encomiums. The place is indeed built more like a cabinet than any thing compos'd of stone and mortar; it has in the middle a hall furnish'd with excellent marbles and rare pictures, especially those of Gioseppi d'Arpino; the moveables are princely and rich. This was the last piece of architecture finish'd by Giacomo de la Porta, who built it for Pietro Card. Aldobrandini in the time of Clement VIII.

John Evelyn, *Diary* (5 May 1645)

Frascati, or Tuscolo, is to the east of Rome, from which it is about 10 or 12 miles distant; and is on a hill . . . it is a small city. In France there is not a church to be found as pretty as its cathedral, of which the architecture is of the best taste.

The countryside all round Frascati, far and near, is sprinkled with fine villas.

The Belvedere [Villa Aldobrandini] is the charming villa of Prince Pamphili: there is a cascade of the most beautiful architecture − superior to any fountain at Versailles. Then there is the Villa Conti. Further on, the Villa Montalto [Villa Grazioli], where there are marvellous pictures by Domenichino and Annibale Carracci.

Baron Montesquieu, *Voyage en Italie* (1729)

The Belvedere Aldobrandini, belonging to the Pamphili, and the Mondragone, to the Borgheses, and the Villa Ludovisi [Villa Conti], are the three finest gardens of Frascati. There are half a dozen others which would be well enough if they were better kept, but much inferior to the above, of which the villas are very handsome, the gardens very extensive, well laid out, and containing marvellous fountains. The Belvedere and the park of the Ludovisi villas are mountains cut into terraces covered with verdure, containing grottoes and superb cascades. The great fountain in the Belvedere is nearly equal to that of St Cloud; it is one of the finest things of its kind that can be seen. It descends, with a terrific sound of air and water, through pipes arranged expressly to make a perpetual cannonade. Besides this great fountain, there are numerous smaller ones; many in very good taste. The hill of the Belvedere is scooped out into three terraces, ornamented with grottoes and with façades, in rustic architecture, all ornamented with cascades in full play. The great cascade is crowned with columns with twisted flutings, through which the water circulates in spiral lines. The Ludovisi cascade has above it a platform containing a huge fountain basin. The long façades of grottoes, with porticoes, fountains, and statues are beautiful, both here and in the Aldobrandini gardens.

Président de Brosses, *Letter* (1739) (translated by Lord Ronald Sutherland Gower)

The rest of our company are already in bed, and I am writing in the sepia I use for drawing. We have had a few days of genial sunshine, so that we don't long for the summer. This town lies on the slope of a mountain, and at every turn the artist comes upon the most lovely things. The view is unlimited; you can see Rome in the distance and the sea beyond it, the hills of Tivoli to the right, and so on. In this pleasant region the villas have certainly been built for pleasure. About a century ago, wealthy and high-spirited Romans began building villas on the same beautiful spots where the ancient Romans built theirs. For two days we have roamed the countryside, always finding some new attraction.

Johann Wolfgang von Goethe, *Italian Journey* (15 November 1786) (translated by W H Auden and E Mayer)

SITED close to the old Roman retreat of Tusculum in the Alban hills some 15 miles south of Rome, the town of Frascati became a popular center for the seasonal *villeggiatura* of Renaissance and seventeenth-century princes and prelates. The practice of quitting the great city during the intense heat of the summer months goes back to the days of ancient Rome when Tusculum, and to a lesser degree Frascati and Tivoli, became favored locations for the siting of villas and country estates. Indeed this practice became so widespread that it provoked Marcus Terentius Varro (116–27? BC), author of *De Re Rustica*, to complain that there was no more room left for market gardens and that Rome in consequence was suffering from a shortage of vegetables. Contemporary authors recorded 43 villas in and around Tusculum, including residences belonging to Pliny the Younger, Cicero and the emperors Nero and Titus.

The revival of Frascati's popularity as an attractive location for the annual summer retreat to the cooler air of the Alban hills dates to 1548 when Cardinal Alessandro Rufino, possibly at the instigation of Pope Paul III, erected a small villa there (La Rufina). Before long other villas sprang up about the surrounding hillside and the area soon developed into a modern Tusculum whose fame has continued to this day.

The Villa Aldobrandini rises on a plot of land which was originally the property of Pier Antonio Contugi, the patron of the adjacent Capuchin church and convent (*cf* No. 77). To erect his new villa, Cardinal Pietro Aldobrandini, who had been given the site in 1598 by his uncle Pope Clement VIII, had first of all virtually to demolish much of Contugi's existing structure. With Giacomo della Porta (*c*1540–1602) as architect, work on the new *casino* eventually began in July 1602, and continued after his death under the supervi-

Giovanni Battista Falda: *The Cascade at the Villa Aldobrandini, Frascati*

sion of Carlo Maderno and Giovanni Fontana (a specialist in hydraulics). By 1603 the first phase of the development was virtually complete and the villa habitable. Between 1605 and 1620 work progressed on the *casino* and surrounding gardens, with their terraces, *parterres*, spectacular water-staircase and magnificent water-theater. The villa and the layout of the gardens were virtually complete by 1620 when they were represented, along with other buildings, in Matteo Greuter's descriptive map of Frascati published that same year. The screen wall which guards the entrance to the villa towards the town, erected before 1699, is most probably the work of Carlo Francesco Bizzaccheri, though his pupil Gabriele Valvassori has also been suggested as its designer. This wall is seen in the middle distance of AB's view with the great stables of the villa dominating the left foreground.

The rooms of the Casino were richly decorated with paintings by, among others, Federico Zuccaro and the Cavaliere d'Arpino. The most important paintings were, however, the frescos executed by Domenichino (1581–1641) and his assistants for the *nymphaeum* in the garden of the villa. Painted between 1616 and 1618, the frescos remained *in situ* until the 1840s when they were removed to the Palazzo Borghese. After passing through a number of hands, they were ultimately purchased in 1958 by the National Gallery, London, where they are now displayed.

The villa passed by descent to Donna Olimpia Aldobrandini who, in 1683, married Camillo Pamphili. When that branch of the Pamphili family became extinct with the death of Cardinal Girolamo in 1760, it passed, after much confusion, into the ownership of the Borghese family, of which Olimpia's first husband had been a member. The villa still retains its old name, however, as in 1843 the title of Prince Aldobrandini passed to its owner Don Camillo Borghese (Paolo Borghese was the first of that family to win the right to the title of Prince Aldobrandini, in 1767). Though it suffered badly during the Second World War, it has been beautifully repaired and maintained by Prince Aldobrandini, and its magnificent gardens are among the surviving jewels of the Italian Baroque.

For commentary on the authorship of this drawing see No. 14.

75 JEAN GRANDJEAN

AMSTERDAM 1752–1781 ROME

The Villa Conti at Frascati

Pen and bistre ink with light gray ink wash and slight traces of black chalk on laid paper: 267 × 407 mm

Inscribed, verso, bottom left corner, in pencil: *N 4*; bottom right, in ink, in the artist's hand, in ink, retracing the same inscription in pencil: *Veduta dela villa ¹Conti, villa ²Palavicino e una parte / de ³ Frascati. delaparte dela villa ⁴Bracciano./J: Grandjean ad viv. fec. 1780*; center left, in ink: *3*; center right, in ink: *2*; lower left corner, in pencil: *fe.–/4*; lower left center, in ink: *4*; upper center, in ink: *1*.

Border in dark brown ink

WATERMARK

CONDITION: some staining, left center

BODART NO. 143

Coming down again to the town you find on the left the Villa Conti, which is built entirely over Lucullus's *deliciae*. The house is small but its situation is extremely attractive. A pretty balcony runs round the terrace on which it is situated and on an upper level is placed a fountain from which water gushes and tumbles down to the level of the house. You reach the gardens by a great great stair, which repeats itself many times, newly built, made out of the ruins of a great wall which formed part of the beautiful scenery of Lucullus. The destruction of it has been universally condemned and all the more because this ridiculous stairway never gets to the house and is steep, difficult of access and even dangerous if there is rain or ice. The gardens, which are wooded and have fine avenues of evergreen oaks, are refreshing and attractive, laid out as wildernesses.

Marquis de Sade, *Voyage d'Italie* (1775–76)

Higher up, and nearer, bubbles away a fountain in front of the Torlonia Villa [Villa Conti], sending up a crystal current, which falls in foam into the vase below. This villa, surmounted with lightning-rods, stands grandly on a sunny terrace, behind which rise two others, covered with lofty ilex-trees, shielding who can tell how many myriads of nightingales, within their wide-spreading branches! The hospitable gate,

on the two posts of which are stone eagles, their wings outspread, and over the centre, the Torlonia crest, stands open between the hours of eleven and five.

Then, strangers enter the villa, or village couples stroll in its shady walks or sit on the benches, admiring the play of the various fountains in the grounds.

In front of the casino, to which one approaches through avenues bordered with plane-trees, is a moss-grown fountain in the midst of an oval terrace; here, from the stone balustrade, one can enjoy fully the beauty of the entire extended prospect. Ascending then, by massive stairways, somewhat green with time, to the rear of the building, we come to the second terrace, open on one side, for the sake of the view, and adorned on the other by lordly trees. These are but the outer sentinels of the forest-army which covers many an acre on this beautiful estate...

An interesting and varied history, too, belongs to this now Torlonia Villa. Once there were in it, in the lower part of the building, eighteen little chambers, ten feet high, about the same width, twelve feet long, and with a pillar between each two, of about five feet in height. Some considered them habitations for slaves, others ancient baths, since their ceilings were arches, and their walls lined with reticulated stone-work, closely resembling rooms in many of the ruined 'thermae'.

Another improbable suggestion of the archaeologists of the time, was that they were Tusculan shops.

Clara Wells, *Frascati* (1868)

THE origins of the Villa Conti, from which Grandjean sketched this attractive view of the surrounding countryside, go back to 1563 when Annibale Caro (1507–66), the celebrated humanist and friend of Cellini, commissioned the original building. This was later enlarged by Cardinal Tolomei Galli, secretary to Gregory XIII, after whose death it passed to Scipione Borghese in 1607. He commissioned AF Ponzio, Carlo Maderno and Giovanni Fontana to make further improvements, including the waterfall and the fountain known as the 'candelabra' which graced the front elevation. In 1614 the villa was purchased by Cardinal Altemps from whose family it passed, in 1621, to Cardinal Ludovico Ludovisi, nephew of Pope Gregory XIV. It was for him that

Carlo Maderno designed the monumental basin for the water cascade, the Teatro delle Acque, with the sculpture in the niches carved by Jacques Sarrazin. Bought by Pompeo Colonna in 1661, the villa again changed hands in 1680 when it became the possession of Lotario Conti, whose family still owned the villa when Grandjean visited it in 1780. Later, during the second decade of the nineteenth century, the villa became the property of the Cesarini Sforza family. By 1841 it had once more changed ownership, having passed into the hands of the Torlonia family, by which name the estate is still known. During the Second World War Frascati was an important German communications center and was bombed by the Allied forces, and as a consequence the villa was destroyed. It has since been replaced by a modern building, and the gardens, which were once described as 'the grandest of their age, laid out with true appreciation of scale', have been turned into a public park.

In the bottom left corner of Grandjean's view can be seen the Villa Pallavicini, also destroyed during the last war. To the extreme right can be deciphered the twin campanili of the Cathedral of San Pietro, later additions to the original construction of 1598–1610.

The present view, together with the two which follow, is one of a series of panoramas of this celebrated country retreat executed by Grandjean in 1780. Another prospect of the Villa Conti by Grandjean, also executed in 1780, was exhibited in Rome in 1971 (*Vedute Romane* 1971, no. 97; 265 × 406 mm): this shows the terrace of the villa with the fountain known as the Candelabra. A view of the nearby Villa Aldobrandini, drawn in 1779, was shown at the Rijkspréntenkabinet in 1971 (*Ontmoetingen met Italie* 1970–72), no. 10; 322 × 419 mm). Grandjean's contemporary, Daniel Dupré (1751–1815), also depicted the Villa Conti, as a drawing by him in the Rijkspréntenkabinet (inv. no. 21:142: '*Du Pre delt. 1791*') documents.

JEAN GRANDJEAN

AMSTERDAM 1752–1781 ROME

The Villa Grazioli at Frascati

Pen and ink with light gray wash on laid paper: 266 × 408 mm

Inscribed on verso, bottom right, in the artist's hand, retracing the same inscription in pencil: *Veduta del ¹Palazzo dela villa Bracciano a Frascati e la / ²Citta di Roma. ———— J: Grandjean ad viv fec. / A. 1780*; bottom left corner, in pencil: *N 3.*; bottom left, in pencil: *fe.– / 4.*

Thin border of ink

WATERMARK

CONDITION: good

BODART NO. 144

Adjoining the grounds of the Villa Torlonia, although the entrance is some distance farther up the hill on the Marino road, is the beautiful Villa Montalto (formerly called also Acquaviva), now the residence of the Duke Grazioli. The wide spreading domain reaches also down the further slope of the hill to Grottaferrata, and thus the avenues of the villa offer a shorter and more agreeable drive between the two towns than the public roads. Since the purchase of the estate, however, by the Duke Grazioli, the carriage gates are generally closed to the public, except upon fête occasions, as that of the Grottaferrata fair. Before, they were always open, and along the avenues, where grew, in such profusion, long-trailing vines, prickly green shrubs with large red berries and a multitude of floral gems, the appreciator of nature could, even in the winter, gather an armful of beauty, with which to brighten the home fire-side.

Among the acres of olive trees, planted upon the slopes and in the hollows of these extensive grounds, myriads of birds are forever flying and singing, and many of them are entrapped by sportsmen, who, with decoys, allure them to light upon rods smeared with pitch.

But if the wild songsters suffer in these woods, the domestic pets around the ample court-yard, were well cared for, we observed, on our first visit to Villa Montalto. Such brilliantly feathered roosters as strutted about, condescendingly giving a morsel, now and then, to the patient biddies! When the pleasant faced matron, however, brought the mealy repast, all their dignity was forgotten, and they gobbled it down as fast as their plainer wives, until two sheep, who could no longer endure the sight of so much feasting without partaking, ran up to the dish and took all to themselves.

Clara Wells, *Frascati* (1868)

AMONG the most sumptuous of all the Frascati villas is the Villa Grazioli (alternatively the Villa Bracciano) whose origins date back to the late sixteenth century when Cardinal Antonio Caraffa (1538–91) built the original *casino* c1580. On his death it passed to Cardinal Ottavio Acquaviva, to whom he was related. It subsequently became the property of Scipione Borghese, who, having purchased it for 20,000 *scudi* in 1612, sold it again the following year to Cardinal Taverna. In 1614 it was purchased by Prince Michele Peretti from whom it passed by descent to the Savelli who in turn sold it to Livio Odescalchi, Duke of Ceri, in 1683. It then passed to Baldassare Erba who was related to the Odescalchi by marriage. In 1833 is once more changed hands, becoming the property of the Collegio di Propaganda Fide, from whom it was purchased in 1843 by Pio Grazioli, whose family still owns the property.

The villa, which is now in a poor state of preservation, contains many important works of decoration. Among the earliest are frescos by Federico Zuccaro and Cesare Nebbia. Cardinal Acquaviva during his term of ownership commissioned decorations by Agostino Ciampelli and Antonio Carracci. GP Panini painted the Gallery with a series of magnificent illusionistic frescos between 1725 and 1730.

77 JEAN GRANDJEAN

AMSTERDAM 1752–1781 ROME

The Capuchin Convent at Frascati

Pen and brown ink and light gray wash with traces of black chalk on laid paper: 264 × 408 mm

Inscribed, verso, bottom right, in light brown ink: *Vue des ¹Capucins et du ²Noviciaat a Frescati et les ³Campagnes / au Cote de Tivoli —— Jean Grandjean ad: viv fec: / A: 1780*; bottom left, in pencil: *N 3*; bottom left, very faint, in pencil: *fe.*

Border of dark brown ink

WATERMARK

CONDITION: good

BODART NO. 145

Passing one of the entrances of the Villa Aldobrandini and passed, in our turn, by a company of sightseers on donkeys, we arrive, somewhat panting from the steepness of the road, at the foot of the long steps, which lead up to the Capuchin convent. Here is a shrine, containing a painting of the Madonna and Child, partly defaced, and the wall near it, broken, from the belief of the peasants, that with small pieces of it, miracles can be performed, especially for mothers, before the birth of their children.

The steps, and the terrace above, are shaded with fine, old trees. While we enter the simple church, the altars of which are of wood, according to the rules of the Order, the monks are chanting the Offices within the choir, behind the chief altar. Seen there, in the distance, dimly, they appear almost like dead persons, and that strange feeling comes over us, which is seldom experienced, except in the presence of something that brings strongly to mind, the transitoriness of earthly things, and the little worth of pomp, show or display.

For these men are dressed in their rough garb, and live thus, retired, unmarried, and unloved, to show to the world their contempt for it, and their hope of a better, gained honestly by sacrifice in this! They forget, that in violating nature, they are striving to un-do God's work, and that evil is sure to come from it, just as the body, bound too tightly in one place, atones for the pressure, by enlargement of some other part! Chant on, my friends, but be not sure, that

in losing so much of the highest happiness on earth, you are laying up still greater stores of it in heaven.

Clara Wells, *Frascati* (1868)

THE Capuchin friars were called to Frascati by popular request towards the end of the sixteenth century. The move was approved by the provincial council when it met at Palestrina and in 1573 a plot of land was purchased in the area known as the Valle Cupa on a site where there once stood an ancient Roman villa. Work immediately commenced on the construction of the convent and church with funding from the people of Frascati, the municipality proper, and Pope Gregory XIII. Another patron of the undertaking was Pietro Antonio Contugi, who had been doctor to Pope Pius IV (1559–65). Legend has it that he was initially hostile to the establishment of the convent, but changed his mind after miraculously recovering from a fall from his horse. The church was completed in 1575 and was dedicated to St Francis two years later. The convent attached to the church now houses an interesting Ethiopic Museum, the legacy of the great missionary Cardinal Guglielmo Massaia who had spent 35 years in Ethiopia.

In the distance, in Grandjean's view, can be seen the roof of the Villa Rufinella built by Cardinal Alessandro Rufino, who had earlier constructed the Villa Rufina. It was a valuable property with extensive olive plantations attached. In 1740 it was purchased by the Jesuit Order who commissioned Luigi Vanvitelli to expand the building to allow it to function as a summer retreat. With the suppression of the Jesuits in 1773 it became the property of the Camera Apostolica, which retained it until the nineteenth century. Pope Pius VII then ceded it to Lucien Bonaparte, who lived there for a time. In 1820 it became the property of the House of Savoy, in whose hands it remained till 1872 when it was bought by the Principessa Donna Elisabetta Lancellotti, who again put it at the disposal of the Jesuits. During the Second World War it suffered severe bomb damage. In 1966 it was purchased by the Salesian Fathers who have since restored it.

78 JAN DE BISSCHOP

THE HAGUE 1628–1671 THE HAGUE

The 'Tomb of the Horatii and the Curiatii', near Albano

Black chalk with brush and bistre wash: 96 × 158 mm

Inscribed, recto, top left, in ink: *Sepulchrum trium Horationum prope montem Albanum*; on back of inlay mount, bottom left, in red ink: *N 3392*; on front of support mount, below right corner of drawing, in pencil: *J. de Bisschop / 1646–1686*; top right, in pencil: *850*.

Border of thin line in black ink

CONDITION: some staining

BODART NO. 98

…Today we have not been out, but I have paddled [because of atrocious weather] to Aruns' tomb, Porsena's son, who was killed in their attack upon Arriccia during the retreat from Rome – a great ugly Etruscan thing with five ruined cones.

Florence Nightingale, *Letter* (March 1848)

But my chief delight was in sauntering along the many woodland walks which diverge in every direction from the gates of La Riccia. One of these plunges down the steep declivity of the hill, and threading its way through a most romantic valley, leads to the shapeless tomb of the Horatii and the pleasant village of Albano. Another conducts you over swelling uplands and through wooded hollows to Genzano and the sequestered lake of Nemi, which lies in its deep crater like the waters of a well, 'all coiled into itself and round, as sleeps the snake.' A third, and the most beautiful of all, runs in an undulating line along the crest of the last and lowest ridge of the Albanian Hills, and leads to the borders of the Alban lake. In parts it hides itself in thick-leaved hollows, in parts climbs the open hillside, and overlooks the Campagna. Then it winds along the brim of the deep, oval basin of the lake, to the village of Castel Gandolfo, and thence onwards to Marino, Grotto-Ferrata, and Frascati.

Henry Wadsworth Longfellow, *Outre-Mer* (1833)

As soon as the visitor is settled in his hotel he will probably wander up to the end of the street, where he will at once find himself amid the greatest attractions of the place. Just below the road, upon the right, is the tomb of Aruns, son of Porsenna. It is a huge square base with four cones rising from it, and a central chamber, in which an urn with ashes was discovered some years ago. Aruns was killed by Aristodemus of Cumae before Ariccia, which his father had sent him to besiege: his tomb is identified by the description which Pliny gives of that of Porsenna, but it was long supposed to be the monument of the Horatii and the Curiatii.

Augustus Hare, *Days near Rome* (1875)

CLOSE to the church of Santa Maria della Stella rises the somewhat bizarre shape of the ancient tomb known as the Tomba degli Orazi e Curiazi. It has been traditionally identified as the burial place of the five heroes who reputedly perished in hand to hand combat to determine the outcome of the quarrel between the peoples of Rome and Alba (Livy I, 23–24). This struggle was resolved when, after two of the Horatii brothers had been killed, Horatius, the remaining triplet, succeeded in killing the Curiatii, thus obtaining victory for Rome. The reason behind the identification of the tomb seems to be simply the fact that the structure, made up of blocks of *peperino* in *opus quadratum*, displays five large truncated cones on top of its raised square base. In fact there were only four cone-shaped projections; the ruined form sited in the center of the base was originally cylindrical (though a sketch made by Baldassare Peruzzi in the early sixteenth century shows it as a four-sided truncated pyramid surmounted by a cone). It has also been suggested that the tomb is Pompey's and that the five protrusions represent his five great victories. Another hypothesis proposes that the monument is the resting place of Aruns, the son of Porsenna, the legendary Etruscan hero, who is reputed to have been slain by the combined Latin forces at nearby Ariccia around 500 BC. This particular identification has some substance as the unique structure has undeniable similarities with the tomb of Porsenna as described by Pliny the Elder (*Natural History*, xxxvi, 91–93). It may well be that the person who commissioned the work sought inspiration from Etruscan antecedents. It is

Giovanni Battista Piranesi: *The 'Tomb of the Horatii and the Curiatii' near Albano*

now generally believed to date from the end of the Republican era. Its extraordinary shape attracted the attention of many artists including Antonio da Sangallo, Baldassare Peruzzi and Piranesi. The sketches of these artists and of De Bisschop document its condition prior to its restoration in 1825 by Provenzali and Valadier when the ruin was 'tidied up' so to speak. The base of the restored tomb measures 50 feet per side by 23 feet high.

This small attractive drawing is quite typical of the work of Jan de Bisschop. Especially noteworthy is the particular blend of ink the artist used which gives much of his work its distinctive color. Van Gelder (1971) notes that according to his near contemporaries, W Goere and Valerius Rover, De Bisschop mixed Indian ink with copper red. Bodart indicates that the drawing depicting the Pyramid of Cestius in the Ecole des Beaux-Arts in Paris (Lugt 1950, p.6, no. 40; 95 × 158 mm) inscribed '*Sepulcrum C. Cestii Epulonis prope portam d. Pauli extra muros*', is a pendant to the present piece. He also lists a number of other related drawings, some with similar inscriptions in the same hand, as well as noting that there is a slightly larger version of the present subject, reversed, attributed to Jacob van der Ulft in the Fondation Custodia in Paris.

Apart from the drawings here discussed (see especially No. 5), Bodart lists three others in the Ashby collection with attributions to De Bisschop (nos. 100, 101, 102).

79 RICHARD COLT HOARE

BARN ELMS 1758–1838 STOURHEAD

View of Albano

Pen and ink and watercolor with traces of black chalk, laid down:
384 × 498 mm

Signed, recto, bottom left, within bricked arch (visible in certain
light), in ink (?); *RCH 1787*; signed, front of support, bottom right
corner, below drawing, in brown ink: *R.C. Hoare 1787*; inscribed, in
the artist's hand, center of mount, in brown ink: *At Albano – in Italy*;
on front of support, bottom right corner, in pencil: *Sir Richard Colt
Hoare Bart*

WATERMARK on support

CONDITION: slight discoloration in sky and some staining

BODART NO. 152

There is nothing at *Albano* so remarkable as the Prospect
from the *Capucin's* Garden, which for the Extent and
Variety of pleasing Incidents is, I think, the most delightful
one that I ever saw. It takes in the whole *Campania*, and
terminates in a full view of the Mediterranean. You have a
Sight at the same time of the *Alban* Lake, which lies just by
in an Oval Figure of about seven Miles round, and, by
reason of the continu'd Circuit of High Mountains that
encompass it, looks like the *Area* of some vast Amphi-
theatre. This, together with the several green Hills and
naked Rocks, within the Neighbourhood, makes the most
agreeable Confusion imaginable. *Albano* keeps up its Credit
still for Wine, which perhaps would be as good as it was
anciently did they preserve it to as great an Age.

Joseph Addison, *Remarks on Several Parts of Italy, &c. In the Years
1701, 1702, 1703*

The remains of the first of these buildings can be seen in the
gardens of the Villa Barberini.. Those of the second are in
the gardens of the convent of San Paolo, in the upper part of
the town. They consisted in a great round structure the use
of which seems to have been for the combat of wild beasts
and gladiators. There are great arcades which range right
round, which doubtless led into the arena, which cannot be

discerned today given the amount of wood, muck and
other matter with which it is full.

Marquis de Sade, *Voyage d'Italie* (1775–76)

The third hill, surpassing the others in prospect and situ-
ation, appears to have been the seat of pleasure, amuse-
ment, and devotion. On the summit are the remains of an
amphitheatre, with one of its entrances composed of large
blocks of stone. Near it I observed another cavity, which,
from its semicircular shape, and the situation of the *scena*, I
conceived to have been used as a theatre. The Franciscan
convent and church of St Pietro, occupy the site of an an-
cient temple, the magnificent substructions of which are
still visible. Sixteen columns of the Corinthian order sup-
port the tottering roof of the church, and the pavement
contains a few mutilated and uninteresting inscriptions.

Sir Richard Colt Hoare, Bart, *A Classical Tour through Italy and Sicily*
(1819)

One day we walked out, a little party of three, to Albano,
fourteen miles distant; possessed by a great desire to go
there by the ancient Appian Way, long since ruined and
overgrown. We started at half-past seven in the morning,
and within an hour or so were out upon the open
Campagna. For twelve miles we went climbing on, over an
unbroken succession of mounds, and heaps, and hills, of
ruin. Tombs and temples, overthrown and prostrate; small
fragments of columns, friezes, pediments; great blocks of
granite and marble; mouldering arches, grass grown and
decayed; ruin enough to build a spacious city from; lay
strewn about us . . . The aspect of the desolate Campagna in
one direction, where it was almost level, reminded me of an
American prairie; but what is the solitude of a region where
men have never dwelt, to that of a Desert, where a mighty
race have left their footprints in the earth from which they
have vanished; where resting-places of their Dead, have
fallen like their Dead; and the broken hour-glass of Time is
but a heap of idle dust!

Charles Dickens, *Pictures from Italy* (1846)

From Castel Gandolfo two lovely roads fringed with old
ilexes, the Galleria di Sopra and the Galleria di Sotto (the
latter followed by an electric train), lead to Albano. If we

keep to the upper one, along the crater rim, we soon come to the Capuchin monastery of Albano. The old wood behind it occupies a lofty hill, and one would imagine that some temple had once stood there; but not a vestige of antiquity is to be seen. Just below it is an amphitheatre, the upper side of which is mostly cut out of the solid rock, while the lower is built of arches on concrete and supported on a terrace, the supporting wall of which is decorated with niches. It has been computed that it might have held about 16,000 people at most: and the method of its construction showed that it can have had nothing to do with Domitian, but must have been erected by the second Parthian Legion; and indeed two of the brickstamps bear the name of this corps. It lies, too, just above the camp that was erected for it by Septimius Severus, who, having dissolved the Praetorian Guard, brought in this legion to take its place. A number of tombstones of Parthian soldiers were found in the woods between Albano and Ariccia some sixty years ago. The massive walls of the camp, built of blocks of hewn stone, still enclose a roughly rectangular space of about 450 × 250 yards, which is occupied by the upper part of the town of Albano, but do not extend as far as the Via Appia. The camp is very long in proportion to its width, and the closest parallel is found in the camp of Borcovicus (House-Stead) on Hadrian's wall . . .

Thomas Ashby, *The Roman Campagna in Classical Times* (1927)

THE town of Albano, beautifully sited among the Alban hills and overlooking the lake of the same name, was a favorite retreat for the Roman nobility in ancient times. There was already a villa in the area around the time of the Gracchi (mid-second century BC). Pompey constructed a villa there in the first century BC. This was later taken over by Domitian in the first century AD and reworked to become a magnificent complex of impressive dimensions. Domitian's vast estate stretched from Castel Gandolfo to Albano and from the lake to beyond the Via Appia, incorporating a theater, stadium, gymnasium, terraces and promenades, waterside jetties and an abundance of pavilions and fountain buildings. Later the town of Albano became an important military base when Septimius Severus (193–211) posted the second Parthian legion there and constructed barracks and amenities for their use. This work was continued by Caracalla and completed in 212. To supply water for the legion and the baths a massive underground cistern, which remains in use today, was built into the rock. About the military camp grew up the municipality of Albano, with all the usual public buildings associated with a Roman town, including an amphitheater. By the time of Constantine the development had grown rapidly and in 460 it became the seat of a bishopric. In medieval times the Savelli family, from the nearby town of Ariccia, became the feudal overlords of the area. With the demise of the Savelli control of the town passed to the Camera Apostolica.

Richard Colt Hoare's sketch shows a view of Albano from the grounds of the church of the Cappuccini towards the church of San Paolo and the ruins of the Roman amphitheater. The church of San Paolo had been established in 1282 by Cardinal Savelli.

FOR comment on Richard Colt Hoare and his drawings in the Ashby collection, see next, No. 80.

80 RICHARD COLT HOARE

BARN ELMS 1758–1838 STOURHEAD

The Lake of Nemi

Black chalk with watercolor on paper, laid down: 382 × 497 mm

Inscribed on front of support, center, in brown ink: *The Town and Lake of Nemi — — in Italy — — R.C. Hoare 1787*

WATERMARK on support

CONDITION: good

BODART NO. 151

In our Excursion to Albano we went as far as Nemi, that takes its Name from the Nemus Dianae. The whole Country thereabouts is still over-run with Woods and Thickets. The Lake of Nemi lies in a very deep Bottom, so surrounded on all Sides with Mountains and Groves, that the Surface of it is never ruffled with the least Breath of Wind, which perhaps, together with the Clearness of its Waters, gave it formerly the Name of Diana's Looking-glass. — *Speculumque Dianae*, Virg.

Joseph Addison, *Remarks on several Parts of Italy, &c. In the Years 1701, 1702, 1703*

Since writing to Stephen No. 1 of this new series — I have been to pass a few days in the country, at the village of Arriccia — about fifteen miles from the city. It is a very delightful spot — situated on a gentle hill, and surrounded for miles with beautiful forest scenery. The roads, and mountain paths leading from the village are arched and shaded with fine large trees: and the interchange of hill and vale — of woodland and cultivated fields — reminds me more of New England than anything I have seen on the continent. Every day I made some excursion to the neighbouring villages and convents. Not far distant is the Lake of Nemi — called by the ancients the 'mirror of Diana' — on account of the purity of its waters. Lord Byron has a description of it in the fourth Canto of his Childe Harold, where he says

'Lo Nemi! — navell'd in the woody hills'
which description and particularly the epithet 'navelled' —

conveys you a perfect picture of the scene. It continues
 'And, near, Albano's scarce divided waves
 Shine from a sister valley —' &c
All which is very correct and topographical: the lake of Albano being near that of Nemi, and like it buried in the hollow of the wooded hills. There is a convent of the Capuchin monks upon its borders. At no great distance is the convent of Monte Cavi — upon a very high eminence — from which your eye runs over an immense extent of scenery. Rome — with its antiquities — lies hardly distinguished, almost beneath your feet. You see the Mediterranean — and even the island of Corsica — and you have the scene of the last half of the *Aeneid* of Virgil spread out like a map before you. I cannot at present speak more particularly of these scenes. But, I intend returning to Arriccia — and will write more particularly from the spot itself.

Henry Wadsworth Longfellow, *Letter* (11 July 1828)

The lovely little crater, with the 'mirror of Diana' glistening below, is best seen from the garden of the Villa Sforza-Cesarini, the pines of which are seen in the foreground of some of John Richard Cozens' finest watercolours. Below the garden the path following the Roman branch road descends steeply to the lake. Its shores are precipitous on the E., and in the scanty bits of more or less level ground violets and daffodils are grown for the Roman flower market. It is heavily cultivated on the W. and N., where the remains of the great platform on which the temple of Diana stood can be seen: it is probable that there was no large monumental building, but only a group of small chapels; or else some large architectural fragments would surely by now have come to light. The origin of the cult is certainly an old one, for even in Imperial times the priest, usually a gladiator or fugitive slave, won his priesthood by killing the previous holder in fight, having previously plucked a mistletoe bough (the Golden Bough of Sir James Frazer's well-known work) from the sacred grove. Off the temple were anchored two great floating 'barges' (like the College barges at Oxford), equipped with marble pavements and lead water-pipes, and with beam-heads of bronze decorated with the heads of lions and wolves, holding mooring rings for small boats. They are some of the finest bronzes of the kind that we have, and are in the Museo delle Terme in Rome. They

are generally attributed to Tiberius, though the name on the water-pipes is that of his successor, Caligula.

Above the temple lies the picturesque village of Nemi, it is dominated by a mediaeval castle with a large round tower: and behind it is the mediaeval post-road (following, probably, an ancient line) which was in use until the time of Pius VI, and crossed the outer rim of the crater by a steep ascent through the Macchia della Faiola and by a still steeper descent to Velletri...

Thomas Ashby, *The Roman Campagna in Classical Times* (1927)

THE view of Lake Nemi, 16 miles south-east of Rome, with its small town perched high on the rim of the volcanic crater, is one of the most delightful in all Italy. It is no wonder that this enchanting scene has captured the imagination of artists and poets for centuries past. In the early days of Rome, and indeed before, its silent waters and sylvan slopes were haunted with the magic of the gods, particularly Diana, the moon goddess who was especially revered in groves and forests. The reflection of the moon in the still, silent waters of the lake won it the title Speculum Dianae, the Mirror of Diana. The cult of the goddess, established close to the shore, dates back to the days of the first Latin League, towards the end of the sixth or beginning of the fifth century BC. The exact make-up and extent of the sanctuary buildings is difficult to determine today, partly because of the undisciplined manner in which the site was excavated and the remains pillaged. From the evidence that remains it would appear that development of the sanctuary reached a climax around the end of the second century BC, at about the same time as the colossal sanctuary dedicated to Fortuna at Palestrina (see No. 73). A unique feature relating to the rites of Diana at Nemi and Ariccia was the remarkable ritual which evolved to appoint the virgin goddess's high priest, the *rex nemorensis*. The bloody contest to choose a successor to the incumbent high priest meant that only fugitive slaves or criminals would be willing to run the risk of holding the office.

In classical times, the Lake of Nemi also echoed to happier sounds than the bloody combats of aspiring high priests: its waters were an attractive location for the summer retreat, and a number of emperors held splendid festivals there. Suetonius, in his life of Caligula, mentions fabulous boats which were used to sail on the waters, and as early as the fifteenth century attempts were made to salvage the remains of some of these pleasure barges, Leon Battista Alberti being among the first to propose such an operation. Despite the general scepticism of most archaeologists, sporadic attempts were made over the following 450 years to recover the legendary wrecks, until finally, during a campaign working over the period 1927–32, two huge wooden framed barges (256 and 260 feet long) were recovered, after the lake had been partly drained. A special museum was constructed close by to house these superb relics of imperial luxury. During the fighting of the Second World War, in the summer of 1944, however, they were destroyed.

This view of the Lake of Nemi by Richard Colt Hoare shows us the scene with the town of Nemi perched on its lofty ledge above the crater to the right. In the Middle Ages the town was variously under the control of the Frangipane, the Savelli and the Orsini. In 1428 it came into the possession of the Colonna before passing into the hands of Cardinal Estouteville in 1479 and later again returning to the possession of the Colonna. In 1572 the Frangipane again became lords of the district, a title they retained until 1781 when the town was sold to Luigi Braschi, nephew of Pope Pius VI. The castle of the Colonna, which is now the Palazzo Ruspoli, dominates the town.

Another view of Nemi by Richard Colt Hoare was exhibited at Yale in 1981 (*Classic Ground: British Artists and the Landscape of Italy*, no. 23). The sketch, 327 × 498 mm, was one from a volume of 66 drawings which had been bound together and titled *Views Drawn from Nature in the Neighbourhood of Rome and Abruzzo etc., by Sir Richard Colt Hoare Bart. in the Years 1786 to 1790*. Eighteen other bound volumes of drawings were recorded at Stourhead, the home of the writer and artist, in 1840.

Apart from the two drawings exhibited here, the Ashby collection in the Vatican contains five more by the artist showing views of Collepardo (no. 153), Vietri (no. 154), Martorell (no. 155) a mountain lake (no. 156) and the Mediterranean (no. 157).

Apart from sketching his own views from nature, Richard Colt Hoare employed other artists to assist with the provision of drawings to illustrate his travel books, most notably Carlo Labruzzi (*cf* Nos. 68 and 70).

Albert Christophe Dies: *The Lake of Nemi*

81 JACOB VAN DER ULFT

GORINCHEM 1627–1689 NORDWIJK

Imaginary Landscape with Classical Colonnade

Pen and ink with bistre wash and white highlights on laid paper: 234 × 371 mm

Inscribed, verso, bottom right, in graphite: *J. van der Ulft*, bottom center, in pencil: *136*. Attached to the drawing is a cutting from an old auction catalogue which reads: *600. J. van der Ulft. Colonnade romaine a Rome.*

Border of dark brown ink

CONDITION: tear on left side, near top. Lacuna at bottom right corner. Strips of paper applied on verso, along top edge

BODART NO. 305

Having laid out the alleys and determined the streets, we have next to treat of the choice of building sites for temples, the forum, and all other public places, with a view to general convenience and utility. If the city is on the sea, we should choose ground close to the harbour as the place where the forum is to be built; but if inland, in the middle of the town. For the temples, the sites for those of the gods under whose particular protection the state is thought to rest and of Jupiter, Juno, and Minerva, should be on the very highest point commanding a view of the greater part of the city. Mercury should be in the forum, or, like Isis and Serapis, in the emporium: Apollo and Father Bacchus near the theatre: Hercules at the circus in communities which have no gymnasia nor amphitheatres; Mars outside the city but at the training ground, and so Venus, but at the harbour. It is moreover shown by the Etruscan diviners in treatises on their science that the fanes of Venus, Vulcan, and Mars should be situated outside the walls, in order that the young men and married women may not become habituated in the city to the temptations incident to the worship of Venus, and that buildings may be free from the terror of fires through religious rites and sacrifices which call the power of Vulcan beyond the walls. As for Mars, when that divinity is enshrined outside the walls, the citizens will never take up arms against each other, and he will defend the city from its enemies and save it from danger in war.

Ceres should also be outside the city in a place to which people need never go except for the purpose of sacrifice. That place should be under the protection of religion, purity, and good morals. Proper sites should be set apart for the precincts of the other gods according to the nature of the sacrifices offered to them...

Vitruvius, *On Architecture* (early 1st century AD) (translated by M H Morgan)

JACOB van der Ulft, despite his many Italian views, may never in fact have visited Italy. It should not surprise us, therefore, to find that he sometimes fantasized the nature of the Roman landscape he may only have known indirectly from the prints and drawings of others. Because of their very personal nature, being independent of direct models, these works are among the most striking and typical of Van der Ulft's creations. Bodart claims that the monuments depicted in this fantasy are derived from actual buildings, seeing in the great edifice dominating the right corner of the composition the outline of the apse of Santa Maria Maggiore with its campanile, while in the colonnaded superstructure he detects the image of the Mausoleum of Augustus.

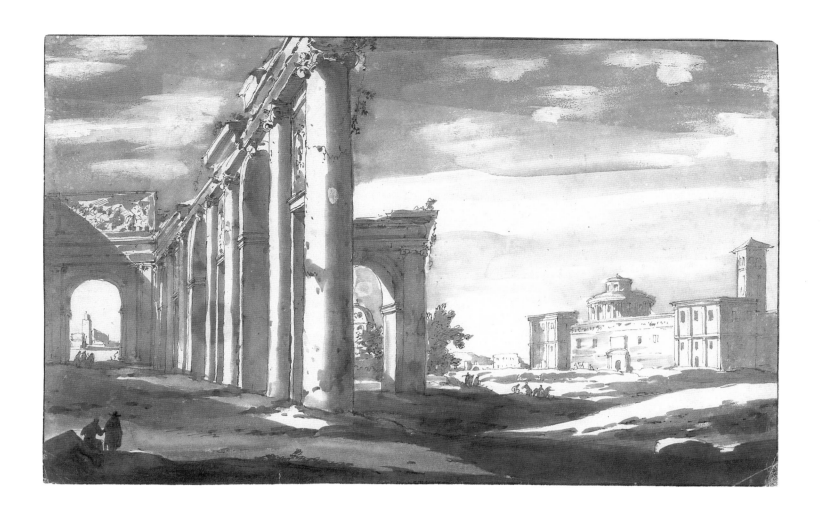

BIOGRAPHIES

Artist using the monogram AB

Active 1723–45

This unknown artist, perhaps of German origin, initialed a series of drawings of Rome made in the eighteenth century. See No. 14.

JACQUES-FRANÇOIS AMAND

PARIS 1730–1769 PARIS

Jacques-François Amand won the Prix de Rome in 1756 with a painting depicting *Samson and Delilah*. He traveled to Rome in 1759 where he was to remain a *pensionnaire* until 1763. While in Rome, like so many of his colleagues, he developed the habit of wandering about the city and its surroundings making sketches of the monuments and scenery. On his return to France he established himself as a painter of historical subjects, though his drawings were also popular with collectors and it is known that Mariette possessed thirteen of his views of Rome.

PAOLO ANESI

ROME 1697–1773 ROME

Paolo Anesi was born in Rome on 9 July 1697. His father was a weaver who had moved to Rome from Venice with his wife some time around 1680 to work in the silk trade, following the incentives offered in this particular occupation by Pope Clement IX. The young Anesi possibly received some of his early training from the marine artist Bernardino Fergione, in the company of his more celebrated contemporary Andrea Locatelli; he was also a pupil of Giuseppe Chiari. Like Locatelli, he developed a talent for view painting and it is as a *vedutista* that he is best known. Most of his work was done in and around Rome, though he spent some time in Florence, as is documented by drawings he did there, depicting among other things the Ponte

Vecchio (dated 1748). According to the Abbate Lanzi he may have given instruction to the young artist Francesco Zuccarelli during his sojourn in that city. In 1725 he had married Anna Maria Sardi, by whom he had twelve children. In 1747 he was received into the Pontificia Congregazione dei Virtuosi al Pantheon as a landscape painter.

Anesi's earliest works date back to about 1715. He usually worked on a small scale and frequently produced pendants rather than single views. In many of his works the figures have been added by other artists, including Panini and Batoni. In 1725 he published a set of 12 engravings, *Varie vedute inventate ed intagliate*, which he dedicated to Cardinal Giuseppe Renato Imperiali. Apart from producing engravings and small canvases, Anesi worked in fresco. Among his most important undertakings in this field were the decorations he executed in the early 1760s for Cardinal Albani in his newly constructed villa [now Villa Torlonia] on via Salaria, where he painted alongside Antonio Biccheria and Nicolò Lapiccola. He also assisted with the decoration of the Villa Chigi and the Palazzo Massimo at Arsoli.

FERDINAND BECKER

BATH, late 18th century–1825 BATH

Not much is known of the career of Ferdinand Becker, a topographical draughtsman who, despite his German sounding name, apparently spent much of his active career at Bath, apart from his travels in pursuit of new motifs. It may be that he was only an amateur artist, though he exhibited two landscapes in crayons at the Royal Academy in London in 1793 ('*Becker Esq., H*(onorary)', nos 643 & 664). He later exhibited another two landscapes at the British Institution in 1810 (nos. 302, 307) where he gave his address as 13 Gay Street, Bath. Becker also executed a number of engravings, including a suite of fifteen views after RF Kobell; a suite of six etchings after nature (inscribed: *Bath, 6*

November, 1821); and a series (?) of etchings loosely devoted to Roman ruins. According to Joseph Farington, he visited Italy around 1785. Thomas Ashby noted, in a remark penciled on to the verso of no. 13 (*The Botanic Gardens, Rome*), that Becker was a drawing master at Bath. Bodart reproduces a notice from the *Bath Chronicle,* of 20 November 1794: *Mr Becker having found a new mode to facilitate the art of drawing and assist natural genius by blots gives lessons . . . also landscape drawing.*

LOUIS-GABRIEL BLANCHET

PARIS 1705–1772 ROME

Blanchet was second to Pierre Subleyras in the Prix de Rome in 1727, yet managed to obtain his *pensionnaire* diploma and travel to Italy, where, like Subleyras, he was to remain for the rest of his life. In Rome he studied at the French Academy, then at the Palazzo Mancini, under the direction of Vleughels; he also frequented the studio of the noted German artist Raphael Mengs, along with Gamelin and Pecheux. Professionally, Blanchet earned his living chiefly through painting portraits, including commissions from the exiled Stuart family. He may be responsible for the portrait of Mozart, now at Glyndebourne, which would have been painted during the composer's visit to Italy between 1769 and 1771. Blanchet also received commissions from time to time to provide canvases for decorative schemes, including a request to provide overdoors with allegorical subjects for the Duc de Saint-Aignan, the French ambassador to Rome. Apart from his portraiture and decorative commissions, Blanchet made numerous sketches of the Roman countryside, mostly using black and white chalk on gray paper, a technique which apparently influenced Richard Wilson (*qv*). When Wilson came to Rome, Blanchet was lodging with the British artist William Forrester in 1758 close to the Piazza di Spagna, and Forrester may have been the means of contact.

CONSTANT BOURGEOIS DU CASTELET

FRENCH 1767–1836

This pupil of Jacques-Louis David was primarily a landscape painter, who also made engravings and lithographs. He exhibited at the Salon from 1810.

BARTHOLOMEUS BREENBERGH

DEVENTER 1598–c1657 AMSTERDAM

Of the early training of Bartholomeus Breenbergh, born in 1598, the son of a well-to-do merchant in Deventer, we have little knowledge; we can only speculate, from the influences apparent in his earliest works, that he initially developed his talents under the influence of Pieter Lastman and Jacob Pynas in Amsterdam. It is in Amsterdam that he is first documented as an artist, in 1619, the year he moved to Italy. In Rome, apart from eagerly sketching the local sights and traveling into the Campagna, and sometimes further afield, he studied the art of Elsheimer and his followers while working alongside Paul Brill (1554–1626), one of the best known exponents of the early modern landscape tradition. Breenbergh's personal vision of the Italian scene marks him out as one of the initiators, along with Van Poelenburgh (*qv*), of the Italianate style of landscape painting. While in Italy he painted a sequence of small, beautifully crafted pictures, showing views of Rome made up of an arbitrary selection of monuments, usually chosen rather for their picturesque than their archaeological character. In 1623 he was one of the founders of the fun-loving *Schildersbent,* the Dutch painters' guild in Rome. On his return to Holland, most probably in 1629, Breenbergh settled in Amsterdam, where in 1633 he married Rebecca Schellingwou, the daughter of a wealthy cloth merchant. Though continuing

to draw heavily on his Italian experiences, he now altered the emphasis of his art away from pure landscapes to subject compositions, usually biblical. In 1652 he is mentioned as a merchant, indicating a dual livelihood, a phenomenon not uncommon among Dutch artists of the seventeenth century. His business career may account for the drop in picture production during his later years.

JAMES BRUCE OF KINNAIRD

KINNAIRD 1730–1794 KINNAIRD

Born at Kinnaird, Stirlingshire, on 14 December 1730, James Bruce was the son of David Bruce of Kinnaird and Marion Graham of Airth. He was educated at Harrow and initially set out, in accordance with his parents' wishes, to pursue a career in law. A young man of great size and strength and considerable athletic ability, he was not all cut out for sedentary pursuits, despite his native intelligence. Following the death of his young wife, the daughter of a Scottish wine merchant active in Portugal, he traveled to the Iberian peninsula and there became fascinated by the languages and cultures of North Africa, particularly Abyssinia. This obsession soon led him to seek an official commission in North Africa. Eventually, through the good offices of his friend Robert Wood, Lord Halifax arranged for him the consulate in Algiers. It was while waiting to take up his appointment in 1762–63 that Bruce visited Italy, chiefly with a view to equipping himself for his task ahead. He set about studying antiquities and employed the Bolognese Luigi Balugani as his drawing master and draughtsman. Apart from sketching trips made in Rome and its environs, Bruce and Balugani visited Paestum (rediscovered in 1746) and made the earliest recorded surveys of its important monuments, which were to prove crucial in the development of the Neoclassical style in architecture. It was

Bruce's original intent to have these drawings published, but this did not come to pass. In March 1763 Bruce finally arrived in Algiers and for the next ten years lived a highly adventurous life as an explorer, documenting and making drawings of his travels (in the company of Balugani for much of the time) as he moved through Egypt and Abyssinia, all the while winning the confidence of the frequently unpredictable and sometimes savage local rulers through his sheer physical size and presence and powerful personality. The burning ambition of his African travels was to locate the source of the Nile, and in the autumn of 1770 he achieved this ambition. Bruce returned to Europe in 1773. Receiving no official honor for his extraordinary exploits he retired to his family estate in Scotland where he passed his time editing his travel journals. These he eventually published in 1790. Bruce passed away following a domestic accident on 27 April 1794.

JAN BRUEGHEL the ELDER

BRUSSELS 1568–1625 ANTWERP

Jan 'Velvet' Brueghel, the son of Pieter Bruegel the Elder and brother of Pieter Brueghel the Younger, was most likely born in Brussels in 1568, although no baptismal records have been found to substantiate the birth-date inscribed on his tombstone in the Sint Joriskerk in Antwerp. According to Karel van Mander, the seventeenth-century artist and biographer, the young Brueghel was first introduced to the art of watercolor by his maternal grandmother Meyken Verhulst (still alive in 1580) who was a miniaturist, and to the art of oil painting by Pieter Goetkindt (died 1583). Van Mander recounts that the young artist visited Cologne before proceeding to Italy where he is first documented in June 1590, in Naples. Between 1592 and 1594 he was in Rome, where he met Cardinal Federico Borromeo,

with whom he was later to maintain a long correspondence. In 1596 he is documented in Cardinal Borromeo's household in Milan, before he continued on to the Low Countries where he arrived in the summer of that year, settling in Antwerp. The following year he was accepted into the local Guild of St Luke. In 1609 he was appointed Court Painter to Archduke Albert of Austria, Governor of the Netherlands, at Brussels, though he continued to reside at Antwerp. He also supplied pictures for Emperor Rudolf II and king Sigismund of Poland. He was a friend of Rubens and collaborated with him on numerous projects, winning for himself considerable acclaim as a painter of landscapes and flowerpieces. He also worked alongside Van Balen, Frans Franken II, Rottenhammer and Joos de Momper. Brueghel died of cholera in Antwerp on 13 January 1625. Apart from his own son, Jan Brueghel the Younger, he had few followers, Daniel Seghers being the best known.

GIOVANNI BATTISTA BUSIRI

ROME 1698–1757 ROME

Giovanni Battista Busiri, also known as Titta or Tittarella, was born in Rome in 1698 the son of Simone Beausire (born Paris, 1648) and Angela Francesca Barlandino Manzoni. He may have commenced his career in a dilettante fashion, only turning to painting full-time when he realized that it could provide him with a livelihood. Certainly, his paintings proved immensely popular with a great number of foreign visitors to Rome, particularly the British *milords* on their 'Grand Tour'. A minor painter, yet one of the most delightful of all the *vedutisti* working in Rome in the eighteenth century, he belongs to the same tradition as his better known contemporaries Van Bloemen and Vanvitelli, though his art is more akin in scale and approach to the more intimate

productions of Paolo Anesi (*qv*). Busiri generally worked in bodycolor on paper or else on a small scale on canvas. In 1735 he is recorded living with the artist Ignazio Stern in via del Babuino and some fifteen years later, in 1750, he is documented in the company of the sculptor Giovanni Maini in via della Purificazione. He died in 1757 or shortly afterwards.

LOUIS CHAIX or CHAYS

MARSEILLE c1740–1810 PARIS

After commencing his artistic studies at the Academy in Marseilles, the relatively little known artist Louis Chays, real name Chaix, was sent to Rome in 1771 by his patron Louis de Borely to further his education. There he studied in the company of his compatriots Joseph Benoit Suvée (1743–1807), Jean Simon Berthélémy (1743–1811) and François André Vincent (1746–1816). When he returned to Marseilles in 1776 he again worked for his patron and his paintings at the château Borely, where he decorated the ceiling of the *grand salon* and the main stairway, reflect the influence of his Roman sojourn.

CLAUDE-LOUIS CHATELET

PARIS c1750–1795 PARIS

The painter and watercolorist Claude-Louis Châtelet was probably born in Paris. We know little of his artistic education though it may be surmised that his vocation for landscape painting was influenced by the Abbé de Saint-Non who commissioned Châtelet, along with Desprez, to illustrate his *Voyage pittoresque à Naples et Sicile*. Châtelet also produced plates for the publication *Picturesque Views of Switzerland*. For Queen Marie Antoinette he painted a sequence of views depicting the gardens at Versailles and it has been suggested that he had a hand in the design of the gardens themselves. Besides topographical views,

Châtelet also painted pastoral scenes in the style of Joseph Vernet, including some landscapes in a proto-Romantic vein. With the outbreak of the Revolution he embraced its ideals and became, like Jacques-Louis David, a member of the Revolutionary Tribunal during the Terror, urging many swift executions. Unfortunately, like so many of his zealous colleagues, he himself became a victim of the Thermidorians and, after the fall of Robespierre, was guillotined on 7 May 1795.

MICHEL CORNEILLE the YOUNGER

PARIS 1642–1708 PARIS

This artist was son and pupil of Michel Corneille the Elder (1603–64) and brother to Jean-Baptiste Corneille (1649–95). Apart from studying with his father he also worked with Charles Lebrun, the foremost master of his day in Paris. In 1659 he won the Prix de Peinture and spent the following four years in Rome. On returning to Paris he became a member of the Academy on the presentation of his reception piece *The Calling of Sts Peter and Andrew* (1663). He was a prolific artist, producing many works devoted to religious and mythological subjects. He made many engravings after Italian artists for the noted collector Jabach, particularly designs based on the compositions of Annibale Carracci. Besides his activities as a painter, Corneille provided designs for the Gobelins tapestry factory.

JAN DE BISSCHOP

THE HAGUE 1628–1671 THE HAGUE

Born in The Hague in 1628, Jan de Bisschop, who sometimes latinized his name to *Johannes Episcopius*, was an exceptionally talented amateur who possibly received his artistic instruction from Bartholomeus Breenbergh (*qv*), but did not proceed to practice art as a career. He earned his living as a lawyer, having studied at Leyden before moving to The Hague where he set up his practice. De Bisschop shared his talent for art with his contemporary and close friend, Constantijn Huygens the Younger, son of the poet and statesman of the same name. In 1653 he married Anna, the daughter of the learned Casper van Baerle. Possibly the following year, 1654–55, he visited Italy where he would have made numerous landscape sketches and drawings after the antique as well as copying the work of contemporary artists. Dr An Zwollo argues, however, that there simply would not have been enough time for the trip, considering his documented presence at home. De Bisschop established for himself a considerable reputation both as a draughtsman and also a propagandist for the role of the study of the antique in the education of young artists, ideas which he developed through his contact with Huygens. Like Castiglione in his *Cortegiano* he saw drawing and a knowledge of the antique as essential elements of a proper education. In 1661, together with some colleagues, he opened a private drawing academy putting into practice his ideals. The most notable artist to have been influenced by De Bisschop was Jacob van der Ulft (*qv*). Apart from producing large numbers of exquisitely conceived drawings, usually on a small scale, De Bisschop published numerous engravings, his most important being a set of prints after celebrated antique statues and contemporary paintings under the title *Paradigmata Graphices variorum Artificum* which appeared in 1671, the year of his death.

ALBERT CHRISTOPHE DIES

HANOVER 1755–1822 VIENNA

Albert Christophe Dies received his early art training in his native town, Hanover, before traveling to Mannheim where he studied under Pigage and then to Basle where he worked with Mechel. He then traveled on to Italy where he visited Rome and Naples and toured the Campagna. Between the years 1792 and 1796 he worked alongside J. hr. Reinhart and J W Mechau and contributed twenty-four plates to the *Collection de Vues pittoresques d'Italie* published in 1799, including a number of fine views of Tivoli. He traveled from Rome to Salzburg in 1796 and on to Vienna where he settled, teaching the art of landscape at the Academy. He died in Vienna in December 1822.

ETIENNE DUPERAC

PARIS 1525?–1604 PARIS

By profession, Etienne Dupérac was an architect. He was born in Paris around the year 1525, but little is known of his early career before he traveled to Italy around 1559. In the many drawings and engravings he made in Rome he expresses a continual fascination with the eternal city, capturing its unique blend of classical and modern, pagan and Christian cultures, documenting its archaeological monuments and recording its modern splendors, some of which, like Michelangelo's designs for the Campidoglio, had not yet even been completed. For his topography of ancient Rome he must have received inspiration from Pirro Ligorio and he may also have consulted Onofrio Panvinio, the greatest living expert on classical Rome. Of the one hundred or so prints from his hand which have come down to us, among the most important are the series of forty published in 1575 under the title *I Vestigi dell'Antichità di Roma . . .*, dedicated to Giacomo Buoncompagni. In 1574 he produced a plan of ancient Rome, *Urbis Romae Sciographia ex Antiquis Monumentis . . .*, which he dedicated to Charles IX of France. In 1577 he completed a bird's eye view of modern Rome, *Nova Urbis Romae Descriptio . . .* Not all his prints, however, were devoted to ancient monuments, and among his earliest productions was a representation of a tournament in the courtyard of the

Belvedere in the Vatican, held on the occasion of the marriage of Giacomo Altemps and Ortensia Borromeo in 1565. Dupérac also made prints after works by Michelangelo, Raphael and other artists. Dupérac revisited his native France on a number of occasions, returning there for good in 1582. Appointed architect to Charles IX, he worked on the Tuileries, where he designed the Pavilion de Flore (completed after his death), as well as at St Germain-en-Laye and at Fontainebleau, where he painted frescos depicting the loves of Jove and Callisto (destroyed 1697).

JACOB FRANCKAERT

ANTWERP c1550–1601 ROME

Jacob Franckaert was born, most probably in Antwerp, some time before 1550. He was registered as a master in the guild there in 1581 and later, c1585, moved to Italy, where he practised for the rest of his career. He apparently first worked in Naples where he was associated with Wenceslas Cobergher who, in 1599, married his daughter Susanna. Later he moved to Rome (before 1598), where he settled in via Paolina (now via del Babuino). He died there on 6 September 1601. His son, also called Jacob, practised as a painter and architect.

'GIMELLY'

ACTIVE c1782

'Gimelly' was a British artist, possibly of Scottish origin, who was active in Rome at the end of the eighteenth century and signed himself thus. See No. 49.

JEAN GRANDJEAN

AMSTERDAM 1752–1781 ROME

Jean Grandjean was born in Amsterdam in February 1752, the son of a glovemaker descended from Huguenot refugees. One of seven sons from his father's second marriage, he quickly showed his artistic talents and was apprenticed to the topographical draughtsman Jacobus Verstegen. After studying there and elsewhere he eventually passed, in 1772, to the studio of Jurriaen Andriessen (1742–1819), where he would have met a number of other young talented artists, including Daniel Dupré and Hendrik Voogd who would later follow his lead and travel to Rome. The young and ambitious Grandjean supplemented his studies at Andriessen's studio with attendance at the Amsterdam City Drawing Academy (1771) and at private drawing schools while, in the meantime, becoming one of the founder members of the Felix Meritis (1777), an artists' society which exists to this day. The goal of all this study was to equip the young artist to become a skilled history painter capable of taking on commissions to depict great biblical or mythological or historical subjects. For an artist of such ambitions, a journey to Italy was greatly to be desired, though the practice of traveling there had virtually died out among Dutch artists of the period.

Grandjean set out for Italy in June 1779. In Rome he became attached to the community of German artists in the city and pursued his studies at the studio established by the sculptor Alexander Trippel as well as elsewhere. Of the drawings executed during the two short years he had yet to live, the most notable are his studies after the antique, his studies done from the live model and his elaborate topographical sketches. His views of Rome and the Campagna are elaborated in a controlled, classical fashion, very different from the contemporary models he would have observed in his native Amsterdam. According to Marco Chiarini these charming scenes anticipate the nineteenth

century in their approach to view painting. Before his death in November 1781 Grandjean managed to complete only one major project indicating his talents as a painter of historical subjects, his series of 37 drawings prepared to illustrate the historical poem *Germanicus*, written by Lucretia Wilhelmina van Merken (1721–89).

JAKOB PHILIPP HACKERT

PRENZLAU 1737–1807 SAN PIERO DI CAREGGIO

Jakob Philipp Hackert was born in Prenzlau, Uckermark (Brandenburg), the son of the portrait painter Philipp Hackert, with whom he started his training. At the Berlin Academy he received instruction from Le Sueur who directed him towards landscape painting and encouraged him to study the art of Claude and the Dutch landscapists. He continued his education with a trip, in 1762–63, to Stralsund and the nearby island of Rugen and from there he traveled to Sweden in 1764. In 1765 he moved to Paris where he was joined by his brother Johann Gottlieb (1744–73) who made his reputation as an animal painter. While in Paris the brothers made trips to Normandy. Their success in Paris enabled them, in 1768, to travel to Rome. Visiting Naples in 1770 they received commissions from William Hamilton and painted a number of views showing the eruption of Vesuvius. The following year Philipp was commissioned by Catherine II of Russia to paint *The Victory of the Russian Fleet over the Turks at Tchesme*. When Johann Gottlieb departed for England in 1772, Philipp called his younger brother Georg Abraham (1755–1805), a printseller and engraver, to Rome to assist him. In 1777 he paid a second visit to Naples and thence to Sicily. The following year he traveled to North Italy and to Switzerland. In 1782 he settled in Pales with his younger brother and there was appointed Court Painter to King Ferdinand IV at Caserta. It was in Naples

that he met Goethe in 1787. The political turmoil of the period, however, eventually forced him, and Georg, to flee their adopted city in 1799, following the capture of the Kingdom by the French. In 1803 Philipp purchased a small estate near Florence, where he died in 1807.

RICHARD COLT HOARE

BARN ELMS 1758–1838 STOURHEAD

The grandson of Henry Hoare of Stourhead, Sir Richard Colt Hoare was a distinguished classicist and antiquarian as well as a talented artist and patron of the arts. He received his training as a painter from Devis at Wandesforth and Dr Samuel Glasse at Greenford.

Having spent some time employed in the family bank, Hoare left for the continent in 1785 following the death of his wife. Among the countries he visited on his wide-ranging travels were France, Italy, Switzerland and Spain. After returning home in July 1787 he soon set off again, this time traveling by way of Holland, Germany, Austria and Trieste. His Continental travel was curtailed during the Napoleonic Wars and during this time he satisfied his wanderlust with trips to Wales and Ireland (1807). A Fellow of the Royal Society and of the Society of Artists, in his later years Hoare concentrated his energies on his archaeological and historical interests, producing books on these topics as well as accounts of his many travels illustrated with his own sketches. His major work was a nine-volume history of Wiltshire (1812–21).

CARLO LABRUZZI

ROME 1748–1817 PERUGIA

Carlo Labruzzi was born in Rome in October 1748, the son of Giuseppe Romano, a weaver. Initially intended for the church, the young Labruzzi eventually turned to a career in art and set himself to study at the Accademia di San Luca where he won a prize for the disciplines of 'figura, architettura e prospettiva'. In 1781 he was admitted to the Pontificia Congregazione dei Virtuosi al Pantheon and some 15 years later was received into the Accademia di San Luca as a landscape artist. Though he was capable of some fine portrait work, Labruzzi established his reputation chiefly as a landscape painter, finding numerous patrons among those visitors to Rome who sought to bring home with them some records of the city they had visited. Among his most enthusiastic supporters were the British *milords* visiting Rome on the 'Grand Tour'. Among these was Lord Herbert who left us this account of the artist in his journal for 26 September 1779: 'From St Peter's I went and drank tea with the Abbate Grant. From him to Labruzzi's, a Landscape Painter, in my opinion a very good one. I had seen his paintings this morning; he is a young man, very modest and sustains by his profession a Mother, Sisters, Children, himself and a Wife who breeds every nine months. I went to his house this evening to hear two extempore poets declaim in singing accompanied by a mandolin.' As noted by Lord Herbert, Labruzzi was a family man, and by his marriage to Flavia Zannoli sired nine children, five girls and four boys between 1773 and 1794.

Another Englishman who appreciated Labruzzi's artistic talents was Sir Richard Colt Hoare (qv) who commissioned him in 1789 to make sketches of the ancient monuments along the Via Appia, from Rome to Brindisi, to be used as illustrations to a volume describing the route. Atrocious weather conditions, however, prevented Hoare and Labruzzi from completing the trip and the project was never realized, though Labruzzi managed to sketch over 400 views. Other similar projects to engage the artist's talents were surveys of the Via Latina from Rome to Capua and the Colli Albani. Labruzzi's views of Rome and its environs, populated with both mythological and contemporary staffage, have earned him a deserved reputation as one of the foremost visual poets of the Roman scene, preceding Bartolomeo Pinelli (1781–1835) as the originator of the genre.

In 1783 Labruzzi was resident in via Gregoriana and in 1809 he was living in the Palazzo Zuccari, built by the artist Federico Zuccari (qv) in the sixteenth century. At some stage in his career he also worked outside Italy, in Warsaw and Leningrad. He later moved to Perugia, where he died on 16 December 1817.

LODOVICO LAMBERTI or LAMBERTINI

ITALIAN 1689–?

Nothing at all is known about this artist, who was probably of North Italian origin, except what is inscribed on his drawings (see No. 31).

CLAUDE GELLEE called CLAUDE LORRAIN

CHAMAGNE c1600–1682 ROME

Born in Lorraine in north-eastern France in 1600, Claude Gellée arrived in Rome possibly as early as 1613. His contemporaries give differing accounts of his first years there. Sandrart says he was initially schooled as a pastry chef in his native Lorraine before traveling to Rome to continue his culinary education there, rooming in the house of the landscape artist Agostino Tassi who gave him his first lessons in art. Baldinucci states that he first trained in Naples (c1618–22) with Goffredo Wals, another landscape painter. He returned to Lorraine in 1625 where he assisted Claude Deruet with the fresco decorations in the Carmelite church in Nancy. By late 1627 he was back in Rome, living in via Margutta close to Piazza di Spagna. Concentrating his talents on landscape, a genre which had become increasingly popular in Rome since the turn

of the century, Claude developed his own version of the newly accepted discipline. His idealized landscapes, recreating the Arcadian world of the Golden Age of Rome, soon won him patronage from the Roman nobility, Pope Urban VIII, and the Spanish crown. Wary of the other artists' cashing in on his popularity through copying or plagiarizing his works, he began to keep, from c1635, a record of his compositions in a bound volume of drawings known as the *Liber Veritatis* (now in the British Museum). Claude had initially developed his skills as a landscapist through his study of the work of Paul Brill and Adam Elsheimer as well as Poelenbergh (*qv*), Breenbergh (*qv*) and Swanevelt. Later, from his study of the compositions of Annibale Carracci and Domenichino, coupled with his growing familiarity with the monuments of ancient Rome and the landscape of the Campagna, his art matured from a picturesque view of Rome based on the conceits of the northern tradition of landscape art to a noble and heroic vision of the Golden Age founded on the humanist tradition of Italian culture. In his finest works, frequently conceived as pendants (a *Morning* — an *Evening*), and resplendent with the subtlest effects of light, the humans, usually figures drawn from classical literature or the Bible, are secondary in scale and importance to the magnificent landscape backdrop.

WILLIAM MARLOW

SOUTHWARK 1740–1813 TWICKENHAM

Born in Southwark, London, William Marlow received his art instruction from the topographical and marine painter Samuel Scott (c1702–72) during the years 1756–61. Other formative influences were a period of training with Richard Wilson (*qv*) and attendance at the St Martin's Lane Academy. Thus equipped, Marlow set about establishing for himself a reputation as a topographical artist and between the years 1762 and 1765 he made a series of tours of England and Wales. By 1762 he

had started exhibiting at the Society of Artists, where he continued to show regularly until 1783, mostly submitting landscape views, the fruits of these early travels. Patronage from the Duchess of Northumberland allowed him to travel to France and Italy during 1765–66 and the many drawings he made during these very active years furnished him with an endless repertoire of motifs for his later career. Back in England he became Vice-President of the Society of Artists in 1778, and began sending works to the Royal Academy. He is best known for his views of the Thames and its bridges, sometimes indulging in *capricci* of the London landscape, mixing fact and fantasy in the Italian style. He is also known for his shipping pictures, some of which recall the work of Joseph Vernet. By 1778 Marlow could afford to settle in the fashionable suburb of Twickenham, comfortably well-off from the sale of his popular views. Joseph Farington remarked that he ceased painting in his later years 'for an amusement more agreeable to him, the making of telescopes and other articles'. By the 1790s tastes had changed and Marlow's reputation suffered a decline. There are relatively few works from his hand which can be dated later than 1795. Though he exhibited frequently at the Royal Academy, Marlow never became an Academician. He died at Twickenham on 14 June 1813.

ALEXANDER NASMYTH

EDINBURGH 1758–1840 EDINBURGH

Alexander Nasmyth, 'the founder of the Landscape Painting School of Scotland' according to his illustrious compatriot Sir David Wilkie, was born in Edinburgh on 9 September 1758, the son of Michael Nasmyth, a master builder. First apprenticed to a coach builder called Crichton, he subsequently trained at the Trustees' Academy under the tutelage of the landscape painter Alexander Runciman (1736–85) before finishing his schooling with the portrait artist Allan Ramsay

(1713–84), who 'discovered' him in 1774 and took him to London as his assistant. Nasmyth returned to Edinburgh in 1778 to set up his own practice as a painter of cabinet-sized full-length portraits and family groups, soon adding landscapes or architectural features as the backdrop to his sitters. One of his most important early patrons was Patrick Millar of Dalswinton, a wealthy Edinburgh banker, who in 1782 offered him the then substantial sum of £500 to finance a trip to Italy.

Nasmyth visited Italy between late 1782 and 1784, touring to Florence, Padua and Bologna during his stay. In 1783, the Scottish antiquarian and art dealer James Byres, resident in Rome, wrote of Nasmyth that 'he is determined to follow landscape painting, and is at present copying a very fine picture of mine by Claude Lorrain'. The influence of Claude as well as Salvator Rosa and the Italianate Dutch masters were critical to his subsequent development as a painter, though he did not set himself up as a landscapist on his return to Edinburgh in 1765, when he became friendly with the great poet Robert Burns, whose portrait he painted in 1787. Gradually landscape art overtook portraiture as the main focus of his practice, a pursuit further fuelled by his activities as a landscape designer, improving the country estates of landowners such as the Duke of Athol. Nasmyth also opened up a drawing school, where he was assisted by his daughters, while interesting himself with the theatre and the provision of stage sets for a number of productions. A founder member of the Society of Associated Artists of Edinburgh, where he exhibited between 1808 and 1814, he also exhibited at the Royal Scottish Academy from 1830 to 1840, and at the Royal Academy in London between 1813 and 1826. He had many children from his marriage to Barbara Foulis in 1786, all of whom practiced painting. Alexander Nasmyth died in Edinburgh on 10 April 1840.

WILLEM VAN NIEULANDT

ANTWERP 1584–1635/36 AMSTERDAM

Born in Antwerp in 1584, according to Van Mander Willem van Nieulandt was in Rome by the year 1600. Certainly he was active in the city by the year 1604 when he was inscribed in the Accademia di San Luca. At this time he worked in the company of Paul Brill, whose art he copied. A drawing attributed to Nieulandt in the Rijksprentenkabinet in Amsterdam (inv no. A 3555) is a copy of Brill's view of the Forum, another version of which is included in the present exhibition (No. 29). While in Rome he also produced paintings and engravings of Roman views. Back in Antwerp by 1605, he moved in 1629 to Amsterdam, where he continued to produce fantastic Italianate landscapes with ruins, populated by figures in antique or oriental costumes. Willem was the brother of the history painter Adrien van Nieulandt (1587–1658).

CRESCENZIO ONOFRIO

ROME 1632–c1713 FLORENCE

Crescenzio Onofrio is the only documented student of the noted landscape artist Gaspard Dughet (1615–75), with whom he is known to have collaborated on the decoration of the Sala del Troni in the Palazzo Doria Pamphilj in Rome. He later worked on the decoration of the Palazzo Colonna (c1670–80) before moving to Florence, c1689, probably at the request of Duke Ferdinando II dei Medici. In Florence his ability as a landscape artist was keenly appreciated and he received a steady flow of commissions for large canvases to decorate various Medici residences, including the Pitti Palace and the villas at Poggio a Caiano and Pratolino. The figures in most of these compositions were added by other artists, including Livio Mehus,

Antonio Giusti, Pietro Dandini, and Alessandro Magnasco. Onofrio was also active as an engraver and his work in this medium influenced the markedly graphic quality of many of his large landscape drawings.

M VAN OVERBEEK

Active 1650–c1680

A minor itinerant artist of the seventeenth century, who drew views in the Netherlands, England, France and Italy.

ELIZABETH SUSAN PERCY

ENGLISH c1778–1847

Lady Elizabeth Susan Percy was the second daughter of the first Earl of Beverley. Her sister was Lady Ashburnham and her brother became the fifth Duke of Northumberland on the death of her uncle. According to H L Mallalieu she was a mirror of the topographical fashion of her time, beginning her training, along with her sister, under the tutelage of Thomas Hearne and ending by way of Girtin and also George Beaumont, with whom she had close personal ties. She accompanied her parents to the Continent in 1802 and was in Geneva in 1804 when war broke out. After her mother's death in 1812 she spent time with her father in Italy where he had settled and also with Sir George and Lady Beaumont. From the mid-1820s she would also have spent time with the Ashburnhams who lived in a villa outside Florence.

CORNELIS VAN POELENBURGH

UTRECHT 1586–1667 UTRECHT

Cornelis van Poelenburgh was a native of Utrecht, as indicated by the inscription on an engraving of 1649 by Conrad Wauman after a self-portrait of the artist. His date of

birth is not certain: Houbraken gives it as 1586, and this accords with the known facts, though it may have been later. Sources indicate that the young Van Poelenburgh was a pupil of the noted Utrecht artist Abraham Bloemaert (1564–1651), who also counted Gerard Honthorst and Jan Both among his students. Like so many of his Utrecht contemporaries Van Poelenburgh was attracted to Rome where he stayed c1617–25, spending some time in Florence also during this period. in Rome, apart from the more or less obligatory sketching trips about the city and into the neighboring Campagna, the young artist had the opportunity to study the art of Adam Elsheimer, Paul Brill, Claude Lorrain, Filippo Napoletano and other contemporaries whose landscape painting was winning new acceptance as a genre worthy of appreciation by the connoisseur. Van Poelenburgh also courted the company of his Netherlandish compatriots who were at the vanguard of the developments of this new genre, among them Breenbergh (qv). He was among the founders of the boisterous northern painters' guild, the Schildersbent. There is considerable difficulty in separating Van Poelenburgh's Italian oeuvre from that of Breenbergh. Overall, Van Poelenburgh's work presents greater maturity and stylistic coherence and is typified by the repetition of compositions and by pendant combinations. Van Poelenburgh generally chose as his subject matter *capricci* of the Forum, landscapes showing existing or imaginary ruins and pastoral scenes or landscapes with religious figures. His compositions, compared to Breenbergh's, are smoother, with simpler and more obvious layouts.

From the beginning of 1627, Van Poelenburgh was back in Utrecht where he established a successful practice and had a large workshop. As well as continuing to create Italianate views, which he, more than any other artist, helped to popularize, he also painted pure history subjects and some portraits and sometimes provided the figures for landscapes by other artists. His art was greatly esteemed and his reputation

spread to England, where he was invited by Charles I during the years 1638–41, before returning to Utrecht to continue his career. He died there in 1667. Among the many imitators of his attractive style were Johan van Haensburgen (1642–1705), Dirck van der Lisse, Daniel Vertangen and Toussaint Gelton.

SIMONE POMARDI

MONTEPORZIO CATONE 1760–1830 ROME

Simone Pomardi was a minor landscape and view painter who worked mostly in Rome, providing his clientele with picturesque images of Rome and the surrounding countryside. His accomplished watercolors appear to have been particularly popular among the French visitors to Rome. One of his most important commissions, however, was for the Englishman Edward Dodwell, who employed him to provide illustrations for his tour of Greece (published 1828). To furnish his contribution to this project Pomardi accompanied Dodwell on his travels during the years 1801, 1805 and 1806. Dodwell himself provided approximately 400 drawings, with Pomardi supplying a further 600 views.

LOUIS TOEPUT called POZZOSERRATO

MECHELEN c1550–1603/05 TREVISO

Most probably born in Mechelen around 1550, Loedewijck Toeput possibly received his early training from Maerten de Vos at Antwerp before moving to Italy c1573. He apparently first settled in Venice, as Ridolfi remarks that he painted the fire in the Doge's Palace there in 1577 (Venice, private collection). At this time he is also known to have assisted with the landscape backgrounds in some of the compositions of Tintoretto. In 1581 he made a trip to Rome, as is documented by an inscription on a drawing in the Albertina in Vienna.

Returning to northern Italy, he moved from Venice to Treviso where he established himself c1582. Painting in a manner reminiscent of Tintoretto and Vos, he painted frescos and easel pictures, particularly for the local religious communities, and decorated notably the Cappella dei Rettori del Monte di Pietà in Treviso. He seems especially to have enjoyed representing garden feasts of one kind or another and in these works he is reminiscent of Veronese. In 1601 Pozzoserratto married Laodamia Aproino. The date of his death is not known, though it is thought likely that he died around 1603–05.

GIACOMO QUARENGHI

BERGAMO 1744–1817 ST PETERSBURG

Born in Capitano a Rota Fuori, near Bergamo, Giacomo Quarenghi trained first as a painter with the local artists Raggi and Bonomimi before leaving for Rome at the age of 19. In Rome between the years 1763 and 1770 he continued his artistic training with Anton Raphael Mengs, touring the city and sketching its ancient architectural monuments, thereby earning a reputation as an expert on classical architecture, a discipline he would eventually take up. In the meantime he developed his talents as a *vedutista* in the tradition of Canaletto before returning to the Veneto in 1771, where he made the acquaintance of Giannantonio Selva and other architects. Shortly afterwards he received the commission for his first major architectural project and the only one which he completed in Italy, the church of Santa Scholastica for the Benedictine monks of Subiaco. In 1779, through the offices of one of Winckelmann's friends, he was called to Russia by the minister Baron Grimm, to work for the Empress Catherine II. The following year he left for St Petersburg where he joined a community of foreign artists and craftsmen in the service of the Tsarina. He was quickly entrusted

with important commissions for public buildings including the State Bank, the Academy of Sciences and the Hermitage Theater. Following Catherine's death he was employed by her successor, Paul I, and Alexander, her cousin. In 1810 he was commissioned by his native Bergamo to design a triumphal arch to honor the victories of Napoleon and he returned to supervise the work. The project was aborted, however, and he finally was persuaded to return to St Petersburg to erect the arch there, in honor of the victories of the Russian army.

ISRAEL SILVESTRE

NANCY 1621–1691 PARIS

Born in Nancy on 15 August 1621, Israel Silvestre moved to Paris in 1631 where he was first a student of his uncle Israel Henriet, painter and draughtsman to Louis XIV and friend of Jacques Callot whose engravings he published. Apart from the instruction of his uncle, Silvestre's development was much influenced by the art of Callot and Della Bella (Etienne Labelle). Like these artists, Silvestre showed a predisposition towards the graphic arts and subsequently became a prodigious designer of prints (over 1000 are known), principally topographical in nature, though including decorative and festive subjects (like Della Bella), a popular genre at the time. Inclined towards topography as he was, Silvestre traveled a great deal, making sketches as he went, which later served as the source material for his many etchings. Between 1639 and 1653 he traveled to Italy a number of times. He published his first set of engravings there in 1639. He also traveled about France, collecting material for his books of prints.

Silvestre's works now form an important source of documentation for the landscape and monuments of France lost or greatly altered through the years. With the death of his uncle in 1661 he inherited the drawings and etched plates of Callot and

Della Bella, to which he added the plates inherited by Callot's widow at Nancy. He thus became the master of a considerable publishing establishment from which he derived a substantial income. In 1663 he was made Engraver in Ordinary to the King, for whom he executed two notable commissions depicting the Royal Festivals, *Plaisirs de l'Isle Enchanté* (1665) and *Carrousel de 1662* (1670).

From 1668 he was repeatedly engaged on a suite of engravings representing the royal châteaux. Elected a probationary member of the Académie Royale in 1666, he was made a full member on 6 December 1670. He was also appointed Drawing Master to the Dauphin. Silvestre died in Paris on 11 October 1691.

JOHN SMITH called WARWICK SMITH

IRTHINGTON 1749–1831 LONDON

John Smith had his first art lessons from Captain John Bernard Gilpin (1701–76), as his father was gardener to Gilpin's sister. Later he was introduced to Sawry Gilpin (1733–1807) with whom he continued his education. It was while he was on a visit to Derbyshire with the latter that he met Lord Warwick, who offered to finance a trip to Italy. This is generally reckoned to be the origin of the artist's sobriquet 'Warwick', though it has also been suggested that this derives from his later residence in Warwick. Arriving in Italy in 1776 Smith mixed with the community of British artists who frequented the area about the Piazza di Spagna. Among those with whom he associated were Francis Towne (1740–1816) and William Pars, and with them he went on sketching trips about the city and into the Campagna. While in Italy Smith developed, under the influence of the brilliant Mediterranean light, an original approach to landscape painting, in a realistic style, although the work of his colleagues in the same mode is generally more accomplished. Returning home in 1781 with pads full of travel sketches,

Smith settled in Warwick. During the rest of his career he continued to travel widely, particularly through Wales and the Lake District, employing his artistic talents in producing and contributing to travel books, among them his own *Select Views of Italy* (1792–99) and *A Tour of Hafod* (Sir J E Smith, 1810). In 1806 he was made a full member of the Old Water-Colour Society, becoming its secretary in 1813 and president, for the first time, in 1814. He last exhibited there in 1823.

GIUSEPPE VALADIER

ROME 1762–1839 ROME

Giuseppe Valadier was born on 14 April 1762, the son of Luigi Valadier, a silversmith and founder. He showed a precocious talent for architecture and at the tender age of thirteen he entered the Concorso Clementino dell'Accademia di San Luca (1775) and at fifteen won the Concorso Balestra. Despite his undoubted genius Valadier did not find it easy to pursue his career, as his father still had hopes that he would abandon his architecture to assist him with his busy workshop. Gradually, however, he began to win approval and recognition and in 1777 he won an appointment as Architetto dei Santi Palazzi in Rome. In 1781 he took time off to travel and study in the north of Italy and France. In 1786 he was made Architetto Camerale, a post which involved responsibility for the care of churches and monuments within the jurisdiction of the Papal States. In 1787 he supervised works carried out following the earthquake in Romagna. Not long after he received his first important commission, the restoration of the Cathedral of Urbino (1789).

This Urbino project was to be the first of many in the realm of restoration, an area in which he was to develop a particular talent and expertise, demonstrating an intelligent sensitivity towards the structural integrity of the monument under his care. Among the best examples of his activity in this field, and the most important undertaken

after his appointment as Ispettore del Consiglio d'Arte per le Fabbriche Camerali, is the work he carried out on the Ponte Milvio (1805), the Arch of Titus (1819–21) and the Colosseum (1822). A feature of his approach to the restoration of ancient monuments was his care to differentiate between the structure of the original building and the additions added to make it sound. Another area where Valadier showed exceptional abilities was in town planning, notably in his schemes for the Piazza del Popolo, Piazza della Rotonda, Piazza Colonna and Fontana di Trevi.

Though taken up with official work for most of his career, both for the Vatican and for the French authorities during their period of power, Valadier received a number of private commissions from time to time, most notably the reconstruction of the villa belonging to Prince Poniatowsky and the façade of the church of San Pantaleone (completed 1806), his most original piece of pure architecture.

JACOB VAN DER ULFT

GORINCHEM 1627–1689 NORDWIJK

Probably self-taught, Jacob van der Ulft spent virtually all of his career in his native Gorinchem. A trip to Italy has been postulated on account of the many Italian influences detectable in his work, though such influences may be satisfactorily explained through his study of the drawings of Jan de Bisschop (q.v.), an artist whose work he is known to have copied and imitated. His extensive graphic output, mostly landscapes, is more highly regarded than his few surviving paintings. From 1661 onwards Van der Ulft became increasingly active in the civic life of his native town, holding at various times the posts of mayor, tax collector, and trustee of the local orphanage.

GIUSEPPE VASI

CORLEONE 1710–1782 ROME

The artist Giuseppe Vasi was born in Corleone on 27 August 1710, the son of Agostino Pietro Vasi and Caterina Pugliesi. In his youth he received a humanistic education at the Collegio Carlino and it has been suggested that he was first intended for the priesthood. Certainly his knowledge of the classical authors and of antiquities was to stand him in good stead in later life. Vasi may have received his early training as an etcher and engraver from Antonio Bova and Francesco Ciche at Palermo. Early in his career he contributed to P Placa's *La reggia in trionfo per l'acclamazione e coronazione della Sacra Real Maestà di Carlo Infante di Spagna*, which was published in Palermo. By the time he moved to Rome in 1736, or shortly thereafter, he would have been an accomplished artist and most probably went there in search of patronage and commissions rather than seeking further instruction. Among the earliest known works he produced after his arrival are a group of three plates dated 1739, based on drawings by Filippo Juvarra (died 1736). While establishing a reputation as an engraver of note, he improved his technique by the study of prints by established masters which he had the opportunity of viewing in the collection of Cardinal Neri Corsini. At the same time he was maturing the idea for a major project to illustrate all the great monuments of Rome, both ancient and modern, complete with an authoritative text. The first volume of a monumental ten volume set dedicated to just such a subject appeared in 1747, and the program was to continue until 1761, when the final volume appeared. In 1763 he produced a guide to Rome – *Itinerario istruttivo diviso in otto stazioni o giornate per ritrovare con facilità tutte le antiche e moderne magnificenze di Roma* – which was to form the basis of a whole progeny of guide books to the eternal city. The summation of Vasi's highly productive obsession with his adopted home was the publication in 1765 of a minutely detailed and highly informative panorama *Prospetto dell'Alma città di Roma dal Monte Gianicolo* (reproduced here as endpapers). Among the artists who worked in Vasi's studio was the young Piranesi.

LOUIS VINCENT

VERSAILLES 1758–?

There is little biographical information available on the French artist Louis Vincent, a pupil of J-J Lagrenée the Younger who exhibited landscapes at the Salon in 1791 and 1795.

THEODOOR WILKENS

DUTCH c1675–1748

The precise date of birth of the minor Dutch landscape artist Theodoor Wilkens is not documented, though it has been calculated that he must have been born about 1675. From the examination of his dated work it is known that he traveled to Italy and worked there over the period 1710 and 1717, during which time he executed many drawings of Italian scenes, mostly in pen and red chalk. His drawings have sometimes been confused with those of his better known colleague Casper van Wittel or Vanvitelli (1653–1736). Another artist with whom Wilkens was friendly in Rome was the landscapist Hendrik van Lint (1684–1763), in whose company, according to Houbraken, Wilkens made a sketching trip to Ronciglione. No paintings by Wilkens have yet been identified.

RICHARD WILSON

PENEGOES 1713?–1782 COLOMMENDY

Richard Wilson was born, probably in 1713, at Penegoes in Montgomeryshire in North Wales. His father, a member of the clergy, occupied a respectable position in local society and the young artist received a good education, including a sound grounding in the Latin authors. His early artistic education was probably subvented by Sir George Wynne, who may have been his uncle. It was Sir George who sponsored his move to London in 1729 where he received his initial training with the little known portrait artist Thomas Wright. During his early career Wilson concentrated on portrait painting, though he had begun to paint landscapes by 1737. In 1750 he traveled to Italy, staying first in Venice before moving on to Rome (January 1751) where he was to remain until August 1756. It was during his protracted sojourn there that, under the influence first of the Venetians and later of the Roman school, he developed his innate talent for landscape painting. Initially working in a somewhat florid Rococo style, influenced by Zuccarelli and other Venetian masters, he later developed, during his stay in Rome, a taste for classical landscape art in the grand style, modeled on the examples of Claude and Gaspard Dughet and constantly refreshed through frequent sketching trips into the Campagna.

Back in London Wilson initially found great success in the art world, particularly with his ambitious canvas *The Destruction of the Children of Niobe* (1759–60, Yale Center for British Art). Made a member of the newly founded Royal Academy in 1768, he paradoxically began to find it increasingly difficult to sell his pictures, as the patrons of the mature classical style which he had so passionately embraced became more and more eager to purchase originals by Claude and Gaspard and their Italian followers rather than imitations by their British disciples. A desperate switch to a lighter, more decorative style of painting failed to revive his popularity and in his final years, suffering both from ill health and from bouts of heavy drinking, he needed the support of his fellow artists to survive.

FEDERICO ZUCCARO

SANT'ANGELO IN VADO *c*1540–1609
ANCONA

The younger brother of the more talented
and original Taddeo (1529–66) with whom
he studied in Rome during the 1550s and
early 1560s, Federico Zuccaro developed
into one of the most successful and
influential artistic personalities of the late
sixteenth century. Much in demand, he
traveled widely, visiting Venice, Florence,
London (1573–74), Madrid (1585–88), and
other centers, executing a host of
commissions in a fluent though somewhat
dry Counter-Maniera style, of which he
was a chief exponent. The moving force
behind the founding of the Accademia di
San Luca in Rome in 1593, he became its
first president in 1598. He was the author
of the treatise *L'Idea dei pittori, scultori, et
architetti*, published in Turin in 1607.

THE QUOTATIONS

A BIBLIOGRAPHY

ADAMS, HENRY *The Letters*, edited by J C Levenson and others, Harvard 1982

ADDISON, JOSEPH *Remarks on Several Parts of Italy, &c. In the Years 1701, 1702, 1703*, London 1736

ARMELLINI, MARIANO *Le Chiese di Roma*, Rome 1887 (reprinted 1981)

ASHBY, THOMAS *The Roman Campagna in Classical Times*, London 1927

ASHBY, THOMAS *The Aqueducts of Ancient Rome*, Oxford 1935

BECKFORD, PETER *Familiar Letters from Italy to a Friend in England*, Salisbury/London 1805

BELLORI, GIOVANNI PIETRO *Nota delli Musei, Librerie, Galerie & Ornamenti di Statue, e Pitture, ne' Palazzi, nelle Case, e ne' Giardini di Roma*, Rome 1664 (reprinted Rome 1976)

BYRON, GEORGE GORDON, LORD *Childe Harold's Pilgrimage*, 1812 (reprinted Oxford 1891)

CAPGRAVE, JOHN *Ye Solace of Pilgrims (A description of Rome)*, edited by C A Mills, London 1911

CELLINI, BENVENUTO *The Life of Benvenuto Cellini Written by Himself*, translated by A Macdonnell, London 1907

CHATEAUBRIAND François-René, vicomte de, *Voyage en Italie*, 1827

COLE, THOMAS *Notes at Naples*, 1832

DE BROSSES, PRÉSIDENT CHARLES *Letters*, translated by Lord Ronald Sutherland Gower, FSA, London 1897

DE SADE, MARQUIS DONATIEN-ALFONSE-FRANÇOIS *Voyage d'Italie*, edited by G Lely and G Dumas, 1967

DE STAËL, MME *Corinne ou l'Italie*, 1807 (reprinted 1979)

DICKENS, CHARLES *American Notes, Pictures from Italy and Miscellaneous Papers*, reprinted London

DUDLEY, D R, compiler, *Urbs Roma: a source book of classical texts on the city and its monuments*, Aberdeen 1967

EMERSON, RALPH WALDO *The Journals and Miscellaneous Notebooks*, IV, 1832–34, edited by A R Ferguson, Harvard 1964

EUSTACE, the REV JOHN CHETWODE *A Tour through Italy, exhibiting a view of its scenery, its antiquities, and its monuments*, London 1813, 2 vols

EVELYN, JOHN *The Diary*, edited by E S de Beer, Oxford 1965, 6 vols

GAMUCCI DA SAN GIMIGNANO, BERNARDO *Libri Quattro dell'Antichità della città di Roma raccolte sotto brevità da diversi antichi et moderni scrittori*, Venice 1565

GIBBON, EDWARD *The Decline and Fall of the Roman Empire*, London 1766–88, 8 vols

GIBBON, EDWARD *Journey from Geneva to Rome: Journal from 20 April to 2 October 1764*, edited by G A Bonnard, London 1961

GOETHE, JOHANN WOLFGANG VON *Italian Journey*, translated by W H Auden and E Mayer, Harmondsworth 1970

GRAY, THOMAS *Correspondence*, edited by P Toynbee and L Whibley and revised by H W Starr, Oxford 1971, 3 vols

HARE, AUGUSTUS J C *Days near Rome*, London 1875, 2 vols

HARE, AUGUSTUS J C *Walks in Rome*, 12th edition, London 1893, 2 vols

HAWTHORNE, NATHANIEL *Works*, vols 19–20: *Passages from the French and Italian Notebooks*, Boston 1875

HAWTHORNE, NATHANIEL *The Marble Faun, or the Romance of Mount Beni*, 1859 reprinted Ohio 1971

HOARE, SIR RICHARD COLT, BART *A Classical Tour through Italy and Sicily*, London 1819, 2 vols

IRVING, WASHINGTON *The Complete Works: Journals and Notebooks*, I, 1803–06, Madison and London 1969

JACOBUS DE VORAGINE *The Golden Legend*, translated and adapted from the Latin by G Ryan and H Ripperger, New York 1969

JAMES, HENRY *Daisy Miller*, 1878

JAMES, HENRY *Italian Hours*, reprinted London 1986

JONES, THOMAS *The Memoirs*, ed. A P Oppe, The Walpole Society, London and Cambridge 1946–48

KLEIN, R AND ZERNER, H, editors *Italian Art 1500–1600: Sources and Documents*, Englewood Cliffs 1966

LANCIANI, RODOLFO *The Ruins and Excavations of Ancient Rome*, London 1897

LANCIANI, RODOLFO *New Tales of Old Rome*, London 1901

LEFRANÇOIS DE LALANDE, JOSEPH-JÉROME *Voyage d'un François en Italie fait dans les Années 1765 & 1766*, 1768

LEWIS, N and REINHOLD, M, editors *Roman Civilization: Sourcebook II, the Empire*, New York 1955 (reprinted 1966)

LIVY *The History of Rome*, translated by B O Foster, the Loeb Classical Library, Cambridge and London, 1961–67, 14 vols

LONGFELLOW, HENRY WADSWORTH *The Letters*, edited by A Hilen, Cambridge, 1966, 2 vols

MONTESQUIEU, BARON CHARLES LOUIS DE SECONDAT *Voyage en Italie*, reprinted in translation Bari 1971

MORGAN, LADY SYDNEY *Italy*, London 1924

NIBBY, ANTONIO *Itinerario di Roma e delle sue vicinanze compilato secondo il metodo di M. Vasi*, 3rd edition, Rome 1830

NIGHTINGALE, FLORENCE *Letters Written in Rome in the Winter of 1847–1848*, edited by M Keele, Philadelphia 1981

OVID *Metamorphoses*, translated by M M Innes, Harmondsworth 1955

PALLADIO, ANDREA *The Four Books of Architecture*, translated by Isaac Ware, London 1738 (reprinted New York 1965)

ROSSINI, PIETRO *Il Mercurio Errante*, Rome 1693

SHELLEY, PERCY BYSSHE *The Letters*, edited by F L Jones, Oxford 1964, 2 vols

SHELLEY, PERCY BYSSHE *Complete Poetical Works*, Oxford 1975

SKELTON, JONATHAN *The Letters*, edited by B Ford, The Walpole Society, vol xxxxvi, London and Glasgow 1956–58

SMOLLETT, TOBIAS *Travels Through France and Italy*, edited by F Felsenstein, Oxford 1981

STENDHAL *Voyages en Italie*, edited by V del Litto, Paris 1973

STORY, WILLIAM WETMORE *Roba di Roma*, London 1871

SUETONIUS *The Lives of the Caesars*, translated by J C Rolfe, the Loeb Classical Library, Cambridge 1914

TAINE, HIPPOLYTE *Voyage en Italie*, reprinted Paris 1901

TITI, FILIPPO *Descrizione della pitture, sculture e architetture eposte al pubblico in Roma*, Rome 1763 (reprinted 1978)

VASARI, GIORGIO *Lives of the Most Excellent Painters, Sculptors and Architects*, translated by A B Hinds, and edited with an introduction by Gaunt, London 1927 (reprinted London 1963), 4 vols

VASI GIUSEPPE *Delle Magnificenze di Roma Antica e Moderna*, Rome 1747

VASI, MARIANO *Itinerario istruttivo di Roma*, reprinted with notes by G Matthiae, Rome 1970

VITRUVIUS *The Ten Books of Architecture*, translated by M H Morgan, Harvard 1914

WELLS, CLARA L *The Alban Hills: Frascati*, Rome 1868

WILDE, OSCAR *The Letters*, edited by R Hart-Davis, London 1962

LIST OF REFERENCES

CITED IN SHORT FORM IN THE TEXT

ACKERMAN, J S *The Architecture of Michelangelo*, London 1961, 2 vols

ANGELINI, S *I cinque Album di Giacomo Quarenghi nella Civica Biblioteca di Bergamo*, Bergamo 1967

ASHBY, T *Topographical Study in Rome in 1581*, London 1916

ASHBY, T 'Due vedute di Roma attribuite a Stefano du Pérac', in *Miscellanea Francesco Ehrle: Scritti di Storia e Paleographia*, II, *Per la Storia di Roma*, Rome 1924, pp429–59

ASHBY, T 'The Piazza del Popolo, Rome, etc', *Town Planning Review*, xi, December 1924

ASHBY, T *The Aqueducts of Ancient Rome*, ed. I A Richmond, Oxford 1935

BERCKENHAGEN, E *Die Französischen Zeichnungen der Kunstbibliothek Berlin*, Berlin 1970

BLUNT, A and LESTER COOKE, H *The Roman Drawings of the XVIIth and XVIIIth Centuries in the Collection of Her Majesty the Queen at Windsor Castle*, London 1960

BODART, D *Les Peintres des Pays-Bas Meridionaux et de la principauté de Liège à Rome au XVIIᵉ siècle*, Brussels/Rome 1970

BODART, D *Dessins de la Collection Thomas Ashby à la Bibliotheque Vaticane*, Vatican 1975

BOON, K *Catalogue of the Dutch and Flemish Drawings in the Rijksmuseum. Netherlandish Drawings of the Fifteenth and Sixteenth Centuries*, The Hague 1978, 2 vols

Brueghel: Une Dynastie de Peintres, exhibition catalogue, Palais des Beaux-Arts, Brussels 1980

BURNS, H 'Raffaello e quell'antiqua architettura', in *Raffaello Architetto*, Rome 1983, pp381–421

BUSIRI VICI, A *Trittico Paesistico Romano nel '700: Paolo Anesi – Paolo Monaldi – Alessio De Marchis*, Rome 1976

CHIARINI, M *I Disegni Italiani di Paesaggio dal 1600 al 1750*, Treviso 1972

Classic Ground: British Artists and the Landscape of Italy 1740–1830, exhibition catalogue, Yale Center for British Arts, New Haven 1981

DE BENEDETTI, E *Valadier: Segno e Architettura*, exhibition catalogue, Calcografia, Rome 1985

Dessins Français du XVIIIᵉ siècle, 1967

D'ONOFRIO, C *Il Tevere*, Rome 1980

EGGER, H *Römische Veduten*, 1st edition, Vienna 1911

EGGER, H *Römische Veduten*, 2nd edition, Vienna 1932

FARINGTON, J *The Diary*, edited by J Greig, London 1922–28

FARINGTON, J 'Biographical Note' (on Richard Wilson), published in *Works by Richard Wilson*, exhibition catalogue, Ferens Art Gallery, Hull 1936

FORD, B 'The Dartmouth Collection of Drawings by Richard Wilson', *The Burlington Magazine*, xc, December 1948, pp337–45

FORD, B *The Drawings of Richard Wilson*, London 1951

FORD, B 'Richard Wilson in Rome, II – the Claudean Landscapes', *The Burlington Magazine*, xciv, November 1952, pp307–13

France in the Eighteenth Century, exhibition catalogue, Royal Academy of Arts, London 1968

FRANZ, H G 'Eine unbekannte Zeichnung des Lodewijck Toeput, gennant Lodovico Pozzoserrato', *Jahrbuch des Kunsthistorischen Institutes der Üniversität Graz*, ii, 1966–67

FROMMEL, C L 'San Pietro: Storia della sua construzione', in *Raffaello Architetto*, Milan 1984

GUIFFREY, J and MARCEL, P *Archives des Musées nationaux et l'Ecole du Louvre. Inventaire général des dessins du Musée du Louvre et du Musée de Versailles. Ecole Française*, Paris 1909

HOLLSTEIN, F W H *Dutch and Flemish Etchings, Engravings and Woodcuts, ca1450–1700*, Amsterdam 1949–80, 21 vols

KLOEK, W T *Beknopte Catalogus van de Nederlandse Tekeningen in het Prentenkabinet van de Uffizi te Florence*, Utrecht 1975

LUGT, F *Les Marques de Collections de Dessins & d'Estampes*, Amsterdam 1921

LUGT, F *Ecole Nationale des Beaux-Arts, Paris: Inventaire général des Dessins des Ecoles du Nord, I. Ecole hollandaise*, Paris 1950

LUGT, F *Les Marques de Collections de Dessins & d'Estampes, Supplement*, The Hague 1956

LUGT, F *Musée du Louvre: Inventaire général des Dessins des Ecoles du Nord: Maîtres des Anciens Pays-Bas nés avant 1550*, Paris 1968

MÉJANÈS, J-F 'A Spontaneous Feeling for Landscape: French Eighteenth-Century Landscape Drawings', *Apollo*, civ, 1976, pp396–404

MILLON, H A and SMYTH, C 'Michelangelo and St Peter's: Observations on the interior of the apse, a model of the apse vault, and related drawings', *Römisches Jahrbuch für Kunstgeschichte*, xvi, 1976, pp137–206

Onmoetingen met Italie, exhibition catalogue, Copenhagen and Amsterdam (Rijksprentenkabinet), 1970–72

OPPE, A P *English Drawings – Stuart and Georgian Periods – in the Collection of His Majesty the King at Windsor Castle*, London 1950

Oude Kunst en Antiekbeurs, exhibition catalogue, Prinshof, Delft

Paesaggisti ed altri Artisti olandesi a Roma intorno al 1800, exhibition catalogue, Istituto Olandese, Rome 1984

PASTOR, L *The History of the Popes from the Close of the Middle Ages*, 6th edition, London 1823, 14 vols

PEREZ, M F 'The Italian Views of Jean-Jacques de Boisseau', *Master Drawings*, xvii, 1979, pp34–43

PETROCCHI, G U 'Un' Opera inedita di Carlo Labruzzi', *Atti e Memorie della Società Tiburtina di Storia e d'Arte*, xlix, 1976, pp297–99

Piranesi et les Français 1740–1790, exhibition catalogue, Villa Medici, Rome/Palais des Etats de Bourgogne, Dijon/Hotel Sully, Paris 1976

POLLITT, J J *The Art of Rome* c753 BC–AD337, Cambridge 1983

POPHAM, A E *Catalogue of the Drawings in the Collection formed by Sir Thomas Phillipps, bart, FRS, now in the Possession of his Grandson T Fitzroy Phillipps Fenwick of Thirlestaine House, Cheltenham*, London 1935

POPHAM, A E and FENWICK, K M *European Drawings (and two Asian Drawings) in the Collection of the National Gallery of Canada*, Toronto 1965

REZNICEK, E J K *Disegni Fiamminghi e Olandesi*, exhibition catalogue, Gabinetto Disegni e Stampe degli Uffizi, Florence 1964

ROETHLISBERGER, M *Claude Lorrain: The Drawings*, Los Angeles 1968, 2 vols

ROETTGEN, H 'Vier römische Veduten von Federico Zuccari', *Pantheon*, xxxvi, 1968, pp298–302

SALERNO, L *Via Giulia, Una Utopia Urbanistica del '500*, Rome 1973

SOLKIN, D H *Richard Wilson, The Landscape of Reaction*, exhibition catalogue, Tate Gallery, London 1982

STAINTON, L and WHITE, C *Drawing in England from Hilliard to Hogarth*, exhibition catalogue, British Museum, London 1987

THOENES, C 'St Peter als Ruine: Zu einigen Veduten Heemskercks', *Zeitschrift für Kunstgeschichte*, 1986, no 4, pp481–501

TURNER, N Review of D Bodart, *Dessins de la Collection Thomas Ashby à la Bibliothèque Vaticane*, in *The Burlington Magazine*, cxxviii, June 1986

VAN GELDER, J G 'Jan de Bisschop', *Oud Holland*, lxxxvi, 1971, pp201–28

VAN HASSELT, C and BLANKERT, A *Artisti olandesi e fiamminghi in Italia: Mostra di disegni del Cinquecento e del Seicento della Collezione Frits Lugt*, exhibition catalogue, Florence 1966

Vedute Romane: Disegni dal XVI al XVIII secolo, exhibition catalogue, Gabinetto Nazionale delle Stampe, Rome 1971

Villa Borghese, exhibition catalogue, Palazzo Braschi, Rome 1966

WILDE, H 'Zeichnungen von Jacob Philipp Hackert im Stadtischen Museum Göttingen', *Niederdeutsche Beiträge zur Kunstgeschichte*, vi, 1967

WILLIAMS, I A *Early English Watercolours and Some Cognate Drawings by Artists Born not later than 1785*, Bath 1952 (reprinted 1970)

WILLIAMSON, G C *Life and Works of Ozias Humphry, RA*, London 1918

ZWOLLO, A *Hollandse en Vlaamse Veduteschilders te Rome (1675–1725)*, Assen 1973

READING LIST

The following books have served the author in his exploration of Rome, and may prove valuable to others.

AMADEI, E *Le Torri di Roma*, Rome 1932 (reprinted 1969)

ASHBY, T *The Roman Campagna in Classical Times*, London 1927

ASHBY, T *The Aqueducts of Ancient Rome*, ed. I A Richmond, Oxford 1935

Thomas Ashby: Un Archeologo fotografa la Campagna Romana tra '800 e '900, exhibition catalogue, British School at Rome, Rome 1986 (with listing of Ashby's writings on the Roman Campagna)

BARSALI, I B *Ville di Roma*

BARTOLI, A *Cento Vedute di Roma Antica*, Florence 1911, 2 vols

BLAKE, M E *Roman Construction in Italy from Nerva through the Antonines*, edited and completed by D Bishop, Philadelphia 1973

BLUNT, A *Guide to Baroque Rome*, St Albans and London 1982

BOETHIUS, A *Etruscan and Early Roman Imperial Architecture*, Harmondsworth 1970 (reprinted 1978)

BOSWELL, JAMES *Boswell on the Grand Tour: Italy, Corsica, and France 1765–1766*, edd. F Brady and F A Pottle, 1955

BRIGANTI, G *I Vedutisti*, Milan 1968

British Artists in Rome: 1700–1800, exhibition catalogue, Kenwood, London 1974

BURN, R A *Rome and the Campagna: An Historical and Topographical Description of the Site, Buildings and Neighbourhood of Ancient Rome*, Cambridge and London 1871

CASTAGNOLI, F and others: *Topografia e Urbanistica di Roma*, Bologna 1958

Classic Ground: British Artists and the Landscape of Italy, 1740–1830, exhibition catalogue, Yale Center for British Art, New Haven 1981

COARELLI, F *Guide Archeologiche Laterza: Dintorni di Roma*, Bari 1981

COARELLI, F *Guide Archeologiche Laterza: Lazio*, Bari 1984

COARELLI, F *Guide Archeologiche Laterza: Roma*, Bari 1985

COFFIN, R S PINE *Bibliography of British and American Travel in Italy to 1860*, Florence 1974

DELLI, S *I Ponti di Roma*, Roma 1962, 3 vols

D'ONOFRIO, C *Il Tevere e Roma*, Rome 1970

D'ONOFRIO, C *Castel S. Angelo e Borgo tra Roma e Papato*, Rome 1978

D'ONOFRIO, C *Il Tevere*, Rome 1980

D'ONOFRIO, C *Castel S. Angelo: Images and History*, Rome 1984

D'ONOFRIO, C *Le Fontane di Roma*, Rome 1986

DE ROSSI, G M *Torri medievali della Campagna Romana*, Rome 1981

DI MARTINO, V and BELATI, M *Qui Arrivò il Tevere*, Rome 1980

FRANCK, C L *The Villas of Frascati 1550–1750*, London 1966

FRUTAZ, A P *Le Piante di Roma*, Rome 1962, 3 vols

GREGOROVIUS, F *History of the City of Rome in the Middle Ages*, translated by Annie Hamilton, 1894–98, 9 vols

HEYDENREICH, H and LOTZ, W *Architecture in Italy 1400–1600*, Harmondsworth 1974

IANNATTONI, L *Roma e gli Inglesi*, Rome 1945

IVERSEN, E *Obelisks in Exile: I, The Obelisks of Rome*, Copenhagen 1968

JELLICOE, SIR G & JELLICOE, S *The Oxford Companion to Gardens*, Oxford 1986

KRAUTHEIMER, R and others: *Corpus Basilicarum Christianarum Romae*, Vatican City and New York, 1937–77

KRAUTHEIMER, R *Early Christian and Byzantine Architecture*, Harmondsworth 1965

KRAUTHEIMER, R *Rome: Profile of a City, 312–1308*, Princeton 1980

LANCIANI, R *Rovine e Scavi di Roma Antica*, London 1897 (reprinted, translated by E R Almeida, Rome 1985)

LANCIANI, R *New Tales of Old Rome*, London 1901

LA PADULA, A *Roma e la Regione nell'Epoca Napoleonica*, Rome 1969

LEES-MILNE, J *Saint Peter's*, London 1967

LUGLI, G *Itinerario di Roma*, Milan 1970

MALE, E *The Early Churches of Rome*, reprinted London 1960

MASSON, G *Italian Gardens*, London 1961 (reprinted Woodbridge 1987)

MASSON, G *The Companion Guide to Rome*, London 1965 (reprinted 1980)

MERGE, R *Frascati Sconosciuta*, 1983

NASH, E *Pictorial Dictionary of Ancient Rome*, 2nd edn, London 1968, 2 vols

I Nazarini a Roma, exhibition catalogue, Galleria Nazionale d'Arte Moderna, Rome 1981

NIBBY, A *Viaggio nei contorni di Roma*, Rome 1819, 2 vols

NIBBY, A *Tivoli e le sue vicinanze*, 1825 (reprinted 1942)

The Oxford Classical Dictionary, edited by N G L Hammond and H H Scullard, 2nd edn, Oxford 1972

PERSICHETTI, N *La Via Salaria nei circondari di Roma e Rieti*, Rome 1909

PLATNER, S B and ASHBY, T *A Topographical Dictionary of Ancient Rome*, Oxford and London 1929

PORTOGHESI, P *Roma del Rinascimento*, Milan 1971, 2 vols

QUENNELL, P and others: *The Colosseum*, New York 1971 (reprinted 1978)

QUERCIOLI, M *Le Torri di Roma*, Rome 1985

QUILICI, L *La Via Prenestina: I Suoi Monumenti, I Suoi Paesaggi*, Rome 1977

Roma Antiqua: Forum, Colisée, Palatin, exhibition catalogue, Villa Medici, Rome 1985/Ecole Nationale Supérieure des Beaux-Arts, Paris 1986

Roma Capitale 1870–1911: Architettura e Urbanistica, exhibition catalogue, Rome 1984

ROMANELLI, P *Palestrina*, Rome 1967

SACCHETTI, G C 'Il Cardinale Giulio Sacchetti (1587–1663)', *Studi Romani*, vii, 1959, pp405–16

SALERNO, L, and others: *Via Giulia: Una Utopia Urbanistica del 500*, Rome 1973

SPARTA, S *I Campanili di Roma*, Rome 1983

TESEI, G P *Le Chiese di Roma*, Rome 1986

Tevere: Un Antica Via per il Mediterraneo, exhibition catalogue, S. Michele a Ripa, Rome 1986

TOMASSETTI, G *La Campagna Romana: Antica, Medioevale e Moderna*, edd. L Chiumenti and F Bilancia, Florence 1979, 6 vols

Villa e Paese: Dimore nobili del Tuscolo e di Marino, exhibition catalogue, Palazzo Venezia, Rome 1980

WARD PERKINS, J B *Roman Imperial Architecture*, Harmondsworth 1970 (reprinted 1981)

WEIL, M S *The History and Decoration of the Ponte S. Angelo*, Ann Arbor 1969

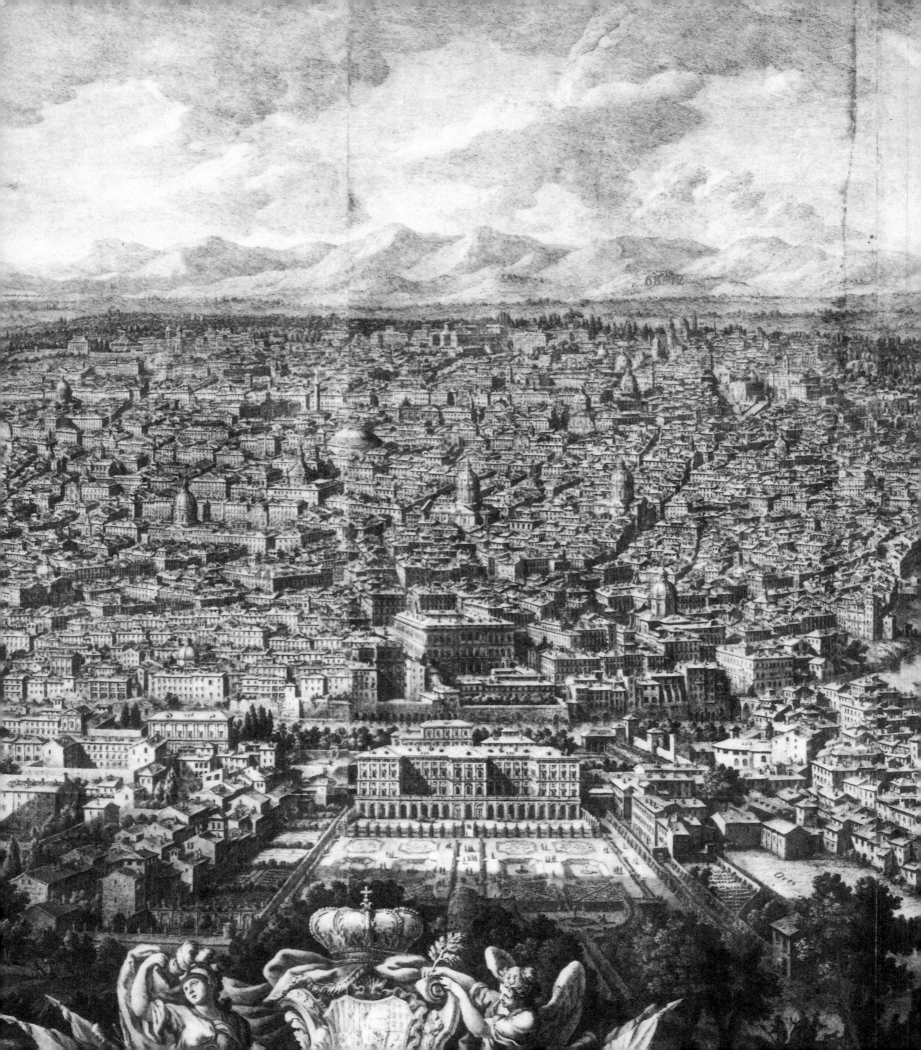